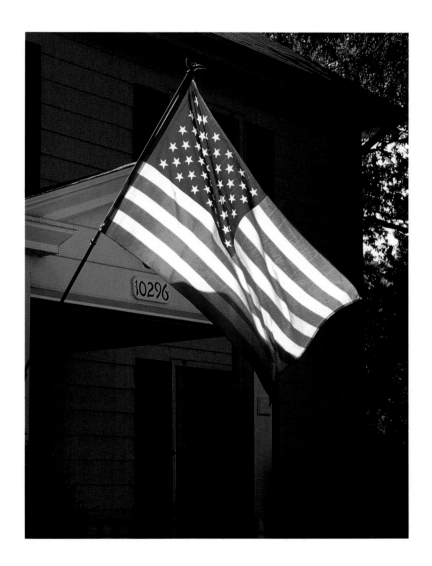

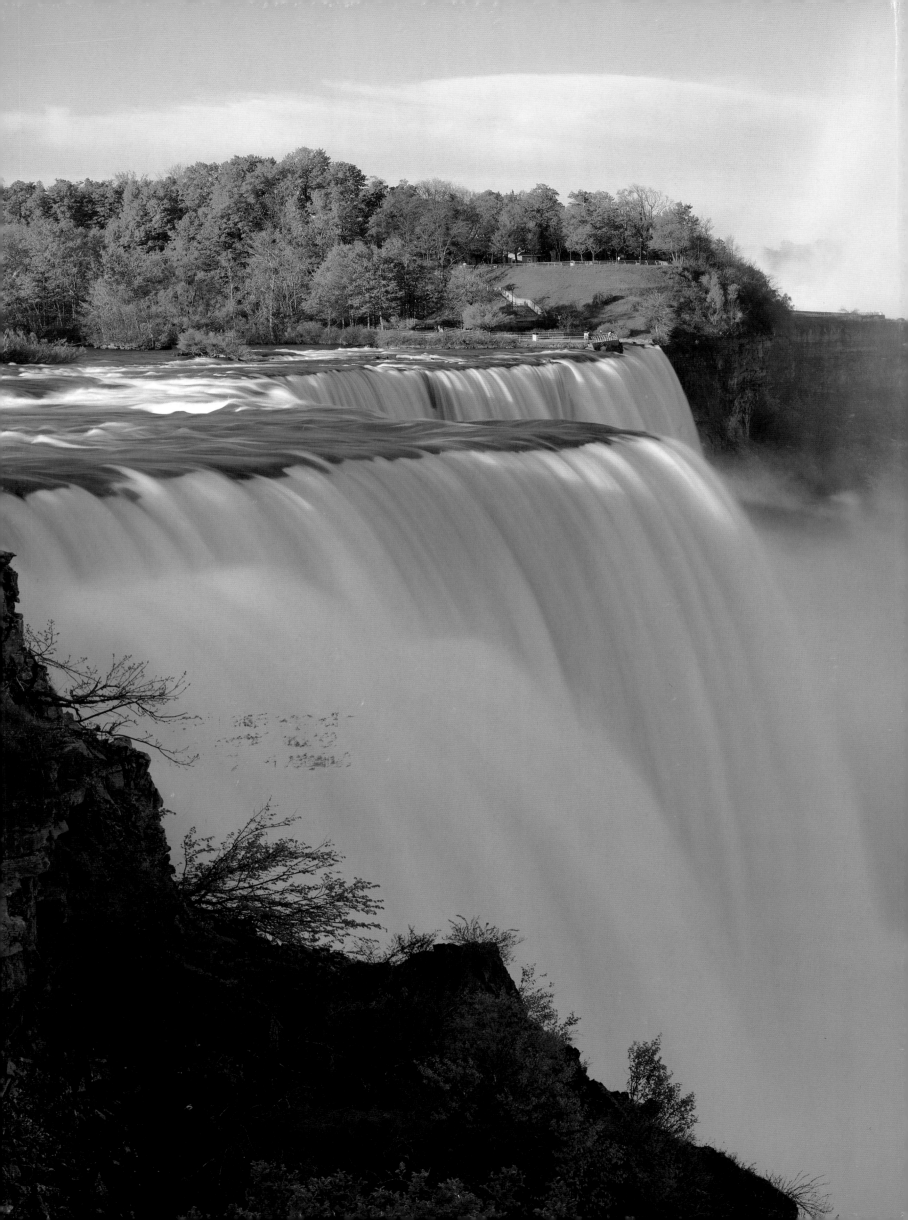

AMERICA

PHOTOGRAPHY BY FRED HIRSCHMANN

ESSAYS BY SUZAN HALL

FOREWORD BY ANN ZWINGER

GRAPHIC ARTS CENTER PUBLISHING®

International Standard Book Number 1-55868-195-7
Library of Congress Catalog Number 94-77261
Photographs © MCMXCIV by Fred Hirschmann
Text and captions © MCMXCIV by
Graphic Arts Center Publishing®
An imprint of Graphic Arts Center Publishing Company
P.O. Box 10306 • Portland, Oregon 97296-0306
503/226-2402; www.gacpc.com

President • Charles M. Hopkins
Editor-in-Chief • Douglas A. Pfeiffer
Managing Editor • Jean Andrews
Designer • Robert Reynolds
Production Manager • Richard L. Owsiany
Printing • Haagen Printing
Binding • Lincoln & Allen Co.
Printed in the United States of America
Eighth Printing

Half title page: A front porch in the town of Massawadox, Virginia, displays America's beginnings, her heritage, and her pride. The American flag's unique stars and stripes design was adopted by Congress on June 14, 1777, one year after George Washington asked Betsy Ross to make the flag. *Frontispiece:* A destination for honeymooners for decades, Niagara Falls embodies both the 167-foot American Falls and the 158-foot Canadian Horseshoe Falls. *Following page:* The Lincoln Memorial in Washington, D.C., was built to honor Abraham Lincoln, America's sixteenth president.

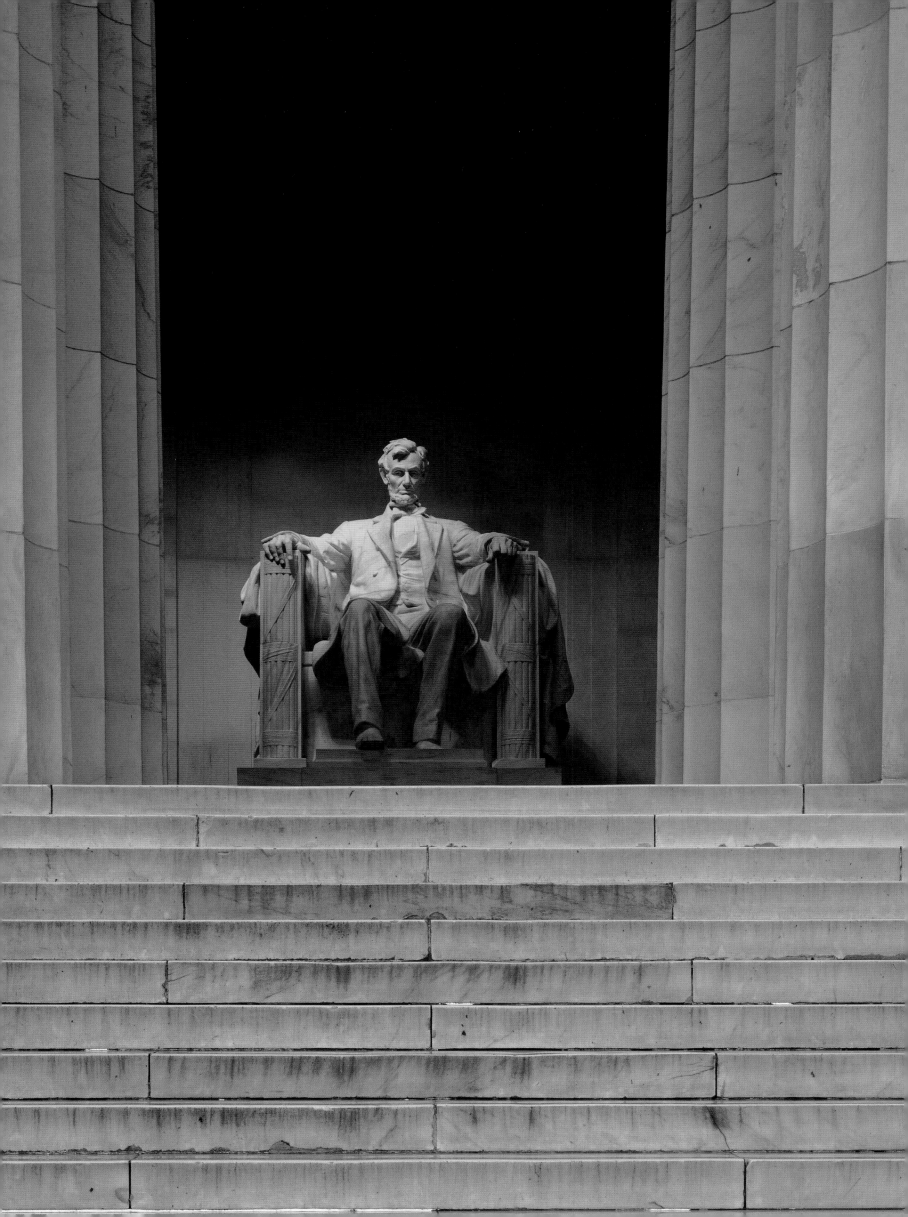

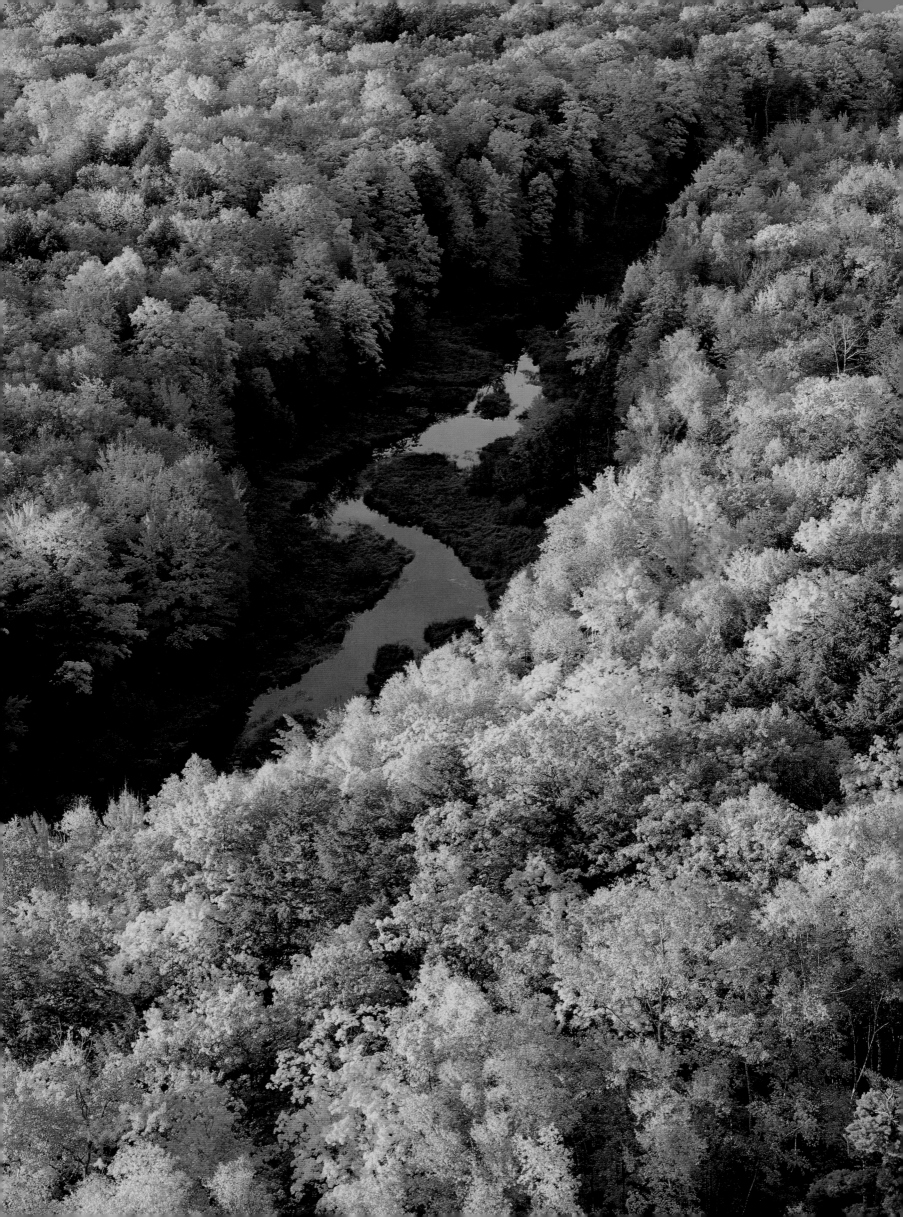

FOREWORD

On Captiva Island off the southern shore of Florida, tiny ovals of limestone intermix with myriads of seashells, whole because of the gradual beach and waves quieted in the Gulf of Mexico. When the waves wash them, they tinkle like an old player piano in the next room. When the highest tides of the year sweep the Olympic Peninsula coastline at the Quileute Indian reservation, the retreating waves rattle and roll the beach

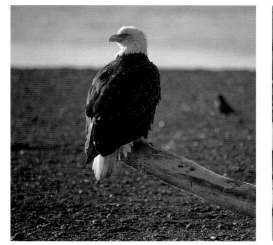

Above: *Familiar to most people as America's national emblem, the bald eagle has a wing span exceeding seven feet. The huge nests of these fish-eating birds can weigh over a ton.* Above right: *Polished beach cobbles pave Lake Superior's shores in Michigan's U.P.* Left: *The Porcupine Mountain Wilderness State Park demonstrates the riot of autumn colors in the deciduous forests of Michigan and other areas east of the Mississippi River.*

cobbles, making them chatter and warble. Shells have been ground to nothing and only the stones remain, smoothed to ovals, hurried down from the straight-up walls that back the beach, bits and pieces of the far northwestern mountains. The oceans that formed these beaches shaped the varied outlines of this country, scalloped and bayed, rough and rocky, flat and gentle.

Scuffling along another kind of beach in the middle of the United States, I watch for the small, dark green stone, inlaid with cream-colored rectangular crystals, that says "Colorado River," a rock born in the San Juan Mountains to the northeast in Colorado and, before Glen Canyon Dam, carried down into the Grand Canyon, occurring only here, a uniqueness that marks many places in this country.

In the small things you can hold in your hand lies the magnificent diversity of this country, pebbles black and ochre, cream and red, green and white, and every shade of gray. Along North Carolina's Outer Banks, Wyoming's Green River, Indiana's

White River, Massachusetts' Assabet River, are pebbles, bits and pieces of mountains and hills, Adirondacks and Rockies and Cascades, carried down rivulet to creek to stream to Mississippi or Connecticut or Columbia, to some shore or backwater somewhere. The river brings the pebbles down; the ocean rocks them back and forth.

The travels of pebbles speak to the journeys of this countryside, a landscape on the move, sometimes imperceptibly, at other times with rude awakenings: two continental plates jockey together and the San Andreas jerks; Mount St. Helens' truncated cone smokes with hidden agendas. In the East, the Atlantic Ocean wedges pebbles into a craggy granite crack on the Maine shore, locking a white quartz hummingbird's egg into a gray matrix.

These pebbly symbols, these small talismans, in all their variety, speak of a vast multitude of journeys and terrains in this country, born of heat and underground fire, cooled and farmed, eroded into places for towns and cities. A huge variety of colors and types and shapes reflects the multiplicity of those of us who call this country home, come from different places, gathered from different shores.

Take a pebble, river-molded or ocean-smoothed, in your hand and turn to the four points of the compass. Envision mountains and canyons, broad meadows and narrow defiles, flat fields and rolling hillocks laid with tall grass prairies and old growth forests and savannahs, wetlands and deserts, places wild and places peopled. Let that nubbin of somebody's mountain evoke this country of magnificent breadth and beauty. By closing a hand over its shape and size and color, we can evoke the movement and change, the yesterdays and tomorrows of this country. By opening this book to Fred Hirschmann's magnificent photographs, we can absorb this country's todays and enjoy the complexities of a country so vast we can never know it all.

Be thankful both for the pebbles and for photographers and what they tell us. They've been there. They tell it all.

ANN ZWINGER

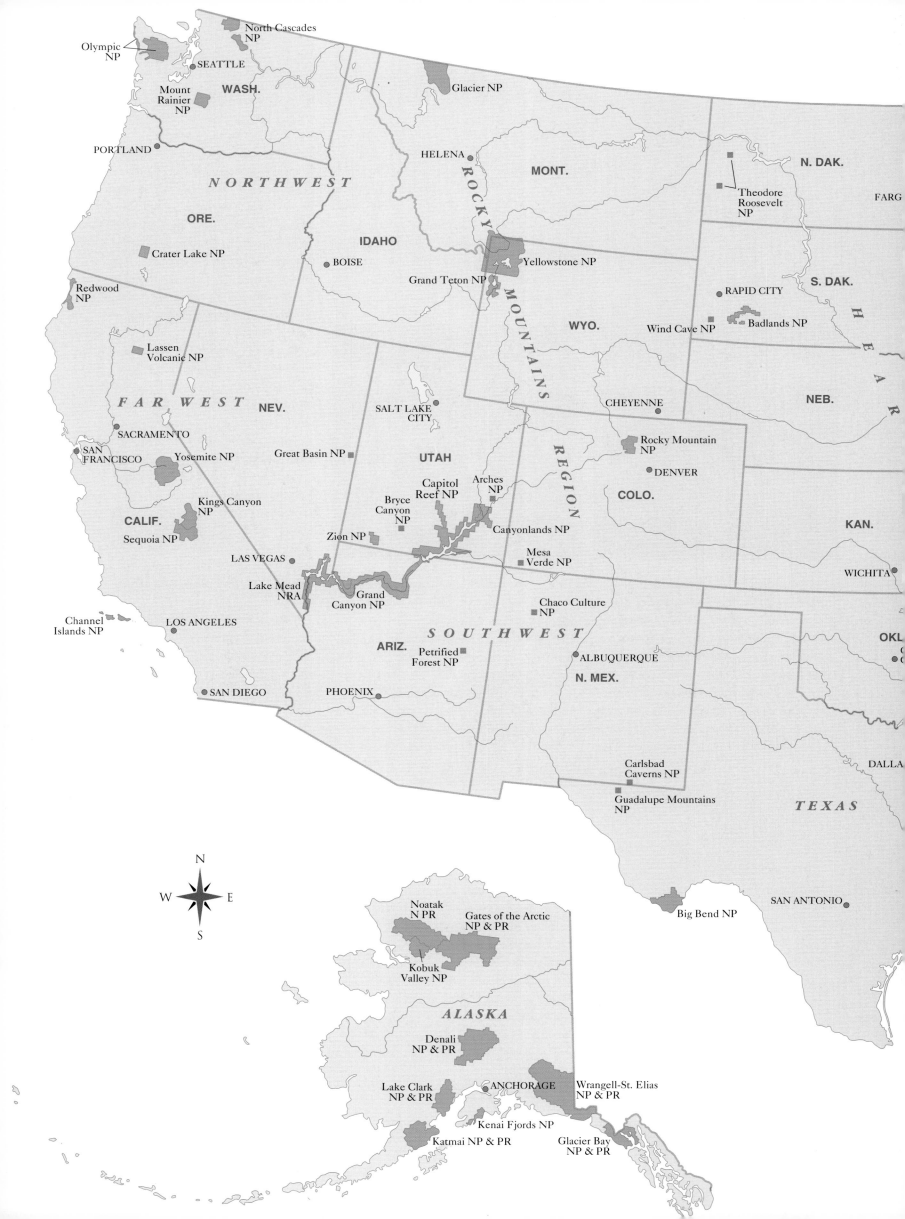

AMERICA

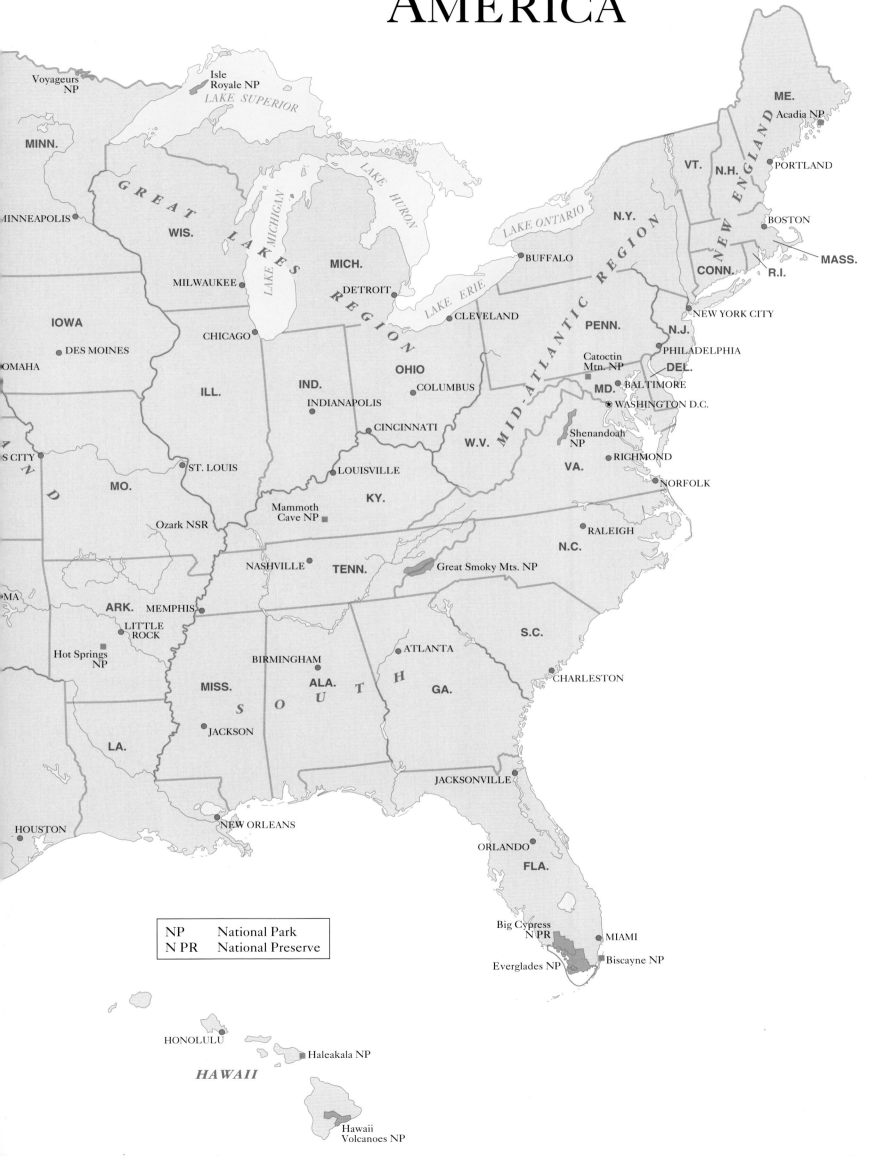

Voyageurs NP

Isle Royale NP

LAKE SUPERIOR

MINN.

MINNEAPOLIS

WIS.

MILWAUKEE

LAKE MICHIGAN

LAKE HURON

MICH.

DETROIT

G R E A T L A K E S R E G I O N

ME.

Acadia NP

VT. N.H.

PORTLAND

N.Y.

LAKE ONTARIO

NEW ENGLAND

BOSTON

BUFFALO

CONN.

MASS.

R.I.

IOWA

DES MOINES

CHICAGO

CLEVELAND

LAKE ERIE

PENN.

N.J.

NEW YORK CITY

OMAHA

ILL.

IND.

OHIO

COLUMBUS

PHILADELPHIA

Catoctin Mtn. NP

DEL.

BALTIMORE

MD.

MID-ATLANTIC REGION

INDIANAPOLIS

CINCINNATI

WASHINGTON D.C.

S CITY

MO.

ST. LOUIS

LOUISVILLE

W.V.

Shenandoah NP

RICHMOND

VA.

NORFOLK

Ozark NSR

Mammoth Cave NP

KY.

RALEIGH

MA

ARK.

MEMPHIS

NASHVILLE

TENN.

Great Smoky Mts. NP

N.C.

LITTLE ROCK

Hot Springs NP

S.C.

Hot Springs NP

BIRMINGHAM

ATLANTA

CHARLESTON

MISS.

ALA.

S O U T H

GA.

LA.

JACKSON

JACKSONVILLE

HOUSTON

NEW ORLEANS

ORLANDO

FLA.

| NP | National Park |
| N PR | National Preserve |

Big Cypress N PR

MIAMI

Biscayne NP

Everglades NP

HONOLULU

Haleakala NP

HAWAII

Hawaii Volcanoes NP

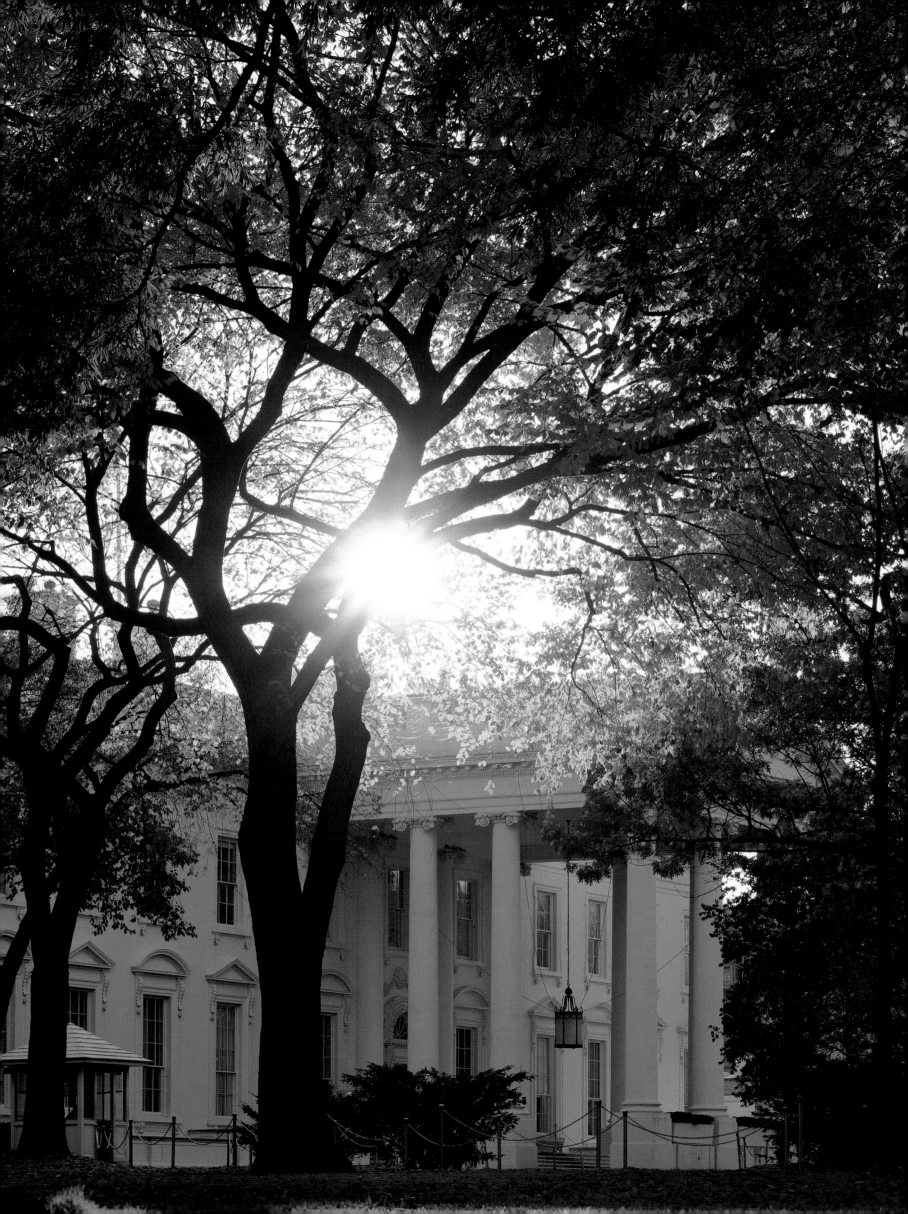

MIDDLE ATLANTIC

This is where the United States of America was born. It was conceived in Philadelphia, in June 1776, when the Second Continental Congress voted to formalize a rebellion already underway and Thomas Jefferson expressed the new nation's credo in the Declaration of Independence.

Then, in six years of war, America's bedraggled, ill equipped, determined rebels wore out the British and won their freedom.

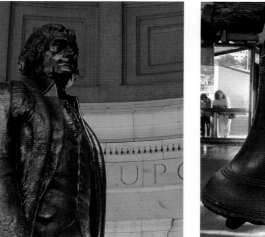 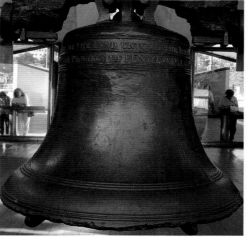

Above: *The Thomas Jefferson Memorial was created to honor America's third president.* Above right: *The Liberty Bell was cast in the mid-1700s to celebrate the fiftieth anniversary of the Commonwealth of Pennsylvania.* Left: *Built in 1792, the White House has been home to presidents since 1800, when it was occupied by John Adams. The British burned it in 1814, but it was rebuilt later.*

The marks of their struggle are scattered through the Mid-Atlantic states; there is no keener distillation of misery and grit than the story of Washington's winter at Valley Forge.

But it was in the sweltering Philadelphia summer of 1787 that American government was truly born. With debate as heated as the weather, fifty-two impassioned delegates to the Federal Convention argued their way to the most successful constitution in history. Most venerable among them were George Washington and Benjamin Franklin.

Visionary as they were, those founding fathers would be amazed by today's realities. Designed for four million people in thirteen colonies along the Atlantic Coast, the Constitution now serves more than two hundred sixty million people in fifty states in a nation that spans the continent and reaches into the Pacific and up to the Arctic.

Washington, D.C., the capital that had not yet been planned, is now a mature city, as grand as any of its older European counterparts, and a potent force in world affairs. New York has become one of the largest cities in the world, an international arbiter of culture and finance.

It has happened quickly. When Thomas Jefferson became America's third president approximately two centuries ago, the White House was one of a scattering of new buildings in a backwoods clearing. The problems of Congress included mosquitoes and red clay mud. The president planted his own lawn, and when Meriwether Lewis brought back bears from his Western expedition, they were kept in Jefferson's fenced backyard.

New York City, while older than the capital, is still a child compared to London or Paris. It is true, the Dutch paid less for Manhattan Island in 1626 than it costs to have a good dinner there today. The transaction was meaningless, though, because Native Americans did not believe that land could be owned. Since then, a million and a half people have wedged themselves onto that 22.6-square-mile island, in a condensation of energy and diversity unlike any other in the world.

The Atlantic seaboard is weighted with population and power. Nearly one-tenth of the nation's population now lives in the crowded corridor between Washington, D.C., and New York City in a nonstop flow of communities that inspired the term *megalopolis*. But to focus on the urban is to miss the richness of the area.

On the map, Manhattan is just a dot in a state that stretches to the shores of two Great Lakes. Playing counterpoint to the City's concrete intensity are the grand vistas of the Hudson River Valley; the verdant Appalachian Mountains; and the cool, clear Adirondack lakes. Pennsylvania, the broad state William Penn founded to nurture religious diversity, reaches westward with rich, rolling farmland, over the Alleghenies and past Pittsburgh, the city steel built.

Beyond the urban hustle, history lingers, tradition persists, and the work of the land continues. While Washington lawmakers debate and Wall Street deal makers negotiate, oyster men haul in bounty from the Chesapeake Bay, New Jersey farmers harvest produce, and Pennsylvania's Amish still work their fields with horse-drawn plows.

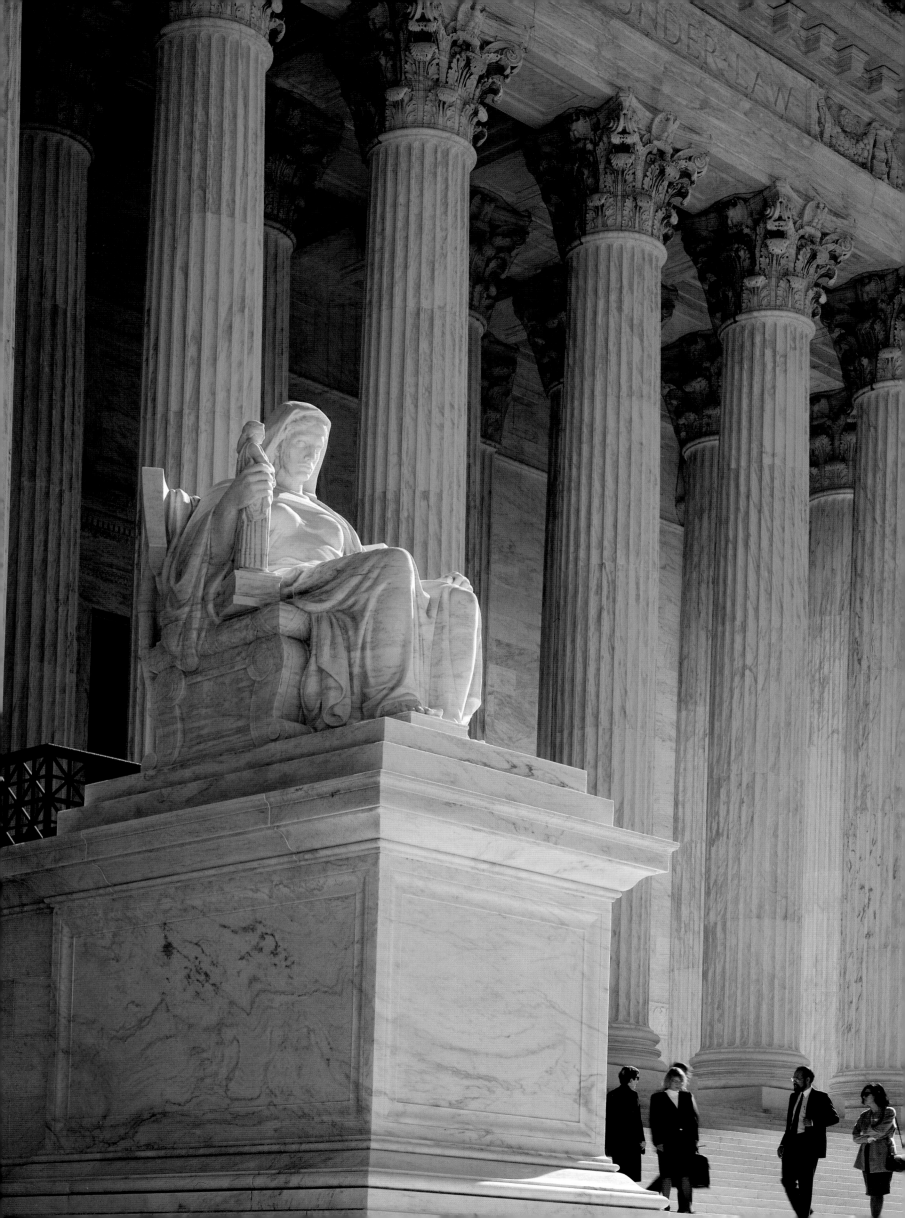

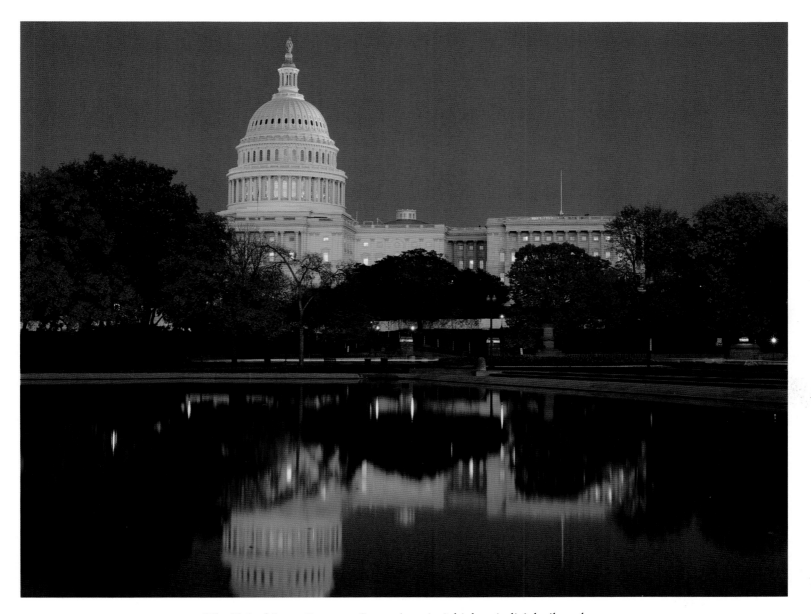

◄ The United States Supreme Court, America's highest judicial tribunal, was established in 1789 with a total of six justices. Today, nine justices make up the Court. Created by the Constitution, the Supreme Court has jurisdiction over all courts in the nation and sets a legal system model for other countries. ▲ Designed by William Thornton, the Capitol is where Legislative Branches of Congress meet. In 1793, George Washington laid the cornerstone.

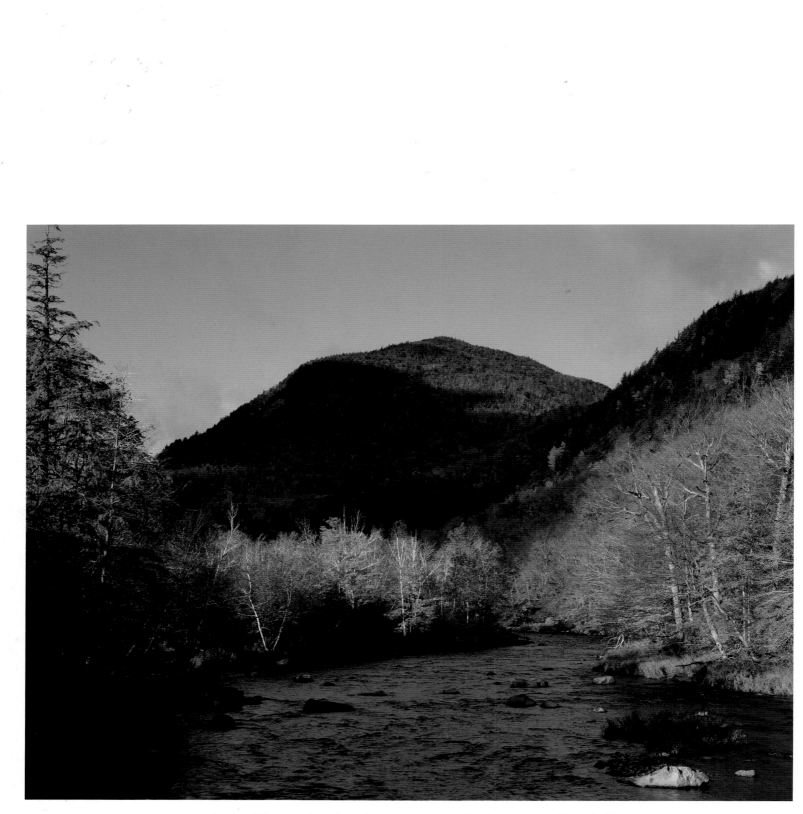

▲ In the Adirondacks of northeastern New York, some two and one-half million acres have been set aside as parklands. The public and private lands of the Adirondacks, with a high point of 5,344 feet, comprise six million acres of beauty, including the Ausable River's falls and rapids. The Ausable and Hudson river drainages encompass one-fourth of the state.
► Manhattan is a major center of world trade and culture with Wall Street, Broadway theaters, and Greenwich Village. The 22.6-square-mile island of Manhattan, purchased in 1626 from the Man-a-hat-a Indians for $24.00, today supports a population of more than one and one-half million.

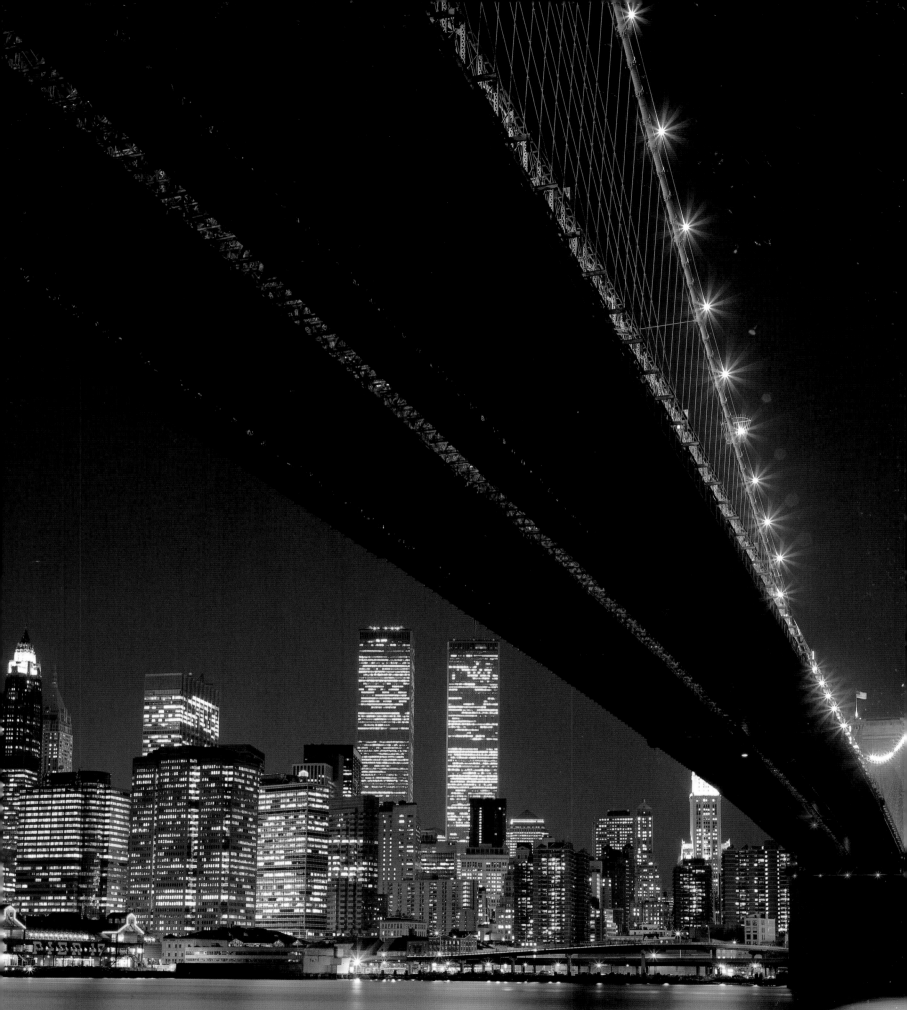

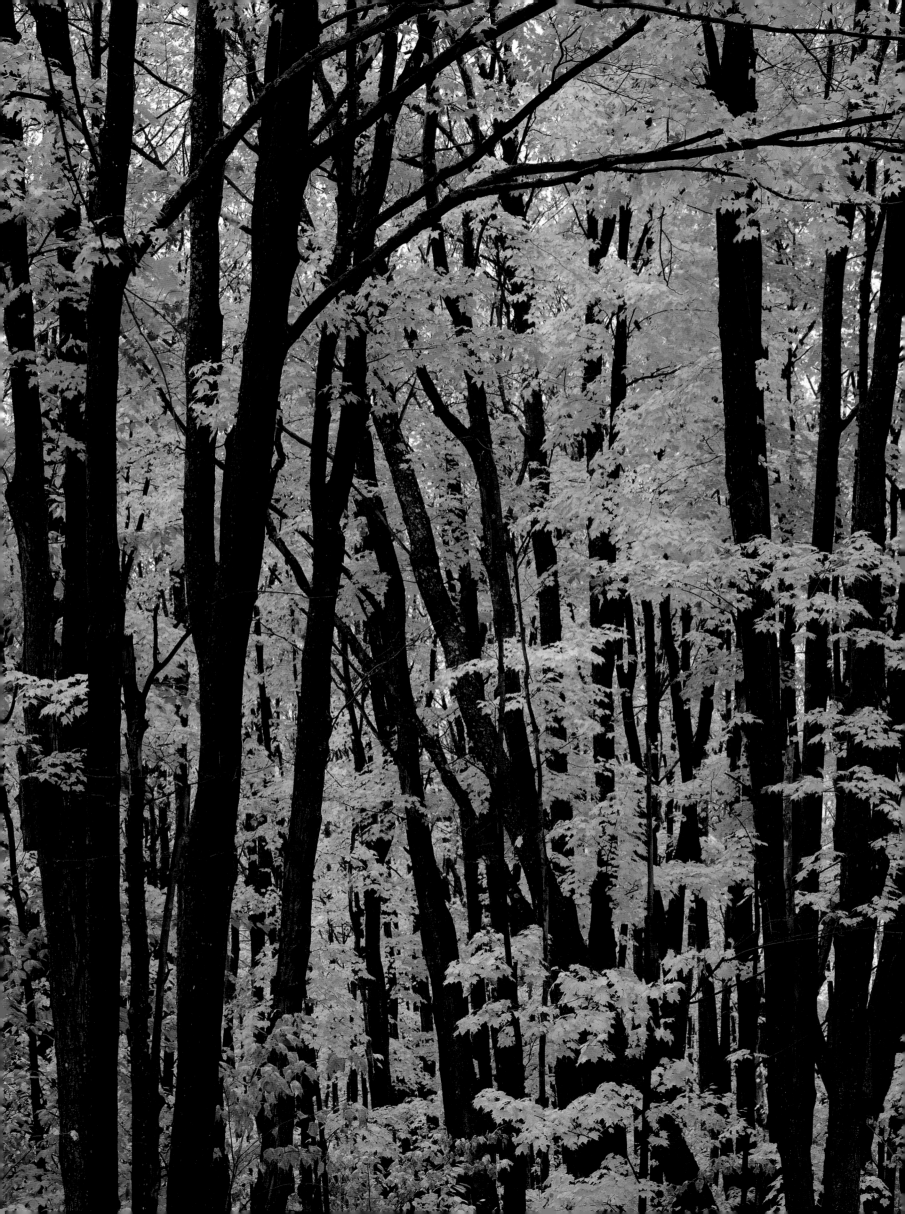

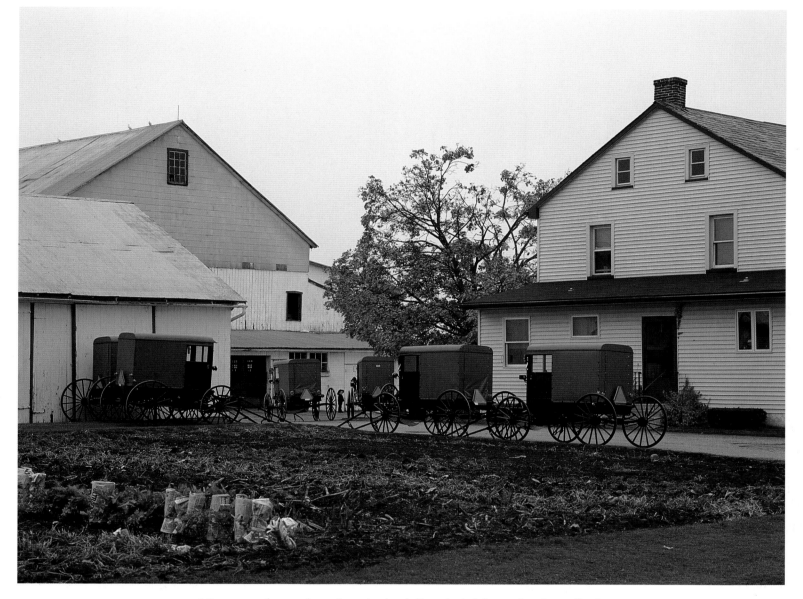

◄ Sugar maples, such as these in the Adirondack Mountains, beautify the Northeast. They are valued not only for their beauty, but for their wood. The sap also produces maple syrup, for which New England is famous.
▲ Part of a group known as the Pennsylvania Dutch, the Amish broke away from the Swiss Mennonites in 1690. The Amish arrived in America around 1727 and today live in communities in twenty-three states. In Lancaster County, Pennsylvania, Amish church services are still held in people's homes. The Amish retain their traditional ways, working some of America's most productive farmlands with the same methods used for centuries.

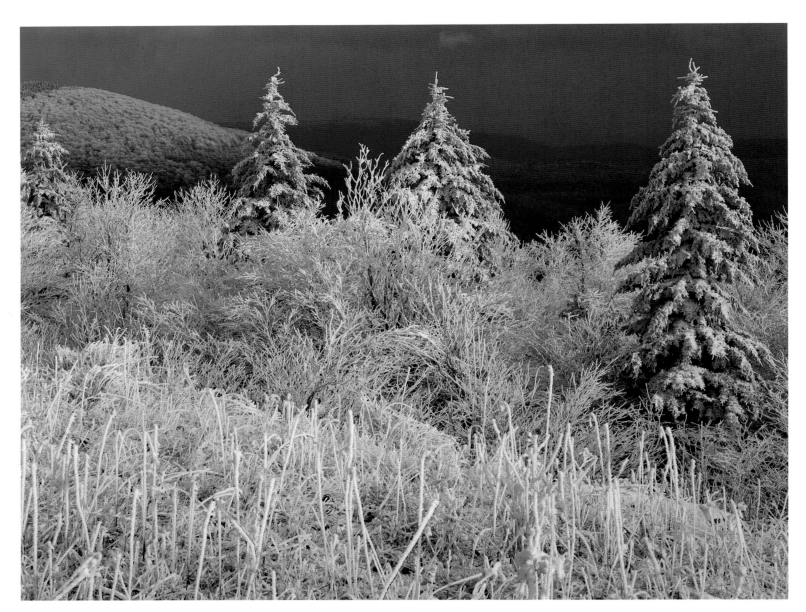

▲ The United States Forest Service began in 1905 and now oversees over 187 million acres. In West Virginia's Monongahela National Forest, rime ice—formed from supercooled fog droplets—clings to subalpine vegetation.
► The "new" Glade Creek Grist Mill in West Virginia's Babcock State Park was completed in 1976. Built as a re-creation of Cooper's Mill, the basic structure came from the Stoney Creek Grist Mill dating to 1890. This is a living monument to some five hundred mills that once thrived in the state.
►► Upon these tilled Pennsylvania fields, in 1863, more men fell than in any other battle ever fought in North America. The turning point of the Civil War, the Battle of Gettysburg left over fifty-one thousand casualties.

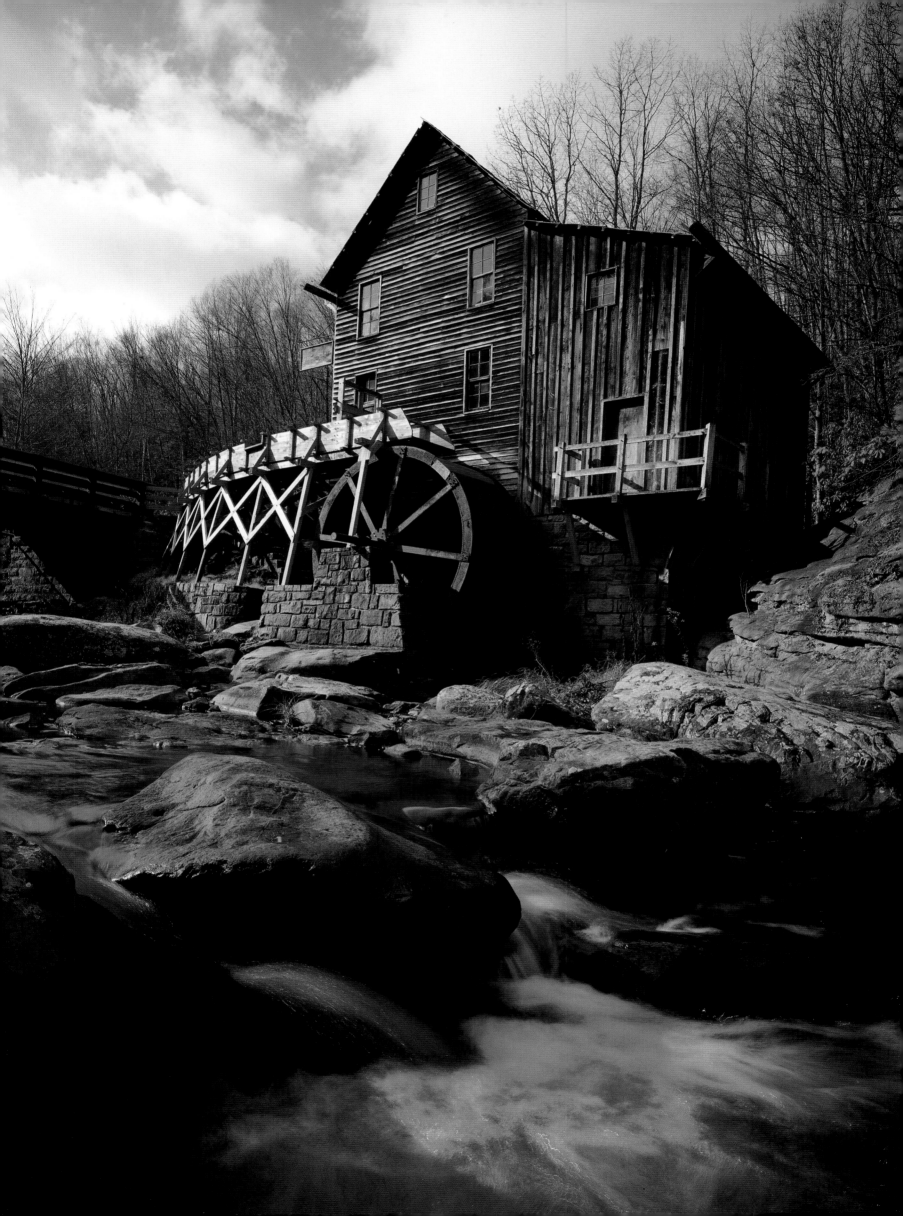

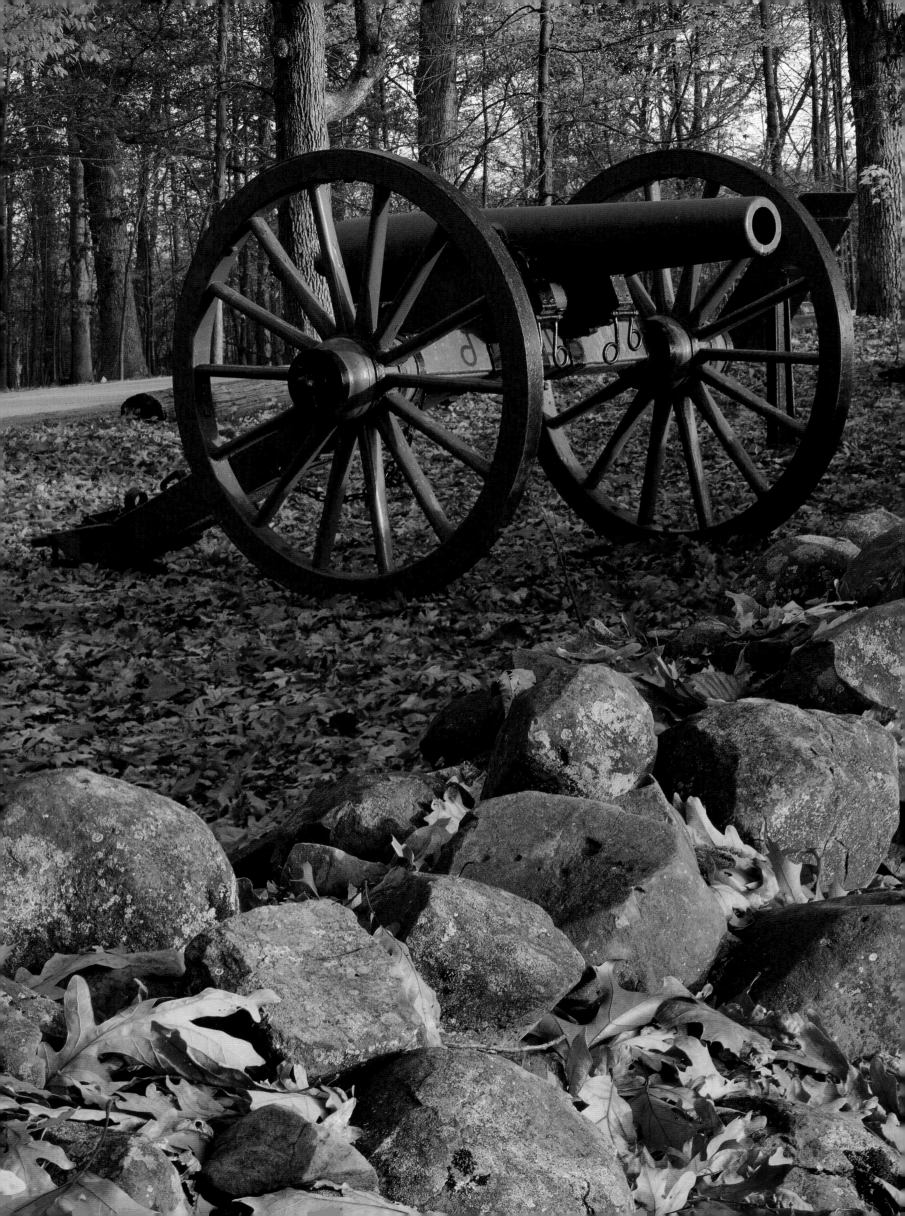

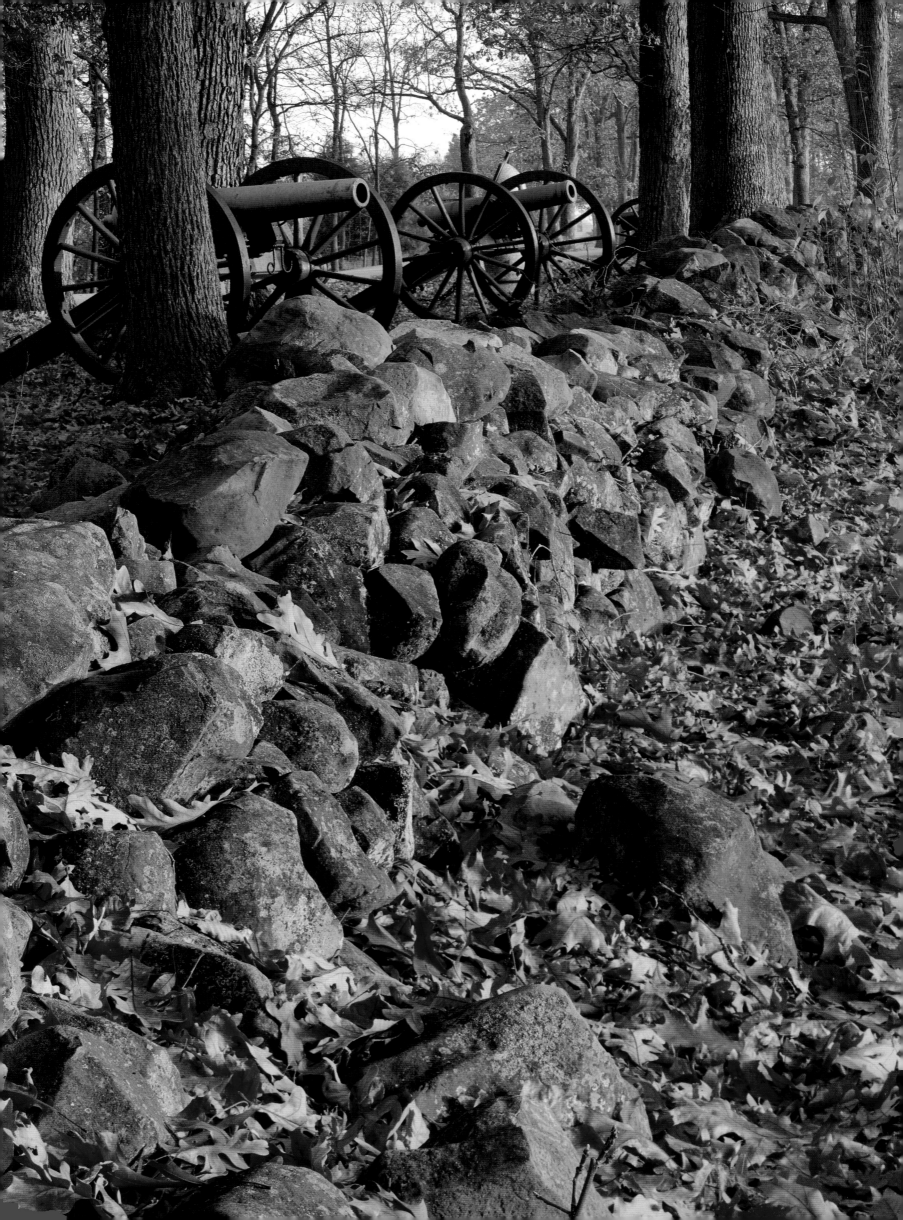

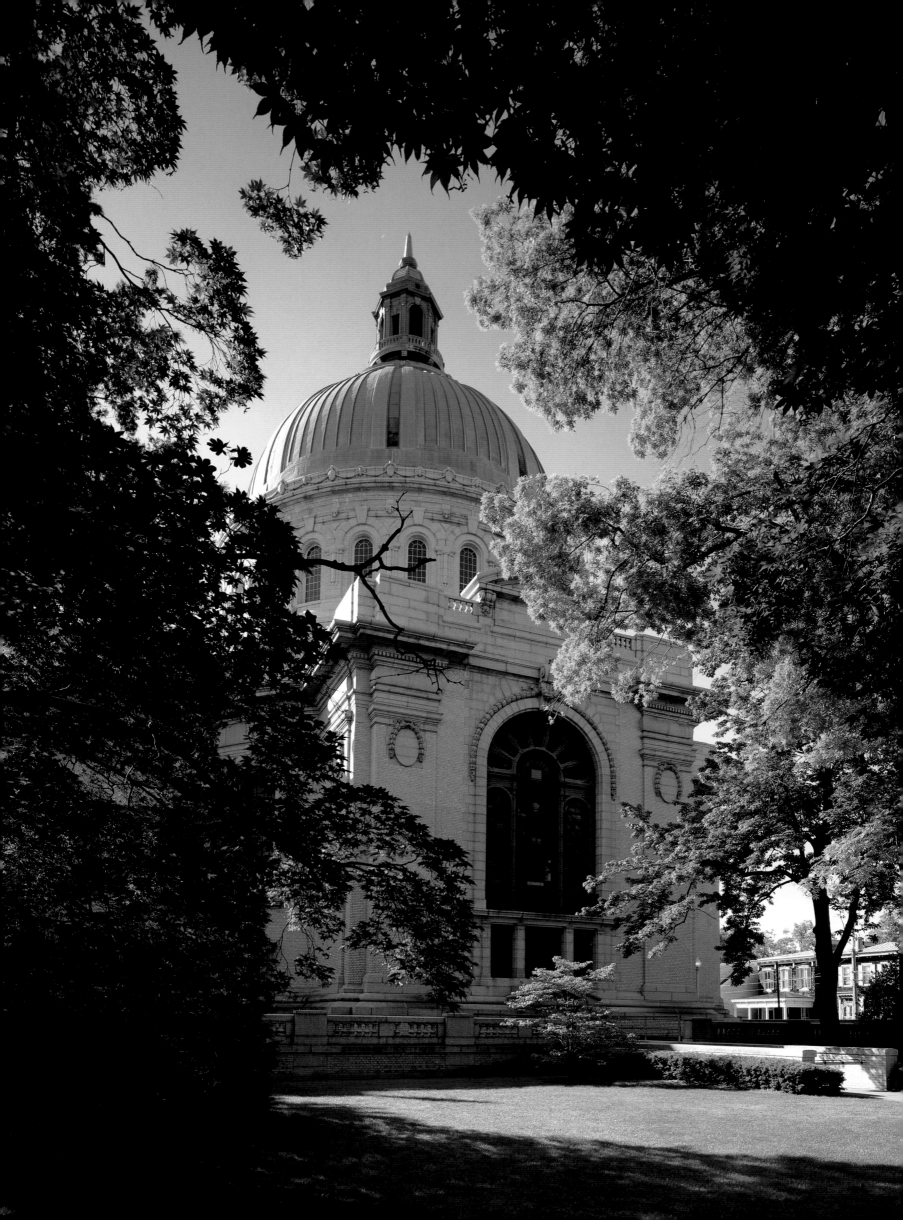

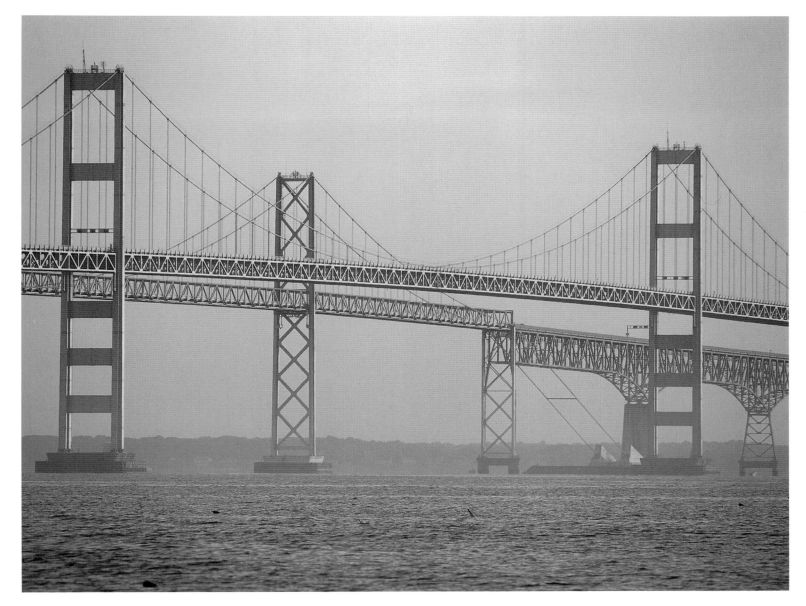

◄ The chapel of the U.S. Naval Academy houses the crypt where John Paul Jones was buried. Established in 1845 at Fort Stevens in Annapolis, the academy has granted Bachelor of Science degrees to some sixty-one thousand cadets—including women, who were first admitted in 1976.
▲ Chesapeake Bay, the largest inlet along the U.S. Atlantic Coast, is spanned by the William Preston Lane Jr. Memorial Bridge (US50), near Annapolis.

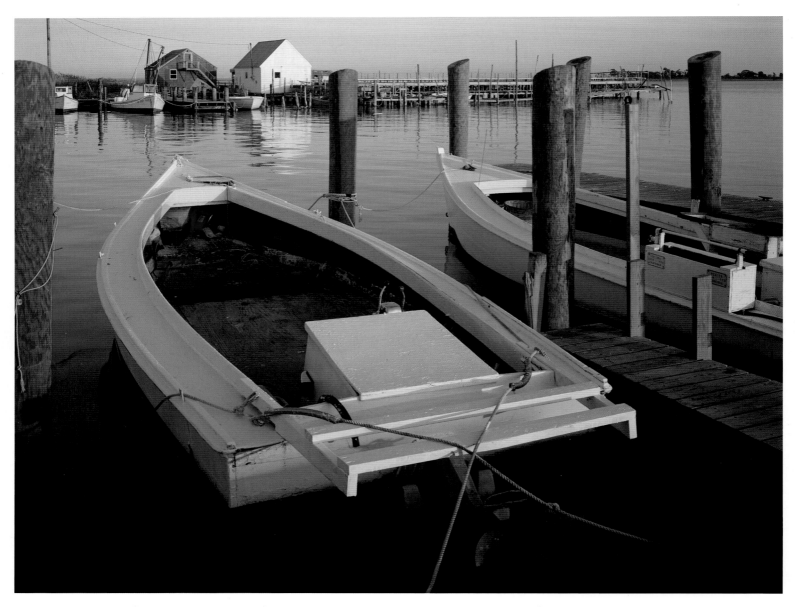

▲ A fishing boat at Saxis, Virginia, on the Chesapeake Bay exemplifies the many working boats that account for the area's shellfish harvests. Important commercial catches include clams, alewives, squeteague, croakers, shad, and oysters. Chesapeake Bay, with its confluence of rivers and its major ports, is a mega-nucleus for commerce and trade. Chesapeake Bay was the site of the first permanent English settlement in 1607—Jamestown, Virginia. ▶ Near Nassowadox, Virginia, a barley field will soon be ready for harvest. Barley—predominantly grown for animal feed and malt—is also an ingredient in cereals and bread, along with other grains such as wheat and rye.

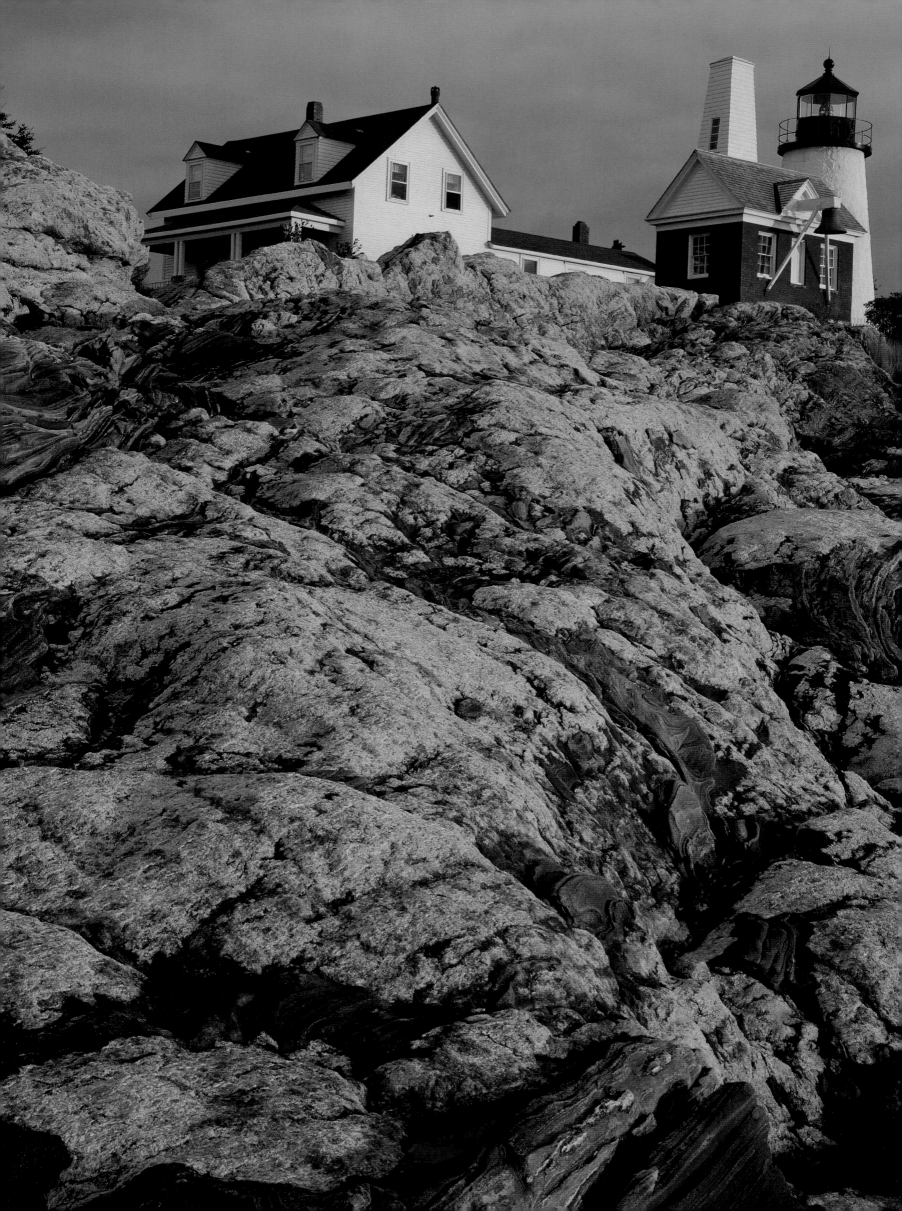

NEW ENGLAND

A covered bridge, a stone fence, a white-steepled church among the crimson trees, a bucket and tap on a sugar maple, a lobster-man in heavy weather gear hauling in his catch—everyone knows these images, and knows where they belong. This is the only region in America whose name references history, not locale. More than two hundred years after the Revolutionary War, this is New England, still.

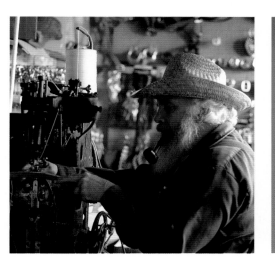

Above: *Vermont harbors highly skilled crafts people. A leather worker preserves traditions that are the fabric of New England's history.* Above right: *Great Stone Face, Old Man of the Mountain, is an icon of New Hampshire.* Left: *Pemaquid Point Lighthouse has stood watch on the shores of Maine since 1827.* Overleaf: *Vermont's Enosburg Falls typifies small-town America. Nearly 25 percent of the nation's population lives in small towns.*

This is where a band of Pilgrims shivered and starved through the Massachusetts winter of 1621 and, the following autumn, celebrated the first Thanksgiving. This is where a handful of stubborn farmers fired the first shots of the Revolution, determined to hold the bridge at Lexington. This is where many of the values we hold most dear were first nurtured.

Those first colonists, who risked their lives for religious freedom, also brought with them strong convictions about government and education. New Englanders remain fiercely protective of individual rights and committed to participatory government. Town meetings are still held regularly in rural New England; to attend is to see elemental democracy at work. The Massachusetts Bay Colony committed early to public education, mandating grammar schools in 1642.

The first college on American soil was chartered in Boston in 1650. Oliver Wendell Holmes may have exaggerated just a bit when he described mid-nineteenth-century Boston as "the thinking center of the Continent, and therefore the Planet," but that city had, and still retains, a distinct academic flavor.

This is a venerable part of our nation, but in the longer view of history, our tenure here has been barely a moment. This land area is one of the oldest on earth. Distant ancestors of the Berkshires and the Green Mountains heaved up from the ocean depth approximately half a billion years ago. During the Ice Age, glaciers scoured the land, creating fertile plains, carving the ponds and rivers, dumping piles of rock and debris, and bestowing upon the land its present face. Then the climate began to warm, and the forests grew.

When the Pilgrims arrived, New England was almost entirely wooded. The rivers and good shallow beaches teemed with fish, and farmland was to be had for the clearing. From the Natives, who were better farmers than warriors, the settlers learned how to take advantage of the bounty. The hook of land they first settled was aptly named Cape Cod, and that practical fish became an unofficial regional symbol.

Geographically, this area is anything but homogeneous. New England breaks into at least three regions: the shore, where the early settlers clustered around the natural harbors and fishermen found wealth; the central valleys, where hardy farmers thrived and the industrial revolution began; and the timber-and-lakes country to the north and west, which is so untouched that, even now, it lures pilgrims from the cities to seek freedom from stress.

The early explorers reported that sweet aromas met their ships as they approached the shores of New England—the fragrances of trees, wild strawberries, and burning cedar. Although the virgin forests no longer reach down to the shore, the New England woodlands still retain a strong allure. In autumn, their flamboyant colors draw "leaf peepers" by the carload.

The wild strawberries are fewer now, but New England still offers sensual pleasures, including wild Maine blueberries, tangy Vermont cheddar, fresh-pressed apple cider, and incomparable steamed lobster.

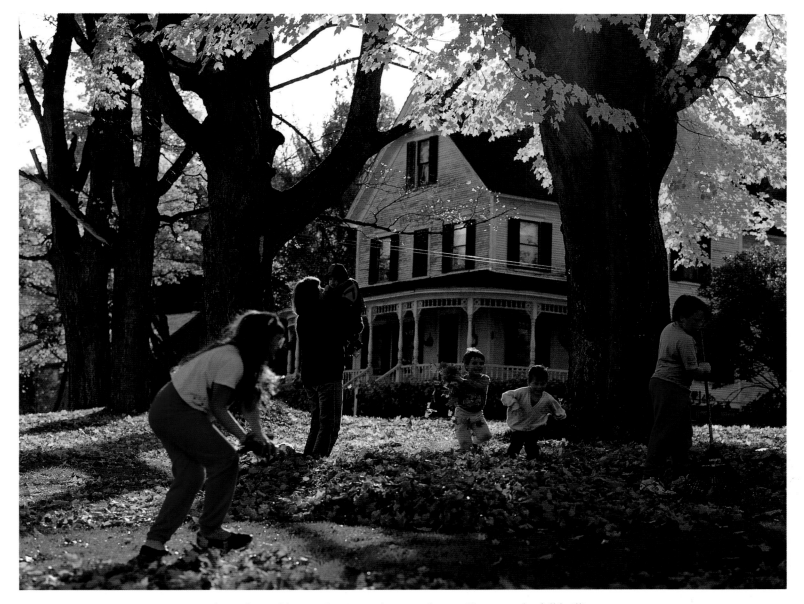

◄ Along the Cold River in Massachusetts, forests illustrate the fall brilliance that prevails throughout New England. In autumn, pine needles and leaves of the red maple—to name just a few of the wide variety of trees indigenous to the area—mingle on the forest floor to create a kaleidoscope of color.
▲ In both rural and urban America, autumn is a time when families share the work, as well as the fun. Cleaning up the season's leaves is a long-standing tradition, not only here in Vermont but also across the rest of the nation.

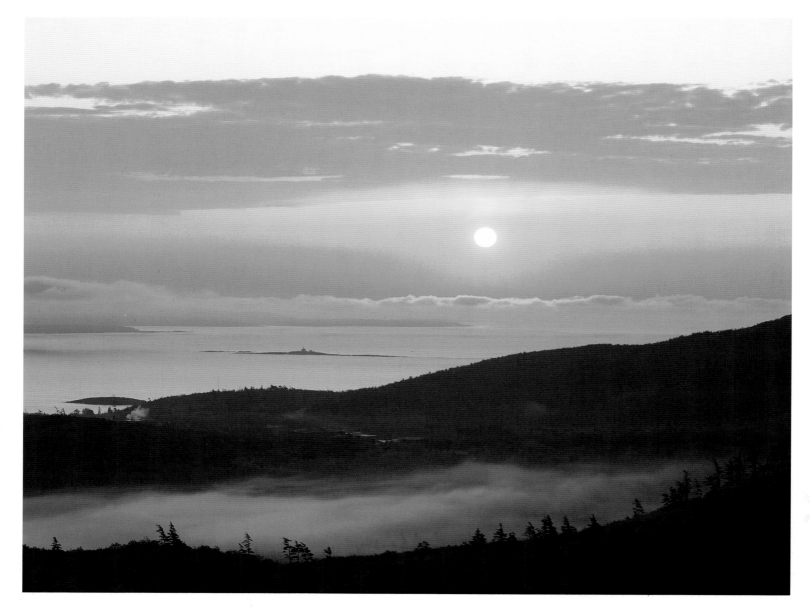

▲ Frenchman Bay is located in the second most popular national park, Maine's Acadia National Park. Established in 1919, the park combines ocean and mountain scenery, along with well-designed carriage roads. This park, neither carved out of public lands nor bought with public funds, was envisioned and donated through efforts of private citizens. Residents and visitors alike contributed time and resources to preserve Acadia's beauty. ▶ Sequestered amidst the hustle and bustle of modern Boston, the quaint Old State House, built in 1713, reflects the colonial days of Massachusetts.

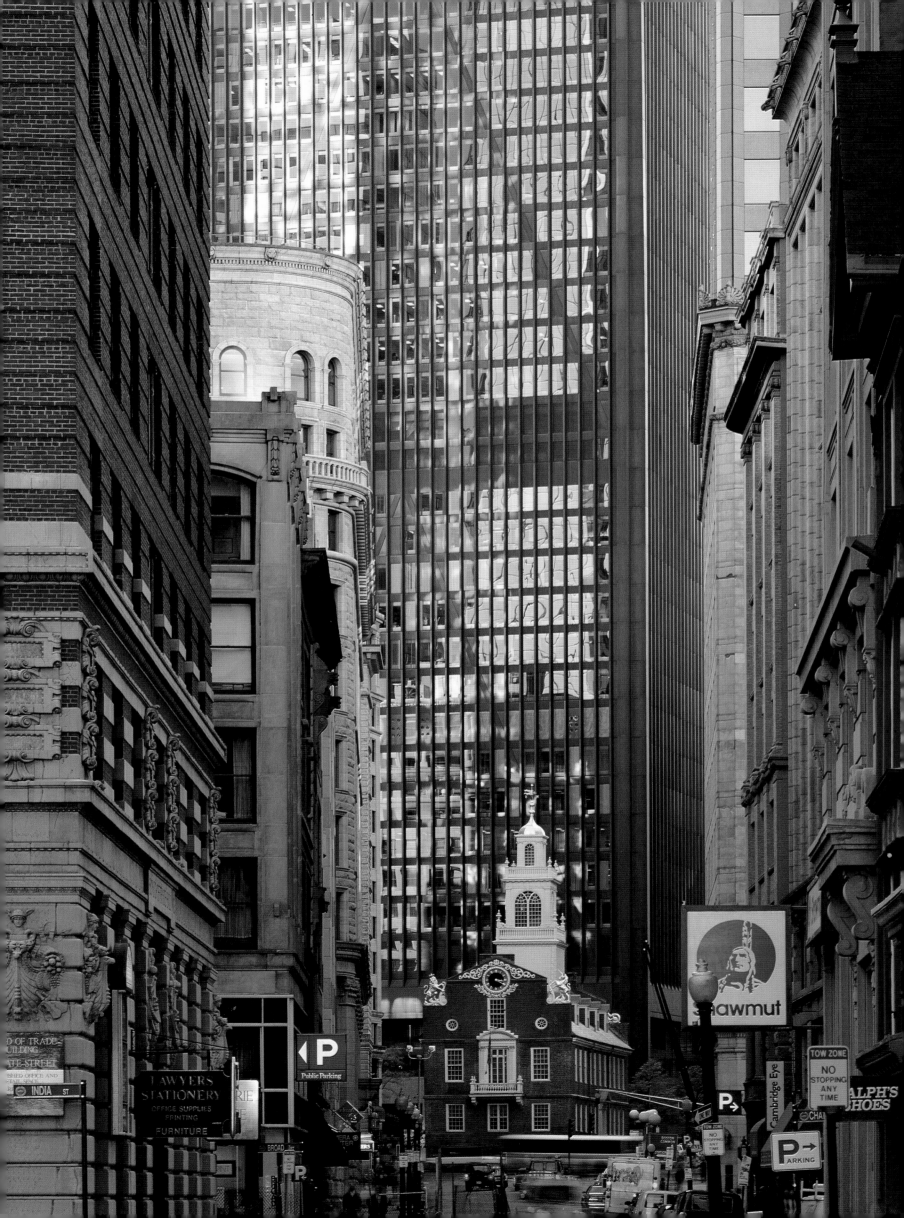

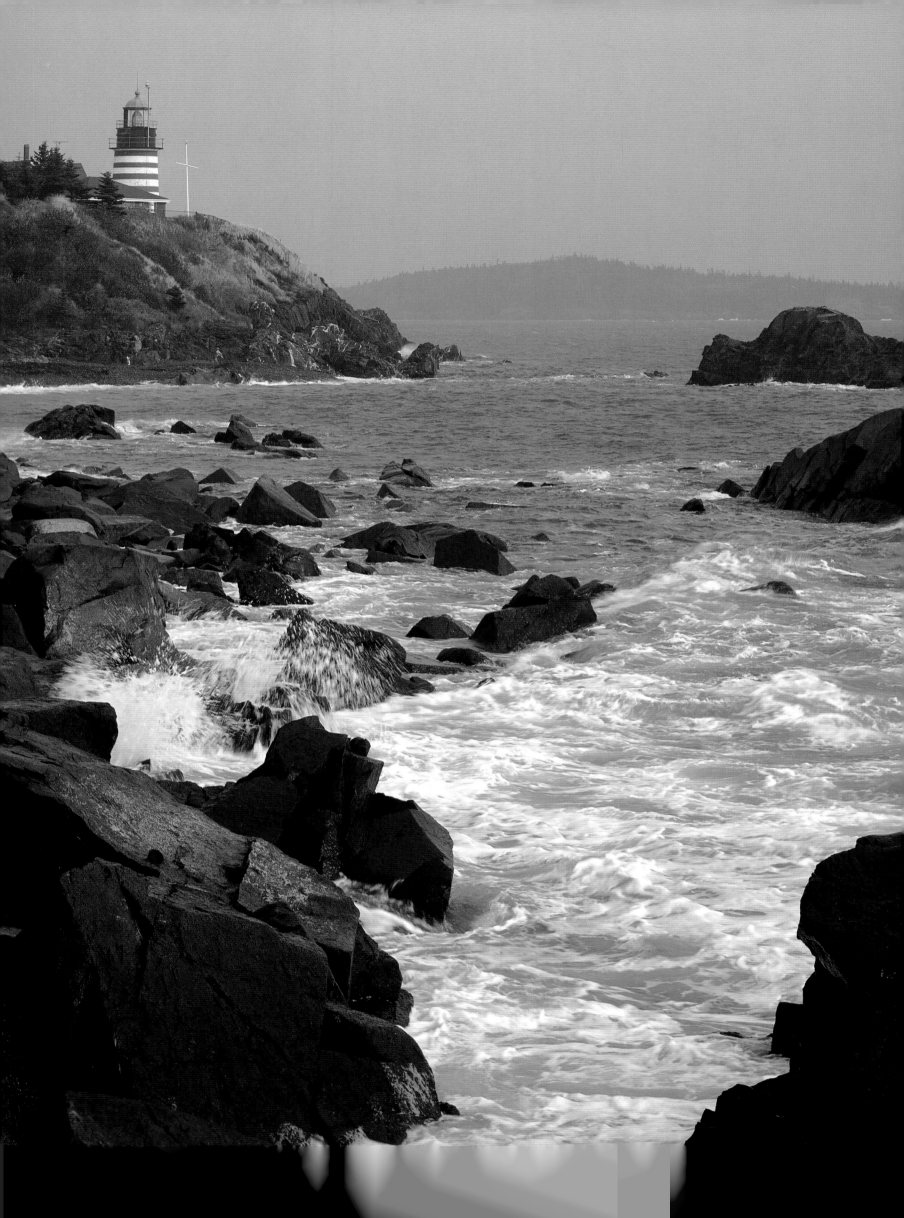

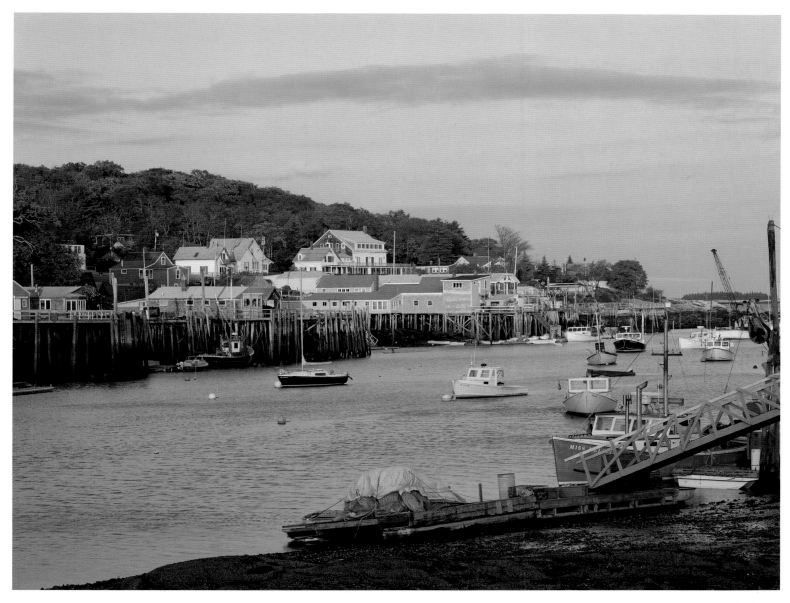

◄ Waves of the Atlantic Ocean strike the rocks of Quoddy Head, the northeasternmost point of the United States. Each lighthouse on the Eastern Seaboard bears distinct markings, helping mariners identify their location.
▲ New Harbor, in Maine's Pemaquid area, boasts a fishing and lobster fleet. New England's coast abounds in cod, herring, flounder, lobster, and scallop.

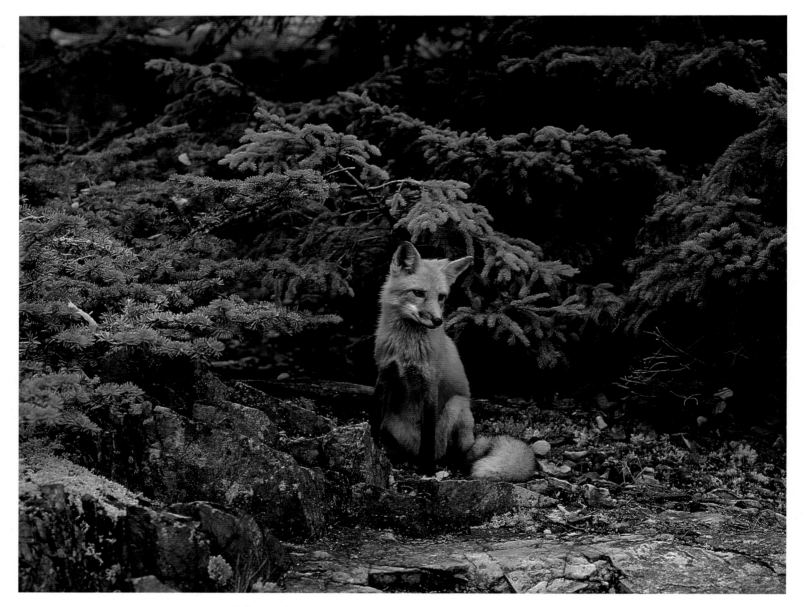

▲ A red fox makes its home in Maine's beautiful Acadia National Park. The surrounding vegetation grows from a thin veneer of soil. During the last Ice Age, continental glaciation scoured Acadia's granite dome.
▶ Bennington Monument, 306 feet tall, commemorates the Revolutionary Battle of Bennington. Fought in Bennington, Vermont, on August 16, 1777, the battle is considered "a turning point of the Revolution," because it halted General Burgoyne's advance down the Hudson River. It also revitalized the young nation's flagging spirits by effectively demonstrating that the colonies could defeat the finest troops the British possessed.

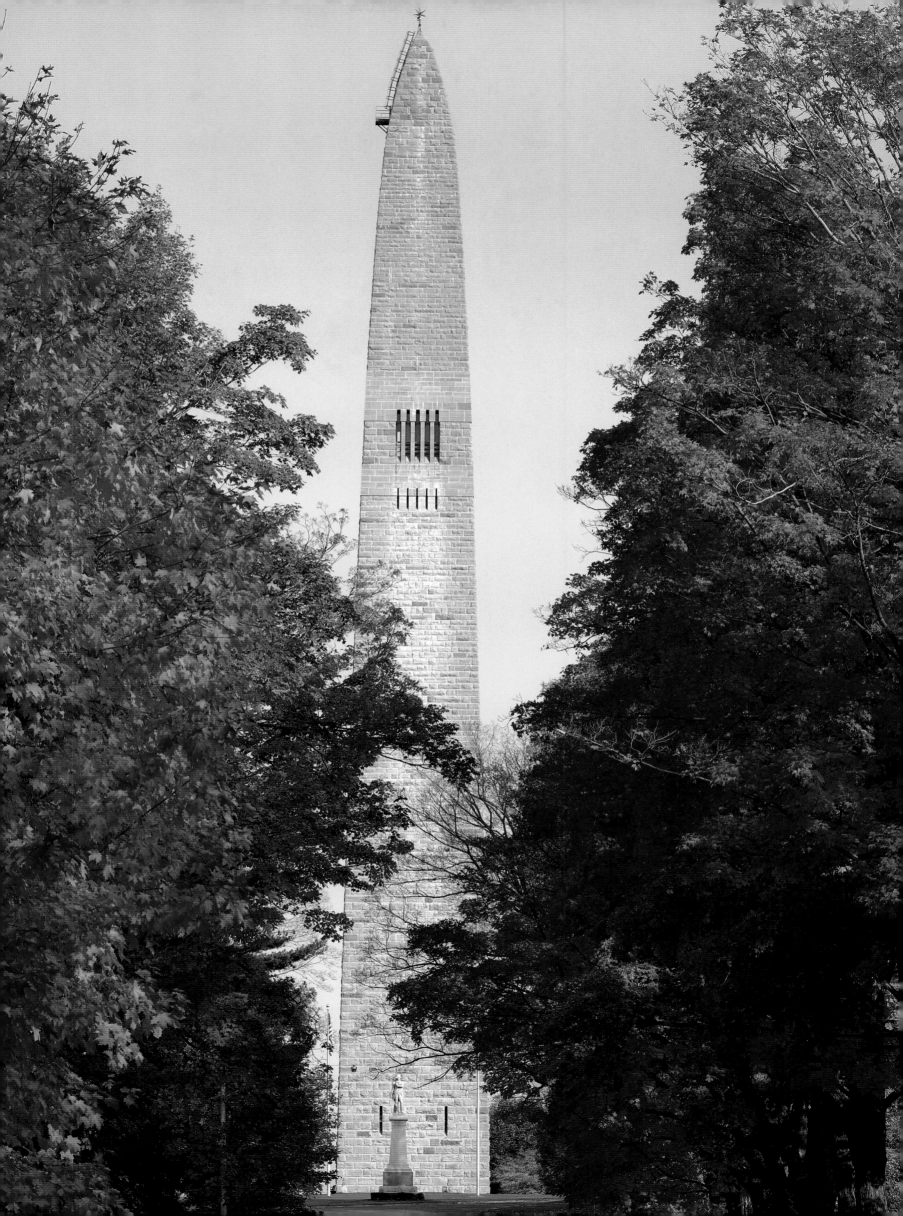

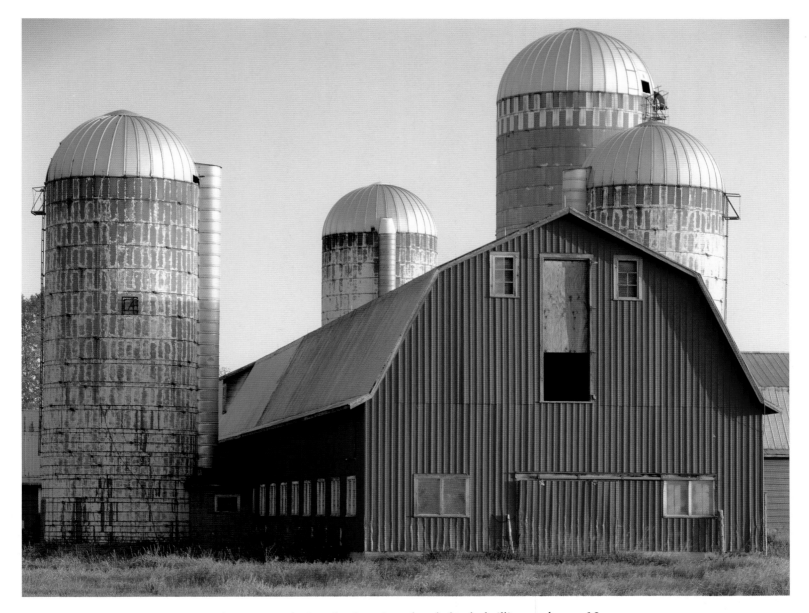

◄ Above Cascade Brook, American beech lends brilliant color to New Hampshire's White Mountain National Forest. This spot lies slightly below the famous Appalachian Trail, which runs north-south two thousand miles across the ridge crests of the Appalachian Mountains and stretches from Maine to Georgia through two national parks and eight national forests.
▲ Dairying is a major farm industry in Vermont. The cows are mostly black and white Holsteins, but Jerseys and Brown Swiss are also used.
►► The churning waters of Texas Falls carved an exquisite pothole in Vermont's Green Mountains. Samuel de Champlain, a French explorer in the early 1600s, was the first European to venture into these mountains.

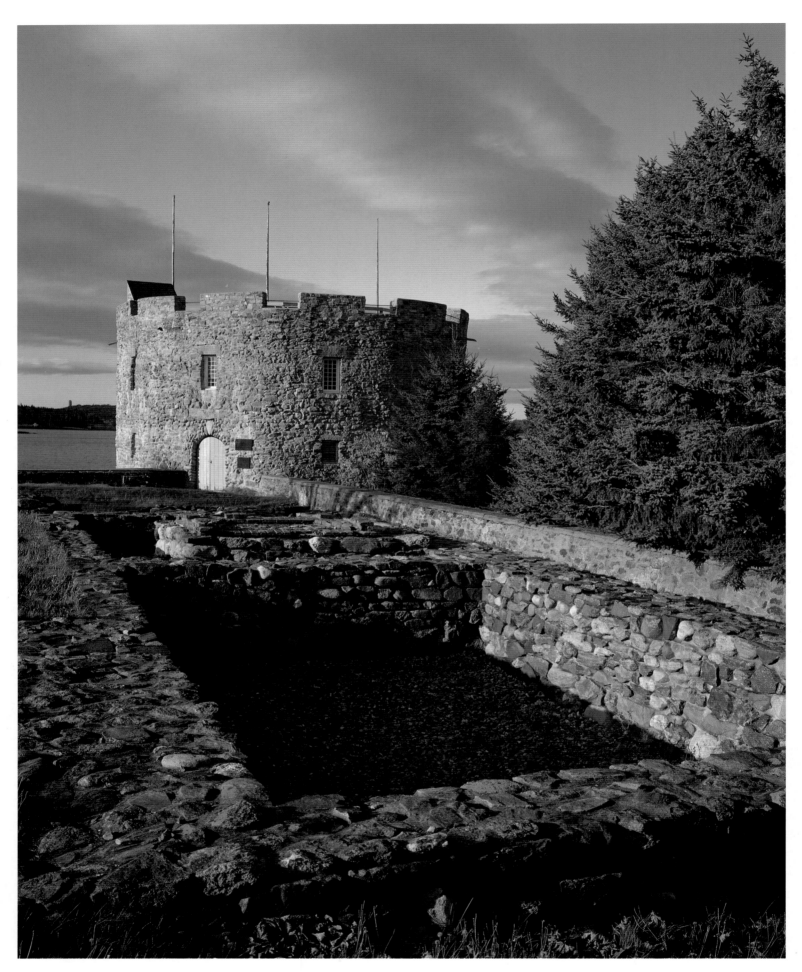

▲ Now restored by the state of Maine, Fort William Henry was where, in the 1600s and 1700s, England defied France with four successive forts.
► The whaleship *Charles W. Morgan*, built and launched in 1841, is preserved at Connecticut's Mystic Seaport, a living history maritime museum.

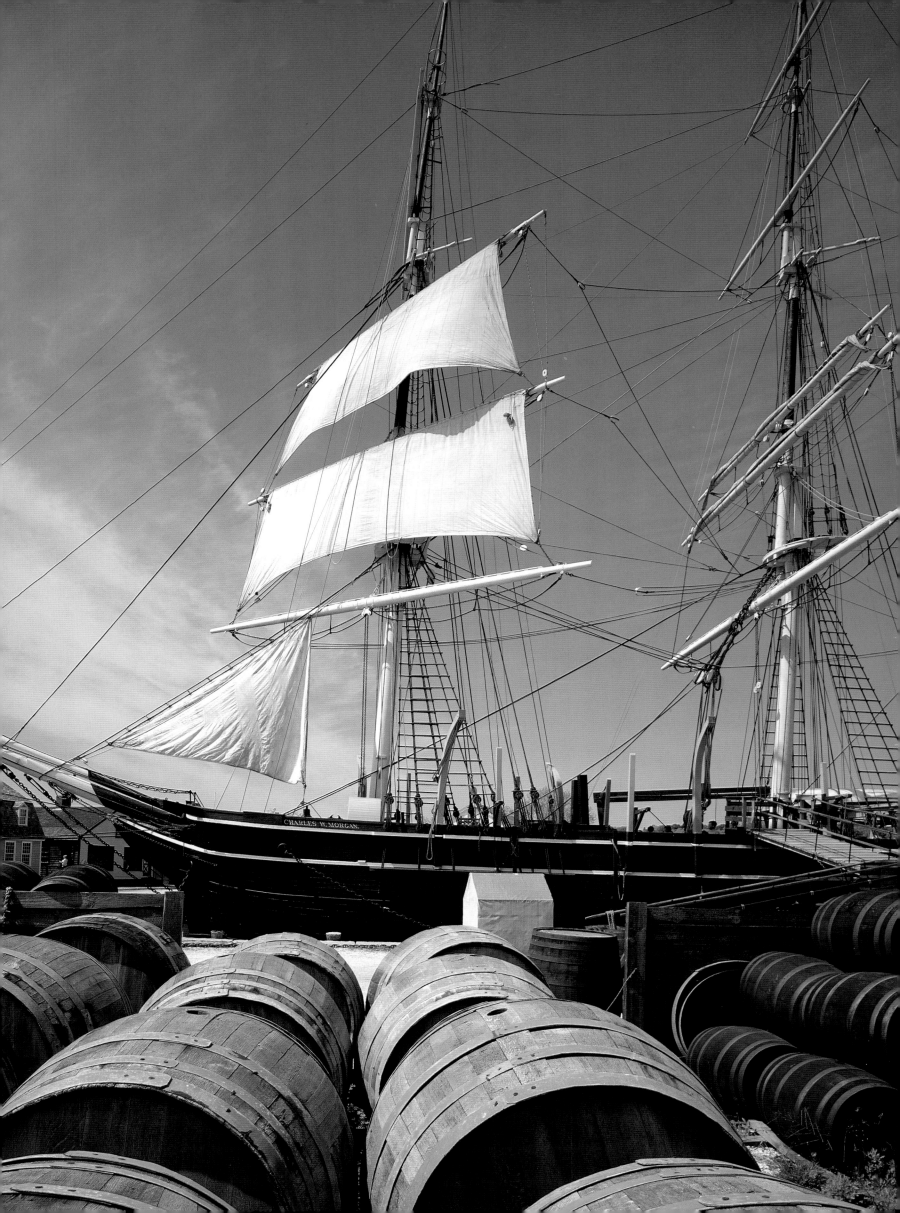

Heritage, tradition, and a strong sense of place are woven into the fabric of Southern life. Outsiders, charmed by the overview, often miss the subtleties. That Southern accent is a case in point. To people from other parts of the country, all Southern accents sound similar. But Southerners will point out, with a certain pride, that there are many variations. Accents differ not just by state, but right down to home county.

Above: *A snowy egret preens in Everglades National Park. A wetland of global importance, the Everglades are a World Heritage Site and International Biosphere Reserve.* Above right: *Thousands of children, as well as adults, delight to visit Virginia's Colonial Williamsburg, where history comes alive.* Left: *Ocracoke Harbor provides refuge in North Carolina's Outer Banks, islands protecting the mainland from the ocean's wrath.*

History is woven into the fabric, too, and it is long and colorful. There is evidence of human settlements in the South as early as 1700 B.C. One of America's most important archeological sites is a Stonehenge-like mound construction in Louisiana.

The French and Spanish established outposts along the Gulf of Mexico a century before Pilgrims arrived at Plymouth Rock. They cared less about settlement than about quick riches, and about defending the fleets taking America's booty back to Europe.

Both countries relinquished territorial claims, but left a rich legacy in the region's architecture, language, and food. No city in America is as European, or as unique, as New Orleans, with its French Quarter, jazz, spicy food, and Mardi Gras. The city's original attraction was its strategic location at the mouth of the Mississippi. Trappers, traders, miners, and farmers depended on that natural highway to move their products to markets at home or abroad.

North along the river, a few sadly splendid plantation houses still bear testimony to King Cotton's reign through the first half of the nineteenth century. Rising above bitter circumstances, the Africans imported as slaves to work those plantations have added another rich component to American culture. African-American food and music have become Southern staples, and slaves' descendants are making powerful contributions in every aspect of American life.

The landscape reinforces the dramatic character of the deep South. Spongy bogs, or bayous, mark the area along the Gulf. Old mossy trees overhang waters that are home to delicacies called crayfish, as well as many less savory creatures. In Georgia's Okefenokee Swamp, cottonmouth moccasins twine the tree roots, and fifteen-foot alligators ply the black waters.

Florida's Everglades Wilderness is a swamp of a different sort. Primarily a marshy grassland, it is punctuated by small islands of hardwood trees. Sawgrass, with leaves like teeth, grows as tall as twelve feet. Alligators, Florida panthers, and three hundred types of birds thrive in the Everglades.

North and east of the Gulf, the climate is more moderate, the landscape less dramatic, and the heritage less eclectic. While the French and Spanish jostled for position along the Gulf, the British put down roots along the Atlantic. Virginia, home of educated gentleman planters like Washington and Jefferson, was a bulwark of the original thirteen colonies. From there, the settlers flowed west through the Cumberland Gap into Kentucky and Tennessee, where the rolling green country is now dotted with white-fenced fields full of thoroughbred horses. North and South Carolina were also among the original thirteen colonies, and the gracious city of Charleston, built on rice and indigo fortunes, was a leading cultural center in Colonial America.

An outsider's South may be only clips from "Gone With the Wind"—columned plantation houses, gentlemen in uniforms, ladies in flowing skirts, with cartwheel hats, white gloves, and parasols. Those images illustrate a broader truth. In imagination, an aura of glamour and drama surrounds the South. Knowing more of the story only confirms that the aura is well deserved.

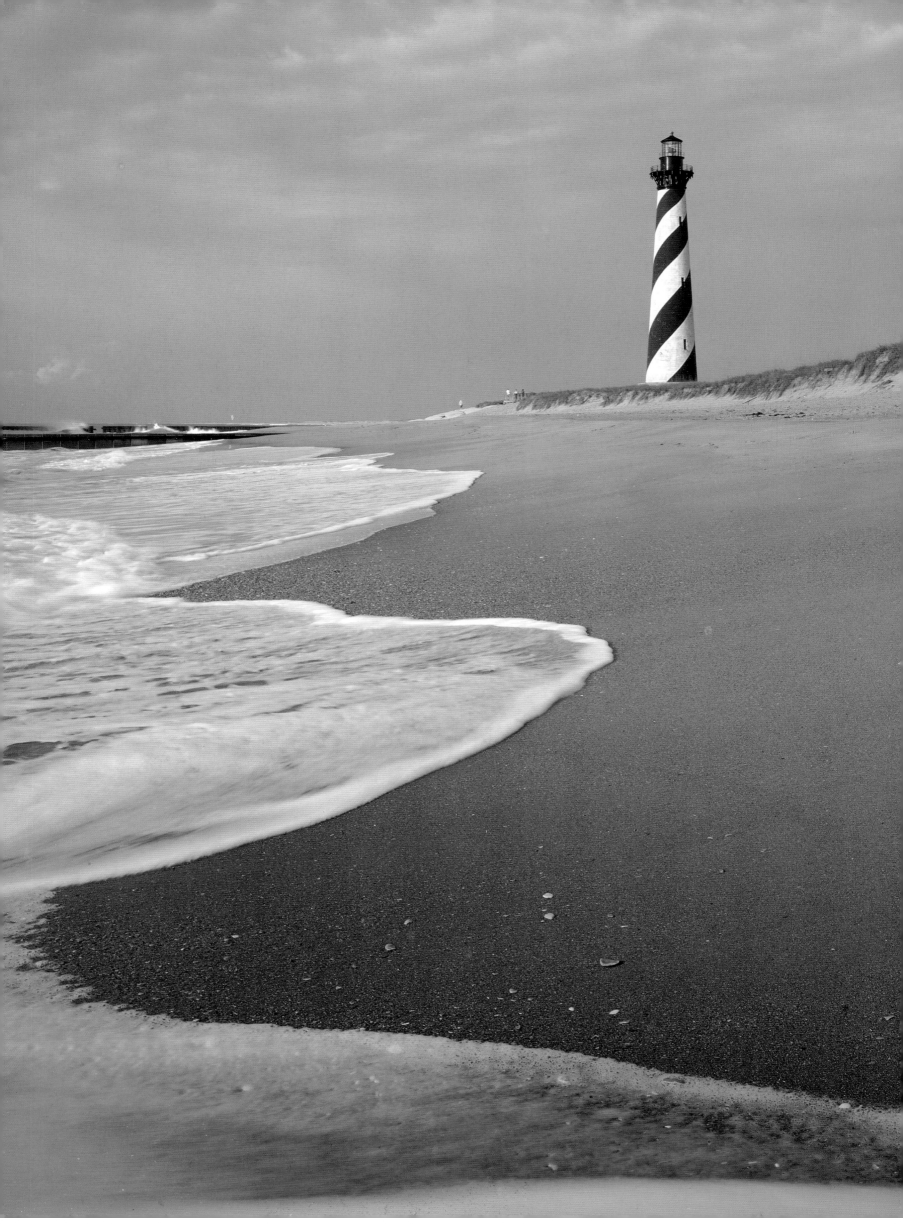

◄ At 208 feet, Cape Hatteras Lighthouse is the tallest in the United States. It was built in 1870 to warn mariners of the treacherous waters off the Outer Banks. Here, more than six hundred ships have wrecked, victims of shallow shoals, storms, and war. During World War II, this Graveyard of the Atlantic became known as Torpedo Junction because of German submarine activity.

▲ The Henry Pigott House was built around 1900 in North Carolina's Portsmouth Village. Between its founding in 1753 and the coming of the Civil War, Portsmouth was a major shipping center. After the war, the town became a more modest fishing hamlet. The establishment of Cape Lookout National Seashore in 1976 has brought new life to the village.

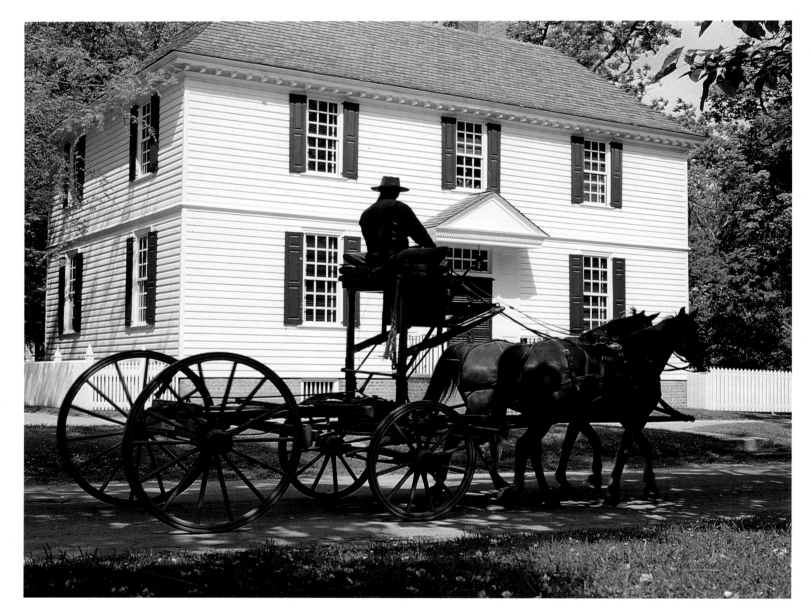

▲ Once Virginia's capital, Williamsburg, between the James and York rivers, was an important site during the American movement for independence. After the capital moved to Richmond in 1779, Williamsburg declined, but in 1926, with the help of John D. Rockefeller Jr. and W. A. R. Goodwin, work began to return it to its original eighteenth-century appearance. One hundred buildings have been restored, and another four hundred reconstructed.

▶ Named for King William III and Queen Mary II, the College of William and Mary was founded in 1693. One of the oldest colleges in America, it is second only to Harvard. This British cannon, captured during the Revolutionary War, rests on the front steps of the college's Wren Building.

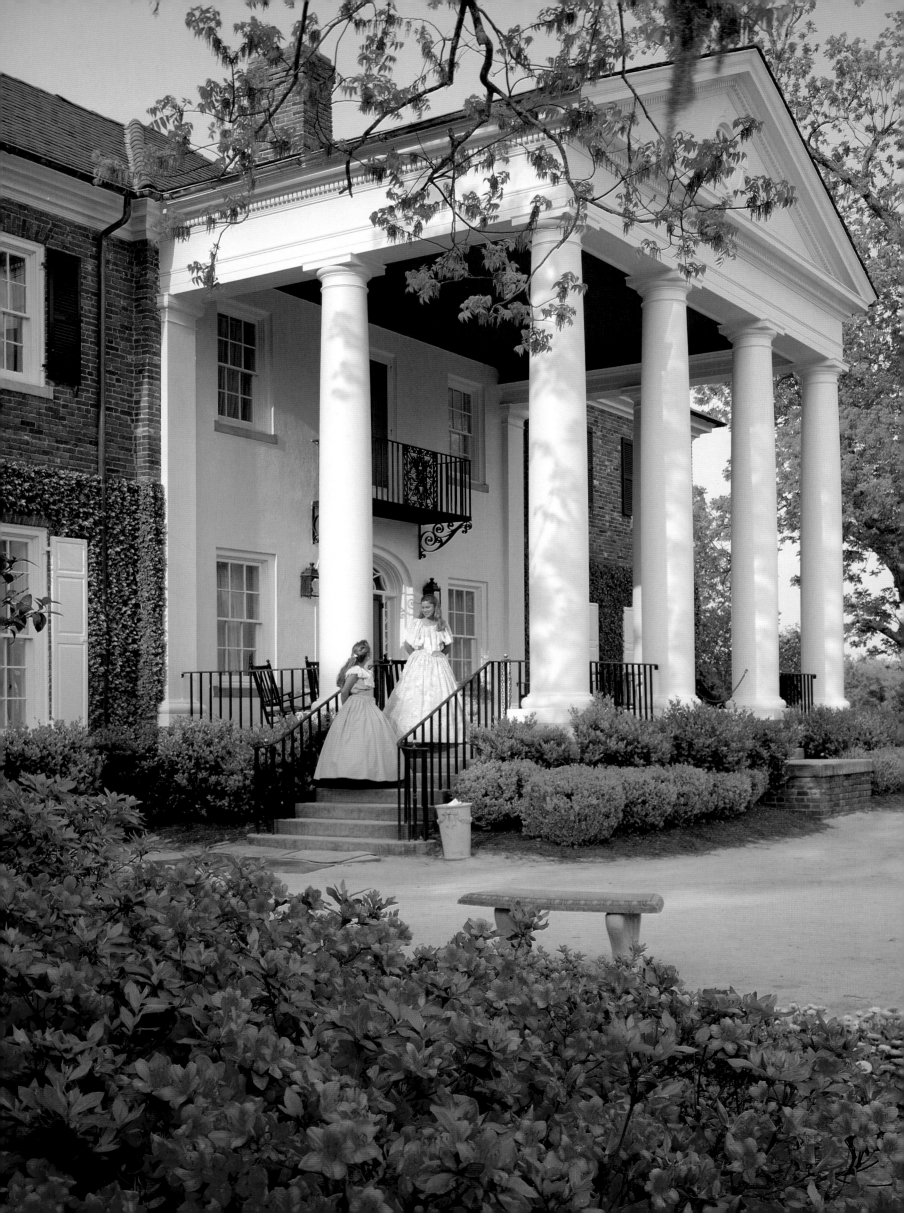

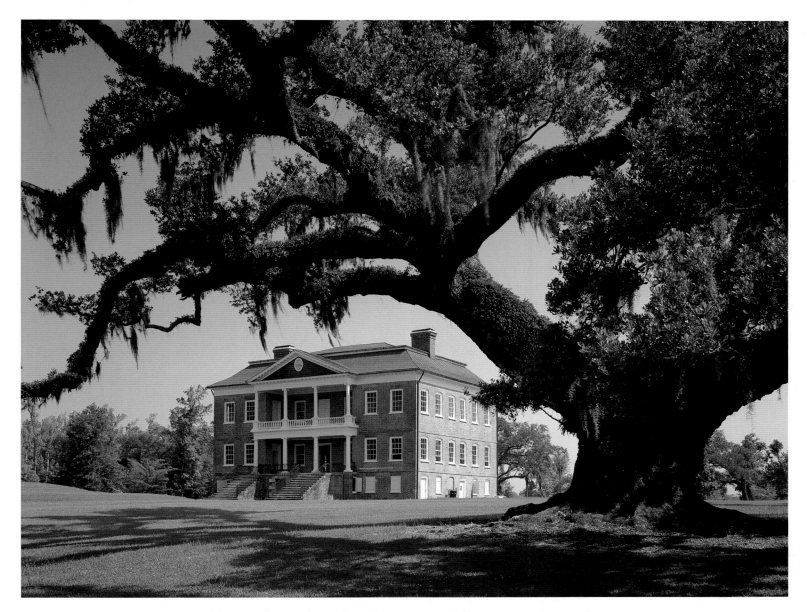

◄ The South Carolina plantation, Boone Hall, was a major producer of indigo and cotton in the eighteenth and nineteenth centuries. Major John Boone who arrived from England in 1681, was granted the land by the Lords Proprietor. Handmade brick, produced on the grounds, can be seen in all the buildings, including this plantation house, rebuilt in 1935.
▲ The only Ashley River plantation to survive the Civil War, Drayton Hall was built in 1738-1742 in Charleston, South Carolina. Preserved through seven generations of Draytons, the plantation is now protected by the National Trust for Historic Preservation as a National Historic Landmark.
►► Pink azaleas and ferns thrive in Virginia's Shenandoah National Park.

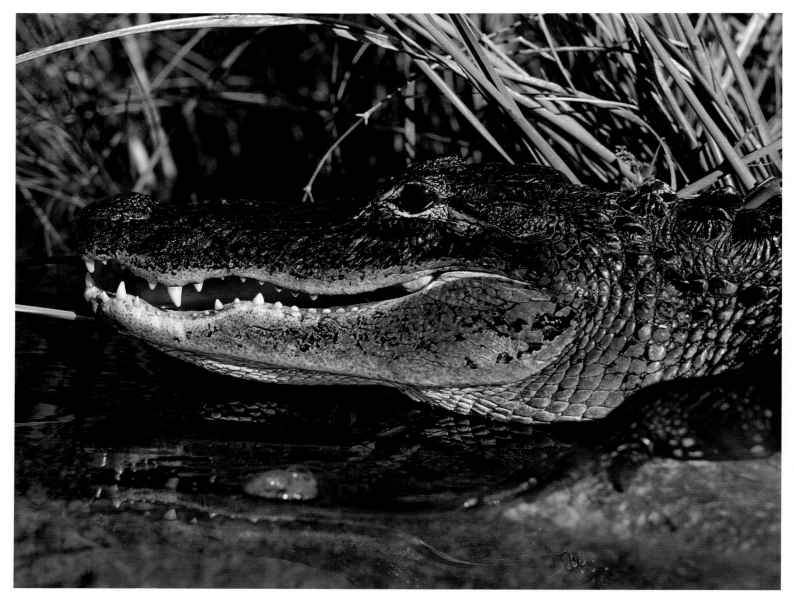

▲ Shark Valley, in Florida's Everglades National Park, provides haven for the American alligator. Classified as an endangered species in 1967 and then reclassified as threatened in 1977, the alligator is the top carnivore at which various food chains converge in this fragile and threatened ecosystem.
► Baldcypress and waterlilies line the Suwanee River of Georgia fame, in the Okefenokee National Wildlife Refuge. The swamp is richly populated with wildlife, ranging from alligators and bears to deer and birds.
►► With piney woods beyond, a carnivorous pitcher plant known as yellow trumpets, *Sarracenia alata,* thrives in an acid bog near Longville, Louisiana.

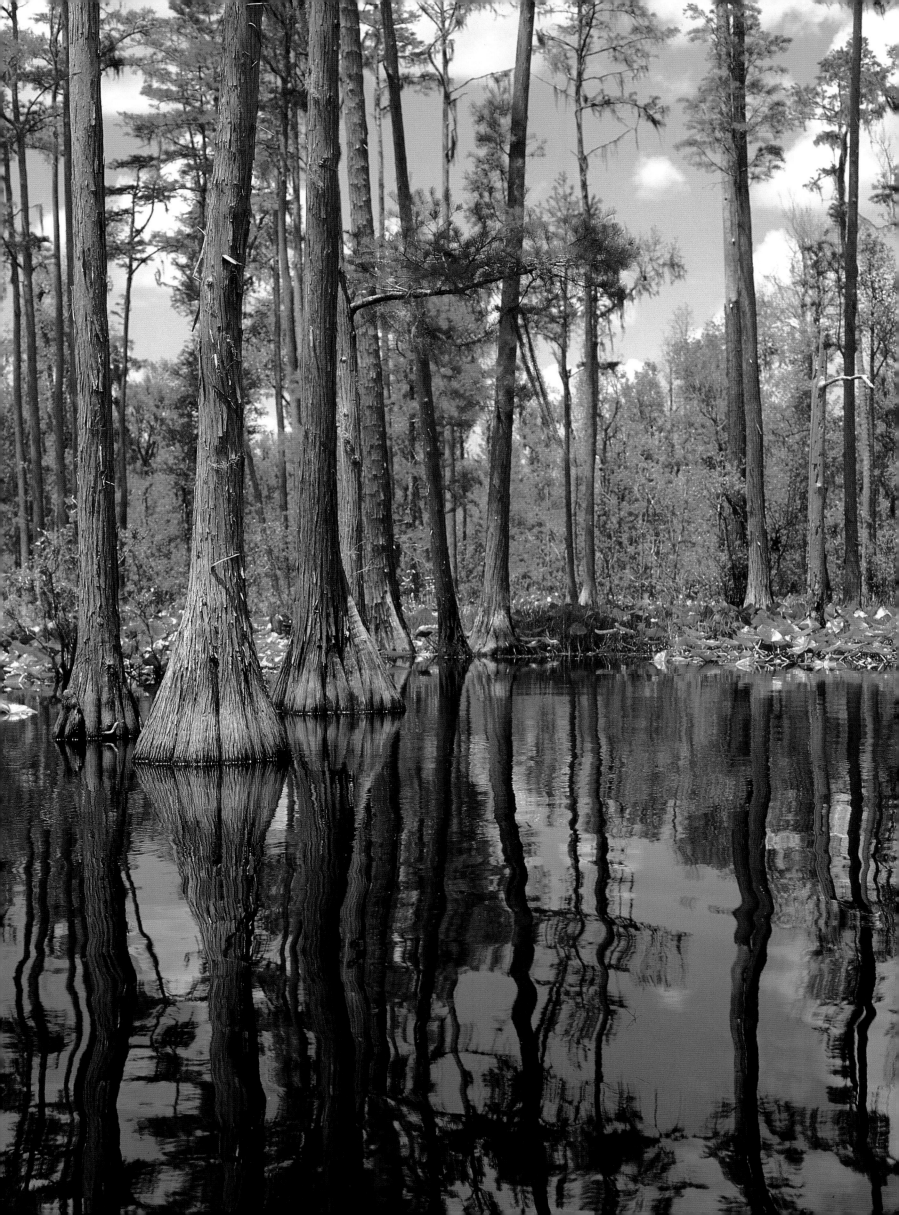

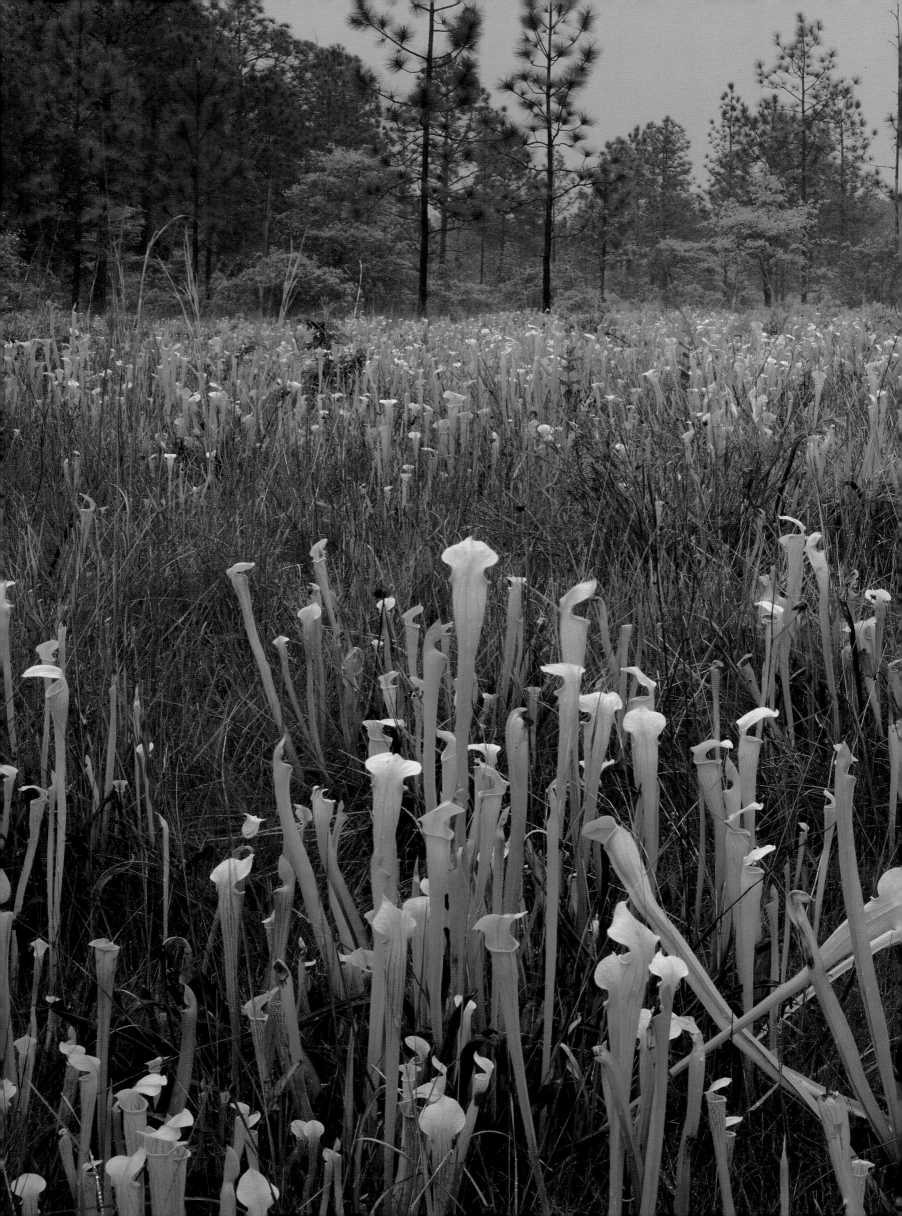

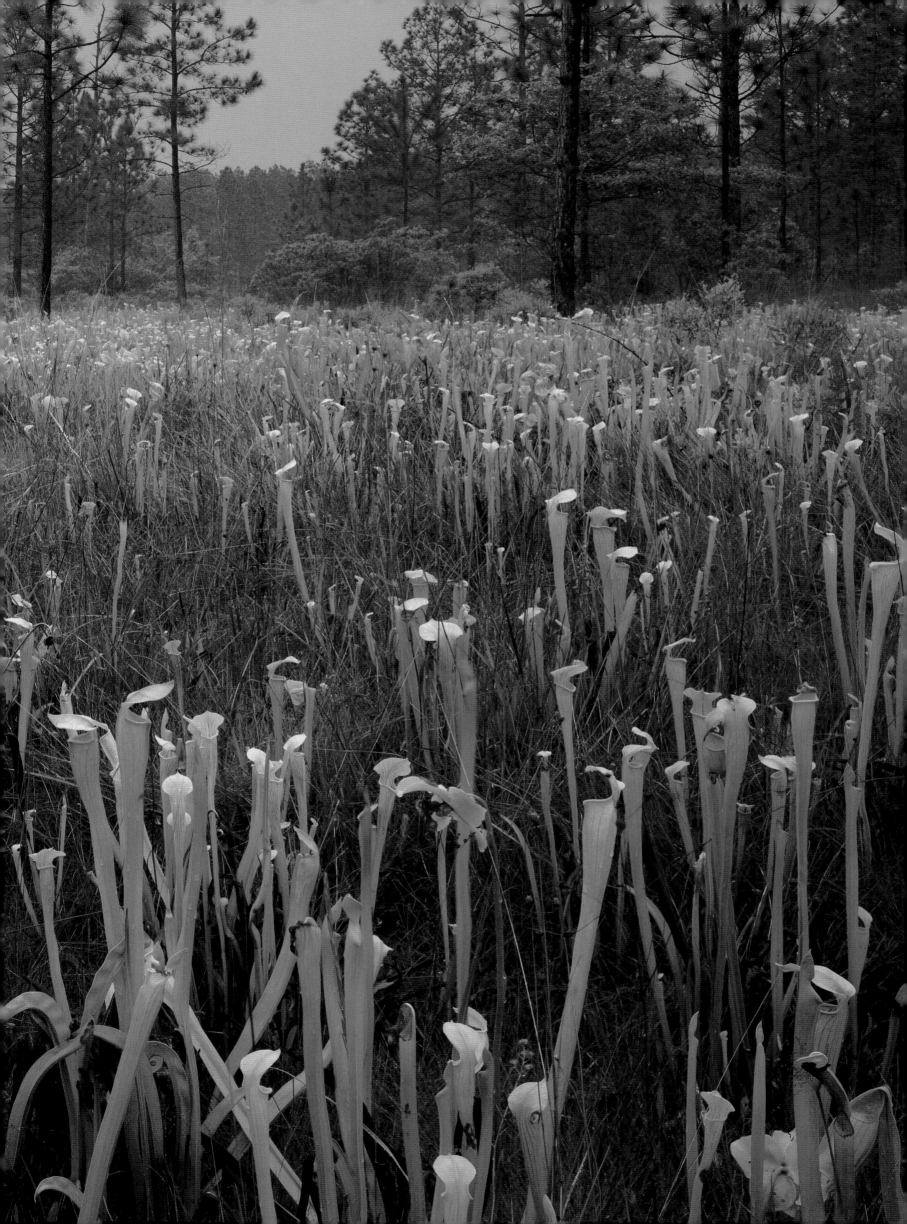

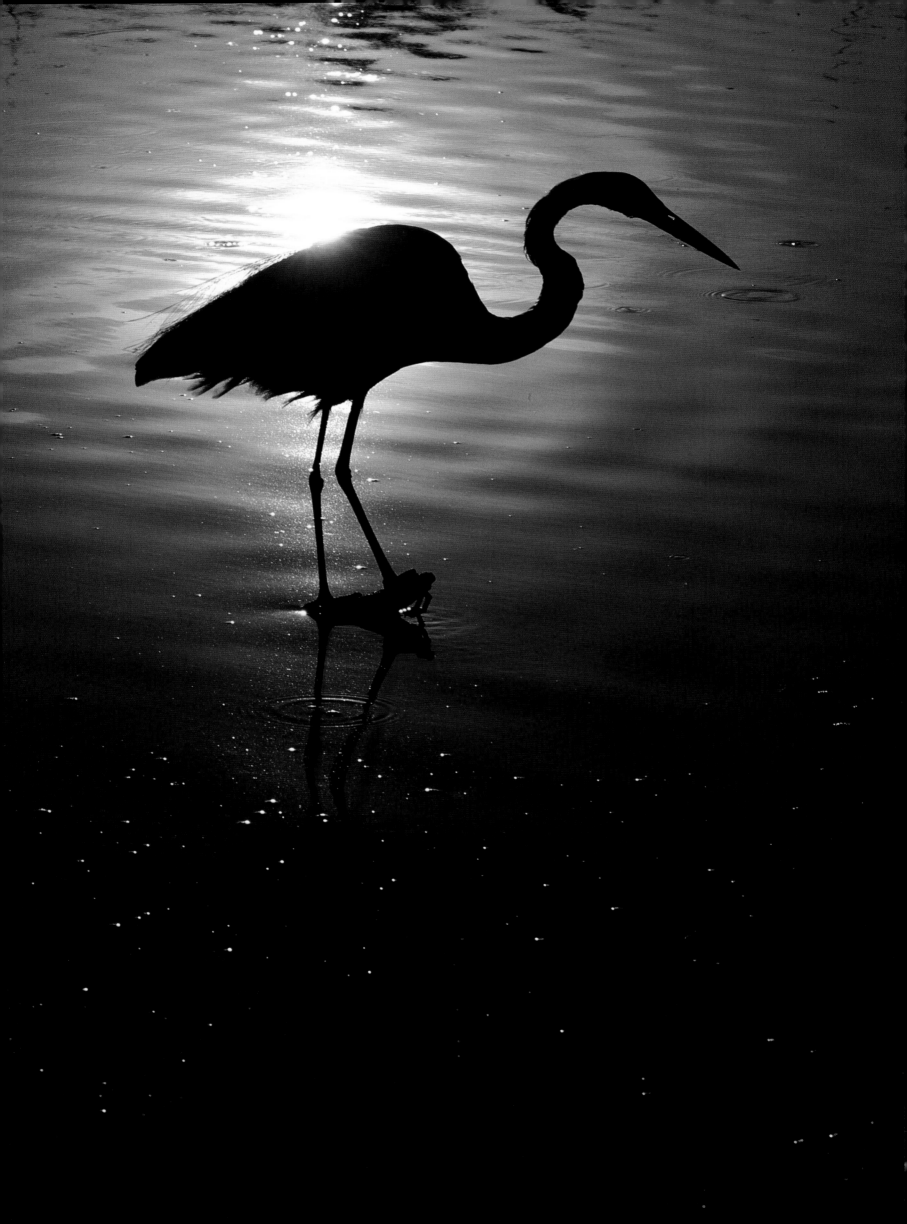

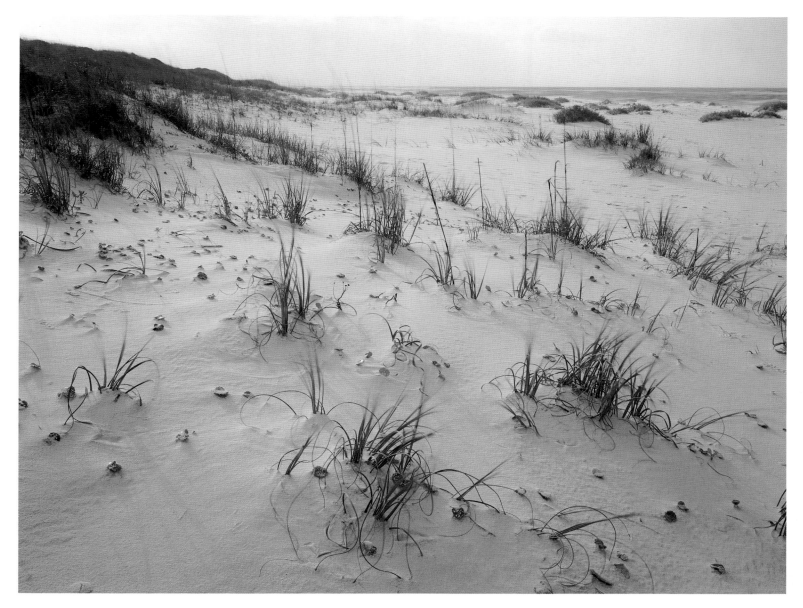

◄ The great egret, *Casmerodius albus*, is part of the heron family and is a protected species. More than three hundred species of birds, including the rare snail kite, are found in Florida's Everglades National Park.
▲ Sea oats and pennywort grow on a windswept beach of Santa Rosa Island, in Florida's Gulf Islands National Seashore. Many of the natural seashore environments are preserved on national, state, and city levels. Not only is wildlife protected and preserved for future generations, but provision is made, under strict guidelines, for human enjoyment of this fragile coastline.

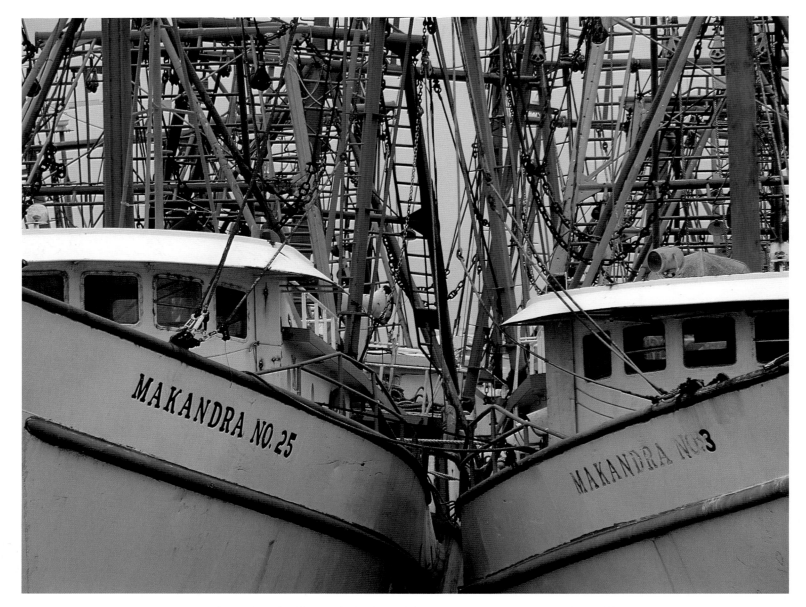

▲ The Makandra fleet is docked at Alabama's Bayou La Batre on the Gulf of Mexico coast. The westernmost extension of the Atlantic Ocean, the Gulf of Mexico supports shrimp, oysters, crab, mullet, and menhaden.
▶ The Royal Cafe is an example of early French architecture. New Orleans, situated between Lake Pontchartrain and the Mississippi River, was a French colony in 1718 and a Spanish colony in 1762 before becoming part of the United States in the Louisiana Purchase of 1803. Since then, it has become one of the world's major ports, with a population of over half a million. The traditional birthplace of jazz, New Orleans is still characterized by its distinctive French Quarter and its Mardi Gras celebrations.

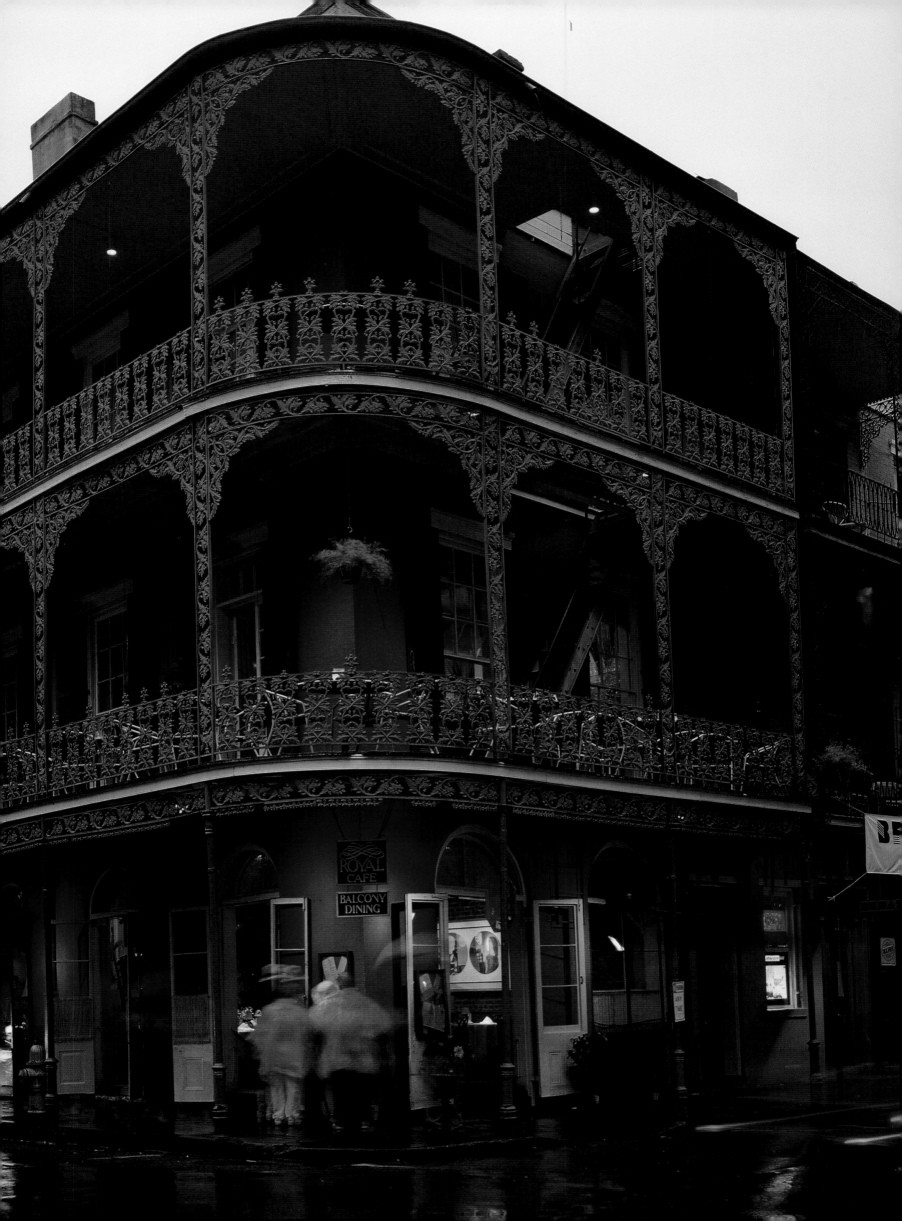

◄ Wild phlox punctuates the landscape near Merryville. The warm and humid southern part of Louisiana is characterized by lush vegetation. The northern part of the state is more heavily forested, chiefly with pine trees.
▲ Built in 1915, Fordyce Bathhouse includes both a spa and a music room. Hot Springs National Park was originally set aside in 1832 as the first national federal reserve to protect a natural feature. Here, people still "take the waters," seeking relief from rheumatism, bunions, and other afflictions. Although the devotees have faith in the water's powers, the park makes no healing claims. Each day about 850 thousand gallons of water, at 143° Fahrenheit, flow from the springs into a piping and reservoir system.

▲ This hay-stuffed Ozark folk family sits outside a country store in Pelsor, Arkansas. The Ozarks are a heavily forested highlands that encompass fifty thousand square miles in Missouri, Kansas, Arkansas, and Oklahoma.
▶ Indian Creek is situated in the Ponca Wilderness Area of Buffalo National River. Originating high in the Boston Mountains, the Buffalo River drops steadily to its confluence with the White River. The area's caves, rock formations, sinkholes, waterfalls, and springs typify the Arkansas Ozarks.

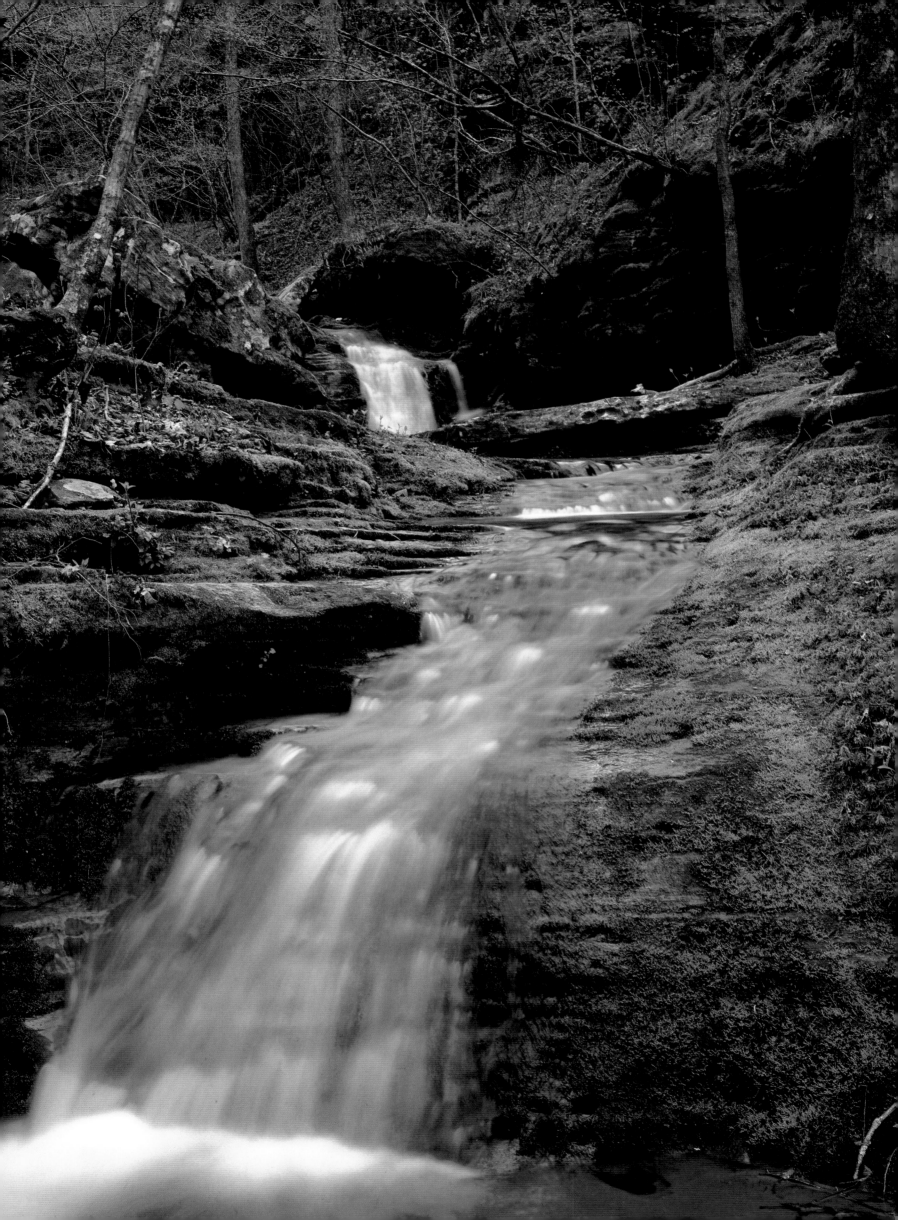

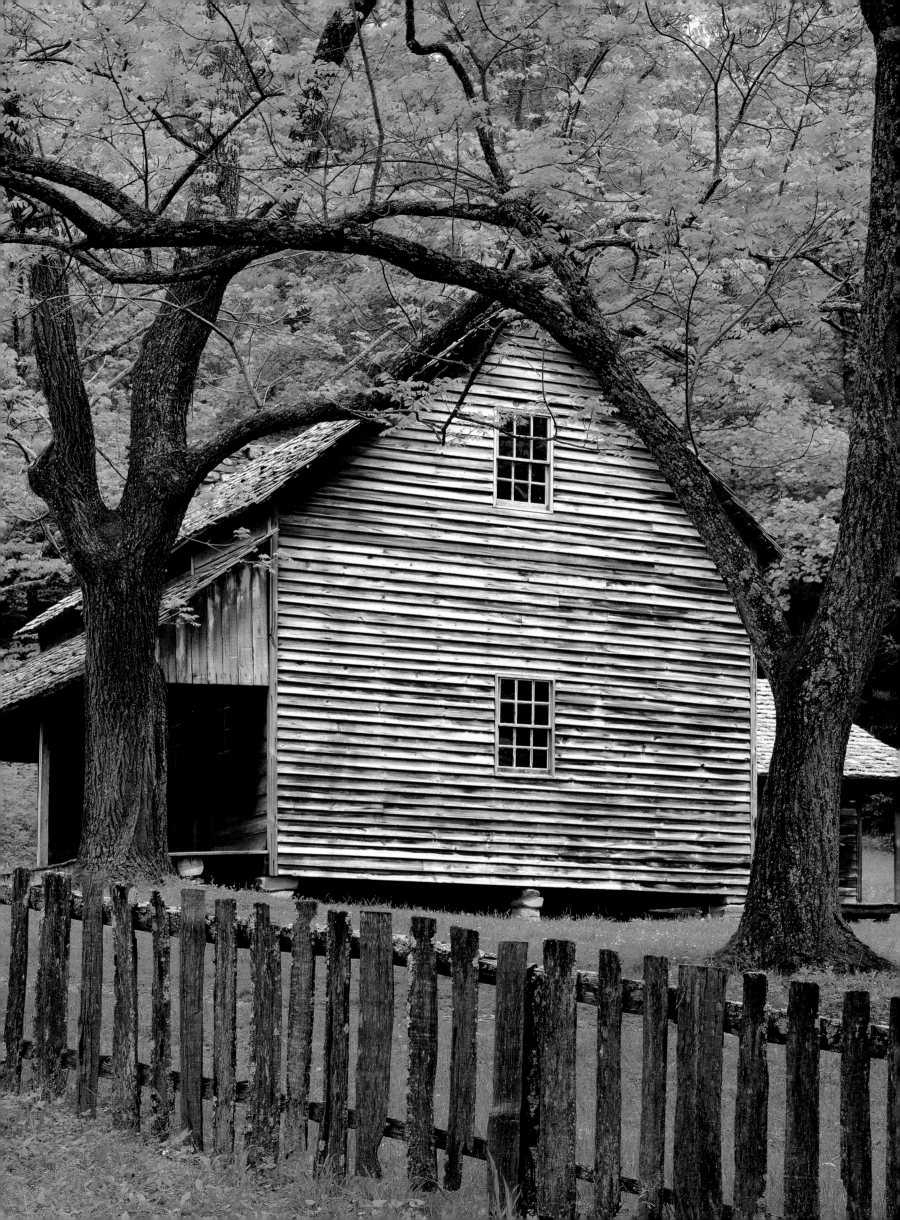

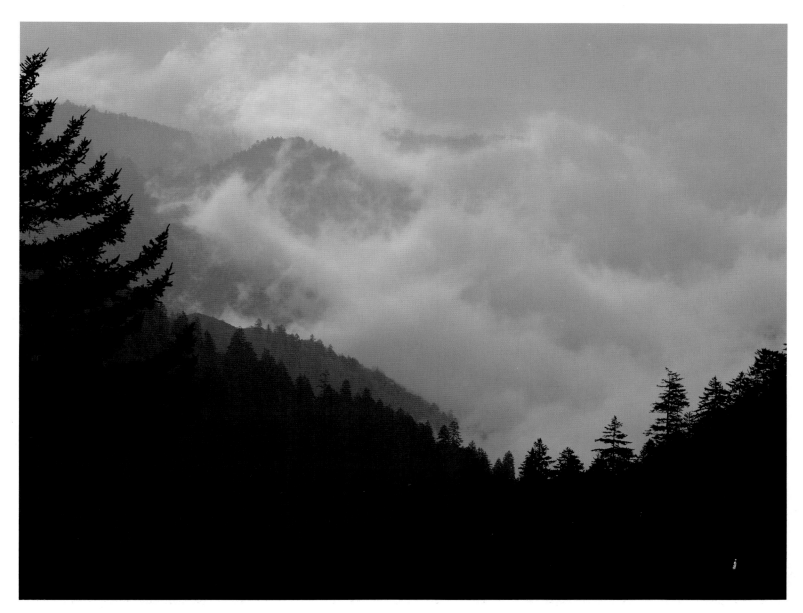

◄ The Tipton Place was built by "Hamp" Tipton in Cades Cove a few years after the Civil War. The Great Smoky Mountains, the powerful crest of the Appalachian Highlands, are a wildlands sanctuary preserving the world's most superb examples of temperate deciduous forest. The "Smoky" part of the name comes from the smokelike haze enveloping the mountains, which stretch in panoramic grooves and mammoth swells to the horizon.
▲ Fog rises from the drainages of Deep Creek in Great Smoky Mountains National Park, established in 1934. Fertile soils and abundant rain have encouraged a diversity of more than fifteen hundred kinds of flowering plants. The park straddles the line between North Carolina and Tennesee.

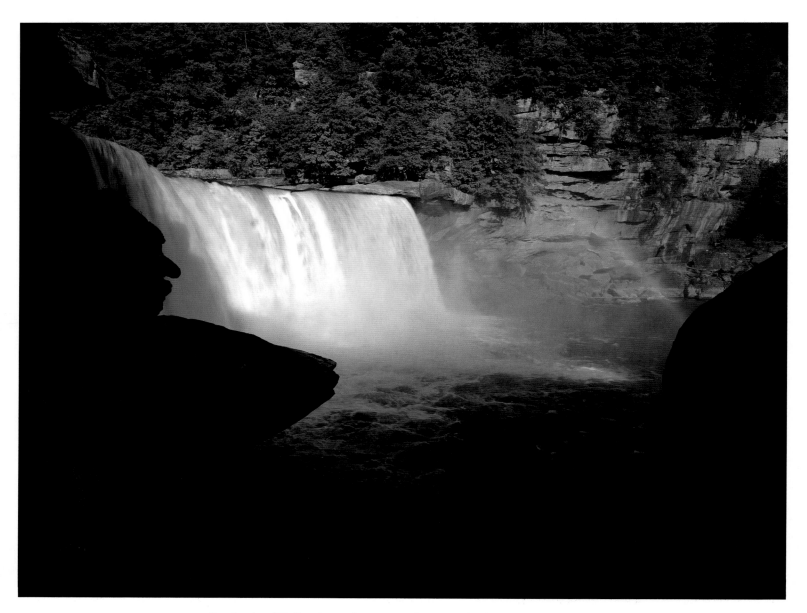

▲ Cumberland Falls, situated in Kentucky's Cumberland Falls State Resort Park, drops some sixty-eight feet and has a width of approximately 125 feet.
▶ Brookside Farms, northwest of Versailles, Kentucky, exhibits one of the best-loved icons of Kentucky—beautiful, thoroughbred racing horses. The Kentucky Derby, which began in 1875 and has continued ever since at Churchill Downs in Louisville, is an annual horse race for three-year-old thoroughbreds. The American Racing Series known as the Triple Crown is made up of the Kentucky Derby, the Preakness, and the Belmont Stakes.

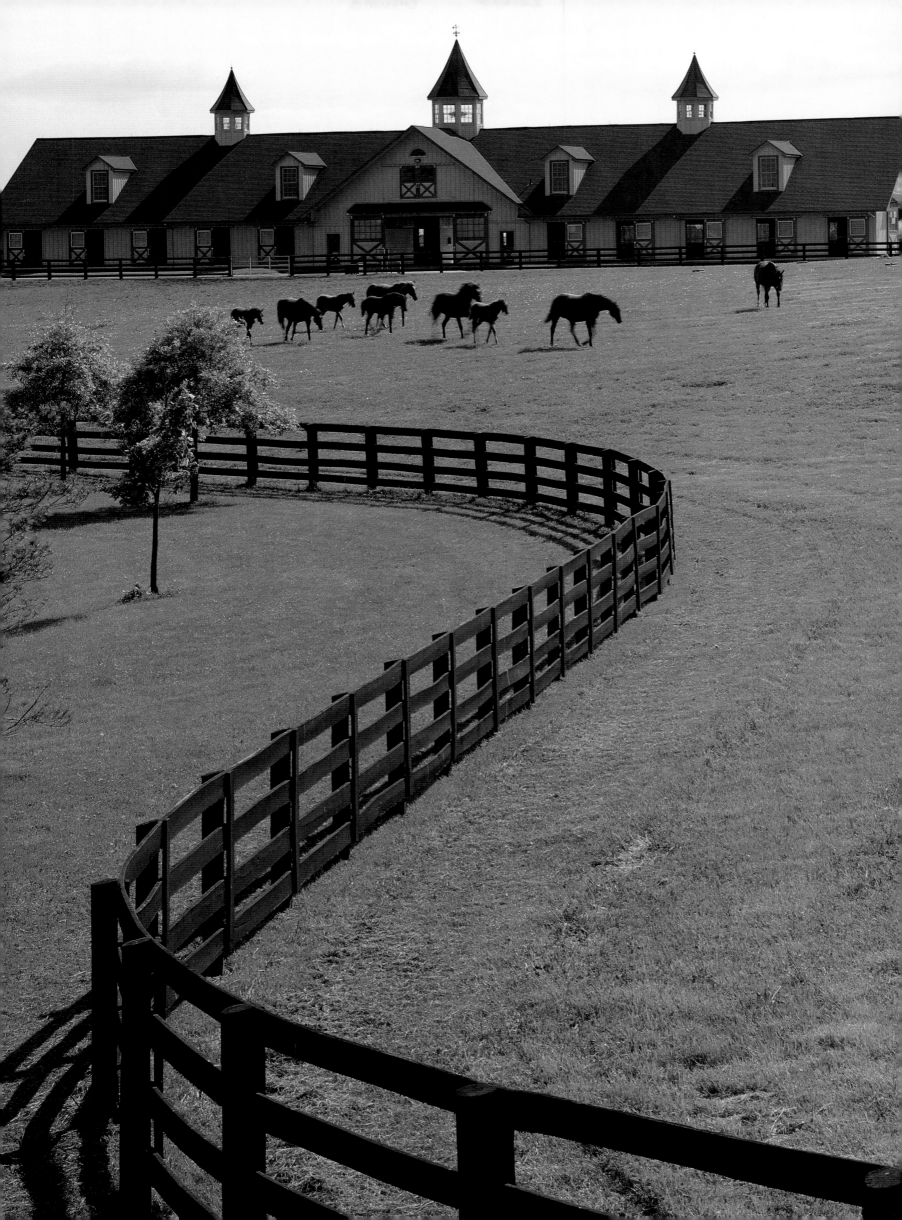

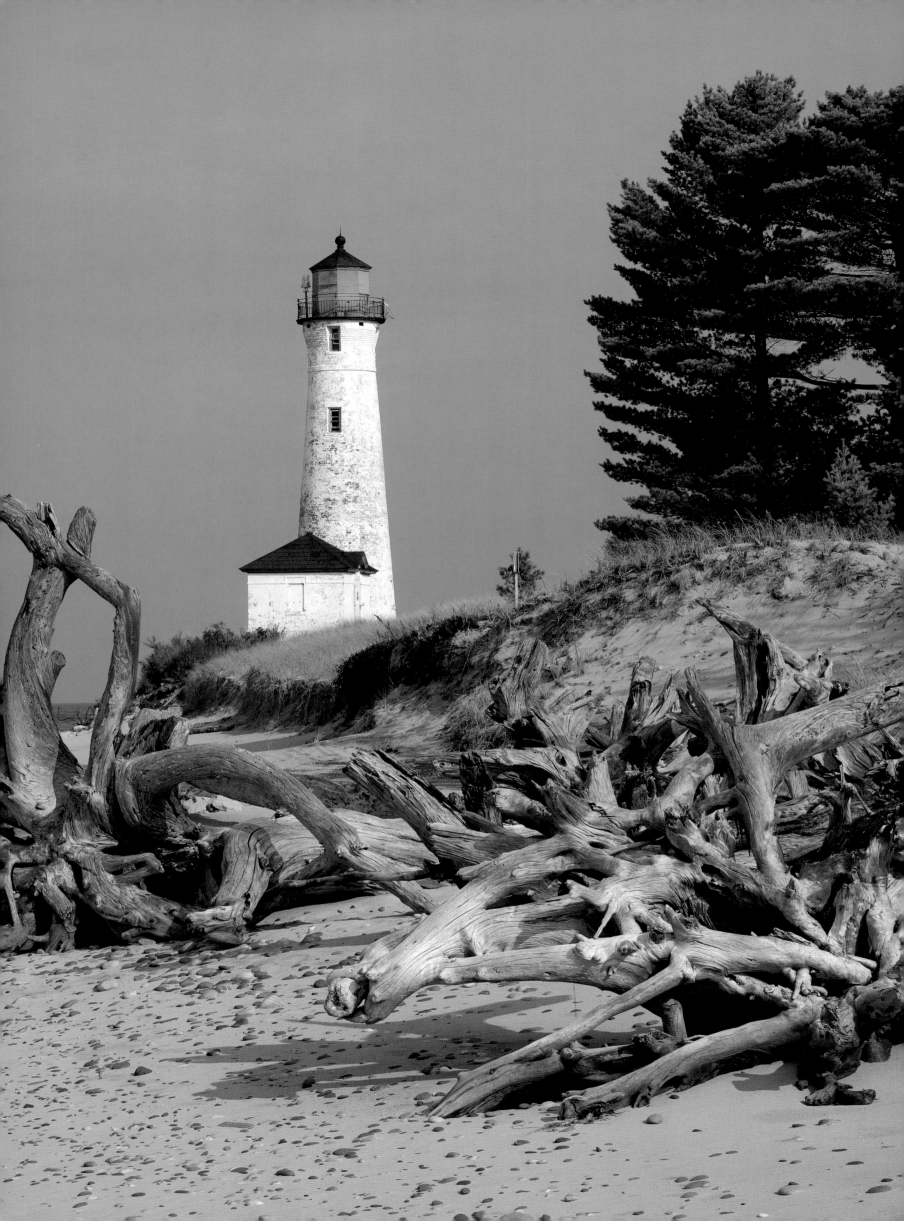

GREAT LAKES

Nearly ten percent of the world's fresh surface water lies in these five interlocking lakes. Covering thirty-two thousand square miles, they constitute the largest body of fresh water on earth. They are like oceans—water as far as the eye can see, ships passing on the horizon, and choppy waves lapping the sandy beach. Lake Superior, the largest, is cold even in August, because it is more than one thousand feet deep.

Above: *A fisherman works the pool below High Falls of the Baptism River, Tettegouche State Park. Freshwater covers over 4,750 square miles of Minnesota, making it a natural area for the enjoyment of water activities.* Above right: *Situated on the shores of Lake Michigan, Chicago is a center for finance, trade, manufacturing, and transportation.* Left: *The Crisp Point Lighthouse stands in solitary splendor on Lake Superior's shore.*

Strung like giant beads on the watery threads of the St. Lawrence Seaway to the east and the St. Croix and Mississippi rivers to the south, the Great Lakes link the North Atlantic to the Gulf of Mexico. The basins, cut by receding glaciers, descend like a series of tipped bowls. Water spills lake to lake from Lake Superior, 602 feet above sea level, until it thunders over Niagara Falls into Lake Ontario and out the St. Lawrence.

The blue thread of another great river, the Ohio, defines the southern border of the Great Lakes region. The water network first drew explorers, then the trappers and traders, to this area. The invention of the steamboat marked the beginning of an era of rapid growth for frontier towns like Cincinnati, which Longfellow called the "queen of the West." The rivers continued to be valuable highways as agricultural production grew and industry was built. The Ohio River, flowing through an industrial heartland of steel mills, factories and power plants, still carries more tonnage than the St. Lawrence Seaway or the Panama Canal.

Along the banks of the Ohio, the land is hilly and heavily wooded. Further north, in the central farm belt, lies a fortune in corn, soybeans, alfalfa, and wheat. Agricultural promise drew homesteaders such as Abe Lincoln's family to states like Indiana and Ohio. As the frontier pushed west, hardy pioneers discovered ever richer land.

North beyond the rich farms and dairies and orchards is the country of lumber and lakes. This is no place for the faint of heart. Winter temperatures often drop below zero and hover there. On the Upper Peninsula of Michigan, as much as three hundred inches of snow falls in winter, and the ground stays white well into spring. Compensation is the great natural beauty of the North Country, and the taste of unspoiled wilderness it offers. Wisconsin's fifteen thousand lakes and twenty-two hundred streams make it a fisherman's paradise. Minnesota's Boundry Water Wilderness, with its rugged forests and one thousand lakes, is the East's largest wilderness, after the Everglades.

Lumber legends were written in Great Lakes North Country. The forests of two-hundred-foot monarch pines on Michigan's Upper Peninsula built countless fortunes. In 1850, the trees were more valuable than California's gold, and the resource looked endless. By 1890, most had been cut. A few token groves remain, now protected.

Tracing a twenty-nine-mile curve along Lake Michigan's southwestern tip is the giant among lake cities—America's third largest. Chicago is called the "Windy City," both for the lake breezes and its politics, but Carl Sandburg may have characterized it best as the "City of Big Shoulders." It came of age as the rail head for massive cattle drives in the early 1800s, built industrial muscle with meat packing and steel, and gathered financial clout in the grain trade. It remains a transportation hub; O'Hare Airport is the busiest in the world.

Birthplace of the school of architecture that inspired Frank Lloyd Wright, Chicago is as expansive and horizontal as New York is vertical and intense. It is vigorous, direct, thoroughly Midwestern. Even as it faces the Lake, it sprawls westward, mirroring the character of the prairies it introduces.

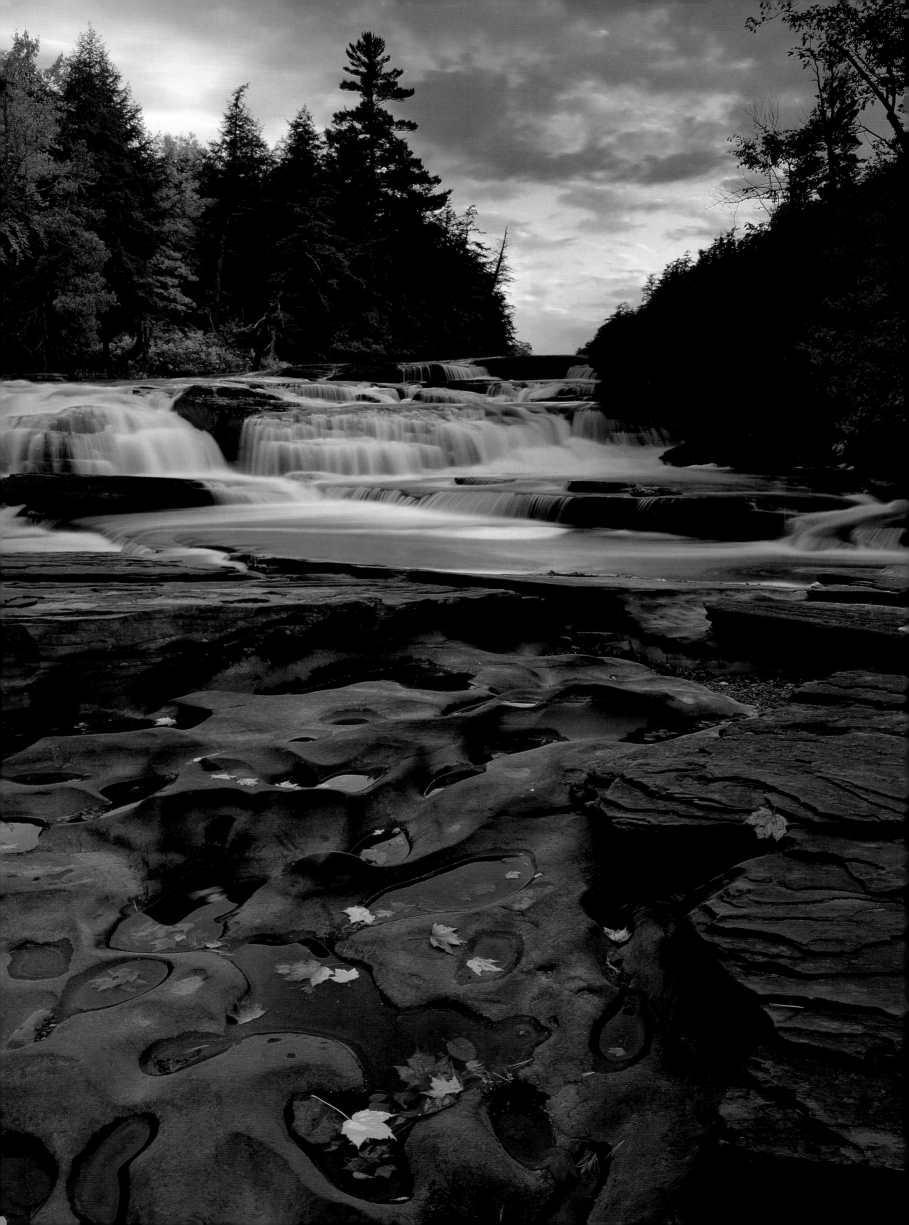

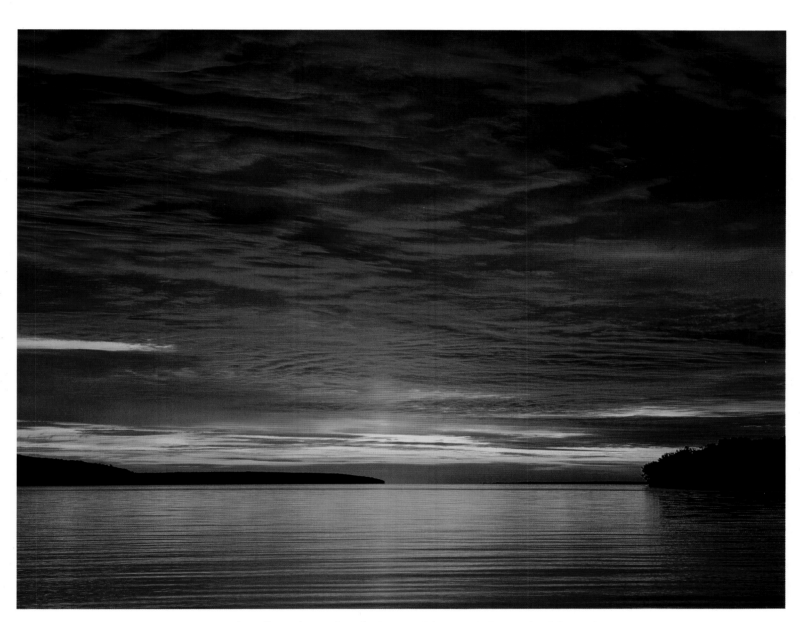

◄ Manido Falls are located on the Presque Isle River in Porcupine Mountains Wilderness State Park, established in 1945 in Michigan's Upper Peninsula. Michigan was shaped by the glaciers of the Ice Age, which created hilly belts, rolling plains, and lakes—large and small. The sixty-three thousand acres encompassed by the park remain one of the few state wilderness areas. ▲ Frog Bay, on Lake Superior, is part of Wisconsin's Red Cliff Indian Reservation and Apostle Islands National Lakeshore. The Chippewa, or Ojibwa, of this area are part of one of the larger tribes north of Mexico.

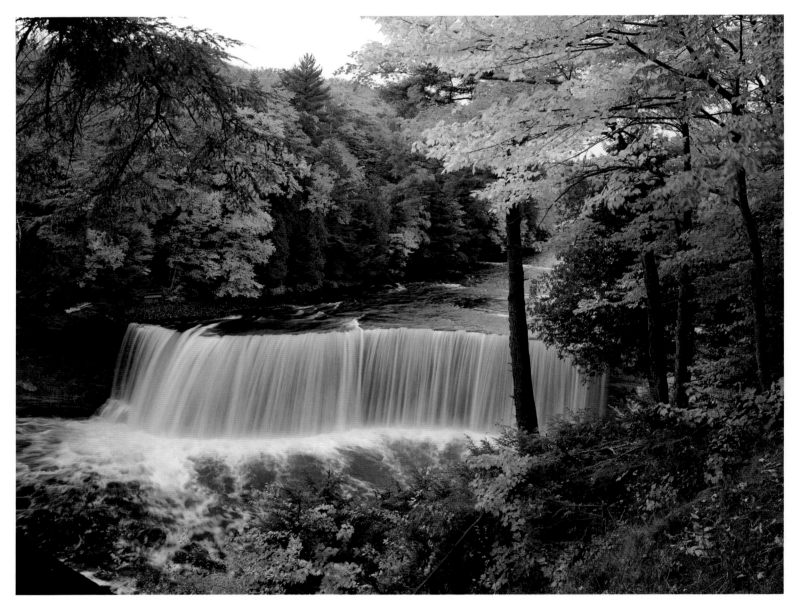

▲ More than two hundred feet across and with a drop of nearly fifty feet, the Upper Tahquamenon Falls have recorded a flow of more than fifty thousand gallons of water per second. Situated in Tahquamenon Falls State Park, the Tahquamenon River is a site mentioned in Longfellow's poem, "Hiawatha."

► Kabetogama Lake lies in fifty-five-mile-long Voyageurs National Park. Across the misty lake come the eerie cries of common loons by day, the haunting howl of wolves at night. With some thirty lakes and nine hundred islands, the park spans a watery stretch of the Minnesota-Ontario border.

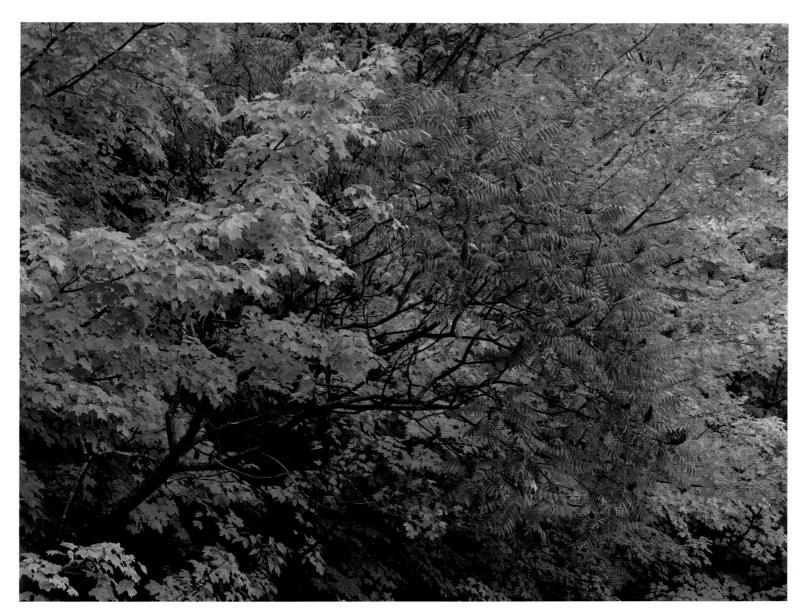

◄ Whitefish Point Light Station stands sentinel between open Lake Superior and the protected waters of Whitefish Bay. The largest ship ever to sink in the Great Lakes was the 729-foot-long ore freighter, *Edmund Fitzgerald*. In November 1975 during a tremendous gale, the *Fitzgerald* sank with its crew of twenty-nine just fifteen miles before entering the safety of Whitefish Bay.
▲ Sugar maples and red sumac line the Presque Isle River in Michigan's Porcupine Mountains Wilderness State Park. The regions of the Upper Great Lakes and New England both support especially extensive arrays of deciduous forests—and the brilliance of fall foliage naturally follows suit.

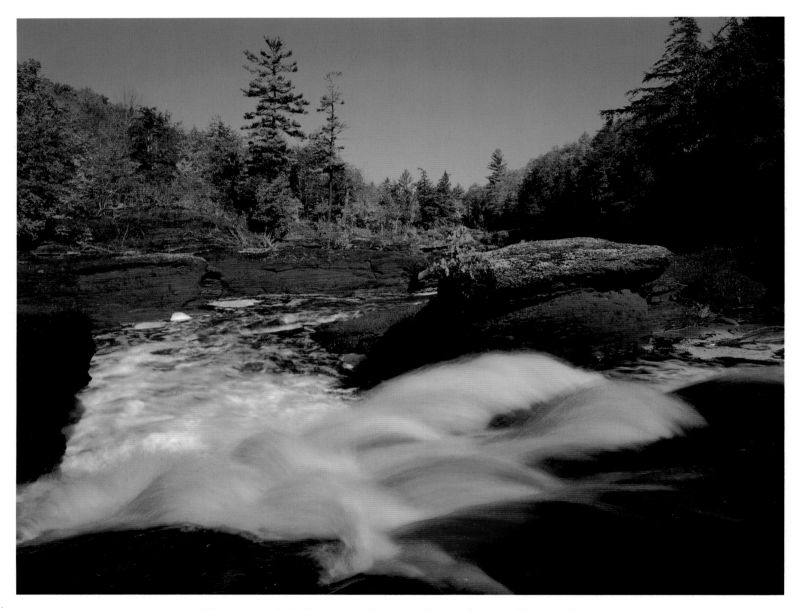

▲ The waters of the Black River flow over the Sandstone Falls in Michigan's Ottawa National Forest. This is wild country, encompassing three wilderness areas, many acres of water, and huge tracts of second-growth forest.
▶ Water Tank Lakes are located in Tahquamenon Falls State Park. Misty mornings typify autumn in the North Country. Cold night air settling over warm ponds creates fog, which will eventually evaporate during the day.

◄ Sugar maples and quaking aspen herald the arrival of the autumn season on Wisconsin's Bad River Indian Reservation. Glaciers from the Ice Age ground rocks into fine powder, thus making them available for the growth of great forests and fertile fields. Bordered by Lakes Superior and Michigan, Wisconsin, nicknamed "The Badger State," joined the Union in 1848.
▲ Much of Ohio is known for its dairy, soy bean, corn, hay, and wheat farming; its livestock production includes cattle, pigs, broilers, and turkeys. With a population of more than eleven million, Ohio's principal industries are trade services and manufacturing of transportation equipment.

▲ Abraham Lincoln spent his youth in a log cabin similar to this replica at the
Lincoln Boyhood National Memorial in Indiana. Born in Kentucky, he
moved to Indiana when he was seven. His formal education was meager, but
instilled in him was a love of reading and knowledge that lasted a lifetime.
► A pumpkin stand in northern Ohio exemplifies the richness of the produce
available throughout rural America, as well as the festivities, such as
Halloween, that make up such a large part of the fabric of America.
►► Cincinnati, Ohio, lies across the Ohio River from Covington, Kentucky.
Because of the great transportation routes—including the Ohio River, Lake
Erie, and the railroad system—Ohio became a main artery for settlers.

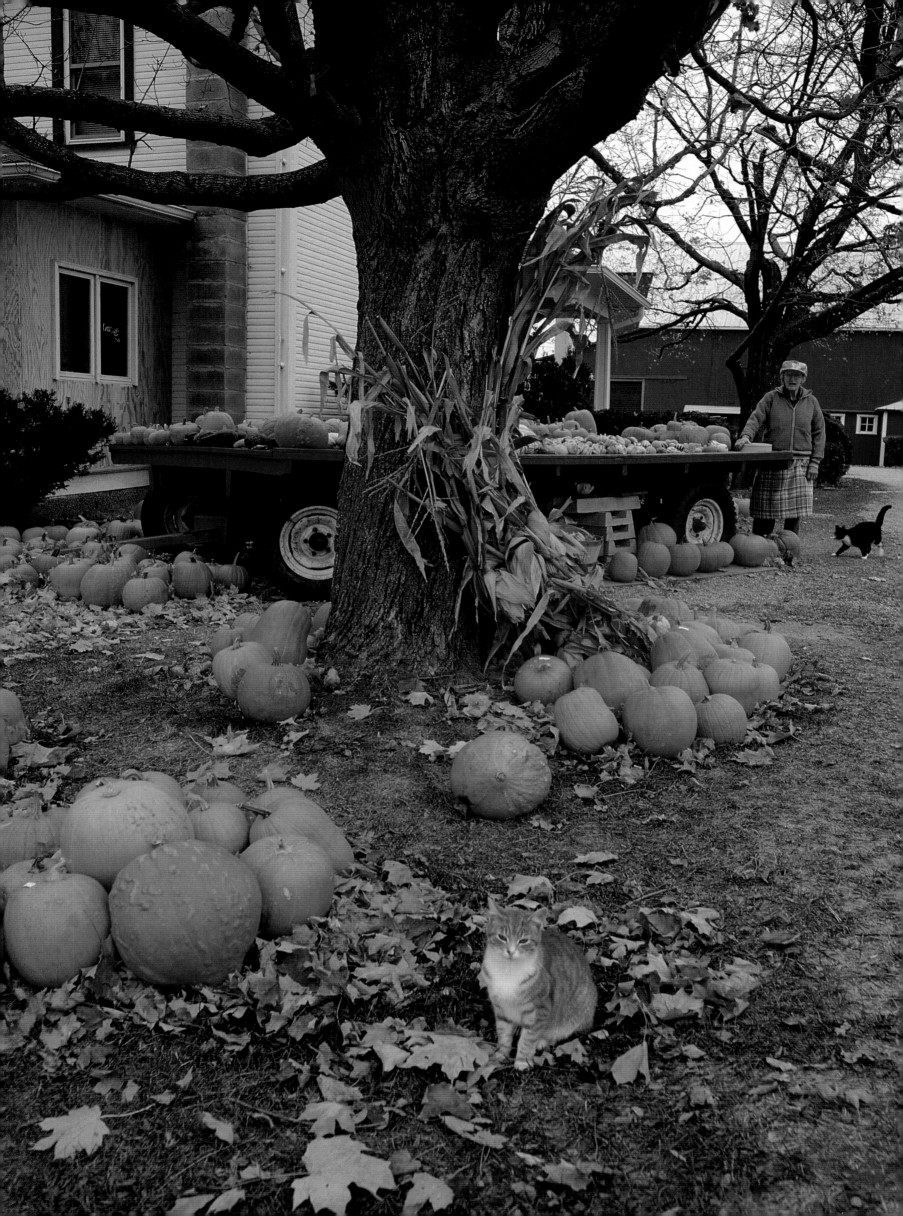

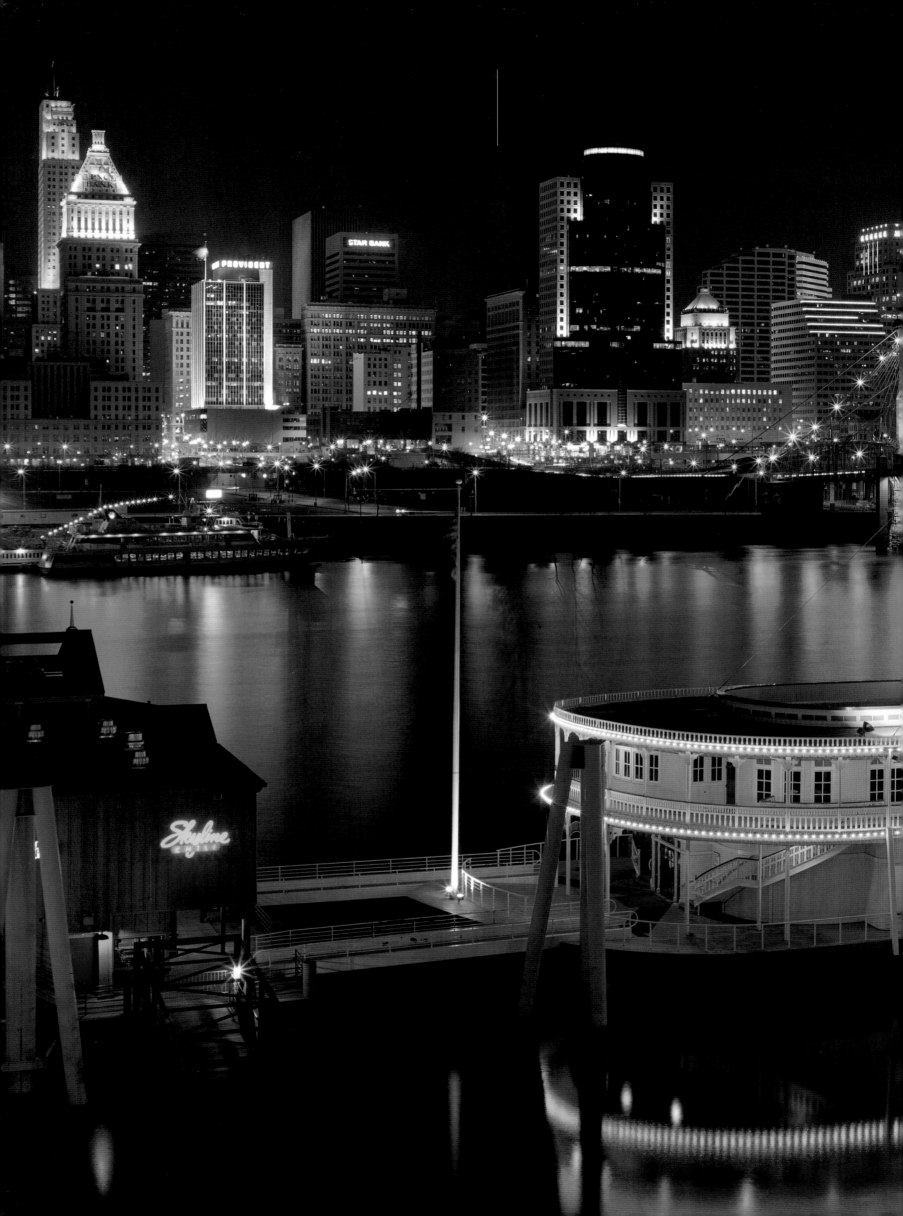

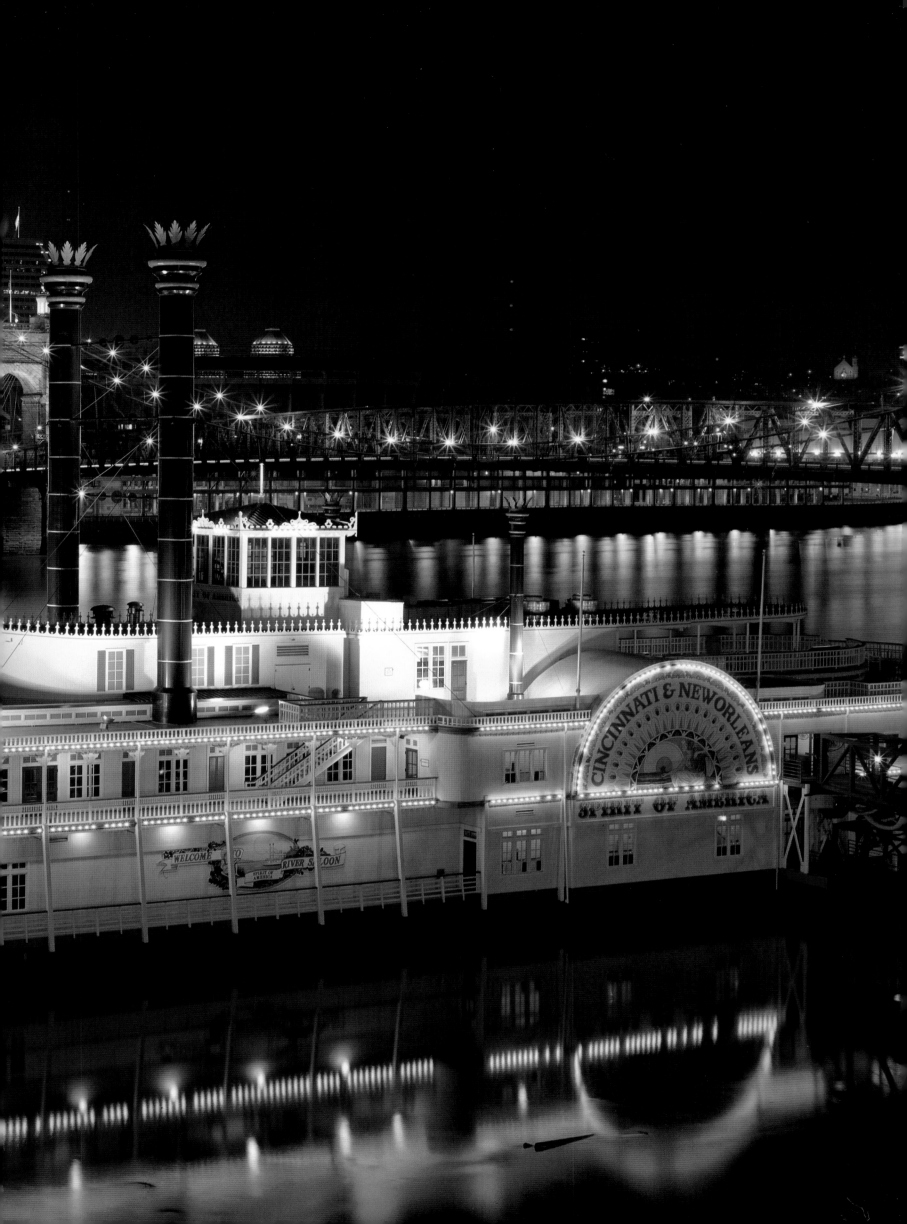

THE HEARTLAND

A chunk of rusty armor in a Lyons, Kansas, museum bears testimony to the fact that Coronado and his conquistadors rode that far in 1541, chasing a myth about seven cities of gold. They were disappointed. They found only endless grassland, grazed by vast herds of the thin-shanked, long-horned, bearded beasts we call buffalo.

Sixty million American bison roamed the plains then, in herds large enough to drink

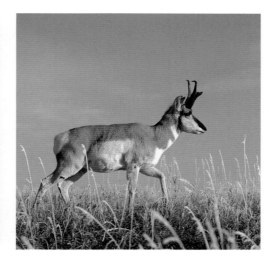

Above: *Plots of nursery stock and giant fields of wheat, corn, and hay present an agricultural tapestry across America's breadbasket. Above right: Pronghorn antelope range in South Dakota's Badlands National Park. Speeds up to sixty miles per hour make them the fastest land animals in North America. Left: North Dakota farms, huge and productive, needed grain elevators and the railroad to store and transport crops to the cities.*

whole rivers dry. The agile Natives who hunted them—on foot, with spears and arrows—were also the fiercest warriors on the continent. The Spanish introduced them to horses and guns.

French trappers and explorers next laid claim to the plains. When Jefferson tried to buy New Orleans in 1803, Napoleon, in need of money, insisted on selling the entire Louisiana Territory. Congress reluctantly voted fifteen million dollars for the land between the Mississippi and the Rockies. They felt they already had enough land: the great treeless plain was useless for agriculture, anyway. On an 1820 map, the plains were labeled "The Great American Desert."

When pioneers did cross the Mississippi, they found not a desert but a sea of grass, deep as a man was tall. The tallgrass prairie rolled out all the way to eastern Kansas, and its deep roots created soil so dense that homesteaders often broke their plows trying to turn it. Plow it they did, though.

It was not easy. Pushing westward, the wagon trains left a trail of possessions and

gravesites. Homesteaders fought Indians, tornadoes, locusts, dust, and loneliness. The dugouts and sod houses where they weathered Nebraska winters bear testimony to the early settlers' tough pragmatism.

Now, in the prairie, it is corn that grows taller than a man's head, in mile after mile of green fields. Beyond the corn belt, the amber waves of grain ripple out to the horizon, and fat beef cattle graze. The "desert" is America's breadbasket and steak platter.

It is a common misconception that the prairies are flat. The central plain actually slopes up to the west, gaining five thousand feet from the Mississippi to the Rockies. It also ripples with hills, from Missouri's Ozarks to the lake-filled Flint Hills of Nebraska. Precipitation diminishes, east to west. Iowa, the nation's leading corn producer, receives about thirty inches of rain a year, while Nebraska gets fifteen. Rainfall dictates transitions in crops, as it did the length and profusion of prairie grasses.

St. Louis, the French-founded port on the Mississippi, was the gateway for westward immigration and inspiration for Mark Twain's stories. Kansas City, on the mighty Missouri River, was built by the railroads and the meat packing industry. To tell the tales of towns like Abilene and Dodge City would take another book. But cities and sagas are not what this region is about.

It is about the land.

From a plane, it spreads below like a giant quilt. Country roads define the miles, in a grid that is the legacy of Jefferson's town-and-range system. The fields make a pattern of green and gold and rich black earth, their angles overlaid with the perfect circles scribed by giant sprinklers. A barn, a house, and a clump of trees pin down one corner of each farm spread. The pattern is broken, occasionally, by a winding stream edged with cottonwoods, or a town marked by a water tower and a tall grain elevator.

It is about broad vistas, green fields, and miles of road. It is about hard work and home-grown values, elbow-room and independence, blizzards and forked lightning, and sunflowers six feet tall. It is about seeing for miles in every direction—and feeling both very powerful and very small.

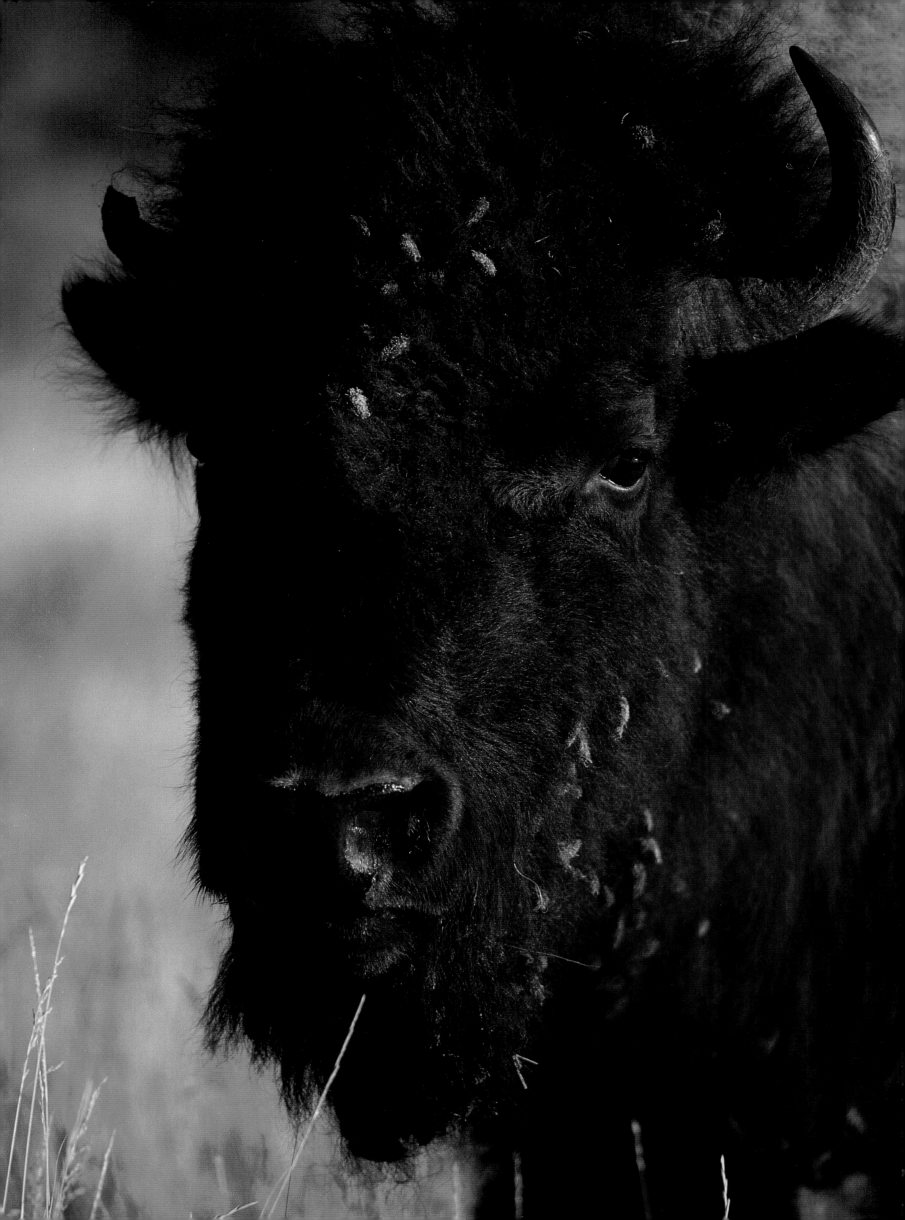

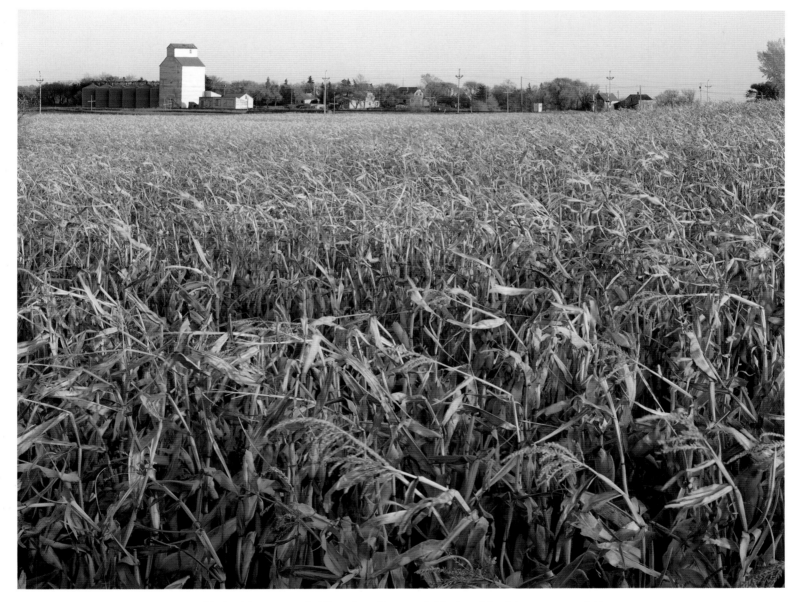

◄ Today bison graze in Theodore Roosevelt National Park just as peacefully as they once freely grazed the prairies. Nearly extinct by 1900 due to hunting by whites, they were saved through the efforts of Roosevelt and others and now number close to twenty thousand; extinction is no longer a threat.
▲ A cornfield and a grain elevator in Mapes, North Dakota, exemplify land uses in the plains. Since the early days of white settlement, agriculture has been the dominant force in the region's economy. Less than 10 percent of the plains is forested, leaving massive space for crop and livestock production.

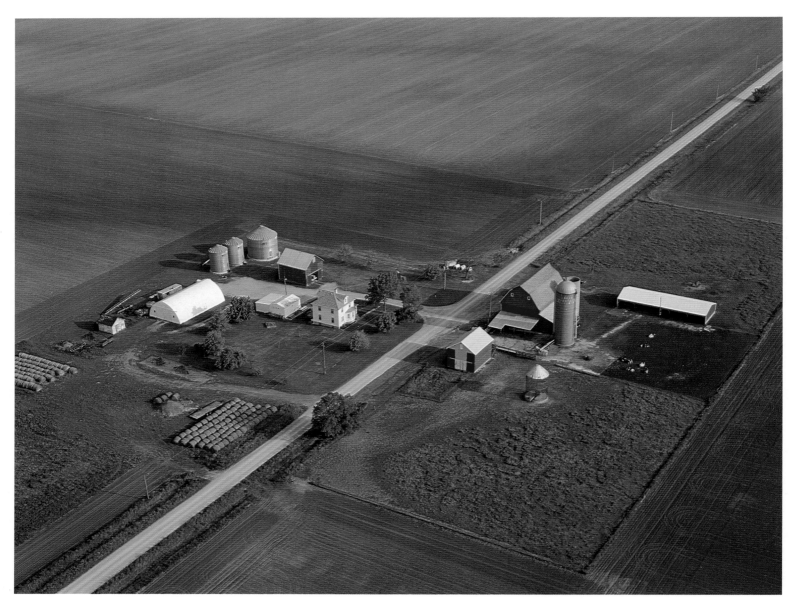

▲ America's breadbasket, including Illinois farmland, annually produces some three and a half billion bushels of corn and a billion bushels of wheat.
► Badlands cover some six thousand square miles of South Dakota and Nebraska. The rapidly eroding hills of Badlands National Park expose an awesome array of fossilized bones. Ancient rhinoceroses and saber-toothed cats are but a few of the myriad animals preserved in the fossil record.
►► Noted for traditional ways, the Amish of Iowa live chiefly by farming. Home church services and barn raisings demonstrate community spirit.

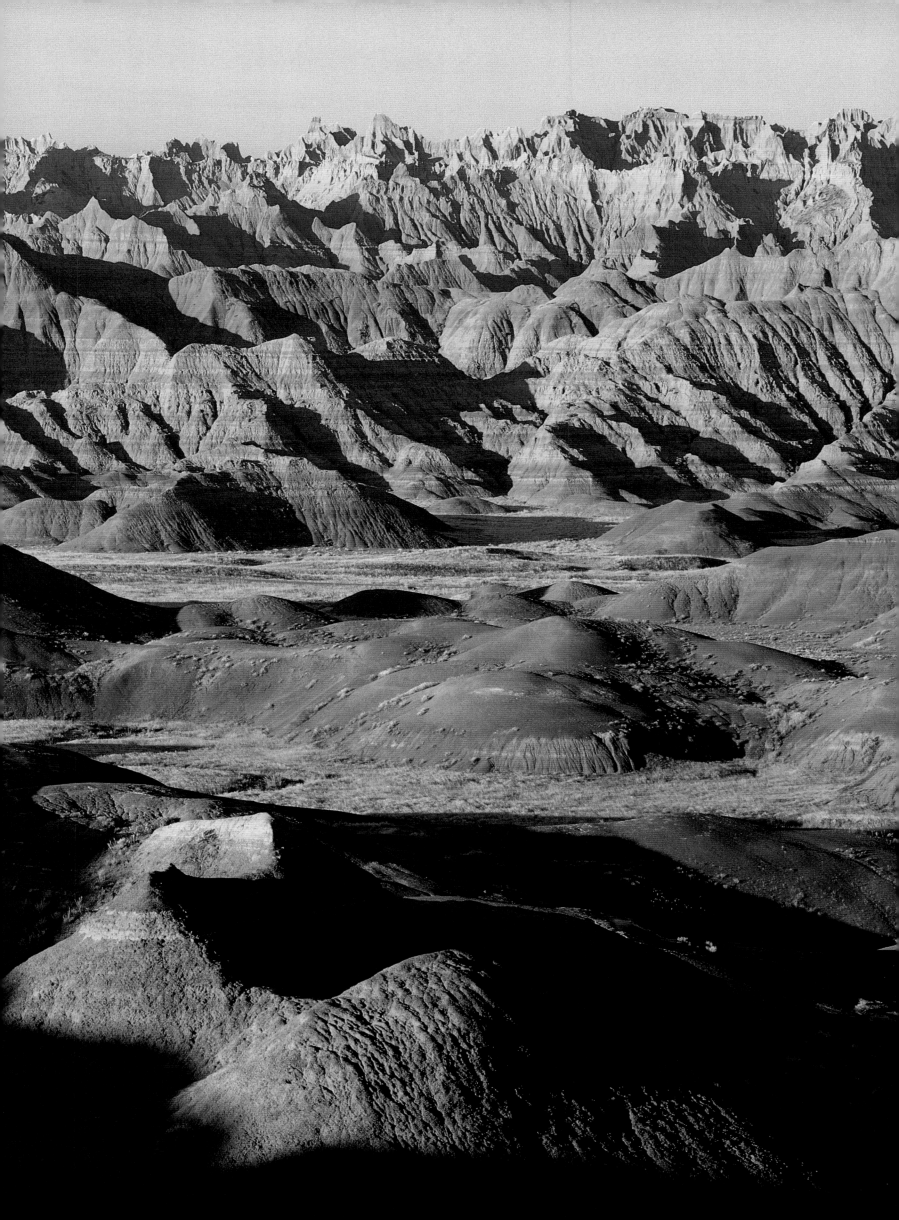

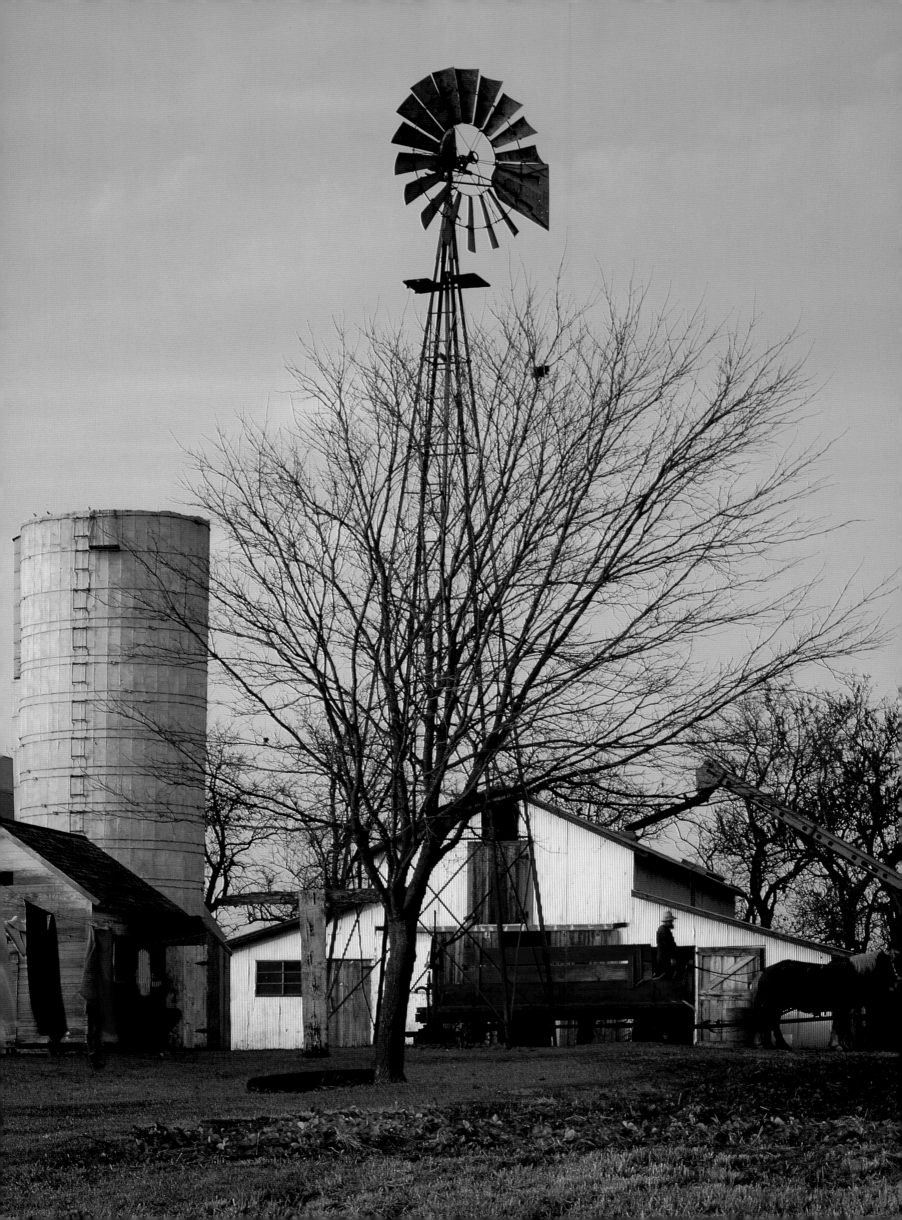

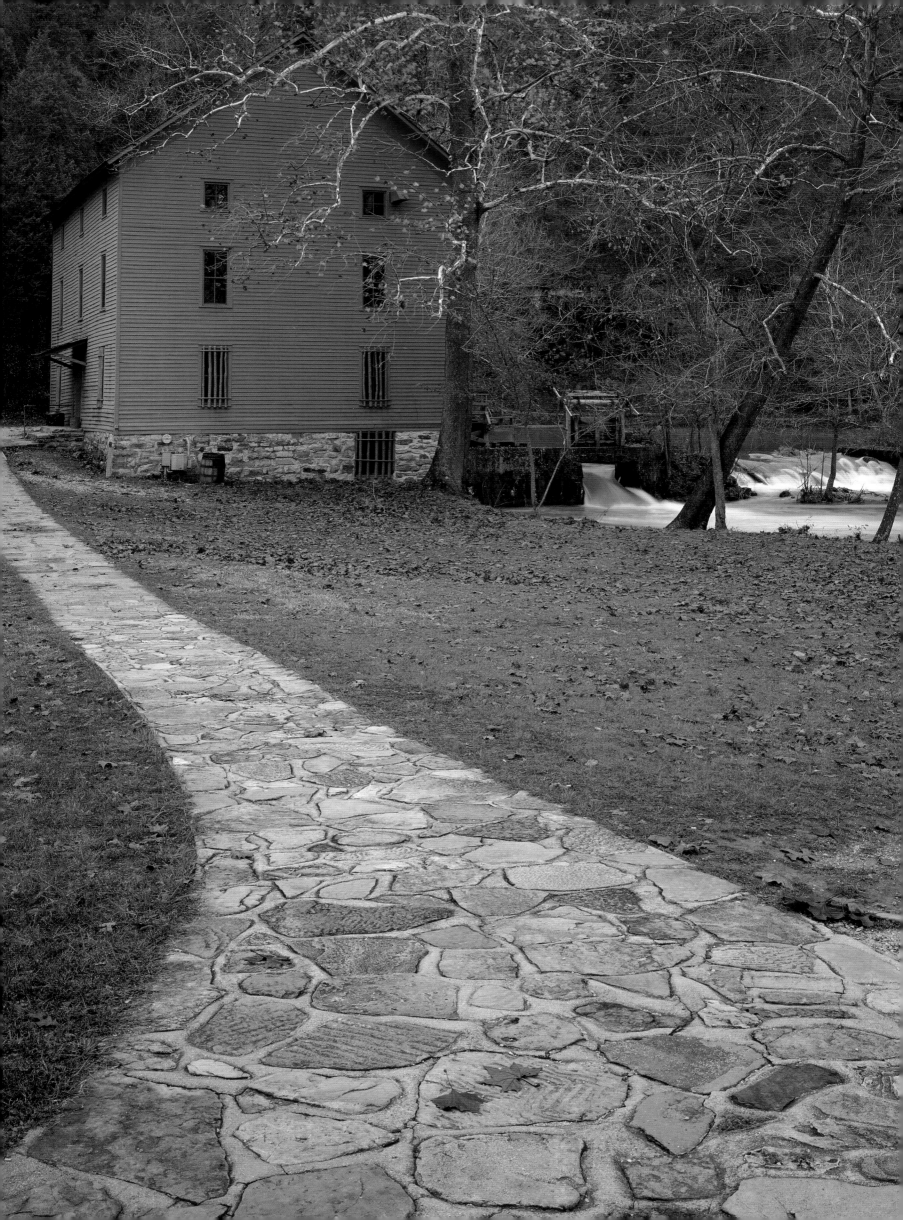

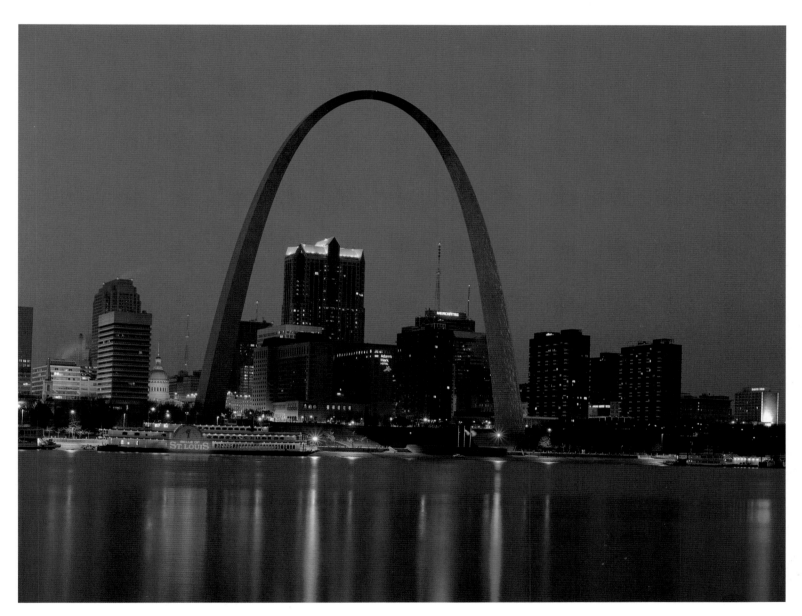

◄ Alley Spring Mill, now preserved in Ozark National Scenic Riverways, Missouri, was once a vital link to survival of those who called the area home.
▲ The Mississippi River was labeled early on as the Gateway to the West. Today, the Gateway is exemplified by the Jefferson National Expansion Memorial Gateway Arch of St. Louis. The Mississippi was a major transportation artery during America's formative years, and along with St. Louis as its major port, served as a great influence in the nation's growth. Together, the Mississippi and the Missouri rivers travel some four thousand miles.

▲ Due west of Oklahoma City, Red Rock Canyon State Park is an icon of Oklahoma. Here, the Fort Smith-Santa Fe Trail crossed the colorful red sandstone. Oklahoma is rich is western history and Native culture.
▶ A winter ice storm coats the grass and fence near Osage City in eastern Kansas. Kansas was explored by Francisco de Coronado for Spain, and by Sieur de La Salle for France, more than a century before it was ceded to the United States as part of the Louisiana Purchase in 1803. In 1822, the wagon route of the Santa Fe Trail ran from St. Louis through Osage City to Santa Fe in New Mexico Territory. Kansas achieved statehood in 1861.

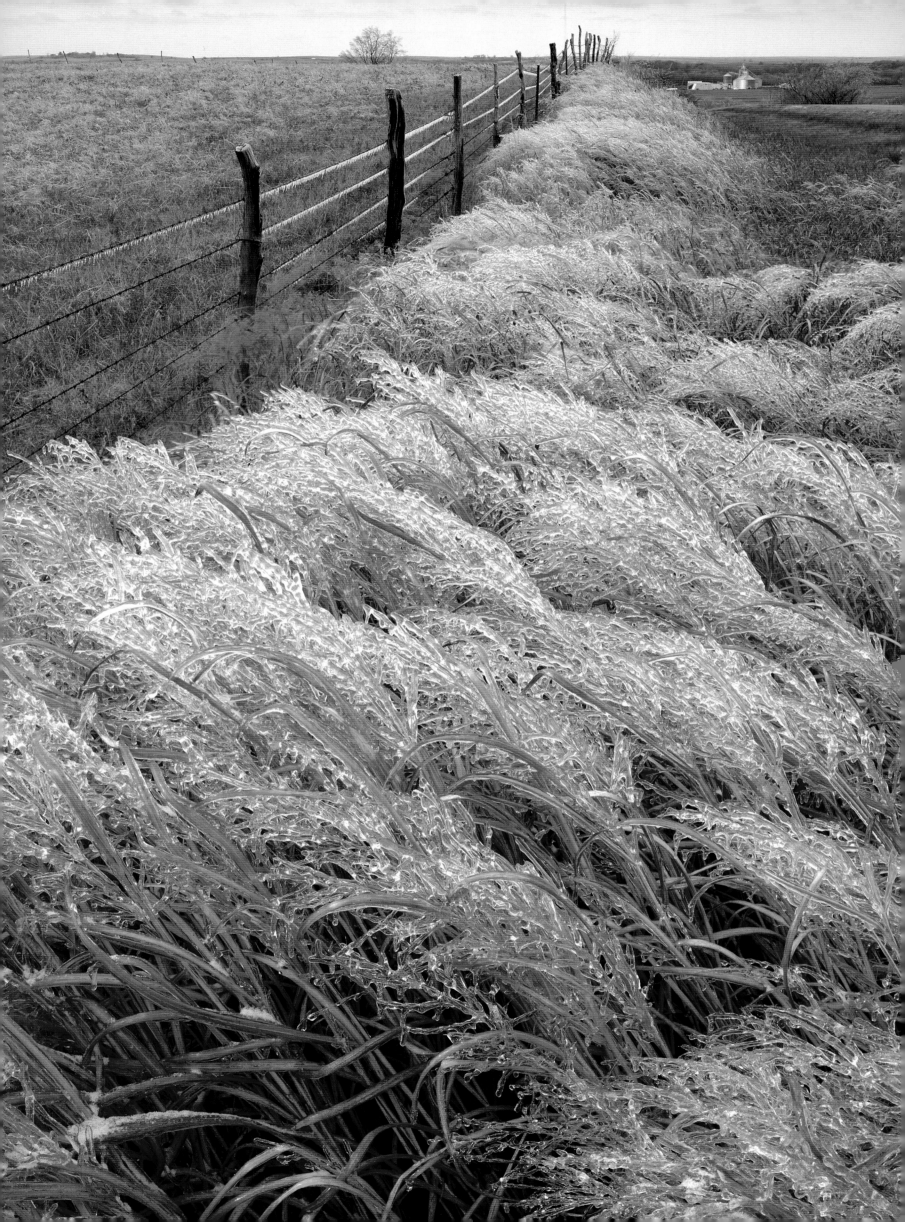

TEXAS

As everyone knows, the word that goes with Texas is BIG.

Our second-largest state could swallow all of New England. It is larger than most European nations. But Texas looms large for more reasons than its square miles. Texas has a big, flamboyant history, and a style to suit its size. Things happen on a grand scale here—wells gush oil by the millions of barrels, cities sprawl, ranches

Above: *In addition to Mission San José, founded in 1720, the San Antonio Missions National Historical Park encompasses the Concepción, San Juan, and Espada missions. Above right: Near Fredericksburg, a wagon wheel speaks of the rich history of Texas. Left: Houston skyscrapers indicate just how far Texas has come since it was a Mexican colony. It became an independent republic in 1836 and achieved statehood in 1845.*

spread for miles. Texans favor ten gallon hats, tall boots, and big silver belt buckles; they like big stories, and have big hearts.

Of course, not all Texans are cowboys, nor is all of Texas oil wells or range land. Texas is a leader in the production of oil, cotton, cattle, sheep, and goats, and it ranks third in agriculture. But Texas is also becoming a mecca for the chemical and aerospace industries, and boasts sophisticated cities like Houston and the Dallas-Fort Worth "Metroplex."

Nor, as some people believe, is Texas all flat and dry. This broad landmass contains every kind of terrain, and a diversity of cultures and attitudes to match.

Sandy beaches, protected by the Barrier Islands, line the Gulf Coast. East Texas is an area of forests and streams, given to cotton plantations and timbering. South Texas, along the Rio Grande, is a subtropical plain, with citrus plantations, palm trees, and massive ranches. It is the source of the Texas buckaroo, and the place where the nineteenth-century cattle drives began.

The Edwards Plateau in central Texas is a prized retreat area, with clean rivers and rolling hills. Central Texas is the plains area cattle trains once traveled, a region of folklore and political history. The northern panhandle, the Staked Plain, gives Texas its reputation for being hot and dry. The Trans-Pecos, between the Rio Grande and the Pecos, is an extension of the Southwest—beautiful, mysterious, desolate, and the source of legends about Texas lawlessness.

Texas got its name from *Teychas,* a word used by East Texas Indians. Explorers took it to mean the land; it really meant "friend." Hence, the state's motto, "friendship." The Spanish explorers arrived, searching for gold, in the sixteenth century. Finding none, they built missions, hoping to pacify the Indians through conversion. Their success was limited; the Comanches and Apaches were notoriously resistant. The missions kept livestock, and the mission Indians became the first Texas cowboys.

Spain ruled Texas for three centuries, then ceded it to Mexico after the Mexican Revolution. The Anglo influx really began about 1821, when Stephen Austin got permission from the Mexican government to bring in settlers from the States. By 1835, Texans became impatient with increasing Mexican despotism. Seeking reforms, they rebelled, and emerged independent.

The most famous battle took place in the Old San Antonio de Valero—the Alamo. For thirteen days, fewer than two hundred stubborn sharpshooters fought some four to five thousand Mexican troops, killing hundreds before the walls were breached and all inside were slaughtered. The defenders might have escaped through Mexican lines, but vowed "Victory or Death."

Perhaps that is why the battle so fired American imaginations. "Remember the Alamo" became the Texans' battle cry, and the Alamo became an American icon.

Under General Sam Houston, the Texas rebels won their revolution. Texas was a sovereign nation when it was annexed to the United States in 1845. Nationhood, however brief, made a lasting impression on the Texas psyche. This big state has a spirit of feisty independence unlike any other.

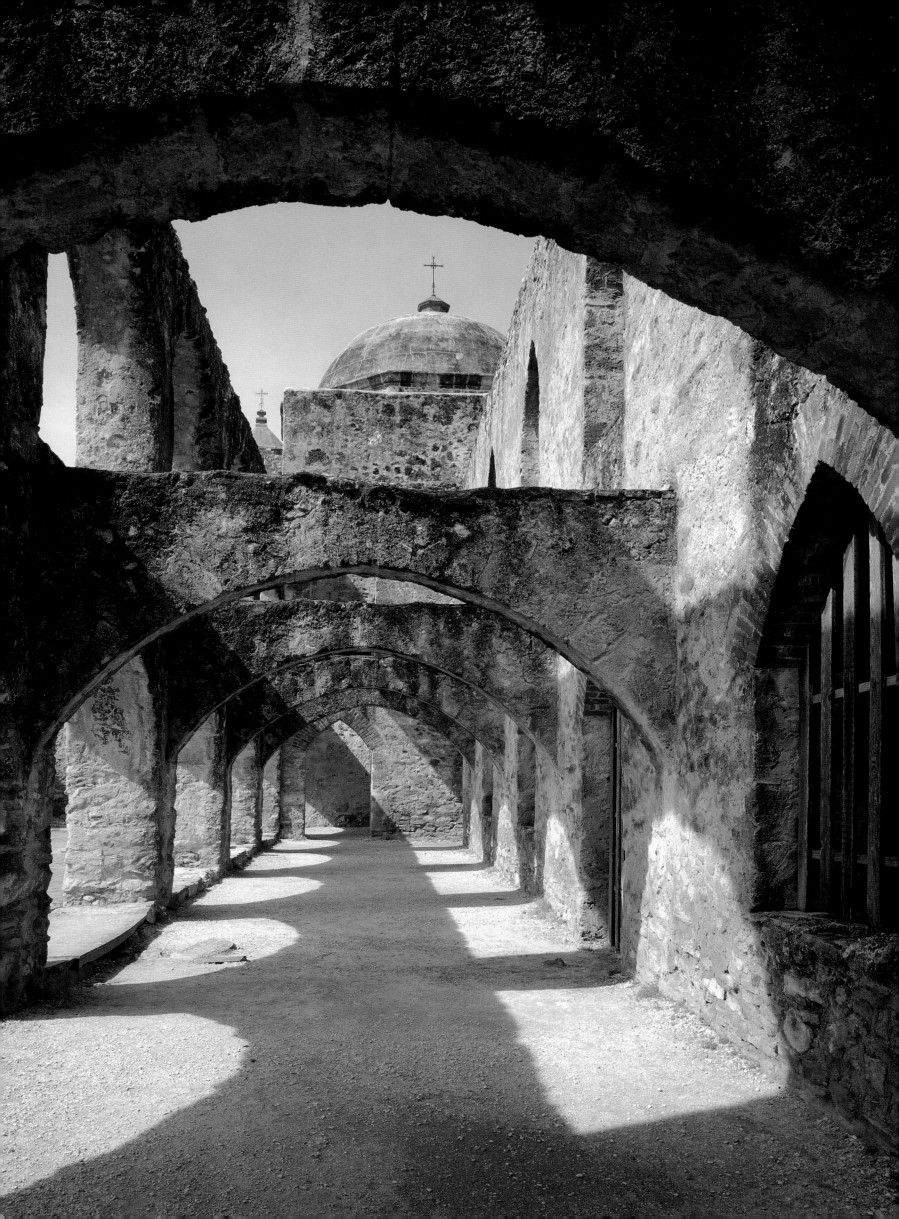

◄ Mission San José is only one of the chain of missions established along the San Antonio River in the eighteenth century. Reminders of one of Spain's most successful attempts to extend its dominion northward from Mexico, they were the greatest concentration of Catholic missions in North America.
▲ Blossoms of pitaya, or strawberry cactus, flourish above Blue Creek Canyon in Big Bend National Park, Texas. Apaches said that after making the Earth, the Great Spirit dumped the leftover rocks on the Big Bend. Spanish explorers, less intimate with the area, dubbed it "uninhabited land." This bare-bones of the western landscape, cut through by the "big river," the Rio Grande, has tenacious wildlife and a veneer of spiny desert vegetation.

101

▲ Texas longhorns were brought from Spain by Columbus. By 1866, herds arrived from Mexico and were flourishing on the South Texas prairies. The hardy longhorns are resistant to ticks and can travel a thousand miles to market, thus making them so important to early ranching that they had a major influence on nearly every development in Texas and the Southwest.
▶ Texas is represented by a variety of symbols: the bluebonnet shines as the state flower; the mockingbird sweetly sings as the state bird; the pecan stands tall as the state tree; and friendship reaches out as the state motto.

◄ Oak forests interspersed with open prairies dot the Texas Hill Country, known academically as Edward's Plateau because of its limestone geology. Deer roam its low, rolling hills, and wildflowers brighten the landscape.
▲ The River Walk, or Paseo del Río, borders the San Antonio River. Picturesque paddle boats glide by shops, restaurants, and hotels in this promenade in San Antonio, a city of over a million. The area's Mexican heritage offers ethnic foods, unique handicrafts, and colorful clothing.

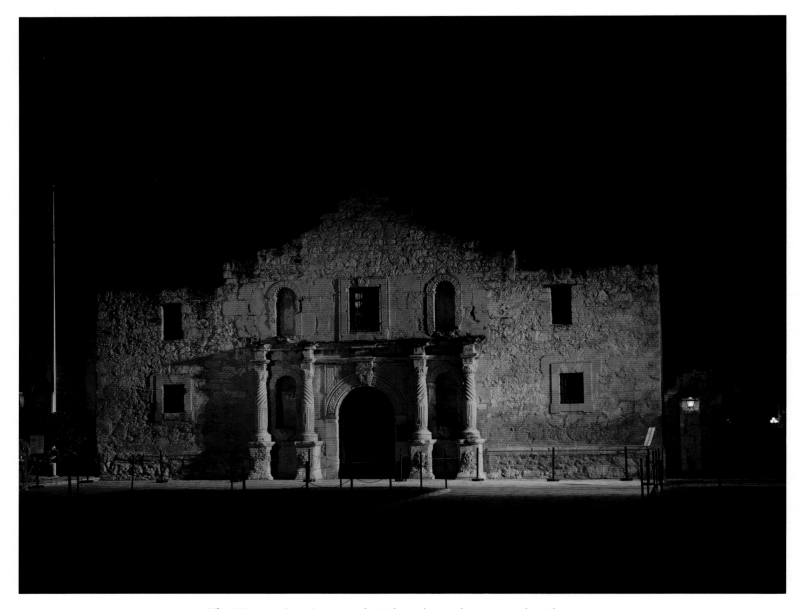

▲ The Mission San Antonio de Valero, better known as the Alamo, was founded in 1718 in San Antonio. This mission fortress was beseiged in 1836 by Santa Anna with some four to five thousand Mexicans. All the defending garrison of less than two hundred, including Davy Crockett and Jim Bowie, were killed. The struggle against overwhelming odds made the battle a rallying cry for settlers in the Texas War of Independence from Mexico.
▶ Home-canned products, such as these at the Sauer-Beckman Farmstead at the Lyndon B. Johnson State Historical Park, are still used by German-Americans. President Johnson's forty-year career as a teacher, public official, and statesman laid an impressive record of labor, success, and achievement.

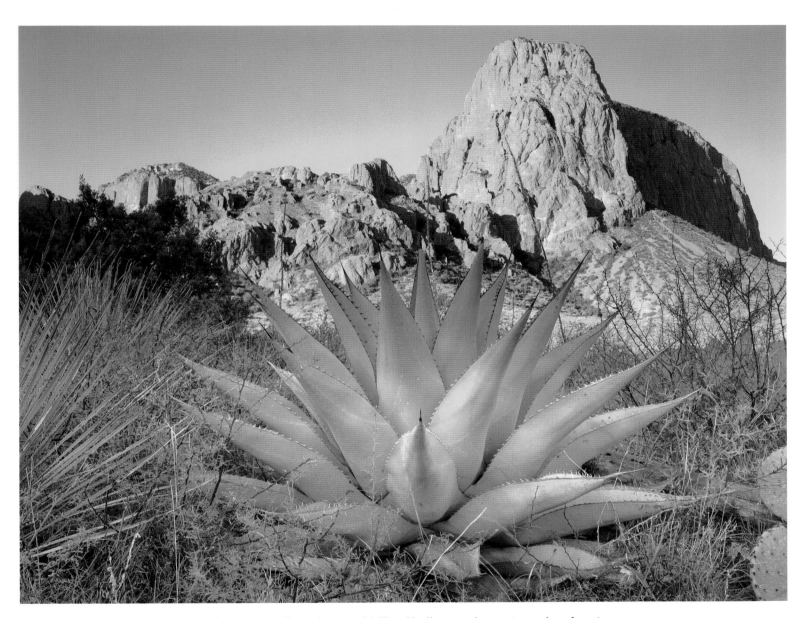

◄ The "Jersey Lilly" saloon and billiard hall remembers a time when frontier justice was carried out by the only "Law West of the Pecos." A Justice of the Peace in Langtry, Texas, Judge Roy Bean converted his saloon to a courtroom as needed, calling a jury from among his customers. Justice was swift, applied with humor, and backed up by the six-shooter on the bar beside him.
▲ Big Bend National Park harbors several types of agaves. Often called century plants, the agave takes many years to bloom—but not a hundred.

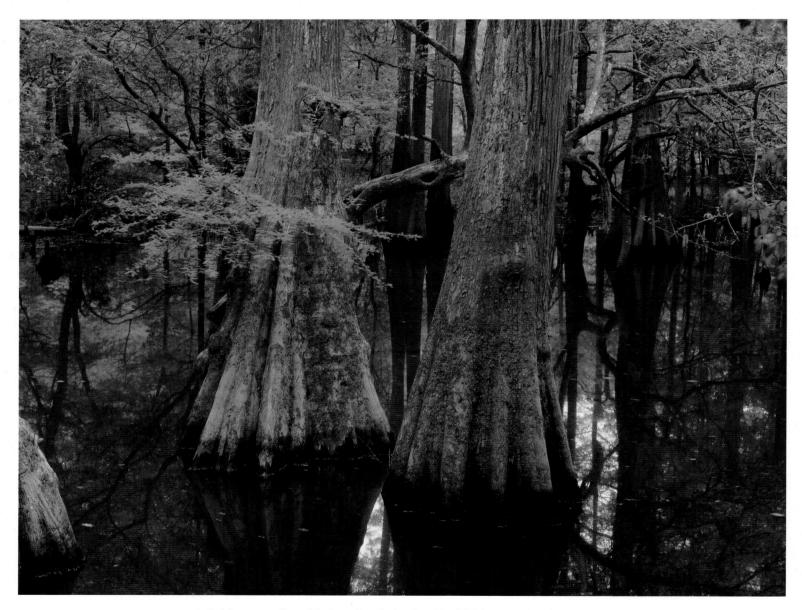

▲ Baldcypress lines Turkey Creek in the Big Thicket National Preserve, established in 1974. Called both an American ark and the biological crossroads of North America, this once-vast combination of virgin pine, cypress, and hardwood forest, of meadow and blackwater swamp is but a remnant. The Big Thicket boasts eighty-five tree species, nearly a thousand flowering plants, some three hundred bird types, and fifty reptile representations.
▶ Plains coreopsis and Drummond's phlox docorate a springtime meadow near San Felipe in eastern Texas. The close proximity to the Gulf of Mexico provides eastern Texas with ample moisture to nurture lush vegetaion.

THE SOUTHWEST

The vast, arid Southwest landscape has the power to inspire words like mystical and magical. Bathed in clear light and over-arched with immense skies, its earthtone expanses are brushed with a rich palette of colors nature seldom uses.

Within that landscape are quiet but persistent reminders of our place in the larger scheme of things—pueblos still inhabited after eight centuries, evidence of cultures

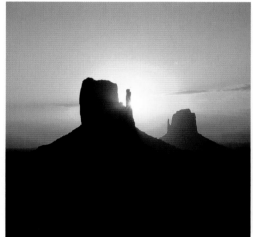

Above: *Beautiful Monument Valley Tribal Park is part of the Navajo nation, now with a population of over two hundred thousand.* Above right: *Arizona's Organ Pipe Cactus National Monument displays the blooms of hedgehog cactus,* Echinocereus engelmannii. Left: *The right combination of winter and spring rains triggers a lush show of desert marigold and owl's clover on the Tohono O'odham Reservation in southern Arizona.*

long gone, strange caverns, soaring stone arches, canyons too deep to comprehend.

The impression is of timelessness. Yet the land is changing, slowly but continuously, as it always has been. The paradox, in this dry part of the country, is that water is the primary cause of that change.

Water, in the form of ancient inland seas, created some of the sedimentary rocks from which the Southwest's canyons and mesas are carved. The seas built layer on layer as they advanced and receded, finally leaving the Great Salt Lake high within the continent. Then, as streams and rivers found swift downhill courses, the silt they rolled along worked like sandpaper to cut through the soft rock. Sometimes it carved strange shapes, because the resistance of the various levels of sediment differed. The cutting water revealed the history of the land's creation, layer by layer, and painted the land with the colors of mineral deposits.

Nearly two billion years of earth's history can be read in the walls of the Grand Canyon. That heart-stopping, mile-deep

gash in the earth is the work of the mighty Colorado River. Long ago, during gradual uplifting of the land, the river stayed its course, slicing through the soft land as a knife would through a cake, if the knife were held firm and the cake raised to meet it. The Colorado, flowing an average of 4.2 miles per hour and twenty feet deep, continues to whittle away at the land.

Bryce Canyon, the place Paiutes named "red rock standing like men in a bowl," is the work of many streams, rather than a single river. Once the shapes are exposed, the sculptures continue to evolve as rain, snow melt, and alternate freezing and thawing gradually eat away at the soft spots.

Underground water, cutting through soft limestone, created the Carlsbad Caverns. Limestone caves are abundant in the United States, but few are as large as Carlsbad, where one chamber is nearly a mile long and 350 feet high. Will Rogers called it the "Grand Canyon with a roof on it."

Within this mysterious landscape is more mystery. Northwest of Albuquerque, in the isolated Chaco Canyon, are ruins of a city that was in its prime during the European Middle Ages. It was built by the Anasazi, precursors of the Pueblos. More than five thousand people lived in its huge sandstone apartment complexes. These agricultural people created splendid jewelry and pottery, had a complex culture, and knew the world beyond; among their possessions were parrot feathers from jungles far to the south and abalone shells from the Gulf of California. In the 1200s, they just walked away, leaving everything, even farming tools. No one is sure why they left—or why they built there in the first place.

One thing is clear: for those who have lived here, this land exerts a powerful spell. In 1868, the Navajo, who had been interred on a reservation, were offered a choice: stay there, resettle in the fertile Arkansas River Valley, or return to their own Four Corners land. The choice was easy; they voted unanimously to return to their birthright. When the old Navajo braves crossed the pass in the Monzano Mountains and sighted their own sacred Turquoise Mountain, it is said that tears of joy rolled down their cheeks.

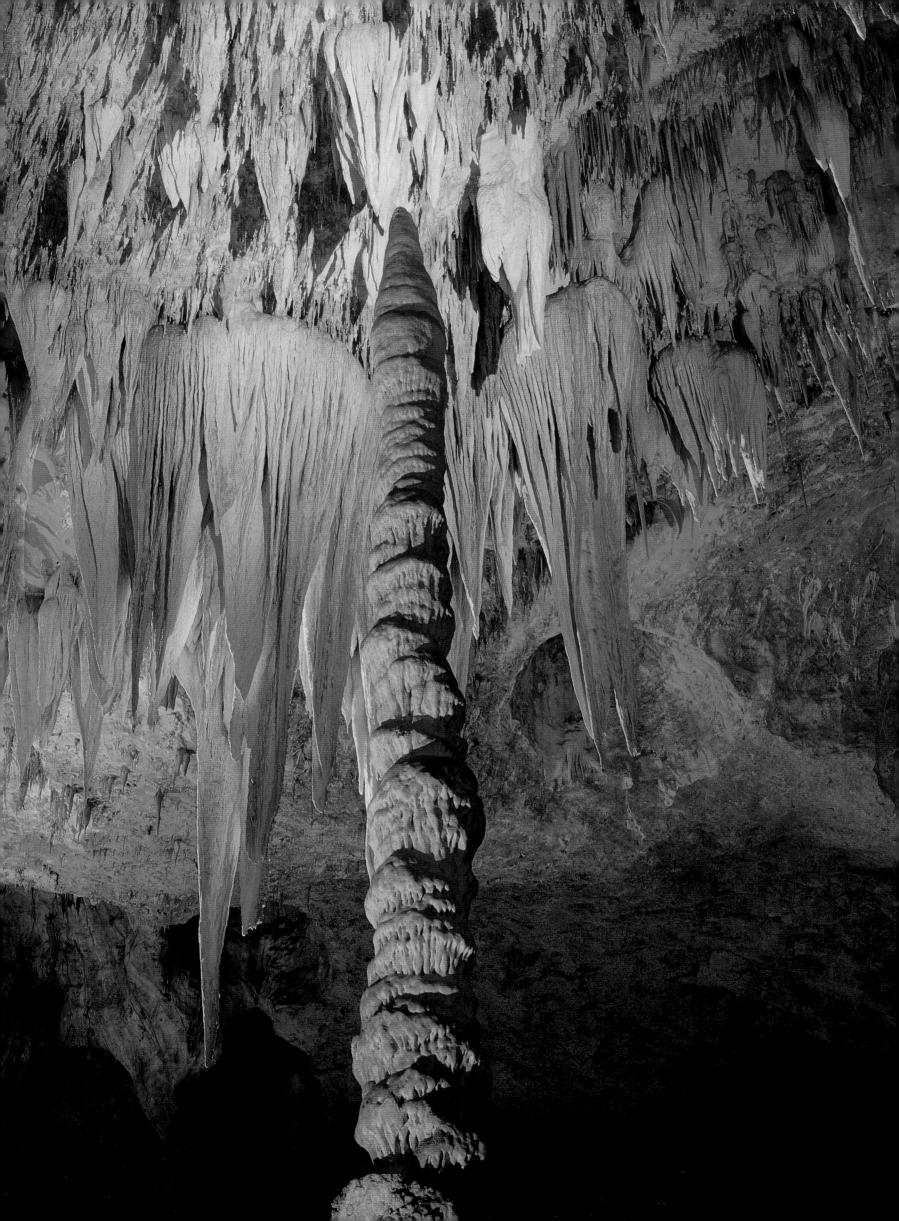

◄ The "Totem Pole" towers about thirty-six feet in the Big Room of New Mexico's Carlsbad Caverns. The ceiling here reaches seventy-four feet high. Millions of years of dissolving away limestone corridors and redepositing ornate speoliths account for Carlsbad's magnificent scenery.
▲ The Sentinel keeps watch over Utah's Zion National Park, established in 1919 and covering 146,551 acres. The scale is incredible—sheer cliffs dropping three thousand feet, massive buttresses, and deep alcoves. Nineteenth-century Mormons saw these beautiful rocks as "natural temples of God."

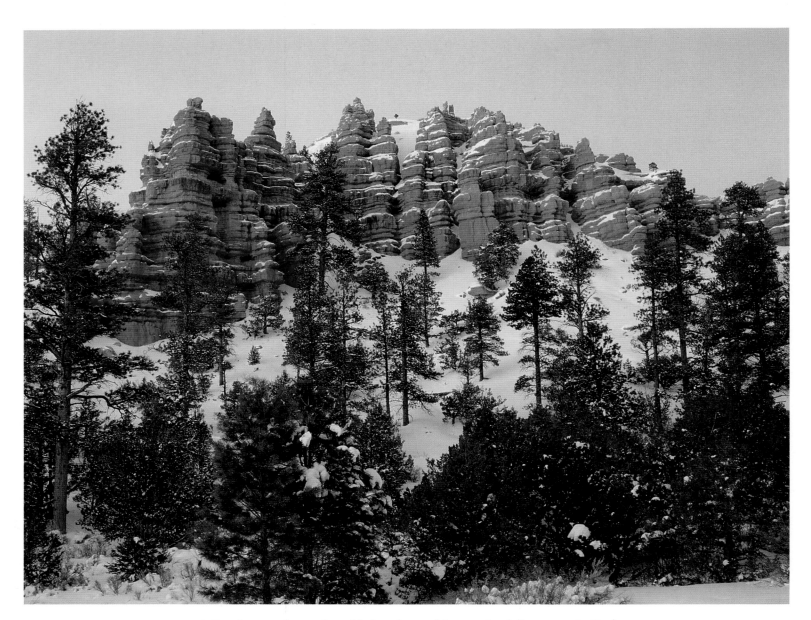

▲ Ponderosa pines mix with hoodoos of iron-stained limestone in Red Canyon of Utah's Dixie National Forest. Hoodoos are rock spires created by natural erosion. A slightly harder cap rock protects softer rock below. ▶ Thor's Hammer basks in the reflected light of sunrise in Utah's Bryce Canyon National Park. Mormon settler Ebeneezer Bryce, whose name is bequeathed to the area, lived here for five years but found the land too difficult to work. The Paiute name for the place was a description that translates: "Red rocks standing like men in a bowl-shaped canyon."

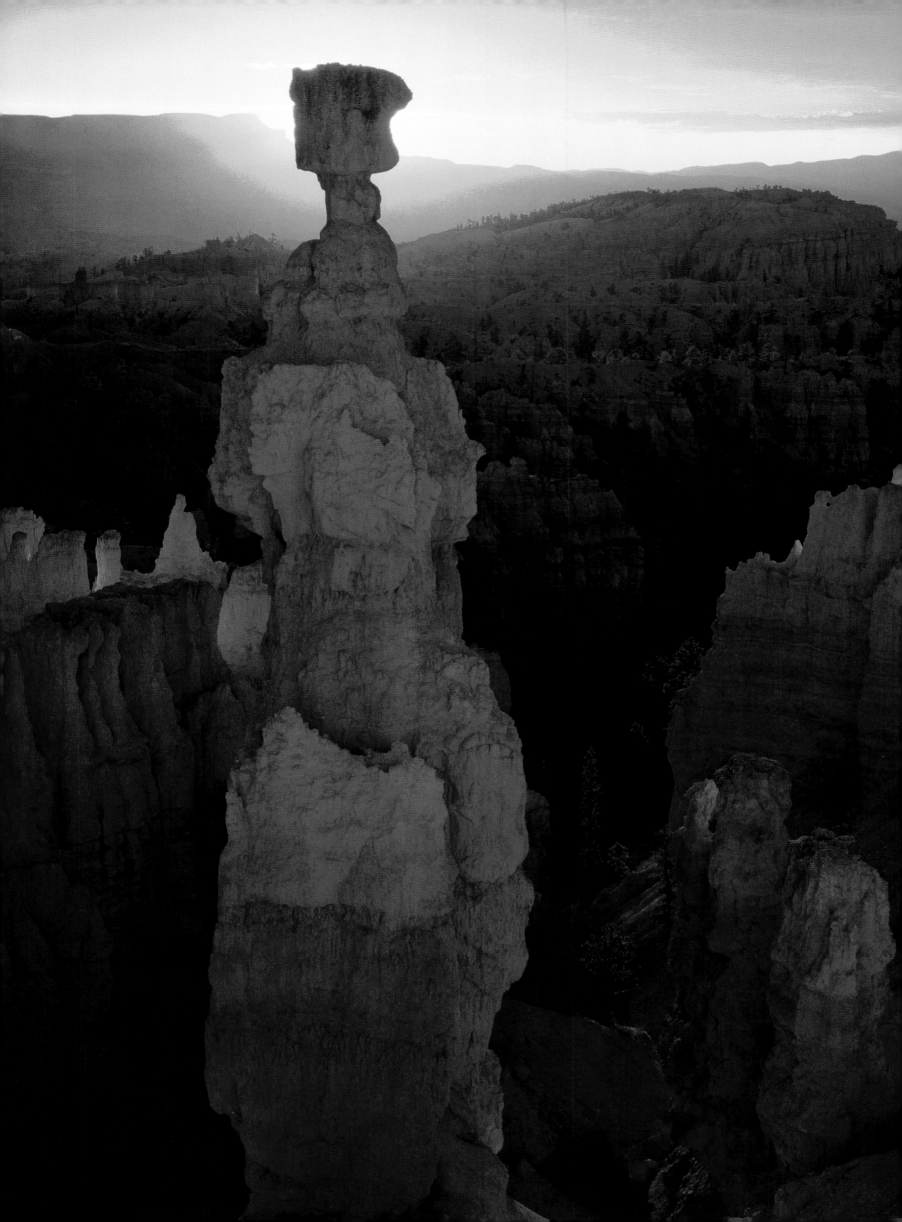

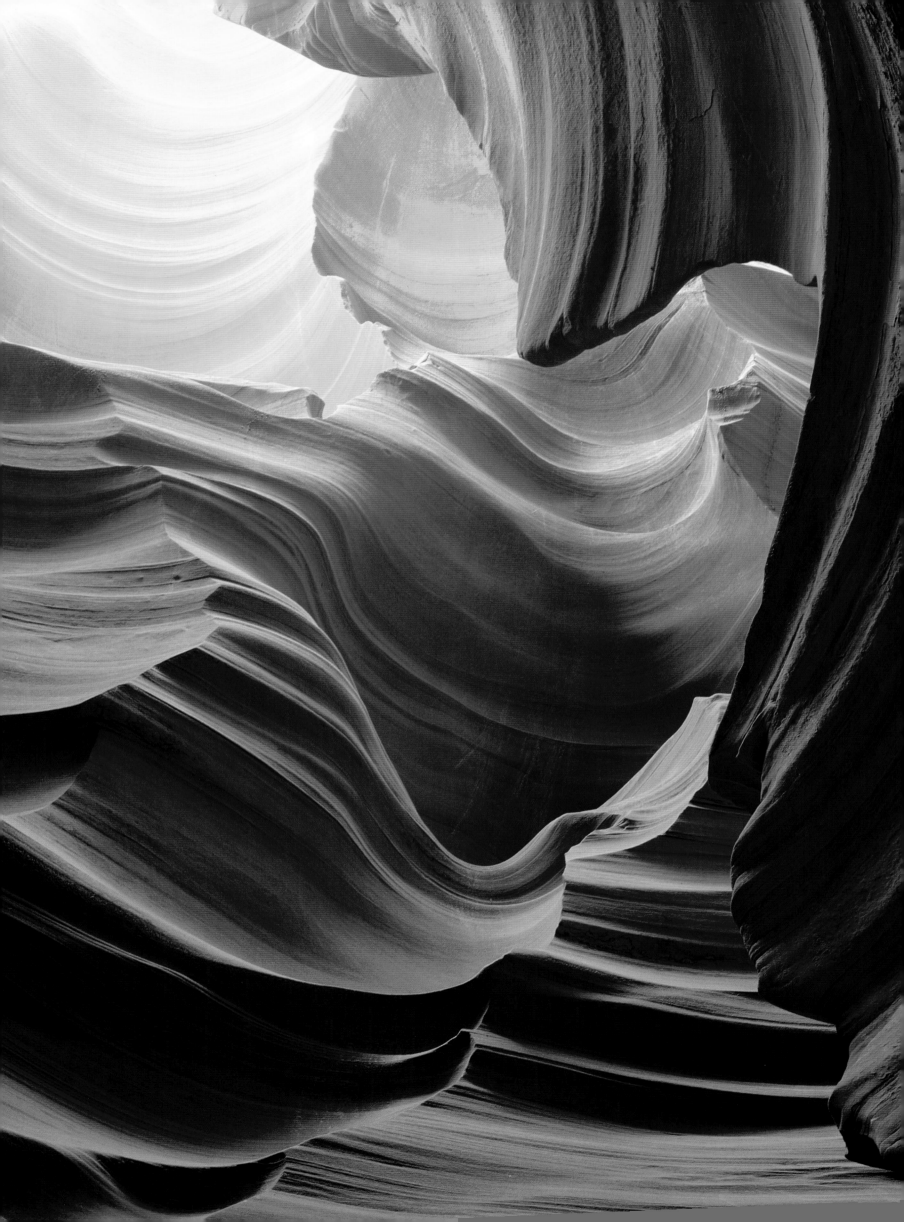

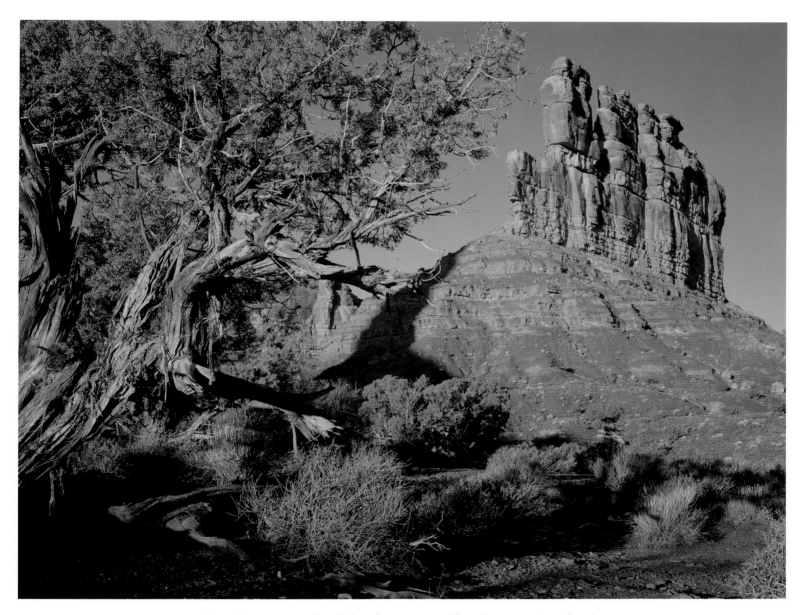

◄ Exquisite water-sculpted chambers scores of feet deep yet only a few feet wide are sometimes found in the slickrock canyons of the Colorado Plateau.
▲ Sandstone monoliths and Utah juniper create unusual vistas in Valley of the Gods, in southeastern Utah. The state abounds with oddly sculpted rock.
►► Entrada Sandstone erodes into fanciful forms in Utah's thirty-six-thousand-acre Goblin Valley State Park. The Entrada Sandstone Formation also appears in Arches National Park and Kodachrome Basin State Park.

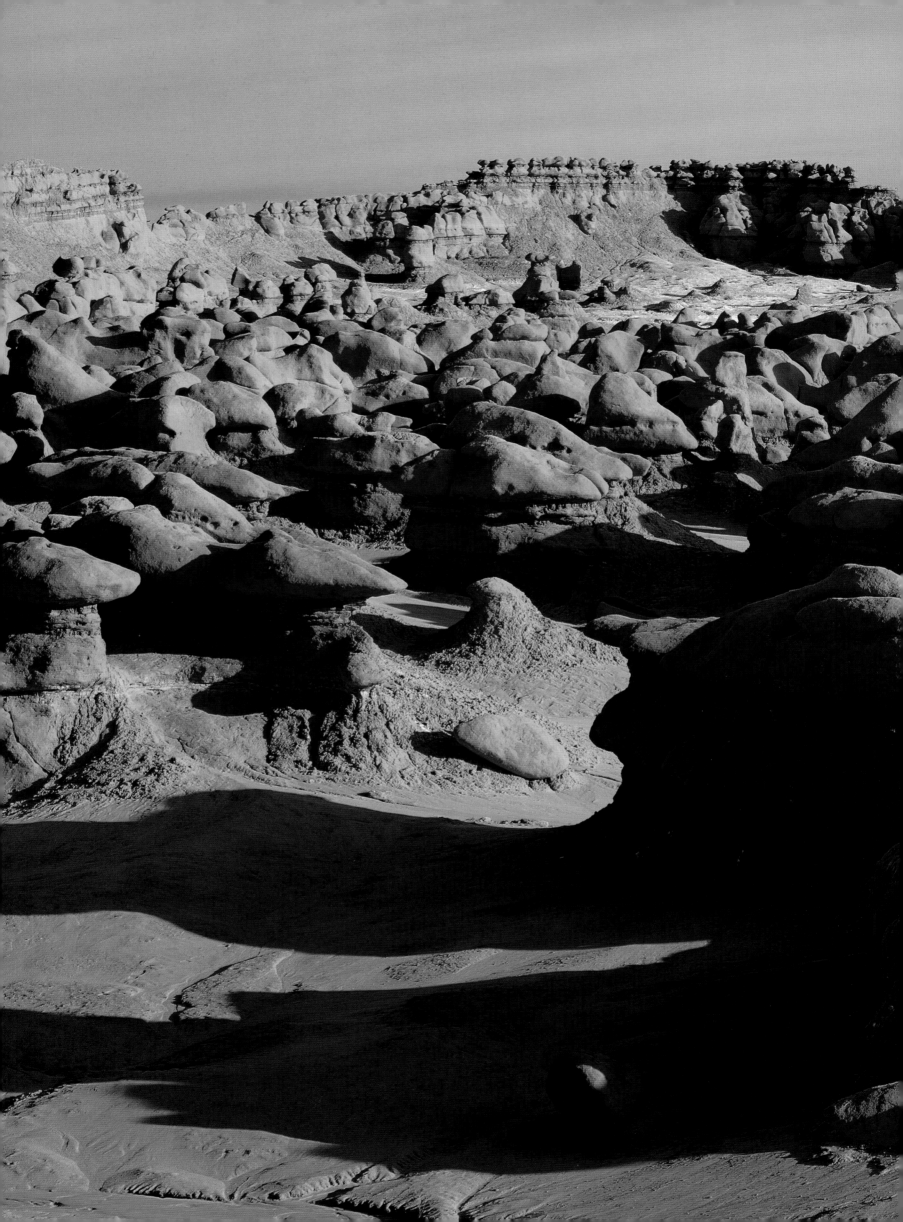

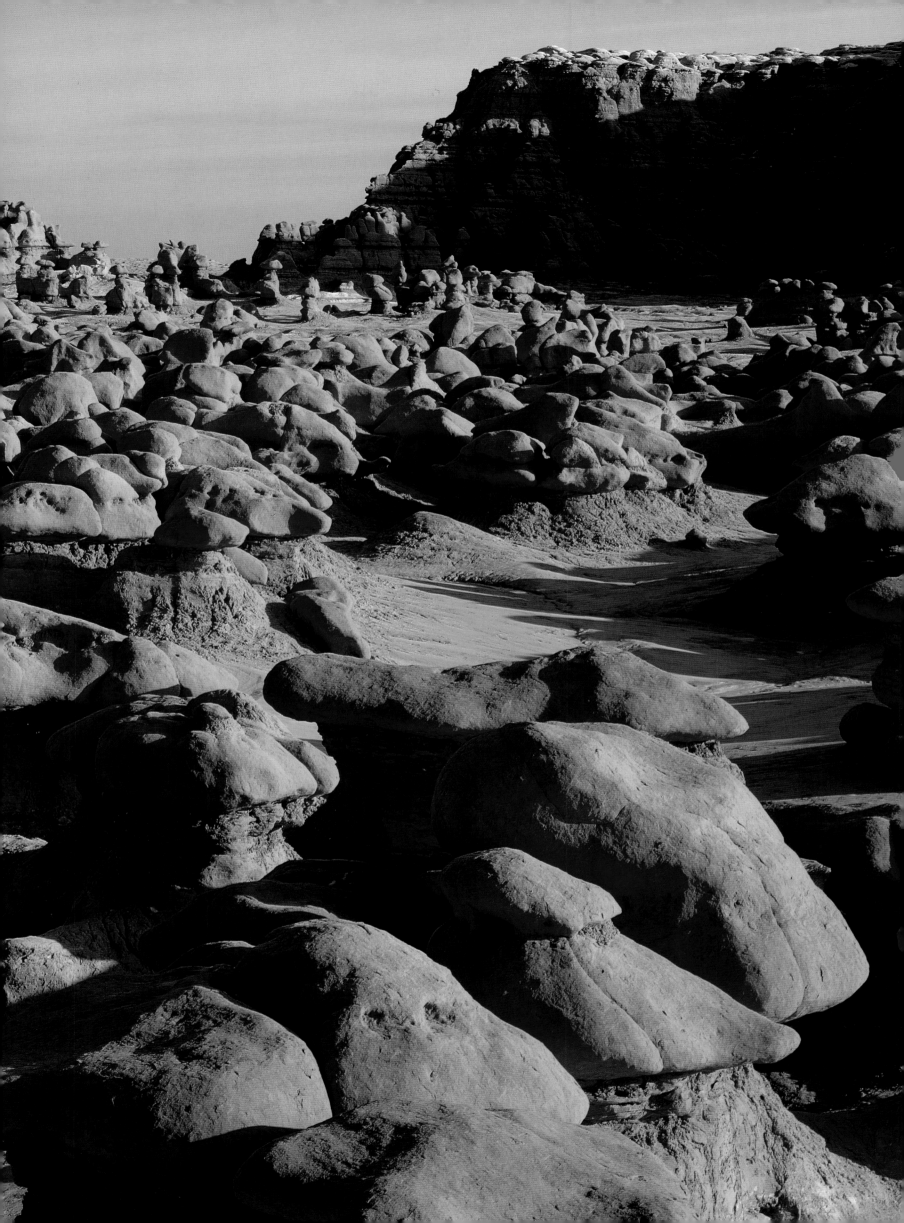

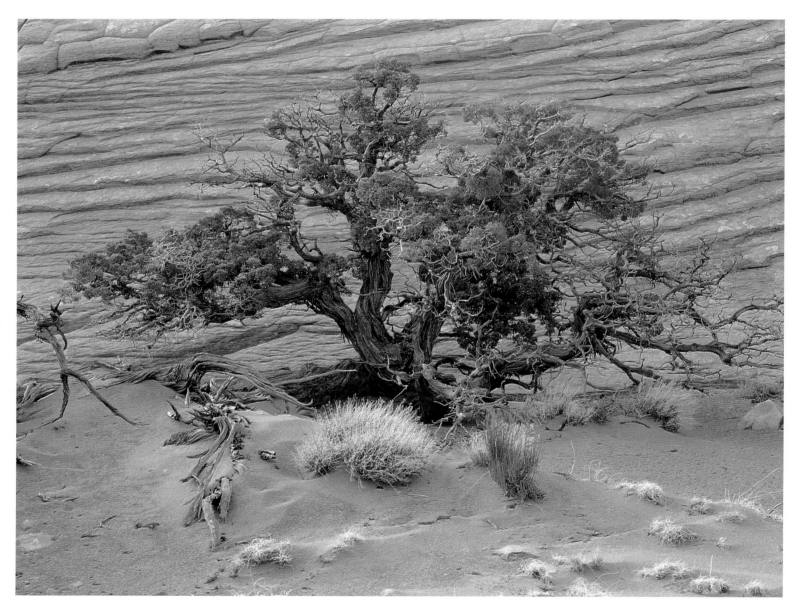

▲ A lone Utah juniper struggles to survive at Egypt in Escalante River Basin.
► Volcanic dust from the Philippine eruption of Pinatubo Volcano casts a warm alpenglow on Delicate Arch, in Utah's Arches National Park. Shaped by eons of weathering and erosion, more than 950 natural arches are perched high above the Colorado River. Most formations at Arches are made of soft red sandstone deposited some 150 million years ago. As the underlying salt deposits dissolved, the sandstone cracked and weathered into vertical rock slabs called "fins." Sections of these slender walls eventually wore through, creating the spectacular rock sculptures.

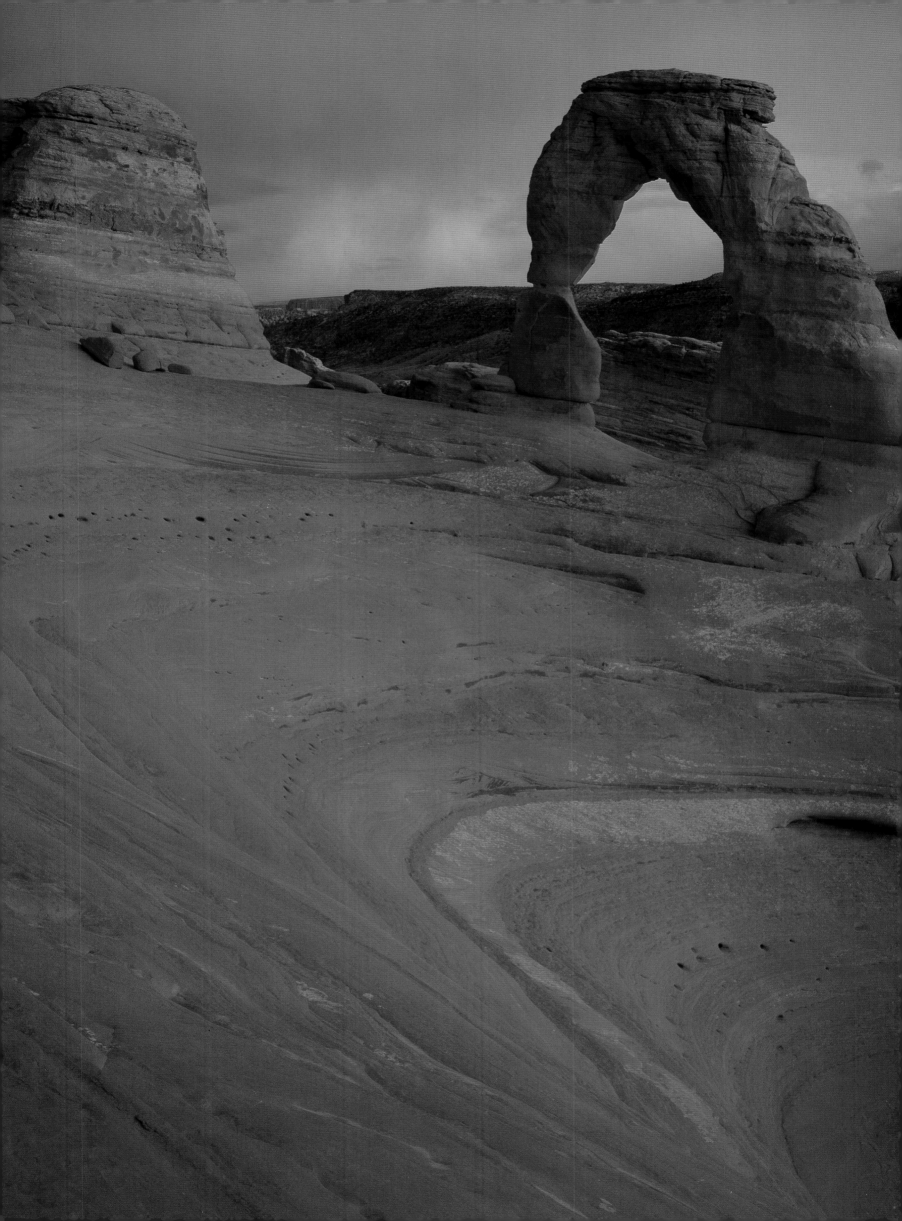

◄ A cottonwood leaf rests on a frozen pool in Horsehoe Canyon of Utah's Canyonlands National Park. Nearby is some of the finest prehistoric rock art to be found anywhere in North America. Archaeologists believe the Barrier Canyon Style pictographs may be more than two thousand years old.
▲ Wind-blasted manzanita struggles to survive on a Colorado Plateau sand dune. Though the plateau is now one of America's least populated regions, archeologists tell us many more Native Americans lived here in the past.

▲ Southern Utah takes in Baker Bench and the canyon of the Escalante River, along with vast, nearly unpopulated open spaces. Ninety percent of the land is rangeland, with old cowboy ways still persisting. The area also boasts opportunities for wilderness recreation, such as hiking and backpacking.
▶ The crest of a volcanic dike leads toward one of New Mexico's most visible landmarks—the fourteen-hundred-foot volcanic remnant called Shiprock.

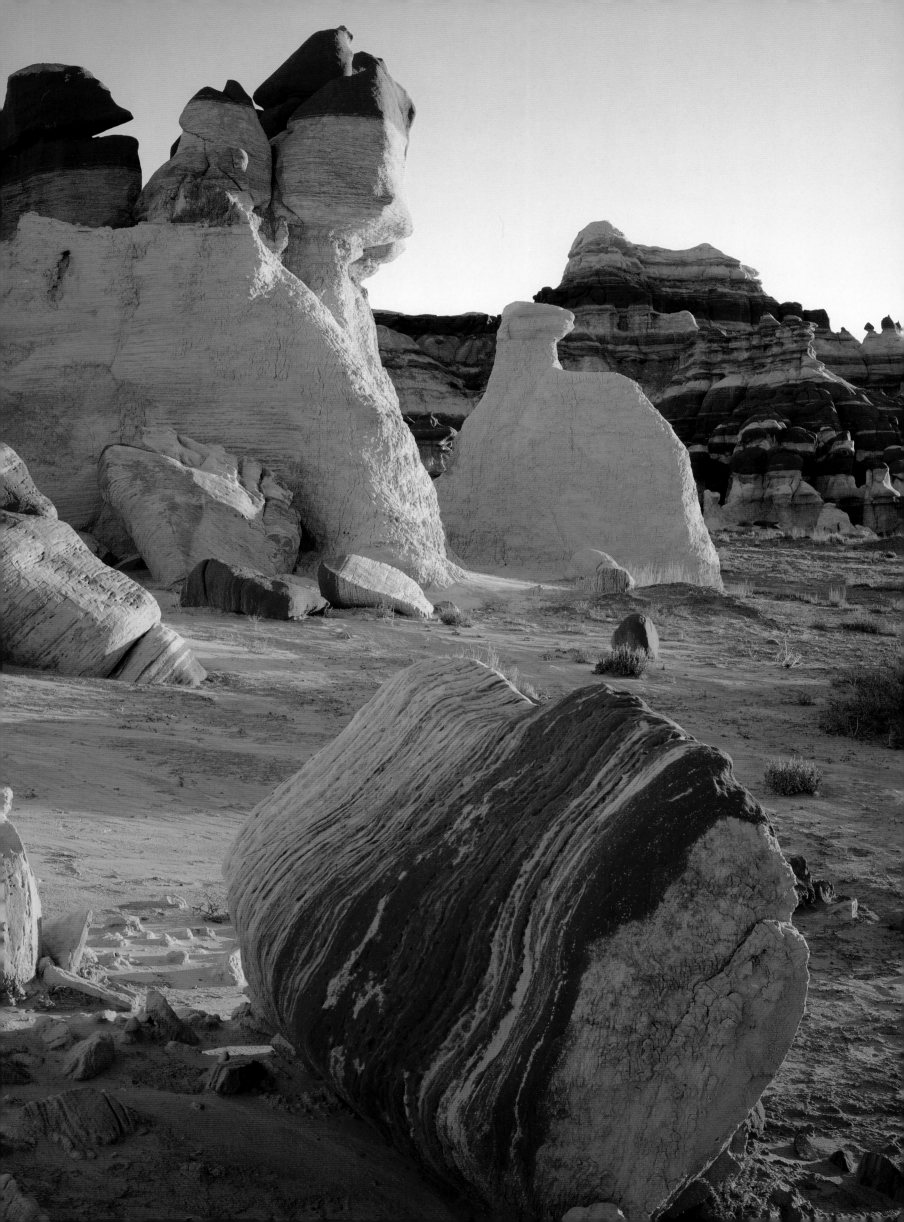

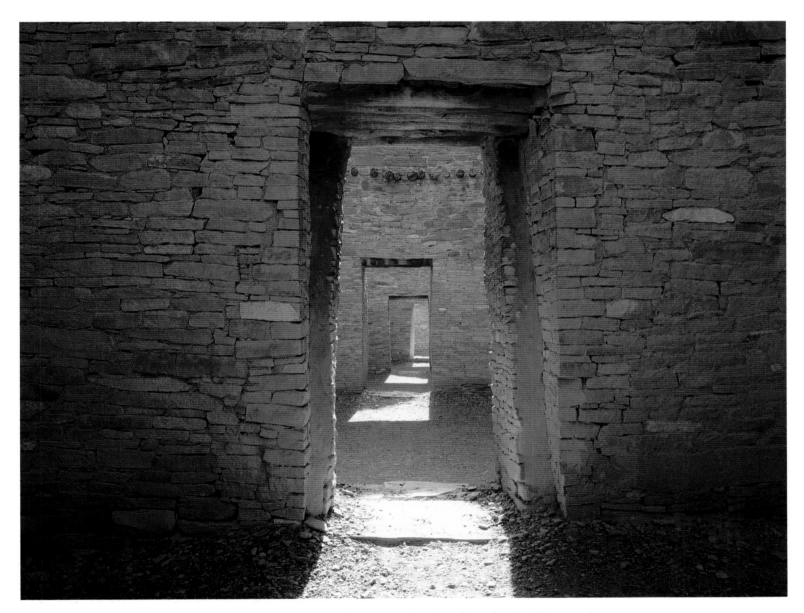

◄ Hoodoos line Blue Canyon in Moenkopi Wash on the Hopi Reservation of Arizona. In 1882, 3,863 square miles were set aside for the Hopi (meaning peaceful people). After initial devastating contact with the White man's diseases, the flourishing Hopi nation continues to practice traditional ways.
▲ Stone masonry and doorways inside Pueblo Bonito, at New Mexico's Chaco Culture National Historical Park, evidence careful planning. Likely the largest Anasazi structure ever built, Pueblo Bonito contained around eight hundred rooms built of mud, rock, and poles. For unknown reasons, the Anasazi abandoned this pueblo, and Navajos arrived centuries later. Anasazi is an old Navajo word, believed by some to mean "ancient enemy."

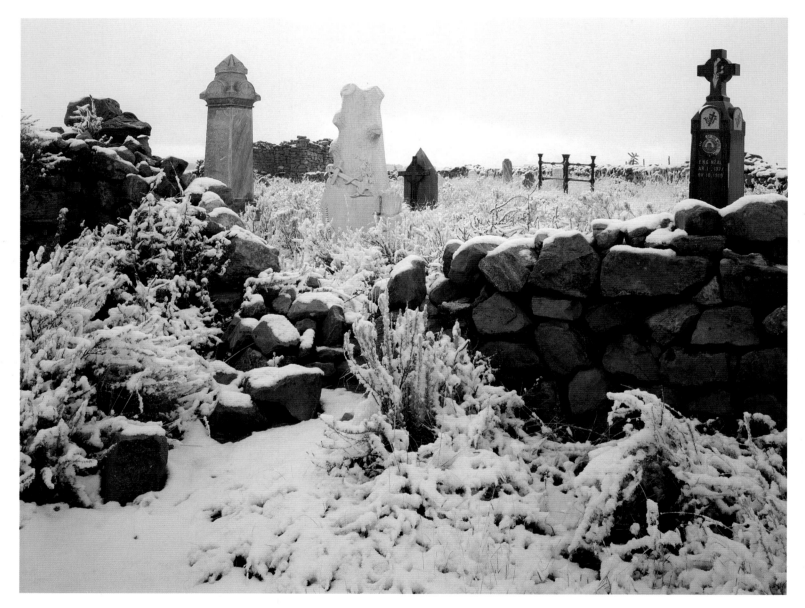

▲ A cemetery at Galisteo reflects New Mexico's rich history. Beginning in 1598, Catholicism was imposed on the Native peoples. In 1680, the New Mexico pueblos revolted, killing missionaries and destroying missions. In 1693, Spain regained control, then lost authority to Mexico in 1821. The Mexican War, which ended in 1848, ceded the territory to the United States. New Mexico was admitted to the Union in 1912 as the forty-seventh state.
▶ Rime ice covers a ponderosa pine at El Morro National Monument, New Mexico. Over centuries, those who passed by Inscription Rock left evidence of their passage—Native American petroglyphs, seventeenth-century Spanish inscriptions, and carvings by 49ers en route to California gold fields.

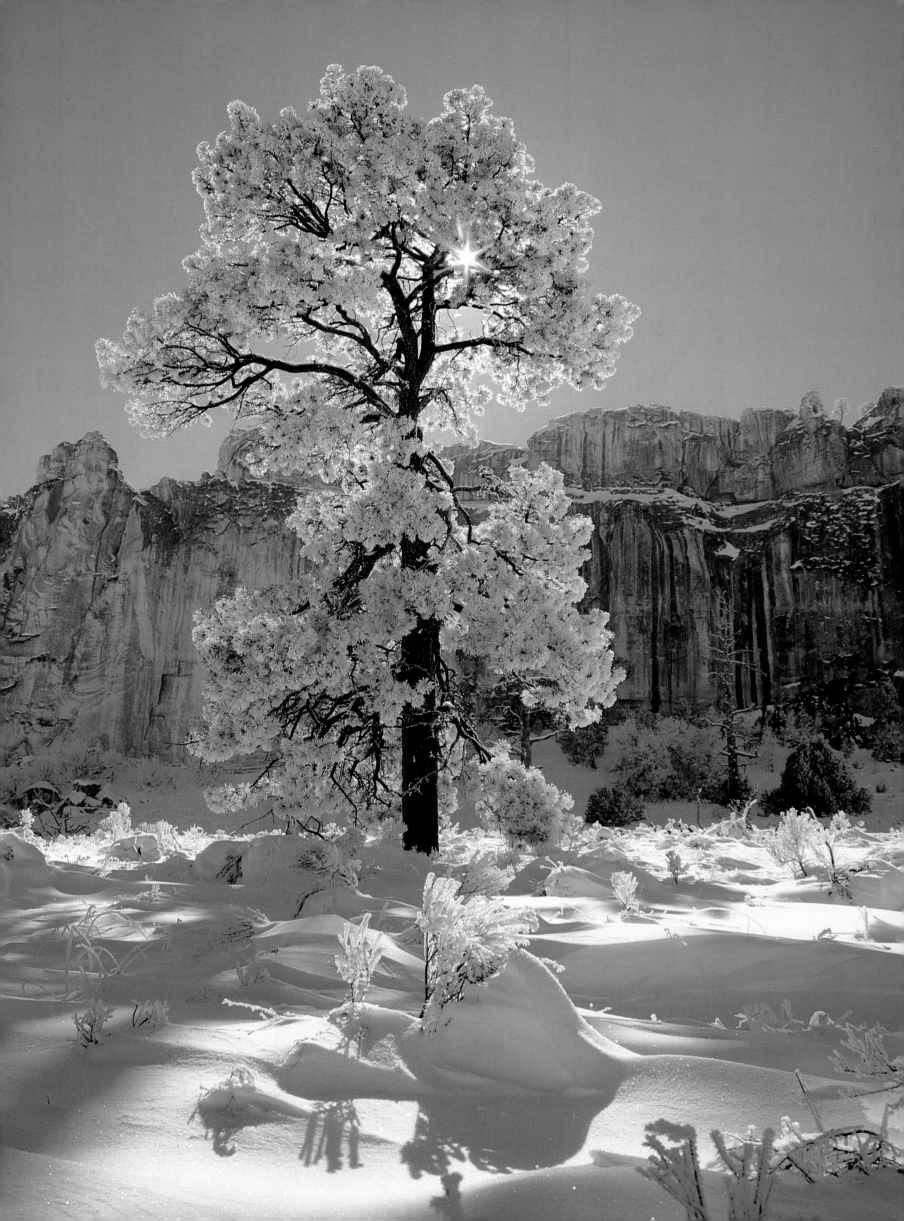

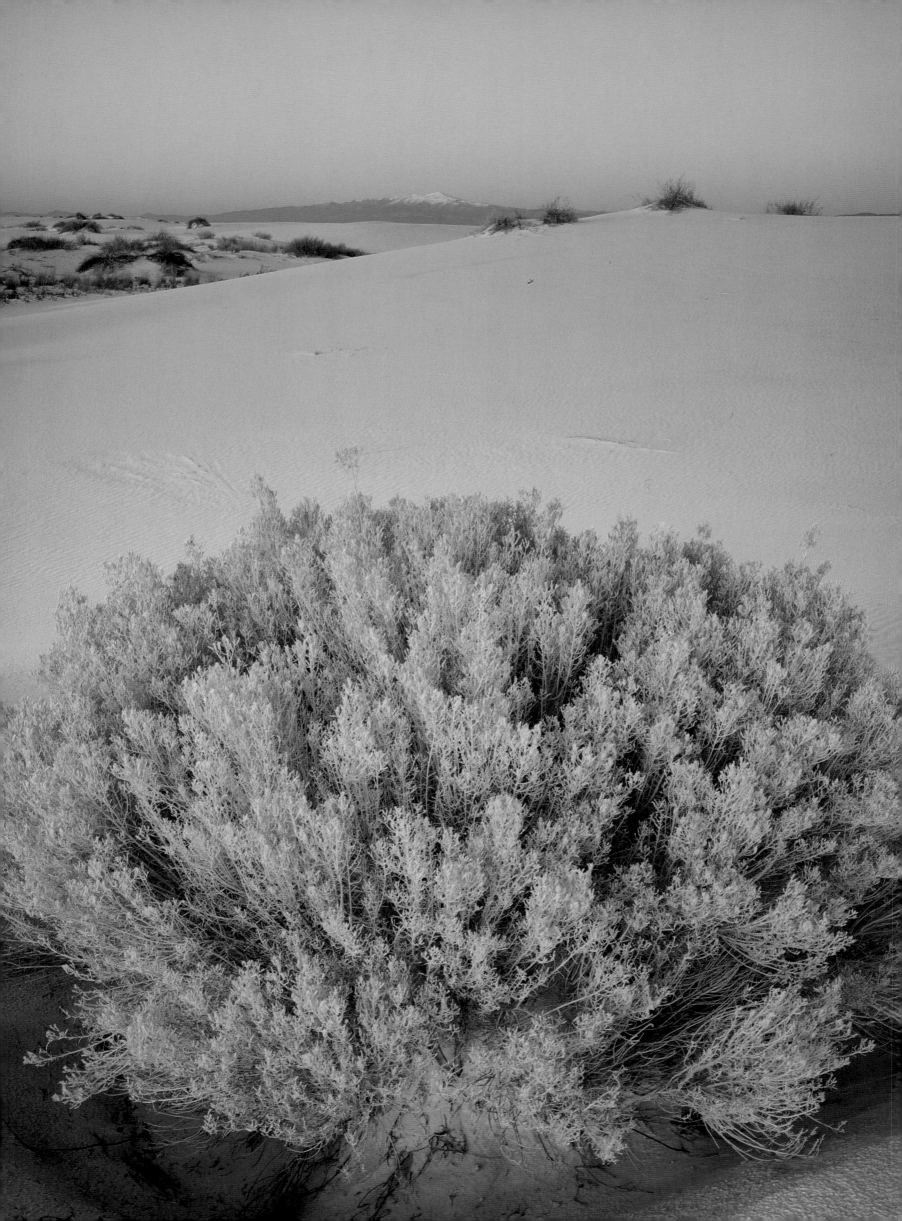

◄ New Mexico's White Sands National Monument preserves an undulating landscape of brilliant white sand, the world's largest gypsum dune field. In this harsh place, plants and animals are adapted to the desert environment.
▲ From this two-lane highway in northern Arizona, a person can drive to practically every town and village in the contiguous United States. Four million miles of open highways cross and recross America's landscapes.

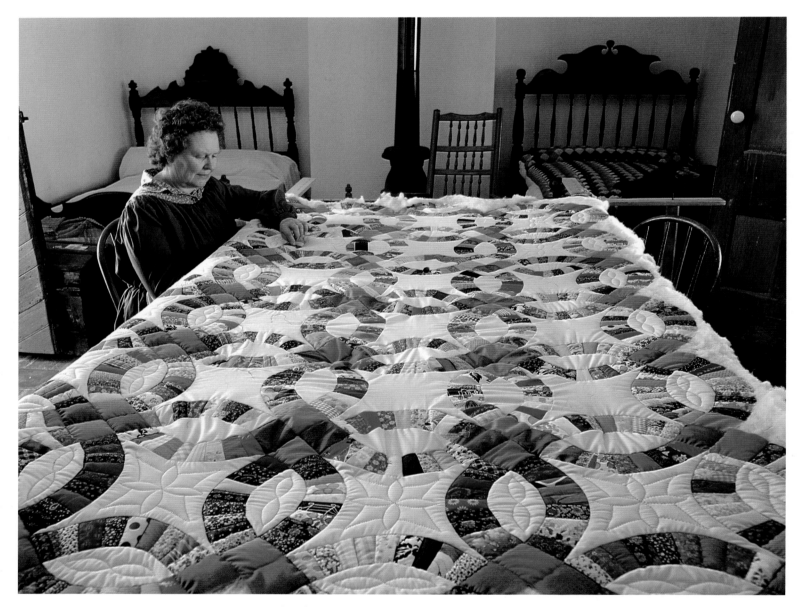

▲ Mormons, who first settled in Utah in 1847, also migrated across the border into Arizona. In 1863, Dr. James M. Whitemore, a Mormon cattleman from Texas, began ranching at Pipe Spring. The ranch is preserved by the National Park Service as a memorial of western pioneer life. Here, Living History Park Ranger Yvonne Heaton works on a Double Wedding Ring Quilt at Winsor Castle, which was built as a fort in the early 1870s.
► Cowboys became famous in post-Civil War days. By the 1890s, the wide open ranges had been closed in by the intricate railroad system.
►► The Grand Canyon is a mile deep, eighteen miles wide, and 277 miles long. Some of the oldest exposed rock in the world lies at the bottom.

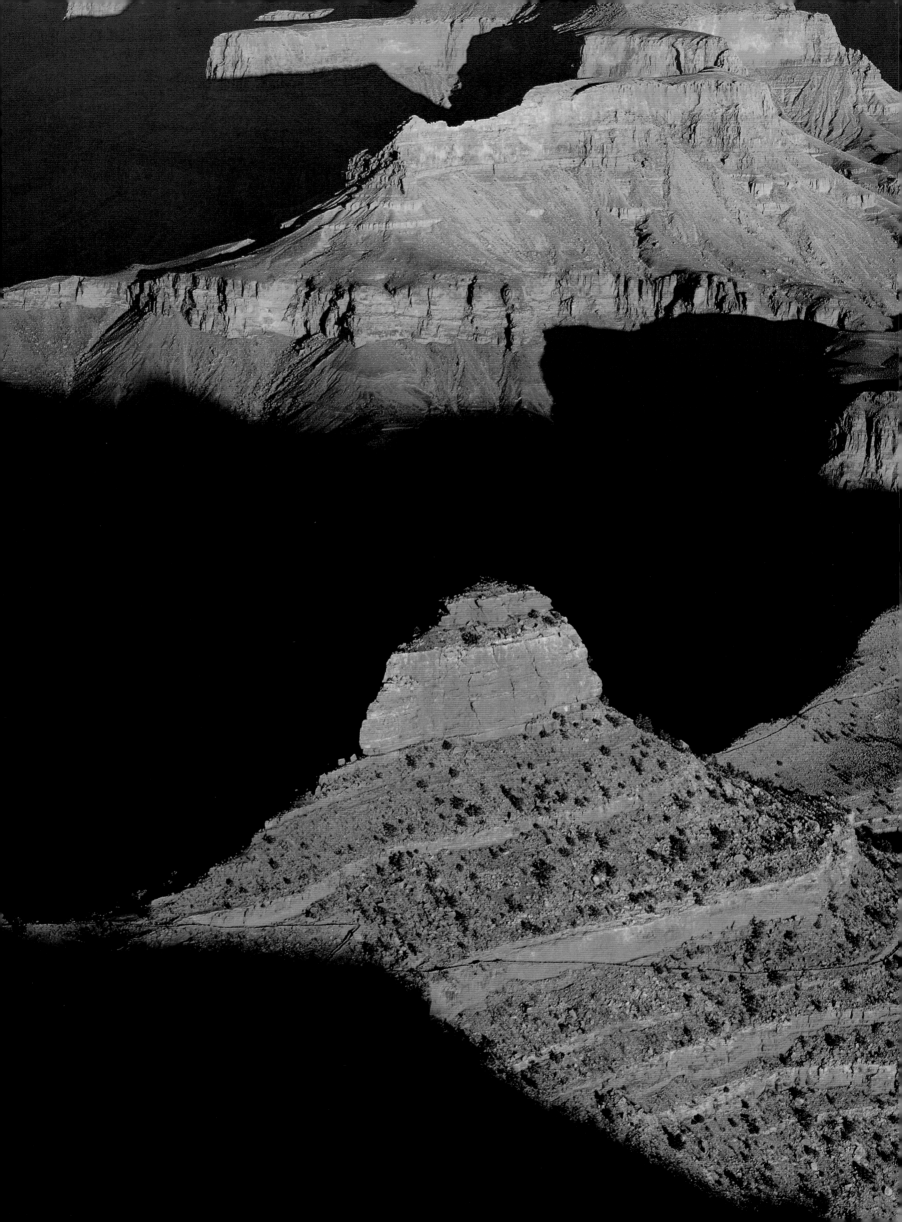

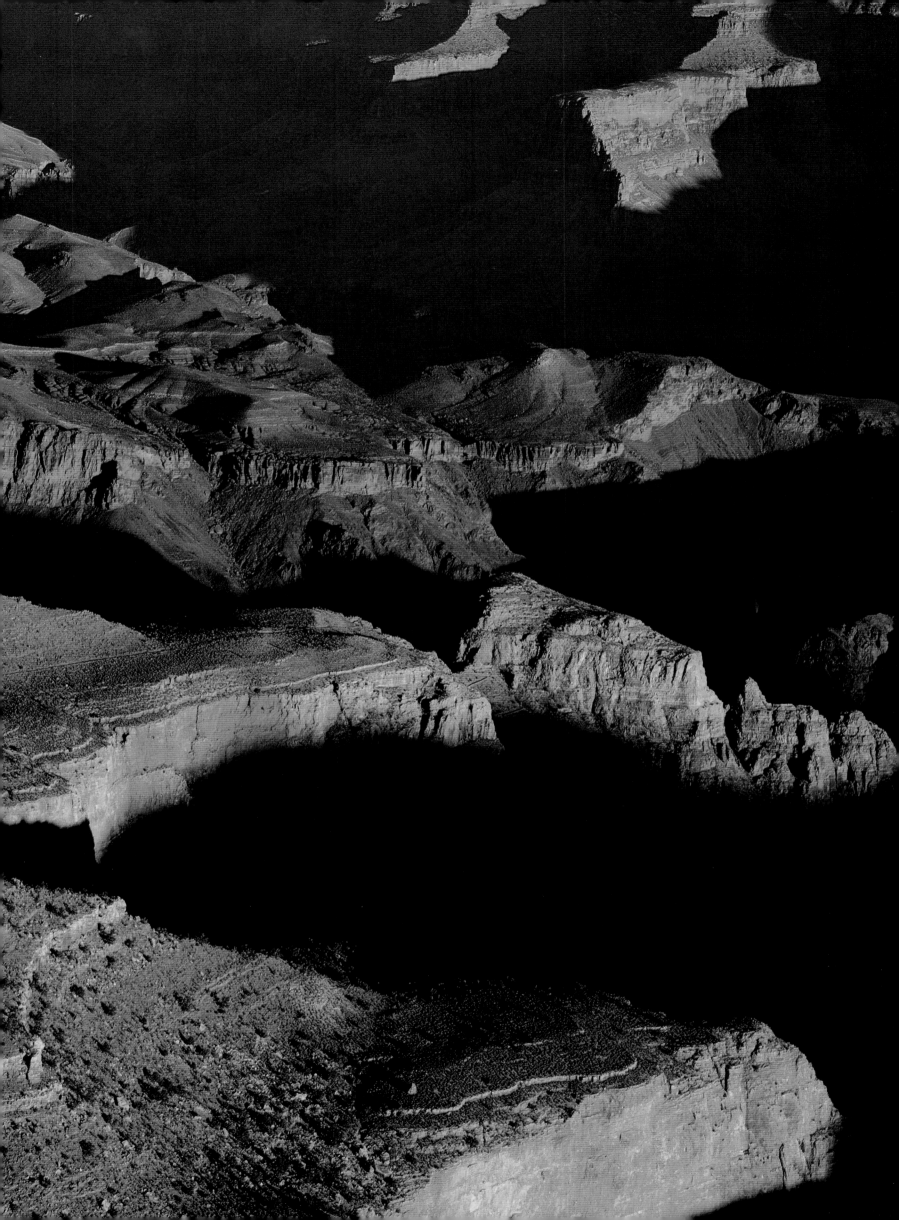

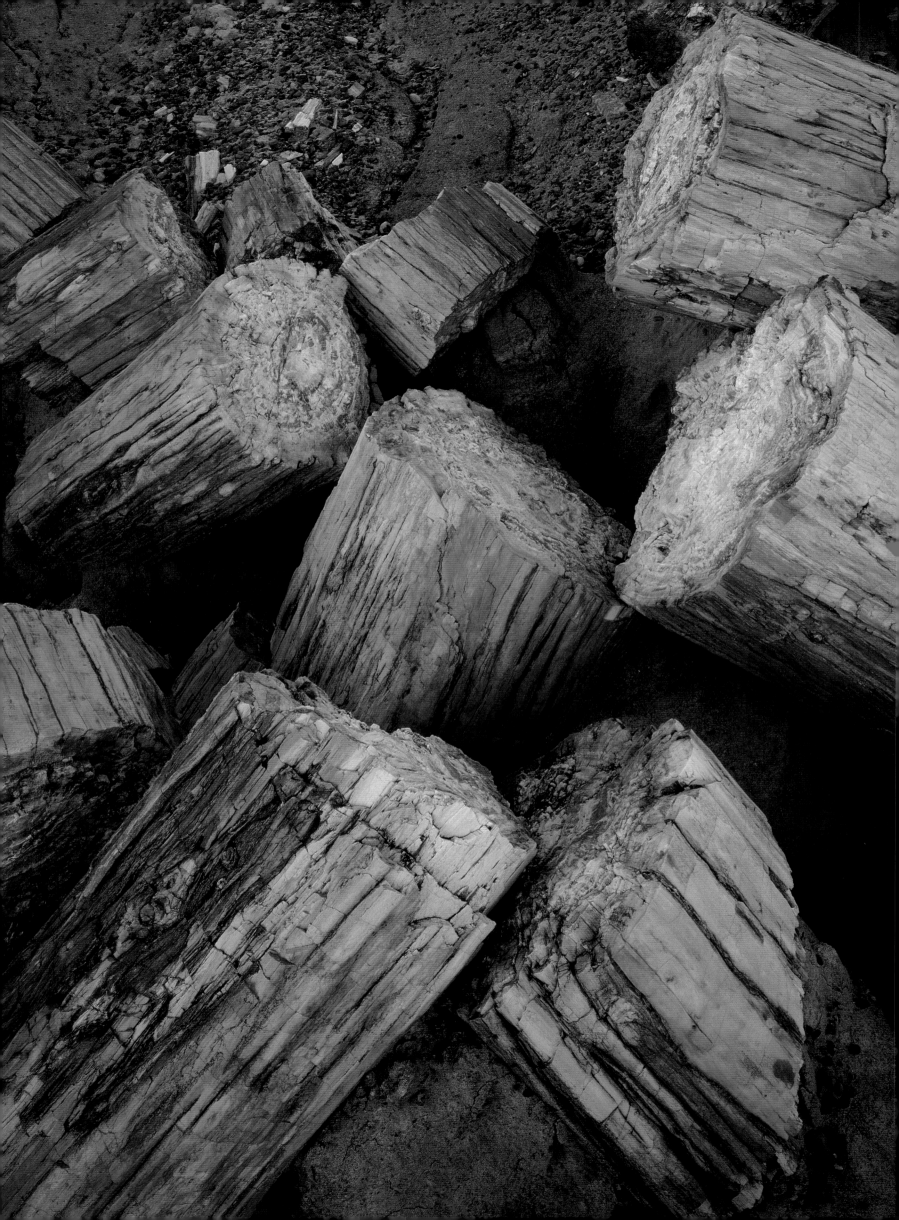

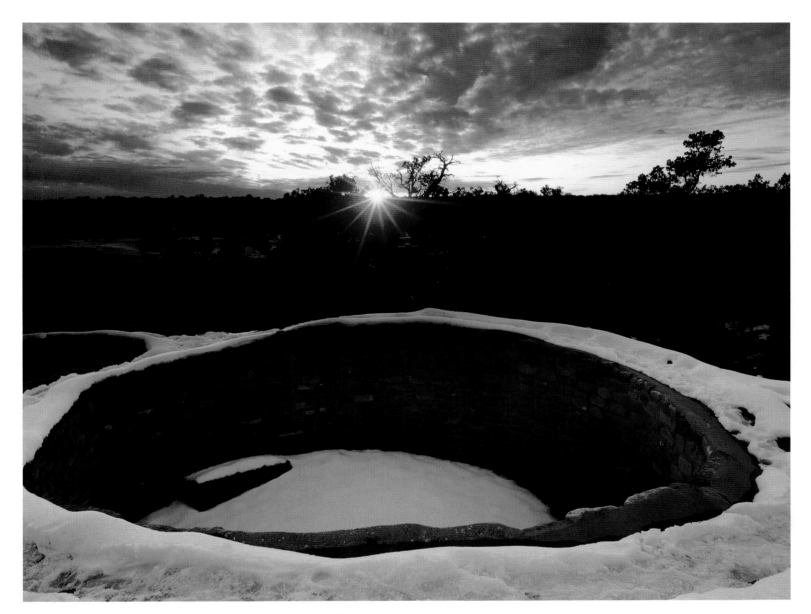

◄ Scientists have identified nearly one hundred species of fossil plants and animals in Arizona's Petrified Forest National Park. Quartz-like rock filled in the spaces between cells of wood that lived some two hundred million years ago during the Triassic Age when dinosaurs first appeared.
▲ The Sun Temple, an Anasazi ruin with kivas in Colorado's Mesa Verde National Park, was never completed. Kivas, usually circular in shape, were important religious chambers associated with most Anasazi pueblos.

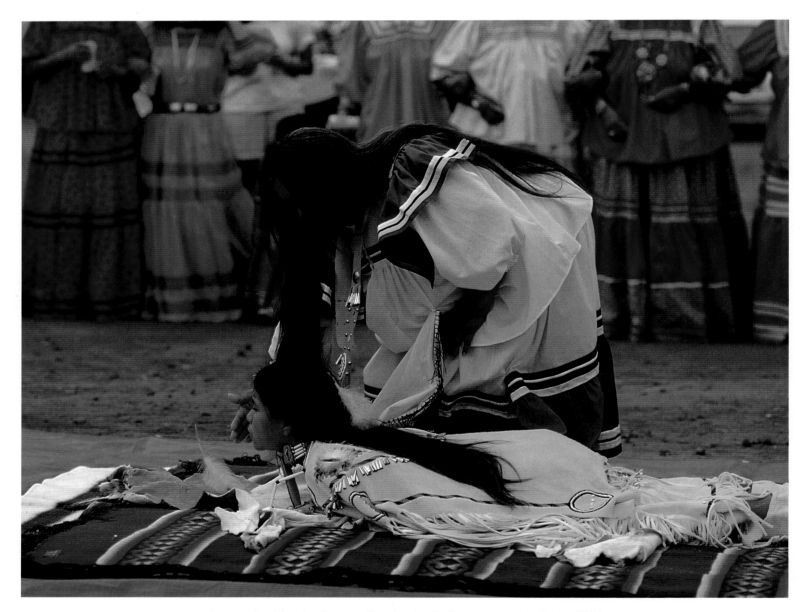

▲ Godmother Phoebe Cromwell molds Carla Goseyun during Carla's White Mountain Apache Sunrise Ceremony at Whiteriver, Arizona. Between May and October, elaborate ceremonies bring young ladies into womanhood.
▶ Brittlebush decorates a volcanic landscape at Arizona's Organ Pipe Cactus National Monument. El Niño is a sporadic occurrence of warm coastal current that alters both oceanic and atmospheric systems. When El Niño causes high rainfall in arid areas, incredible desert blooms may result.

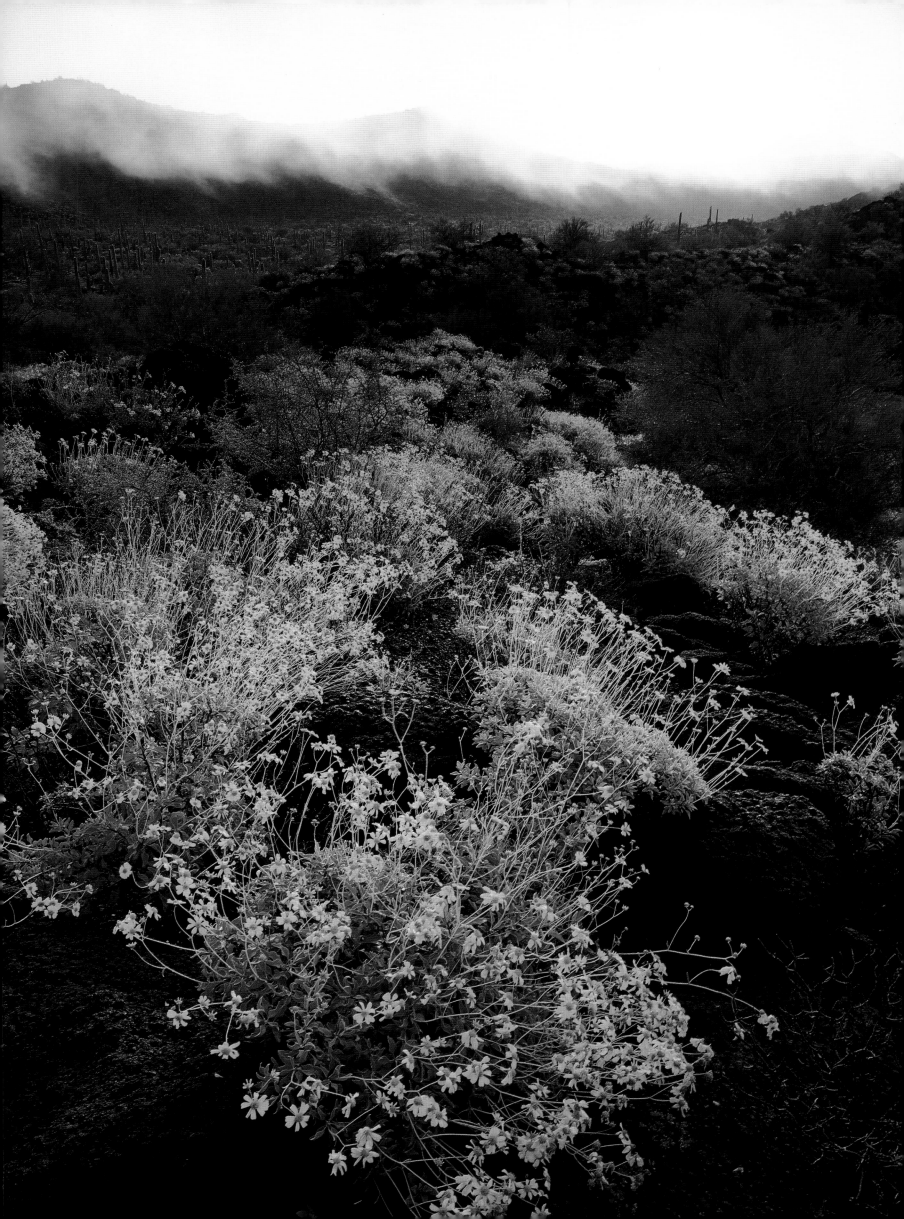

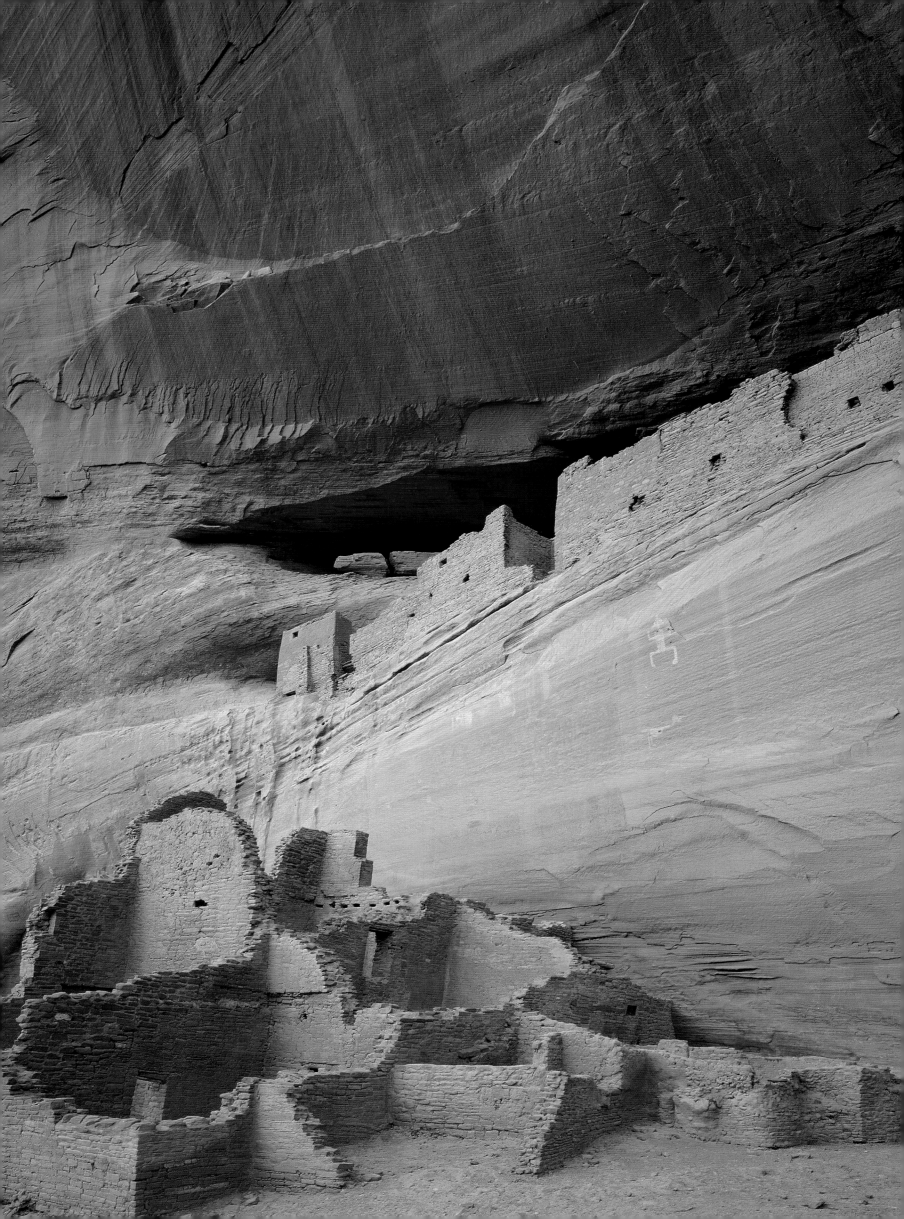

◄ White House Ruin is an ancient Anasazi dwelling in Arizona's Canyon de Chelly National Monument. These canyons sheltered Pueblo people for centuries and later served as a stronghold of the Navajos. "De Chelly" is a Spanish corruption of the Navajo word *Tsegi,* meaning "rock canyon."
▲ Navajo horses graze near Bidahochi on Arizona's Navajo Reservation. In 1863, the Navajos were savagely moved off their land by Colonel Kit Carson, who burned crops and killed livestock, forcing the people on a three-hundred-mile trek called "the long walk." The cruel experiment only caused Navajos to starve, and survivors eventually returned to their former land. Today's Navajo Reservation encompasses eighteen million acres.

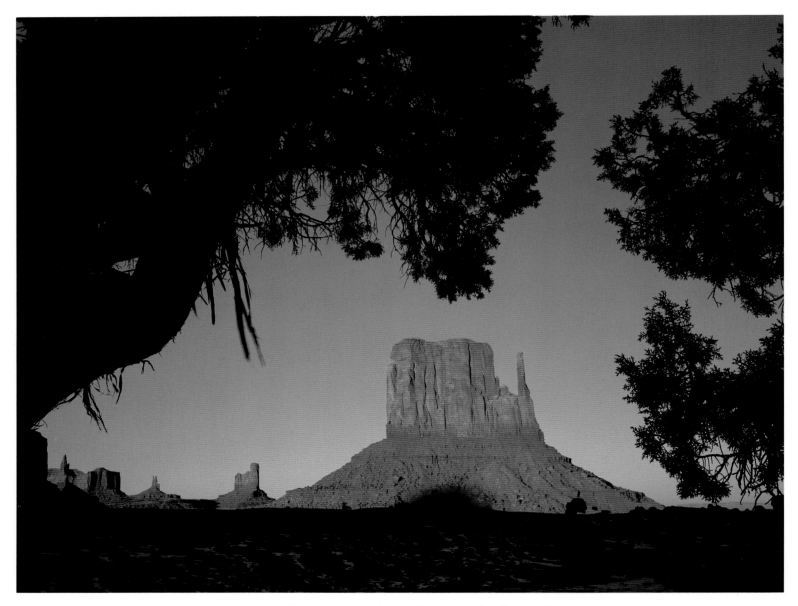

▲ Monument Valley, spanning the Utah/Arizona border on the Navajo Reservation, is a land of thousand-foot-high buttes and mesas, all carved of sandstone. West Mitten Butte looms high above the surrounding plain.
▶ Monument Valley was the first Navajo Tribal Park. Its nearly thirty thousand acres are administered by the Navajo Nation. This relatively unspoiled environment and terrain is sacred to the Navajos, but visitors from around the world are welcome to come and share in the beauty.

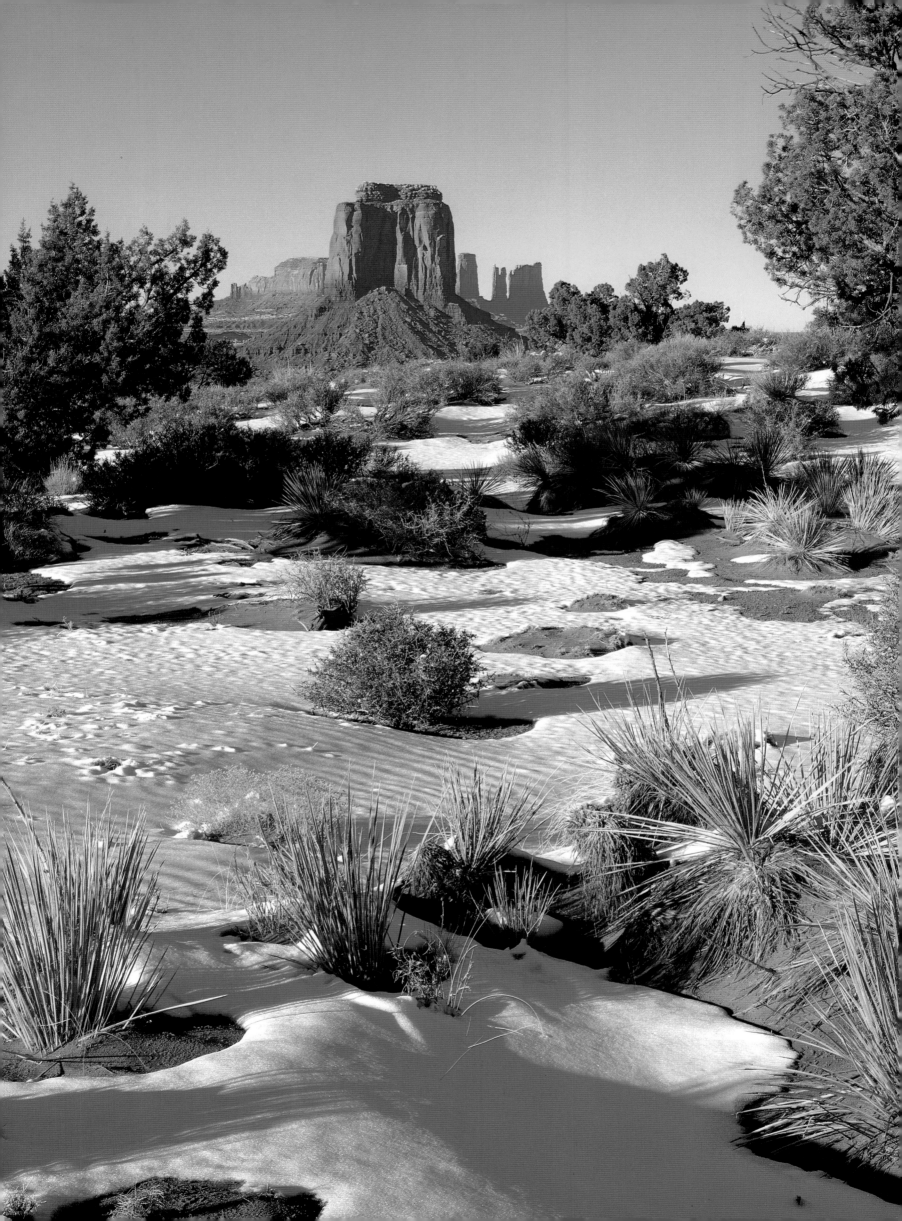

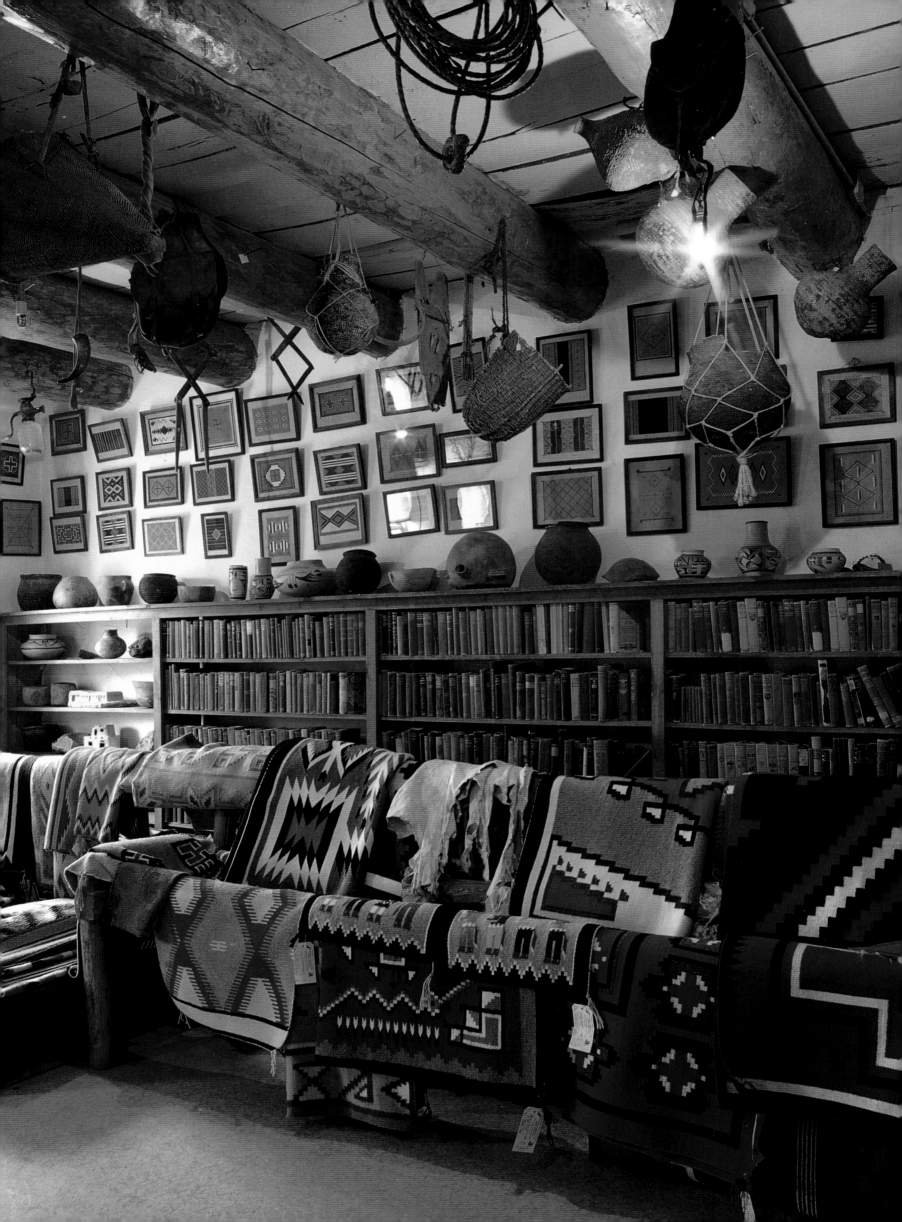

◄ The Rug Room at Arizona's Hubbell Trading Post National Historic Site contains fine works of contemporary Navajo weavers. John Lorenzo Hubbell, dean of traders to the Navajo, was known for honesty in business dealings, hospitality to travelers, and wise counsel to his Navajo friends.
▲ Bisbee, Arizona, like many old American mining towns, has a rich history. Founded in 1880 the year after copper was discovered in the area, the town saw the mining of copper, gold, and silver through the years. Arizona today produces nearly two-thirds of the nation's copper. The decline of mining is due to depletion of high-grade sources, together with foreign competition.

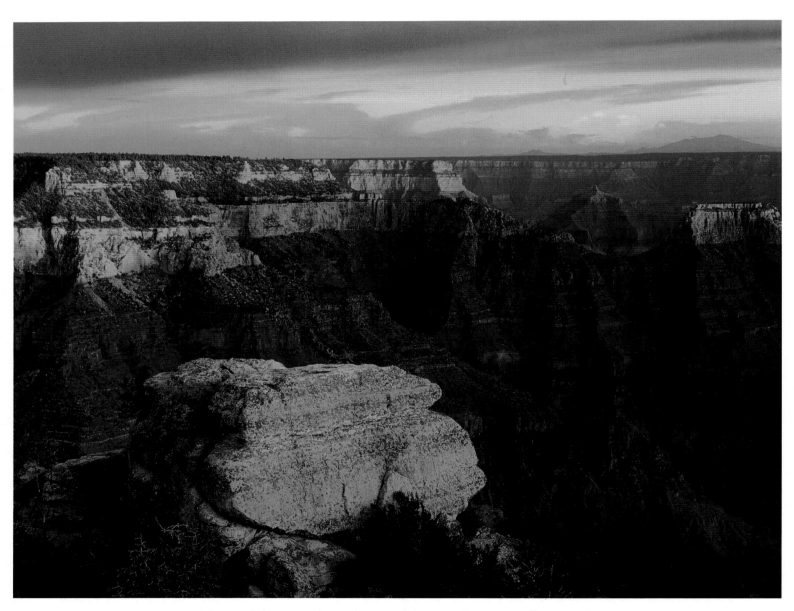

▲ The much less visited North Rim of the Grand Canyon offers majestic views of the geologic past. It sits one thousand feet higher than the South Rim, causing a cooler climate with average annual snowfall of 120 inches.
▶ The saguaro is the nation's largest cactus, sometimes reaching as high as sixty feet. Truly monarch of the Sonoran Desert, it has become a symbol of the American Southwest. Incredibly slow-growing, the oldest saguaros have likely lived 150 to 200 years. The plant stores a huge amount of water, which allows it to produce white blossoms even in the driest of years.

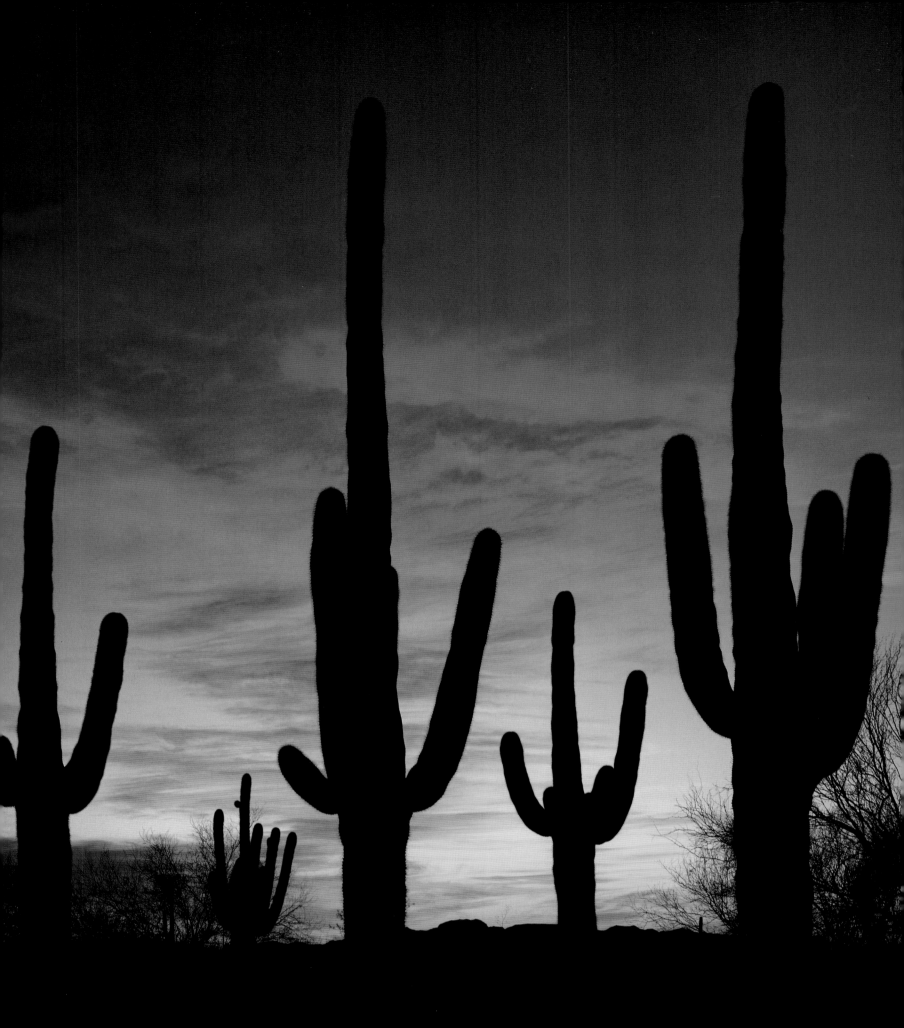

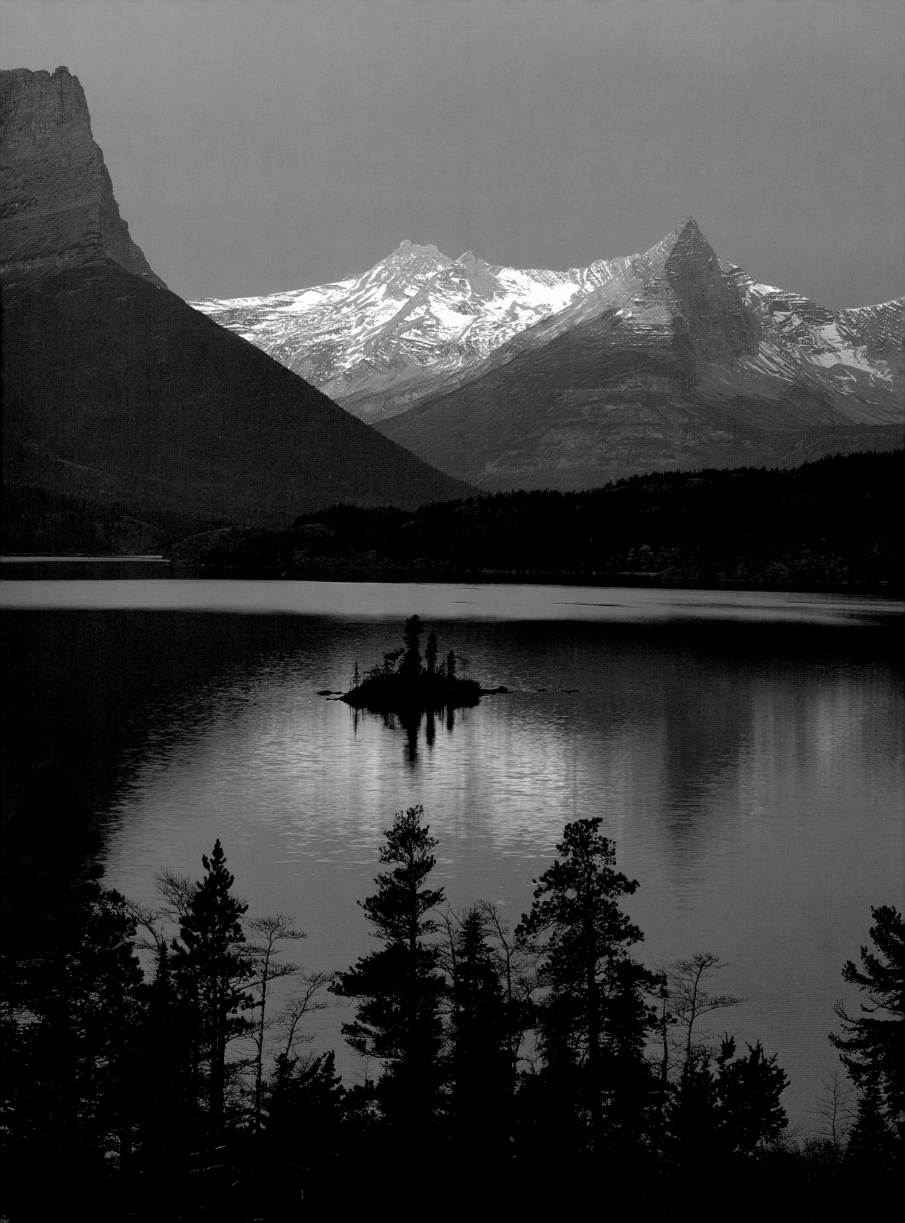

ROCKY MOUNTAINS

The long, slow westward roll of the prairies ends definitively as the Rocky Mountains appear on the horizon—massive, snow-capped sentinels guarding the entrance to the West. Their sheer enormity is breathtaking; in Colorado alone, fifty-two peaks rise more than fourteen thousand feet. Their impact inspires poetry; these are the "purple mountain majesties" of Katherine Lee Bates's "America the Beautiful."

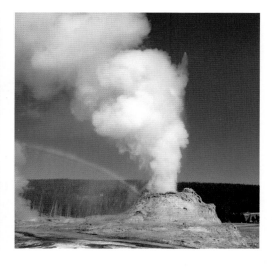

Above: *The mountain goat is a sure-footed, agile mammal who seeks protection from predators on craggy cliffs and outcrops.* Above right: *Yellowstone National Park's geysers, fumaroles, and hot springs speak of the earth's forces. Tremendous volcanic eruptions have occurred here in the past.* Left: *St. Mary Lake lies in Glacier National Park, part of a reserve that straddles the border between Montana and Alberta—the Waterton-Glacier International Peace Park.*

The Rockies are the result of geological forces that began some sixty to seventy million years ago. Gradual uplifting caused the earth to buckle and rise, creating the mountains. The Rockies, not just a single wall of mountains, are rather an interlocking chain of mountain groups forming a rocky continental spine. The Continental Divide, the high point from which streams flow east or west, traces a meandering line along their peaks.

Before trains, planes, and automobiles, crossing those peaks was an adventure at best; at worst, a nightmare. The first non-Natives to challenge the mountains were explorers like Zebulon Pike, scouts like Kit Carson, and hardy trappers of every ilk. Beaver hats were high fashion in the early 1800s, and mountain streams were full of the busy little animals. When the beaver supply was exhausted, buffalo robes became the craze.

Then dawned the realization that those mountains were rich in precious minerals. With the discovery of gold near Denver in 1858, adventurers poured in from all over the world, starting Colorado on a cycle of boom and bust. The largest single nugget of silver, a whopping two tons, was mined at Aspen in 1879.

In 1860, a rich strike at Gold Creek started a rush to Montana, bringing in a million dollars by 1870. The population of "Last Chance Gulch," now called Helena, swelled from one hundred to twenty thousand. During the same decade, a fat vein of silver gave Butte the reputation of being the "richest hill on earth."

Early mining days were a rowdy era of saloons, dancing girls, and vigilante justice. Towns sprang to life on a rumor, as quickly becoming ghosts as their inhabitants moved on. A few, like Breckenridge and Aspen, eventually found second lives as ski resorts. Although recreational skiing did not become a commercial venture until the twentieth century, stories indicate that some miners used primitive skis made of barrel staves, and even formed ski clubs to alleviate their winter boredom.

Neither the rush for mineral wealth nor the gradual influx of farmers and ranchers that followed brought this region more than a scattering of population, by East Coast standards. Montana, the nation's fourth-largest state, has one of its smallest populations. Wyoming's population averages about five people per square mile. For a visitor from New Jersey, where population density is about one thousand per square mile, the sense of elbow room in the Rocky Mountain states may be almost as unique as the boiling pots and geysers of Yellowstone.

Yellowstone—where seething volcanic magma, not far underground, generates some ten thousand geysers, pools, mud pots, and vents—is only one example of how this region brings its inhabitants face-to-face with earth's essence. This region is, after all, defined by its powerful geology.

Anyone who has breathed the mountain air, seen the alpine meadows, fished the cold mountain streams, knows that the real wealth of the Rockies is not minerals. It is in the beauty of the vast, unspoiled wildness. Teddy Roosevelt called it "scenery to bankrupt the English language."

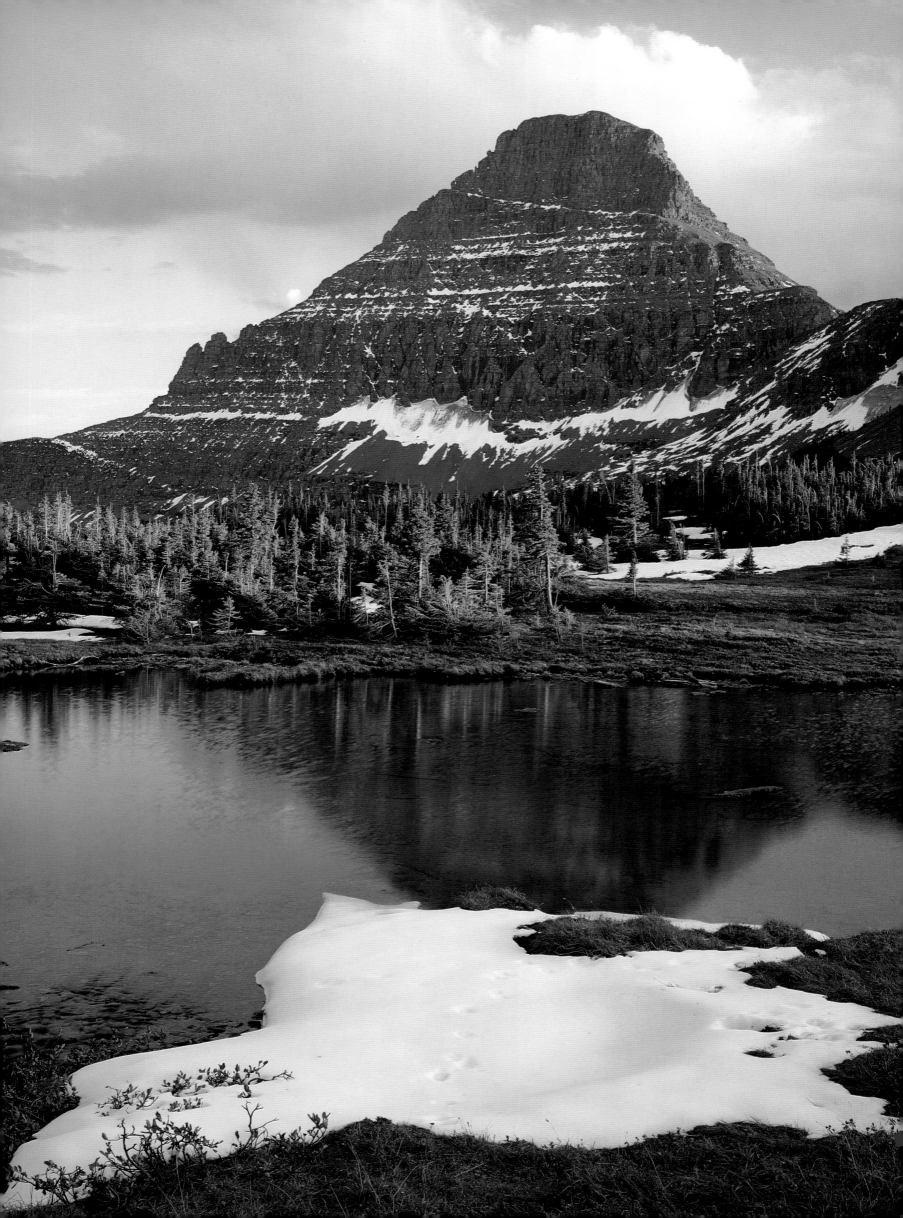

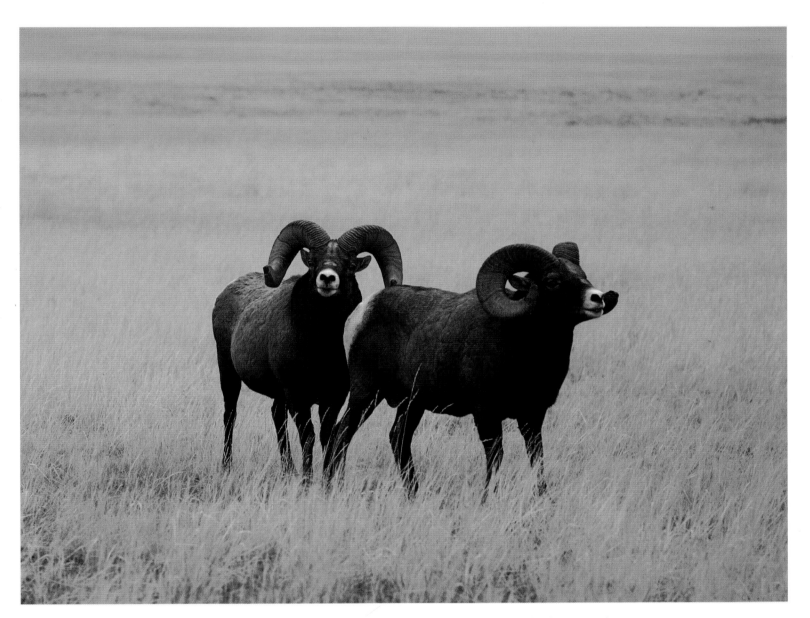

◄ Mount Reynolds, reflected here in a Glacier National Park alpine pond, reaches 9,125 feet high. Overthrusting of large blocks of rock, followed by glacial sculpting, fashioned the rugged Northern Rockies of Glacier.
▲ Bighorn sheep rams find sanctuary for their late fall rutting in Yellowstone National Park. Other wildlife found in the park includes elk, bison, mule deer, moose, pronghorn, coyote, mountain lion, beaver, trumpeter swan, eagle, osprey, white pelican, and—just recently reintroduced—the wolf.

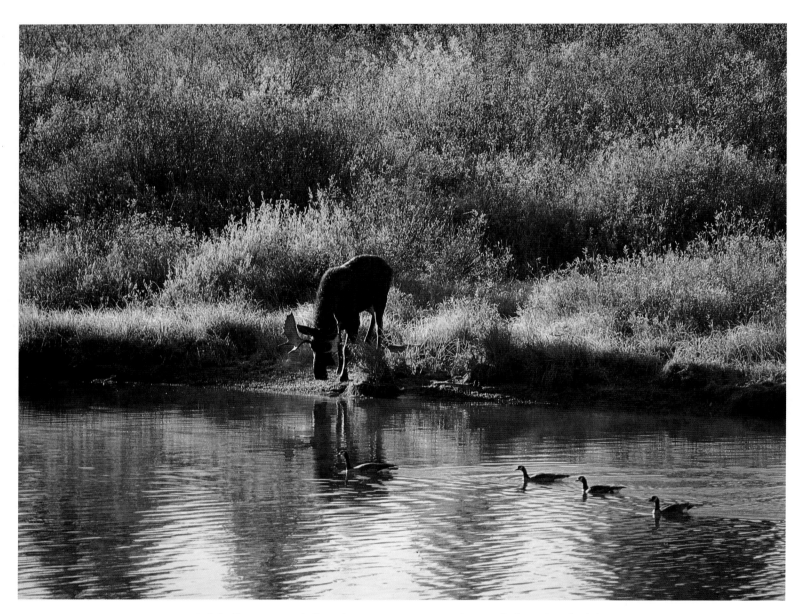

▲ A bull moose and Canada geese eye one another at Oxbow Bend of the Snake River in Wyoming's Grand Teton National Park. The rugged Tetons are one of the youngest ranges in the Rockies, with uplifting earthquakes still prevalent in the area. These are fault-block mountains—one edge went up, the other went down. Another fault-block system is the Sierra Nevada.
▶ The highest point in the Teton range is the 13,770-foot Grand Teton. Today's glaciers are but a vestige of the king-size masses of the Ice Age.
▶▶ Mount Moran punctuates the sky in Wyoming's Grand Teton National Park. Established in 1929, the national park offers spectacular panoramas— naked granite pinnacles, a string of jewel-like lakes, and abundant wildlife.

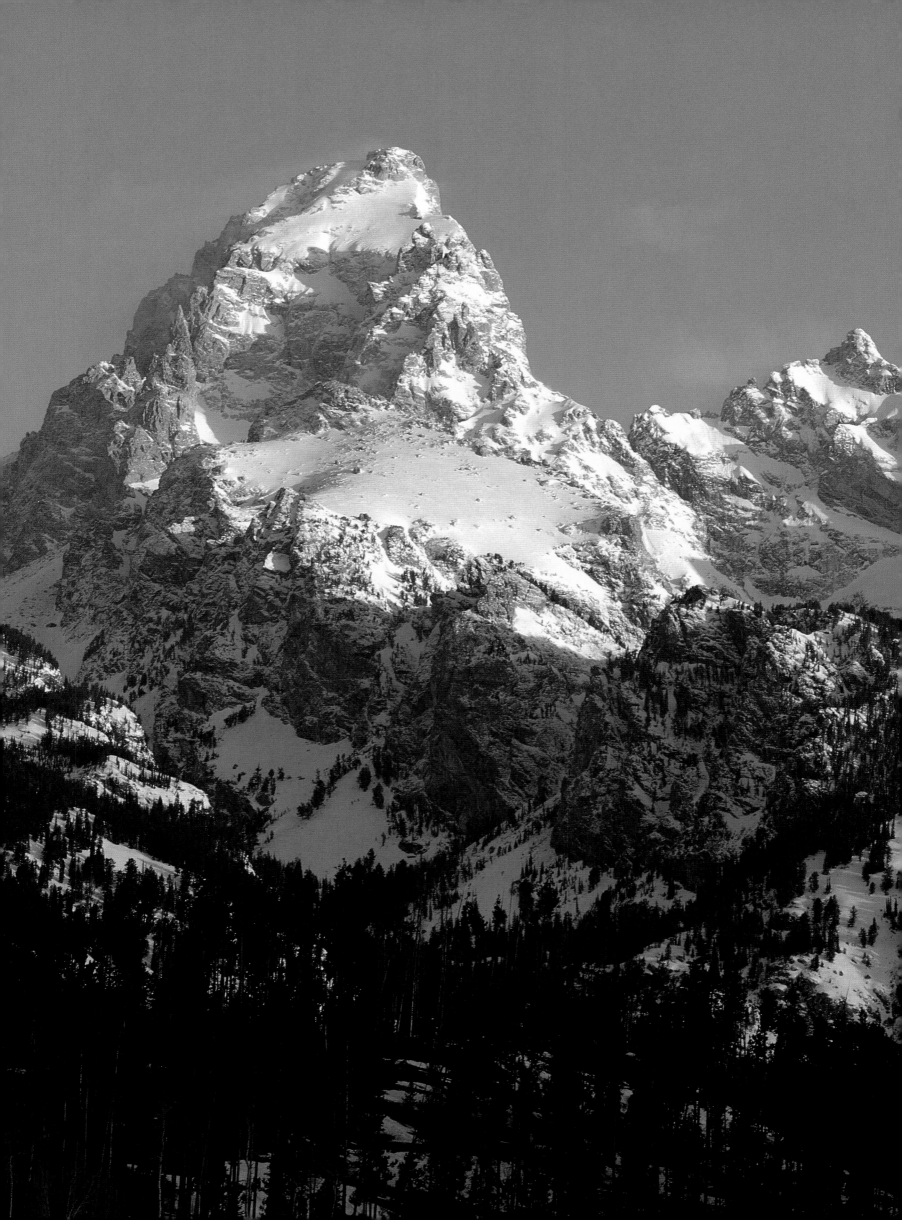

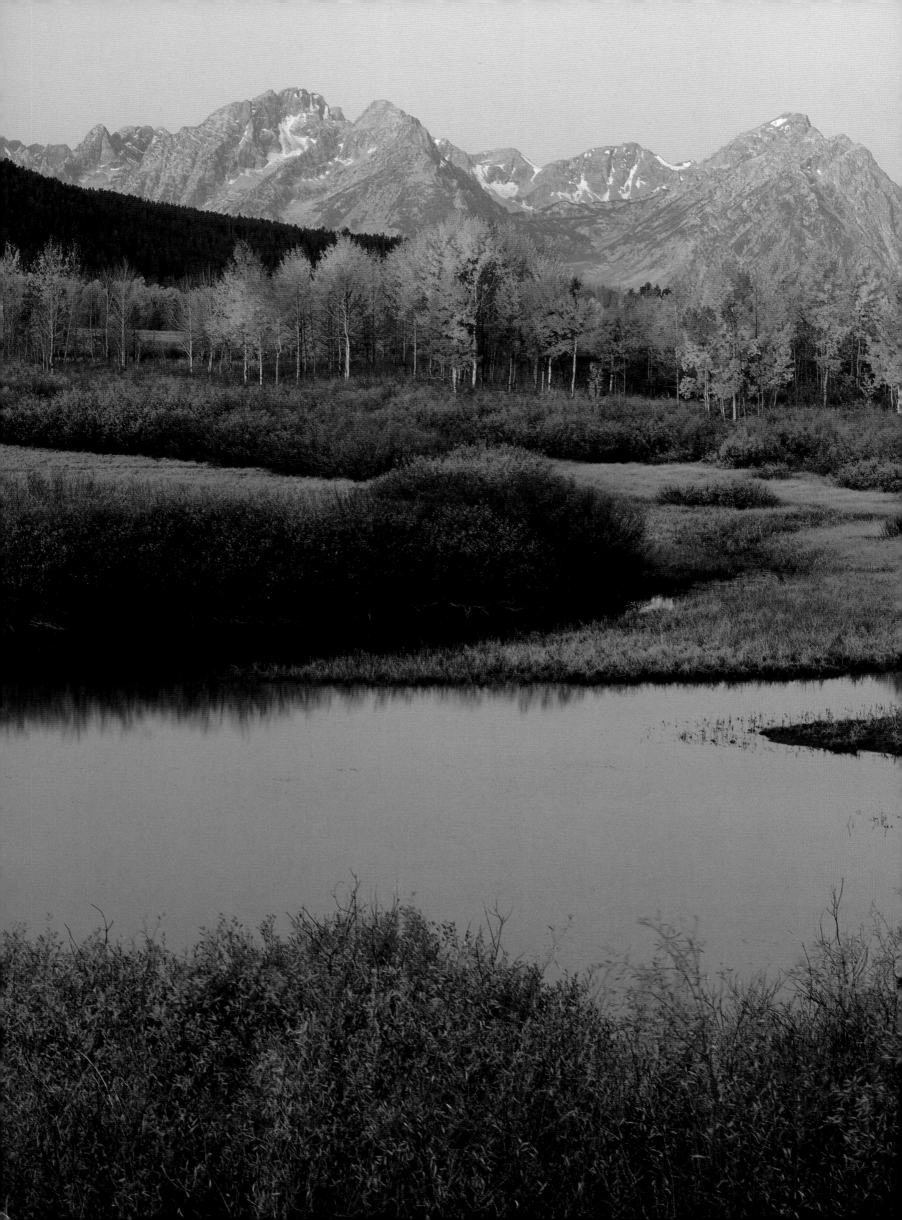

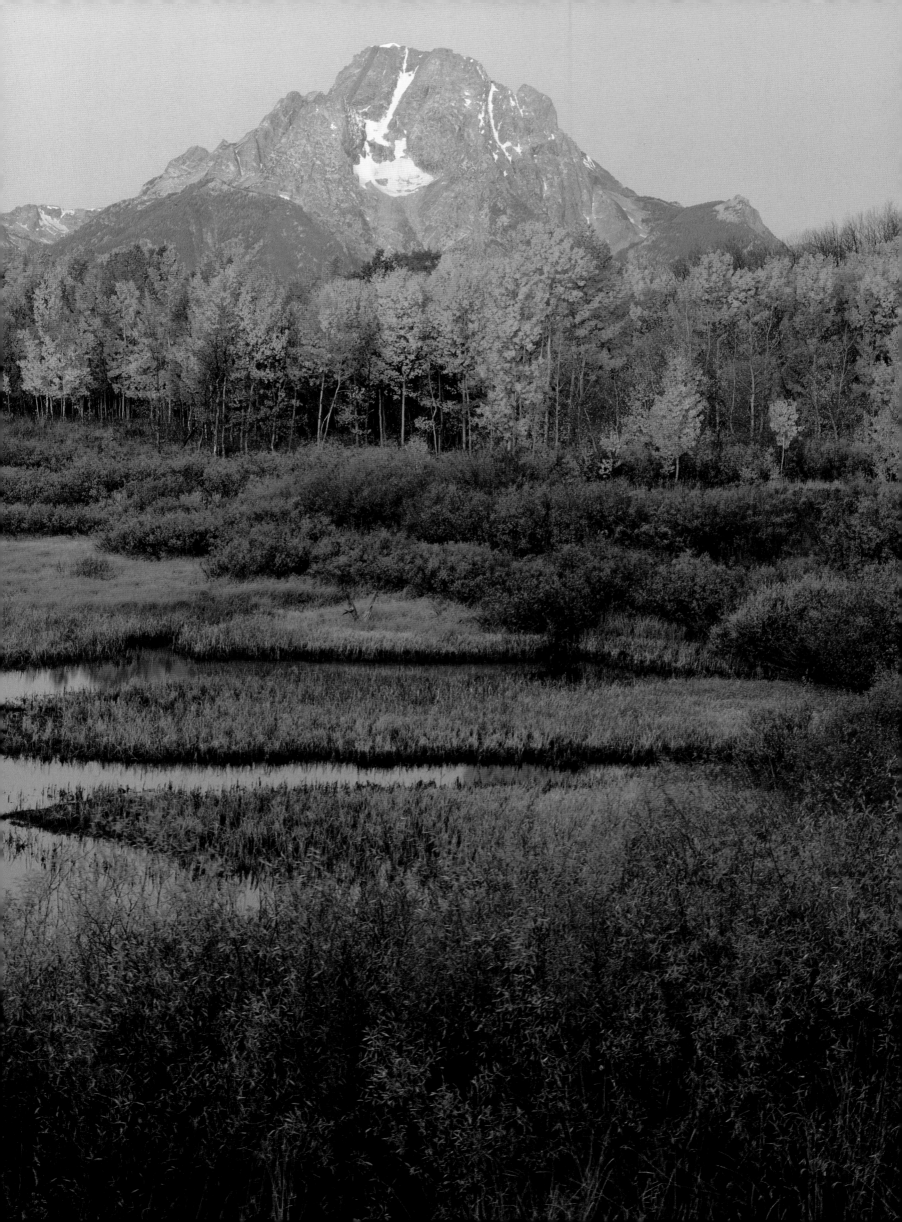

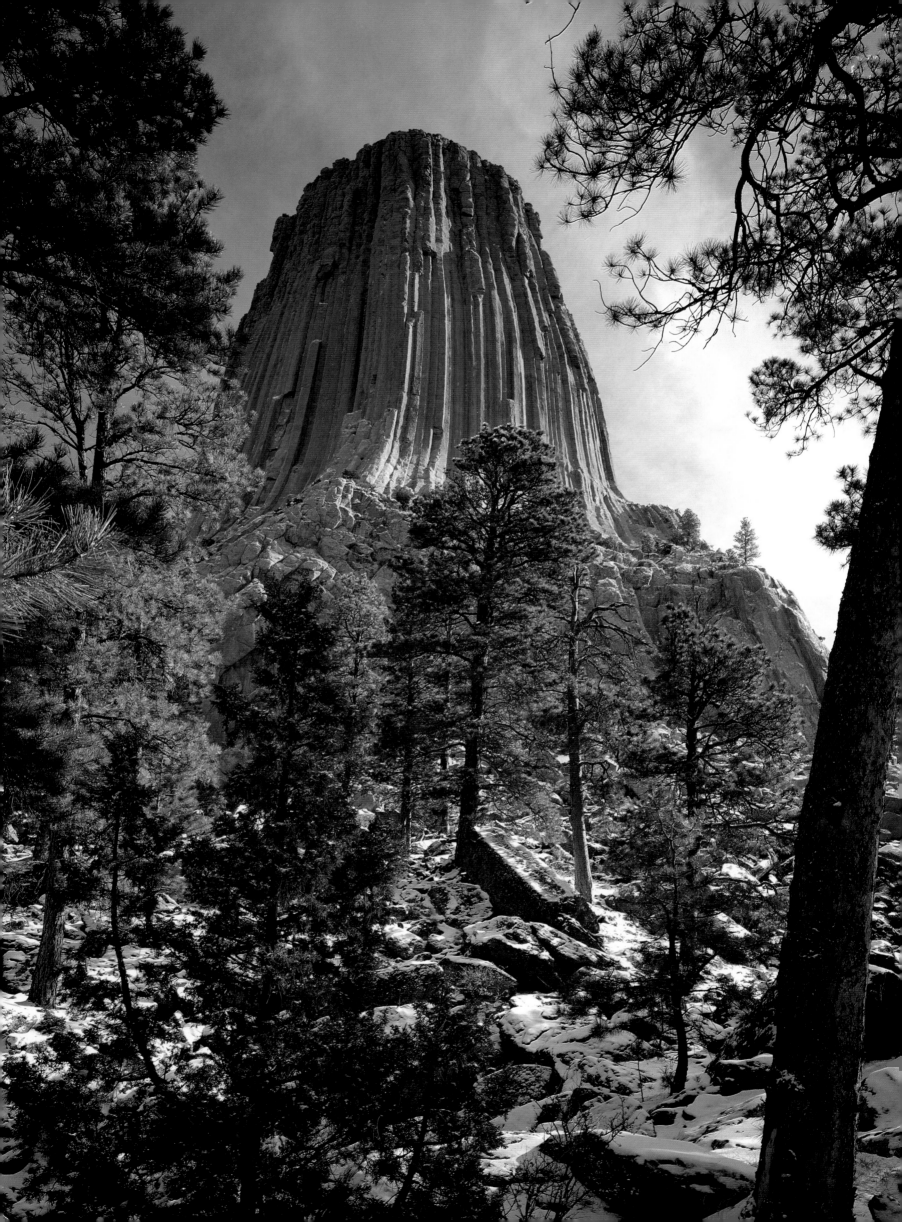

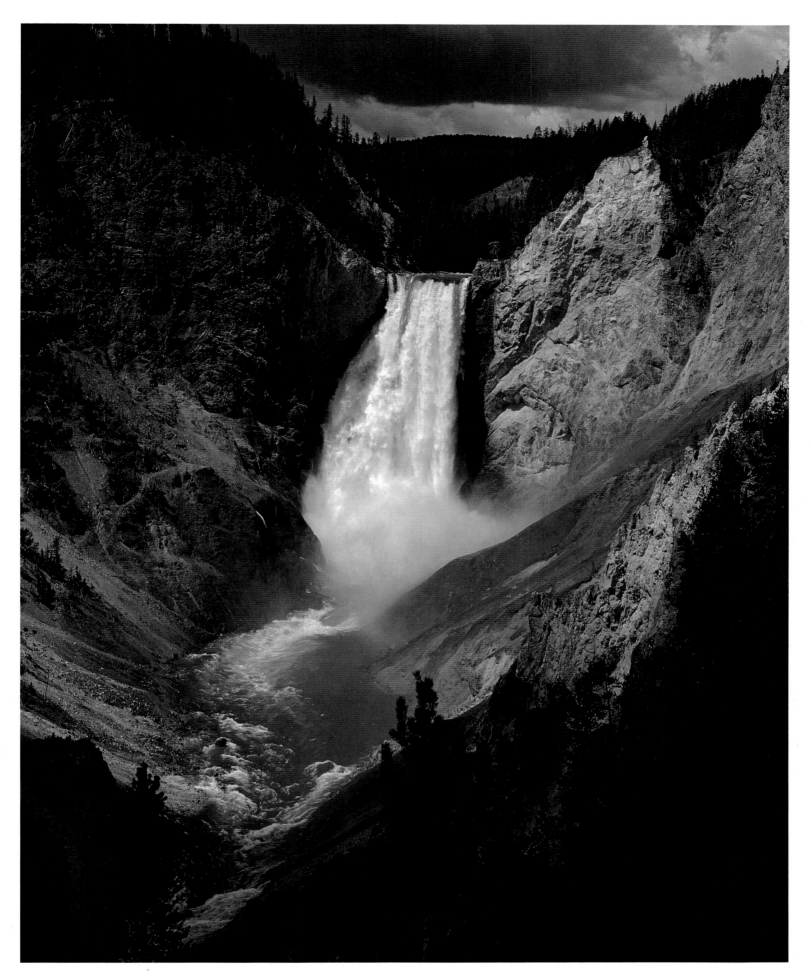

◄ Eastern Wyoming's 865-foot-high Devils Tower, the hardened magma
core of an ancient volcano, was established as a national monument in 1906.
▲ The Lower Falls of Yellowstone River plunge 308 feet. Heat and chemical
action on rhyolite rock caused the bright colors of the canyon walls.

159

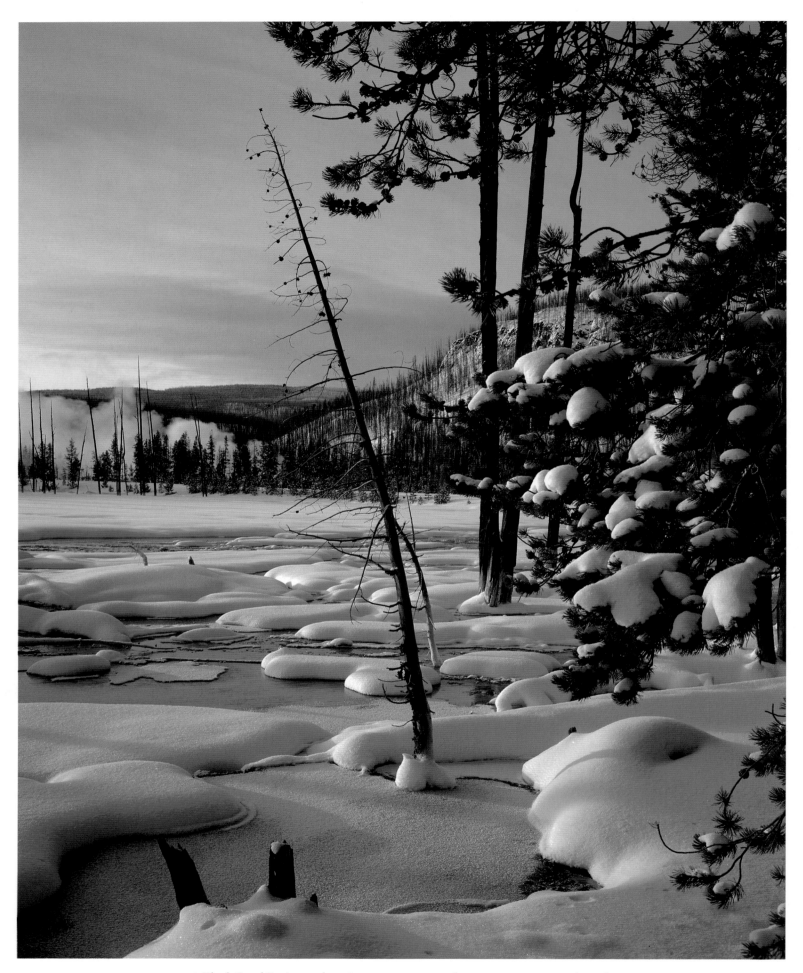

▲ Black Sand Spring melts winter snow among the greatest concentration of hot springs and geysers in the world in Yellowstone's Upper Geyser Basin.
► Geyserite lines the pools of Yellowstone's Great Fountain Geyser. Gigantic bursts of boiling water are hurled into the air, when Great Fountain erupts.

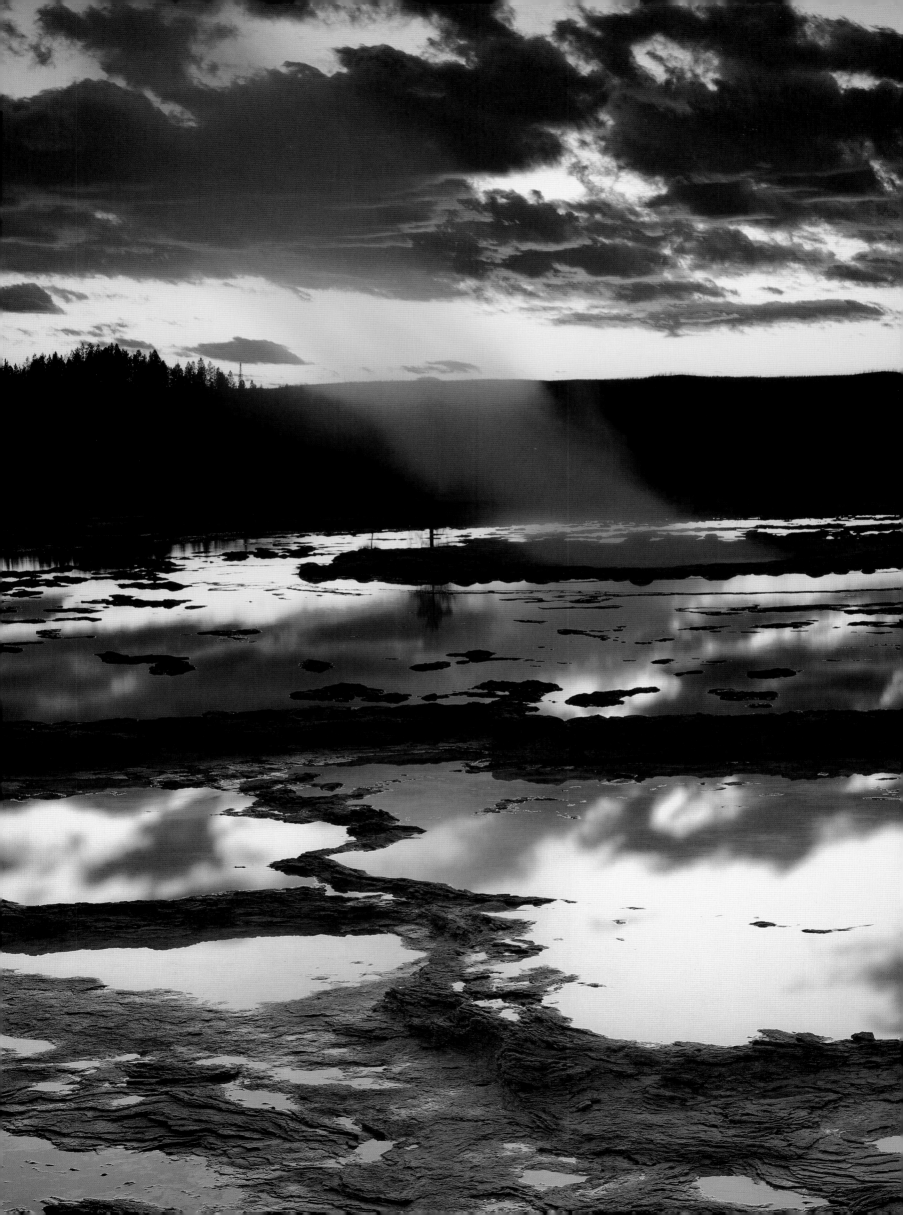

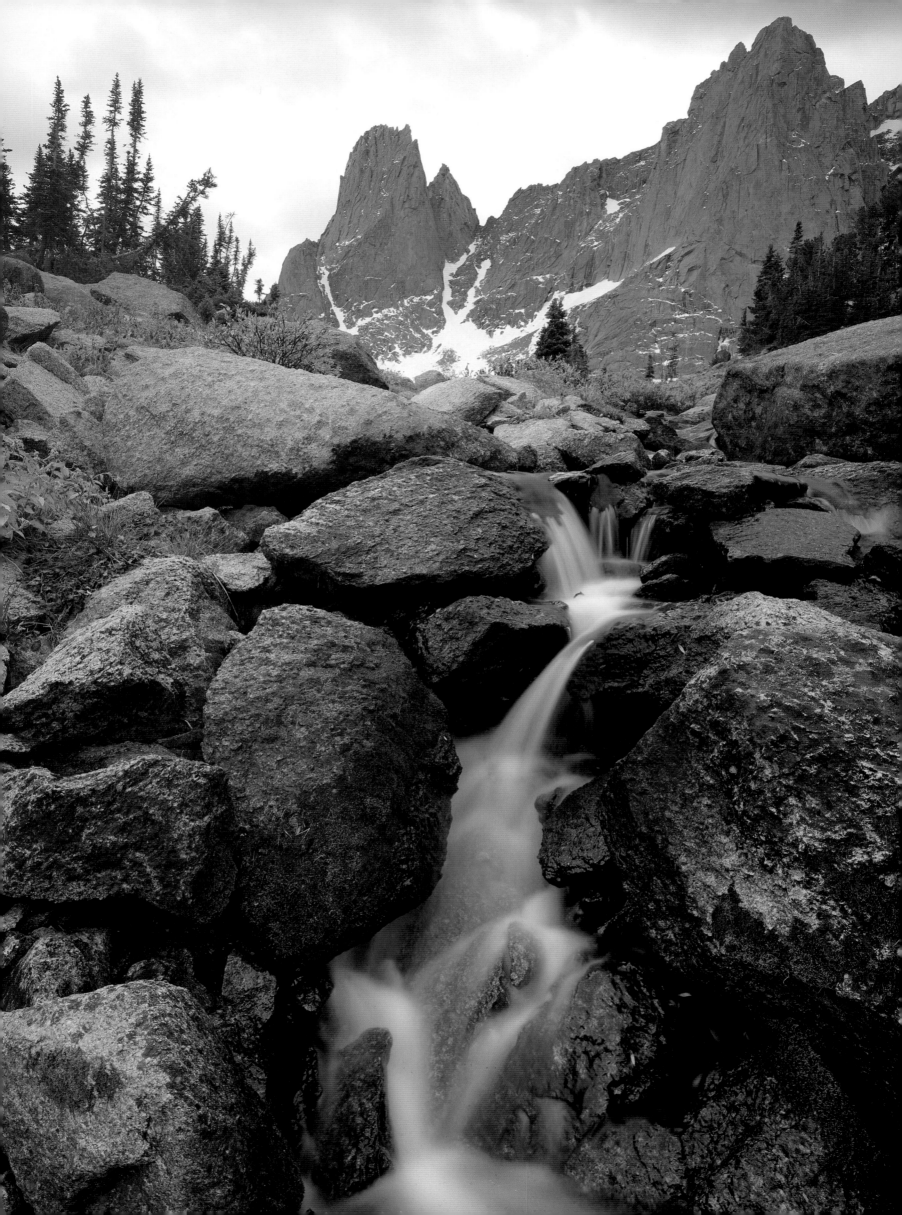

◄ Water tumbles over boulders in the Cirque of the Towers, with Warbonnet and Warrior peaks beyond. Wyoming's Shoshone National Forest, in the lee of the Absaroka and Wind River ranges, shelters bighorn sheep, elk, grizzlies, moose, and deer. President Theodore Roosevelt called Shoshone Forest's Wapiti Valley "the most scenic fifty-two miles in the United States."

▲ Sedges, willows, and blueberries line the shore of Lonesome Lake in the Wind River Range in Wyoming's Popo Agie Wilderness. The alpine tundra vegetation includes grasses, low-flowering plants, lichens, and moss.

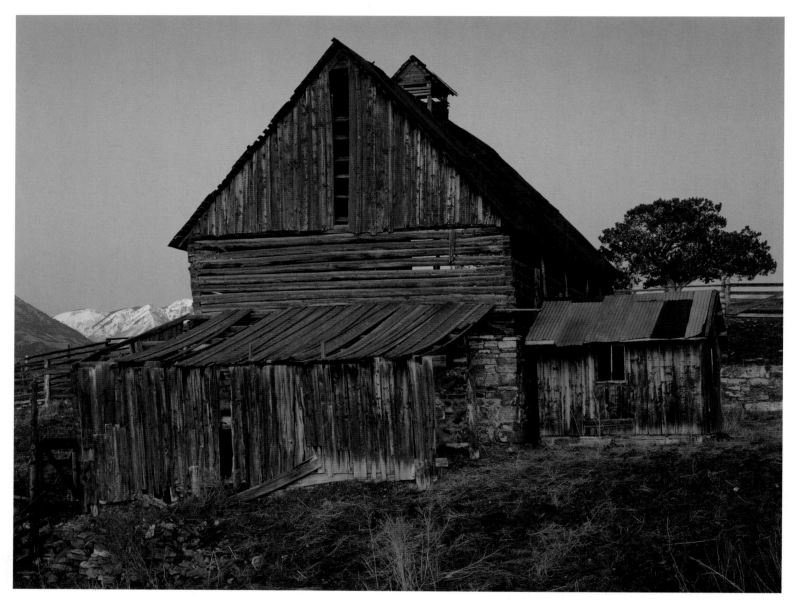

▲ Near Crawford, Colorado, a stone-and-log barn speaks of America's rural lifestyle. About three million people, out of the nation's population of over 260 million, make up the workforce on America's farms and ranches.
▶ The grasslands of the valleys and basins of the Rocky Mountains of Colorado provide an ideal environment for cattle and sheep ranching.

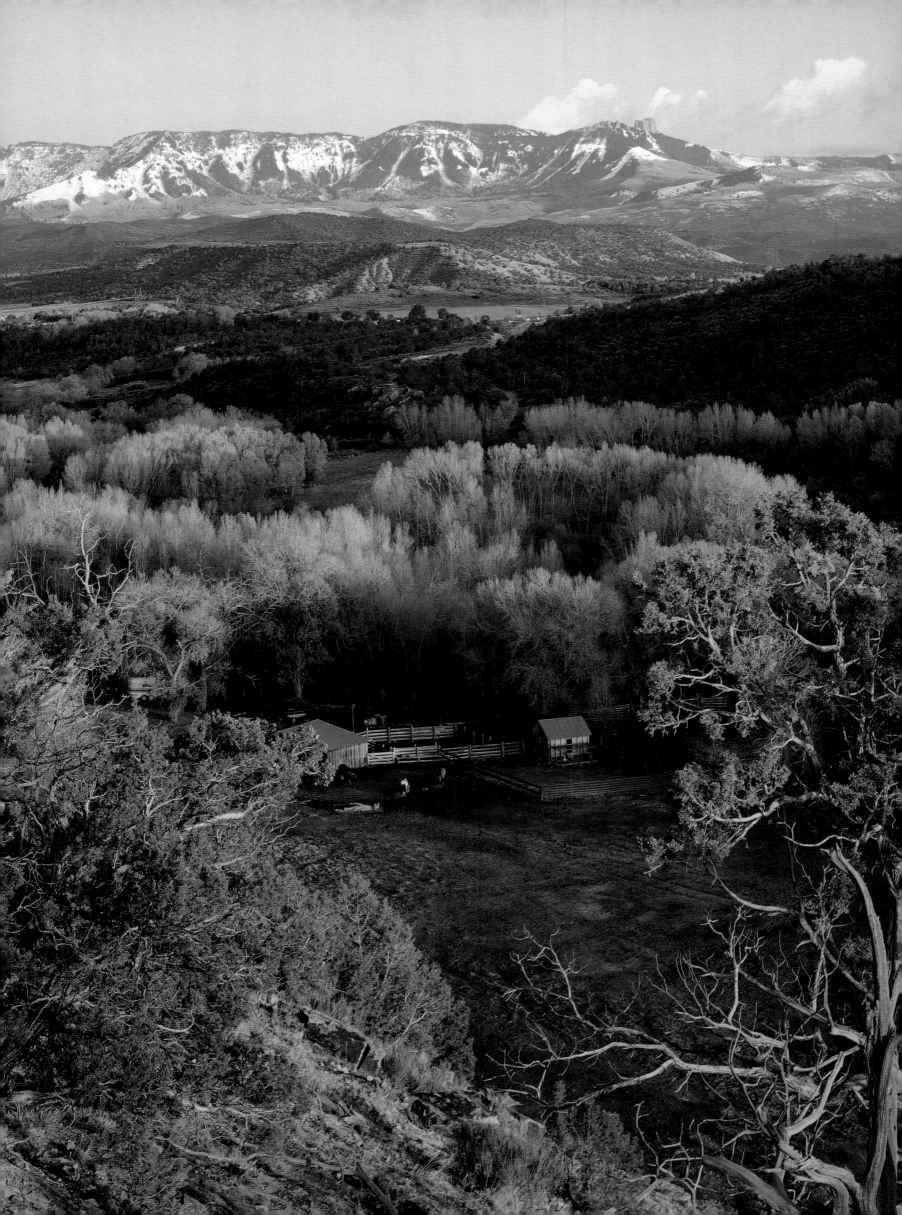

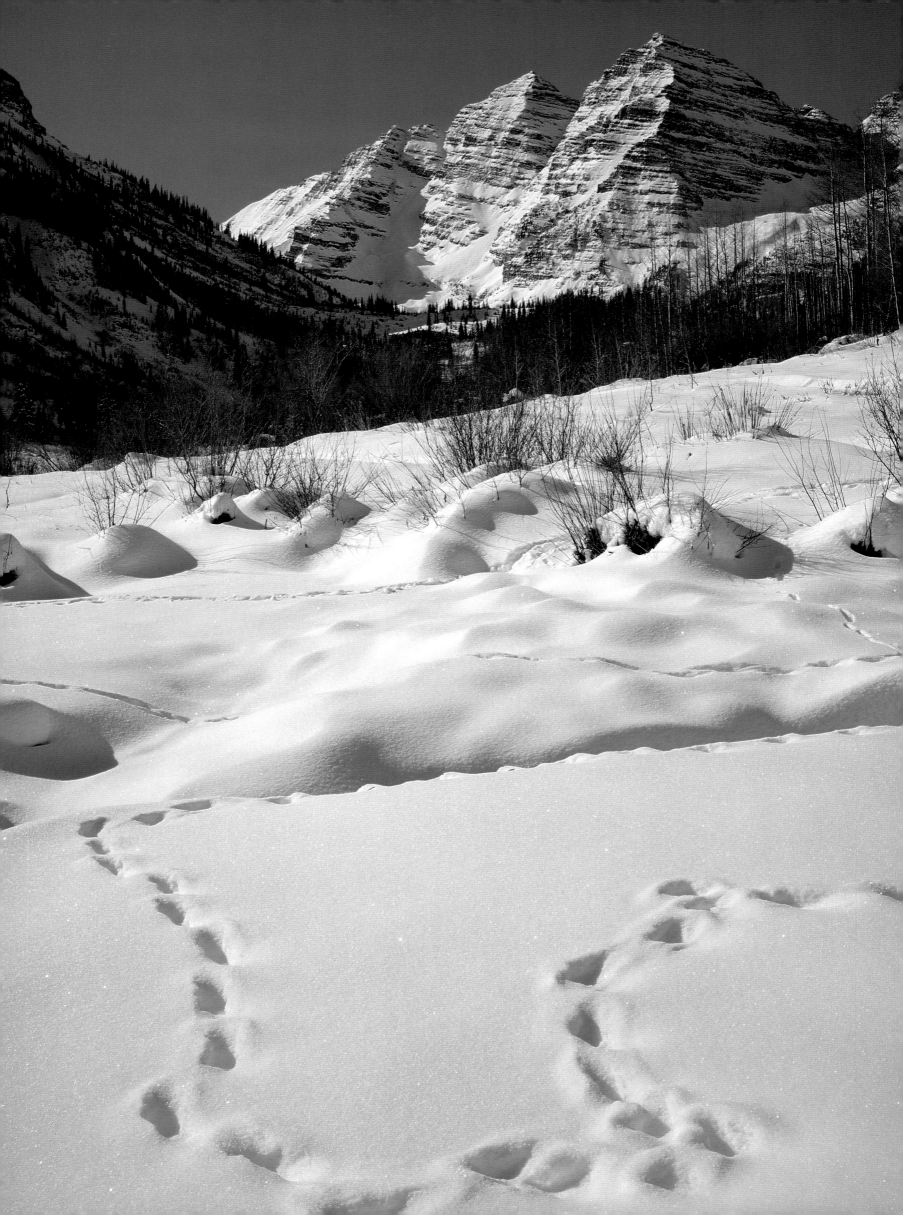

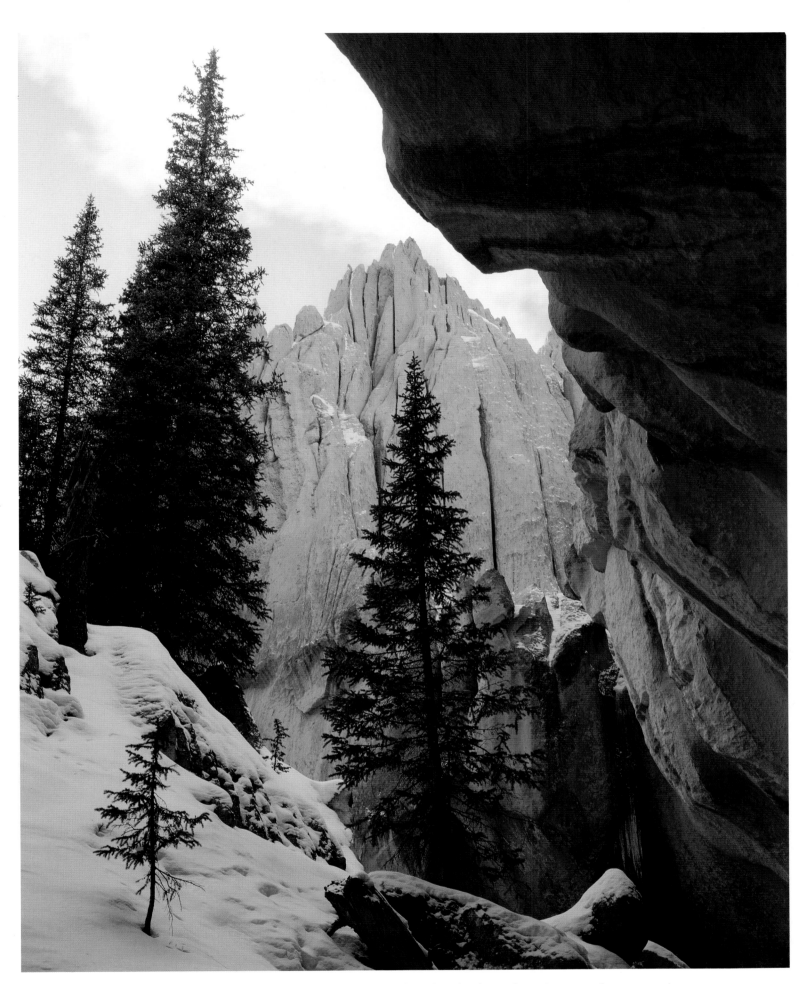

◄ Coyote tracks in the snow tell the tale of a hunt for mice near the base of the Maroon Bells of Colorado's White River National Forest.
▲ Douglas firs grow among volcanic hoodoos in the Wheeler Geologic Area of the La Garita Mountains in Colorado's Rio Grande National Forest.

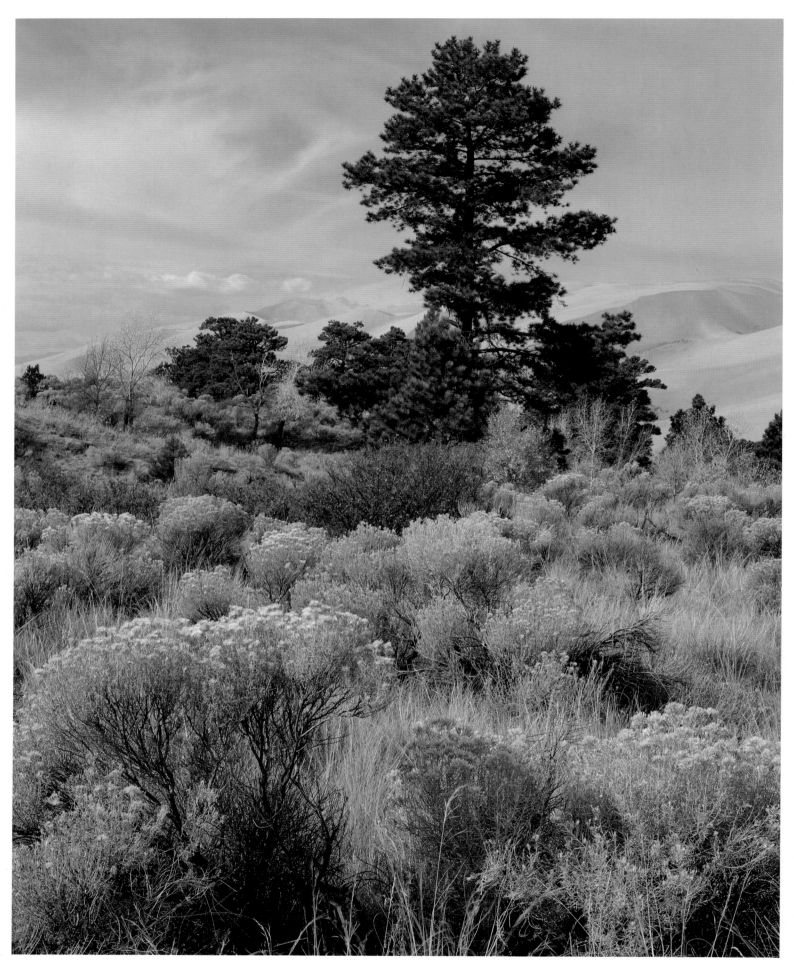

▲ Rabbit brush and ponderosa pines grow in Colorado's Great Sand Dunes National Monument. The 750-foot-high dune field covers 55 square miles.
► Sievers Mountain and Maroon Lake in White River National Forest show part of the variety of scenery found in Colorado—from plains to mountains.

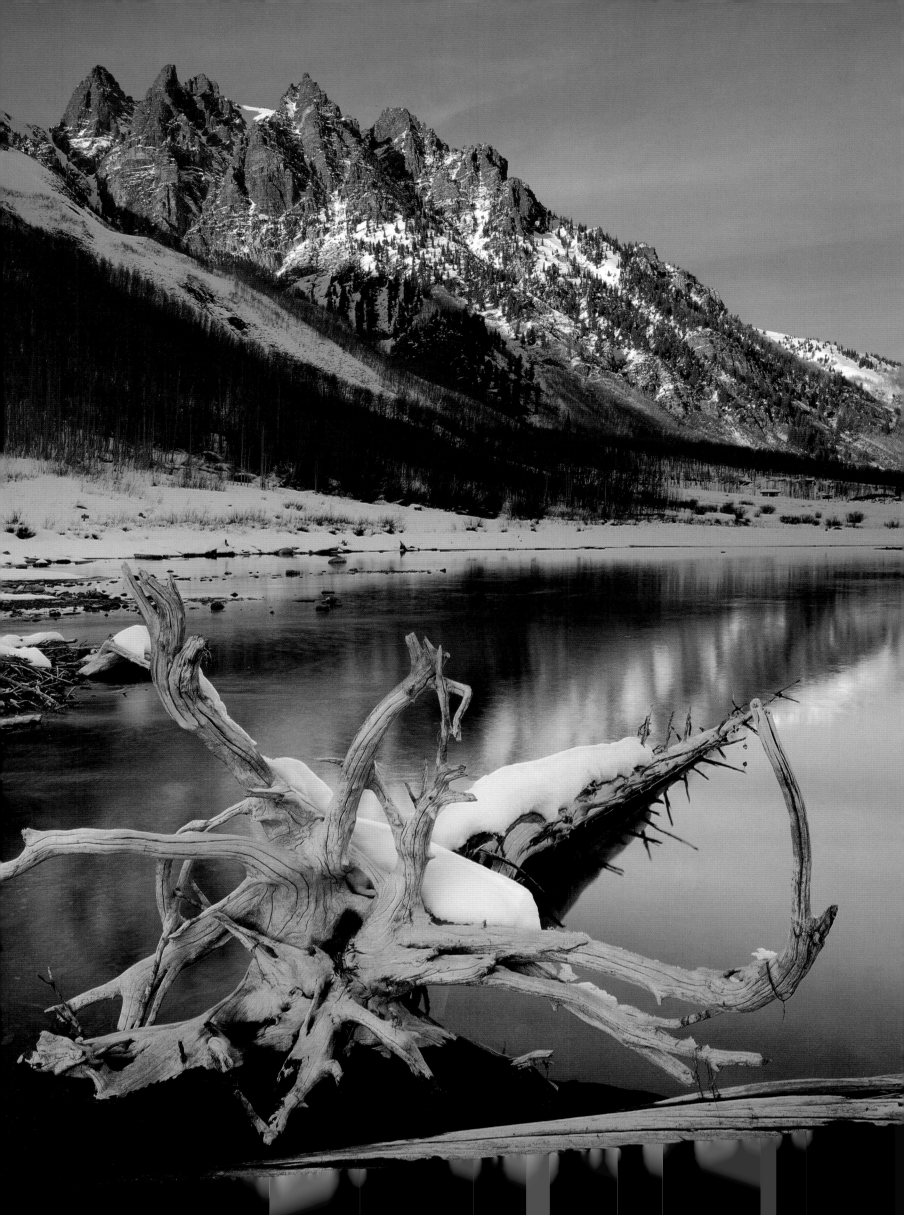

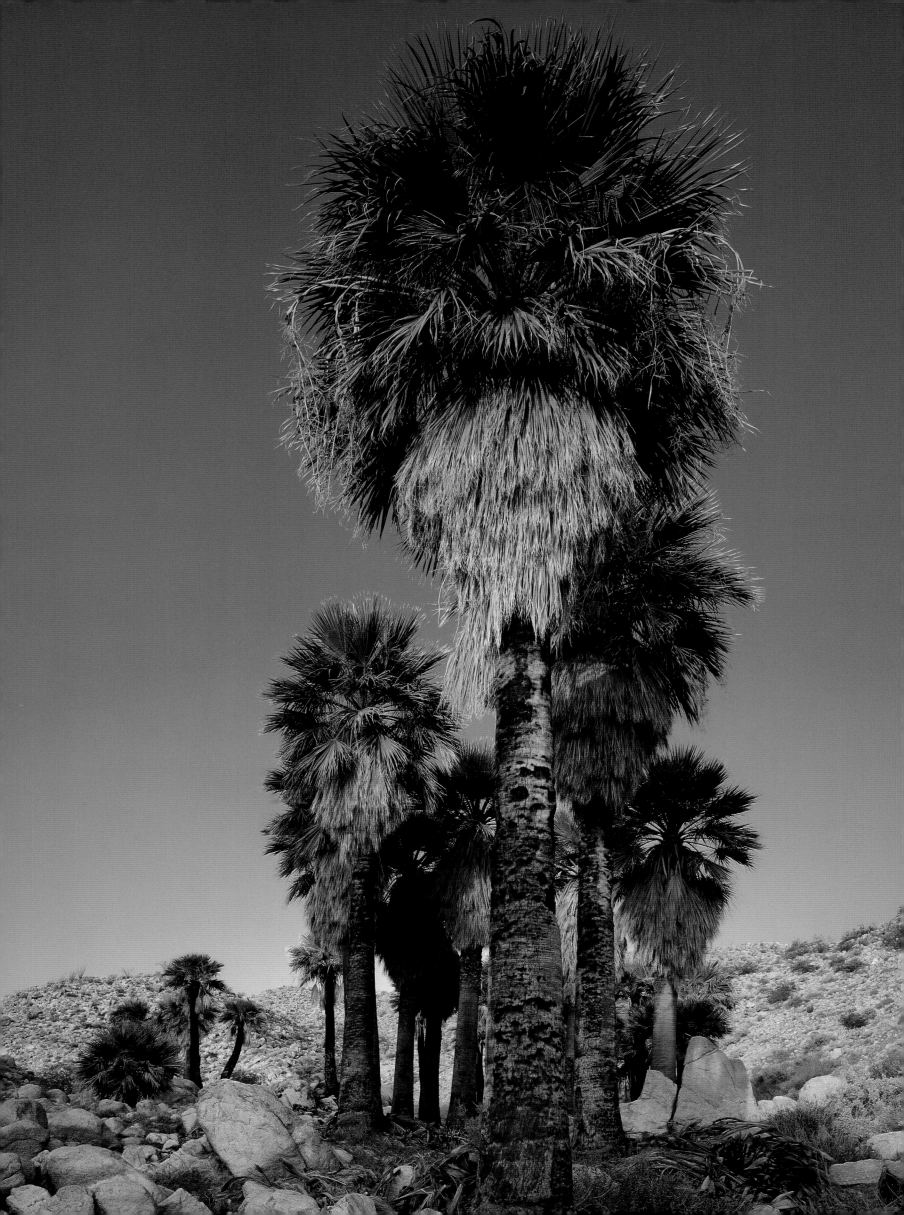

THE FAR WEST

"Turn your face to the great West, and there build up a home and fortune," Horace Greeley advised in a mid-nineteenth-century *New York Tribune* editorial. Go west they did—prospectors chasing the promise of gold and silver in the Sierra Nevada, and families challenging the mountains to claim rich farmland in the valleys beyond.

Easterners often fail to realize how big this region is—and how much diversity

Above: *Bordering Inyo National Forest and Sequoia National Park, California's Mount Whitney, at 14,494 feet high, is the loftiest peak in the contiguous forty-eight states.* Above right: *Piedras Blancas Light, visible from Highway 1, was completed in 1875.* Left. *In Anza-Borrego, the California fan palm seeks natural wet areas in the desert.* Overleaf: *Anza-Borrego Desert State Park surrounds a rich bloom of desert sunflower, dune evening primrose, and sand verbena.*

it contains. Transposed to the Atlantic Coast, California would reach from Cape Cod to Savannah. California and Nevada would blanket more than a dozen states. California's coastline extends 840 miles from cool redwood forests in the north to the sunny Mexican border. Eastward, after rolling past the coastal mountains, this region includes rich farmland, climbs over the beautiful Sierra Nevada, christened by John Muir as the "Range of Light," crosses desert land in the mountains' shadow, and rolls across the arid Great Basin.

Spain laid early claim to the California coast; Route 101 was forged in 1769 as El Camino Real. That Royal Road linked the missions established to make Catholics and farmers of the local Indians. The effort faltered, but Spain's legacy still rings in the names of mountains, streams, and cities.

The discovery of gold at Sutter's mill in 1848 opened a lively chapter in California history. "Forty-niners" poured in from all directions. A few got rich; most merely subsisted. Their story is in the towns they

settled, and quickly deserted—Rough and Ready, Fiddletown, Iowa City, Fair Play, You Bet, Slumgullian, Hangtown.

A decade later, Nevada took the spotlight when silver was discovered in the Comstock Lode. Virginia City became the new mining metropolis, boasting fabulous wealth, 110 saloons, and the only elevator in existence between Chicago and San Francisco. Prosperity propelled the Silver State into the Union in 1864, just in time to cast the final vote for slavery's abolition.

As prospectors panned for gold, more patient immigrants worked the rich soil in California's broad Central Valley, where a temperate climate promised fortunes in fruits and vegetables. Today, abundance of every kind of produce, plus beef and dairy cattle, makes agriculture California's top industry. Napa Valley produces splendid wines, and with irrigation, even the Mojave Desert yields watermelons and almonds.

San Francisco, set on a fine natural bay, grew by leaps and bounds during the late 1800s. By 1904, it had a population of four hundred thousand and was called simply "The City." Then came the earthquake and fire of 1906. The city rebuilt. The earth shook again in 1989, and the spirited city once more rebuilt.

If San Francisco is vintage California, Los Angeles is the city of today. Spilling over the hills and valleys, laced with freeways, it has made the world familiar with places like Hollywood and Disneyland.

Across the mountains are two more cities known for their neon and glitz, Reno and Las Vegas. Beyond is the true Nevada—vast, empty stretches of rangeland, huge, working ranches where cowboys still do serious riding; and authentic small towns that hark back to another generation.

The most venerable living things in the Far West hark back further still, and have nothing to do with roads or cities. In this region live the largest, tallest, and oldest trees in the world. They stand quietly—those giant sequoias, soaring redwoods, and ancient bristlecone pines—waiting, like the mountains, ready to remind anyone who walks among them that the land came first and shaped human endeavors.

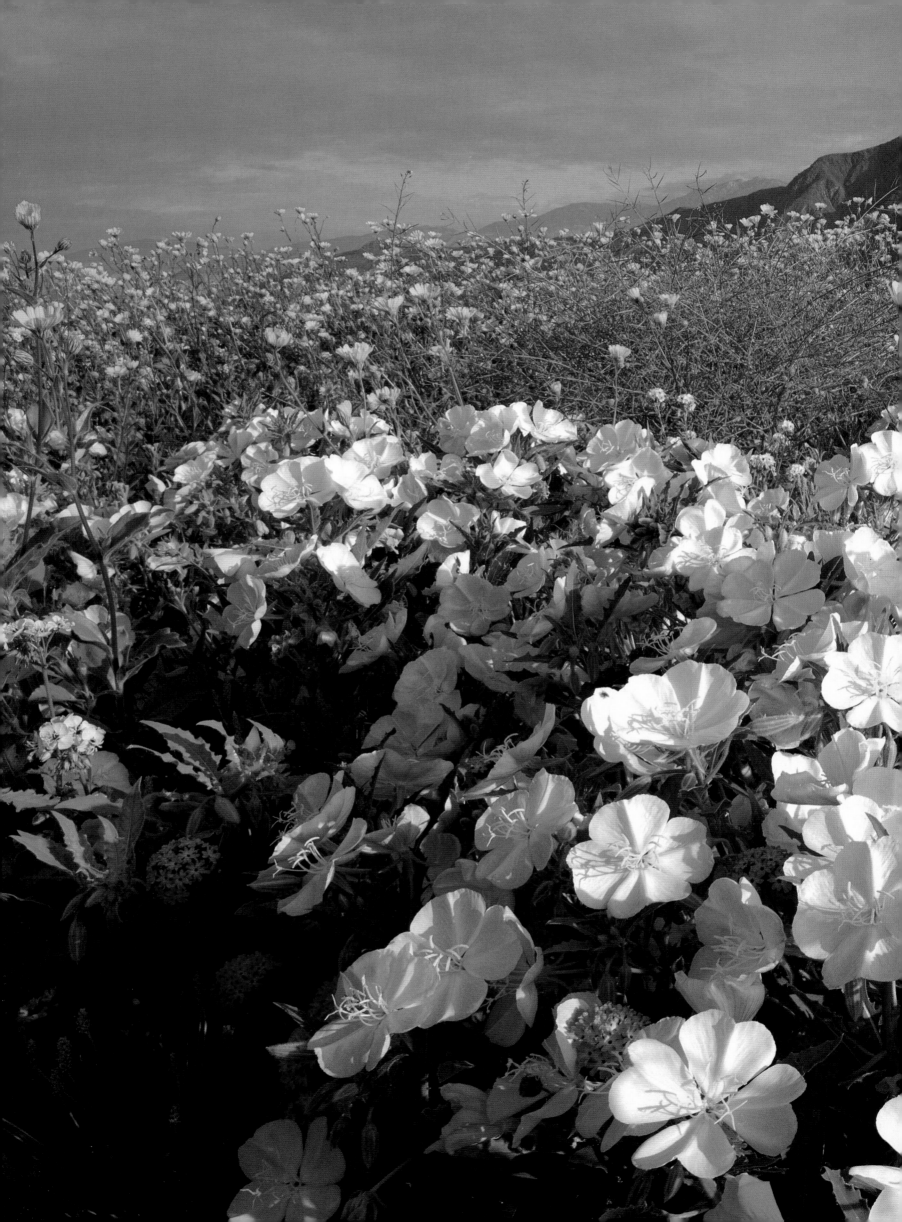

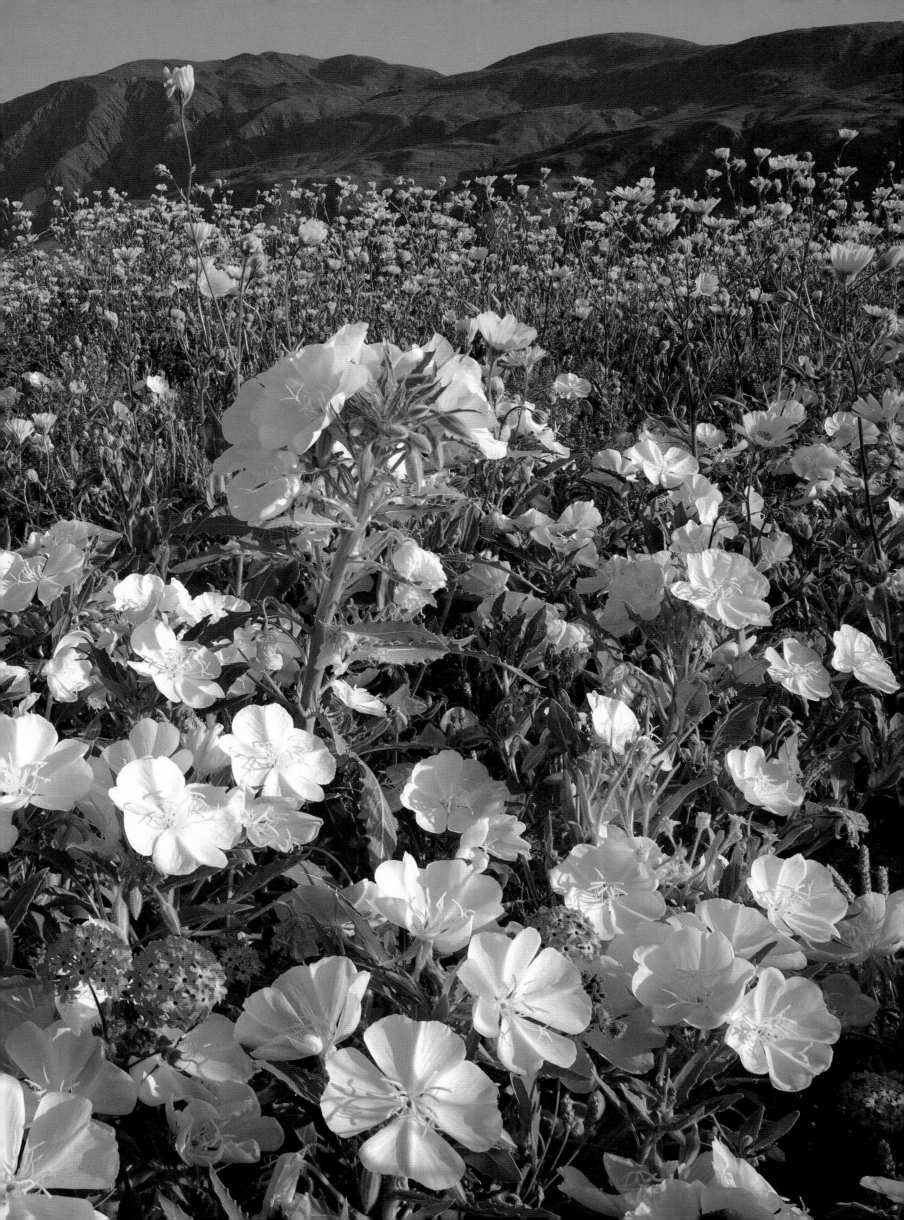

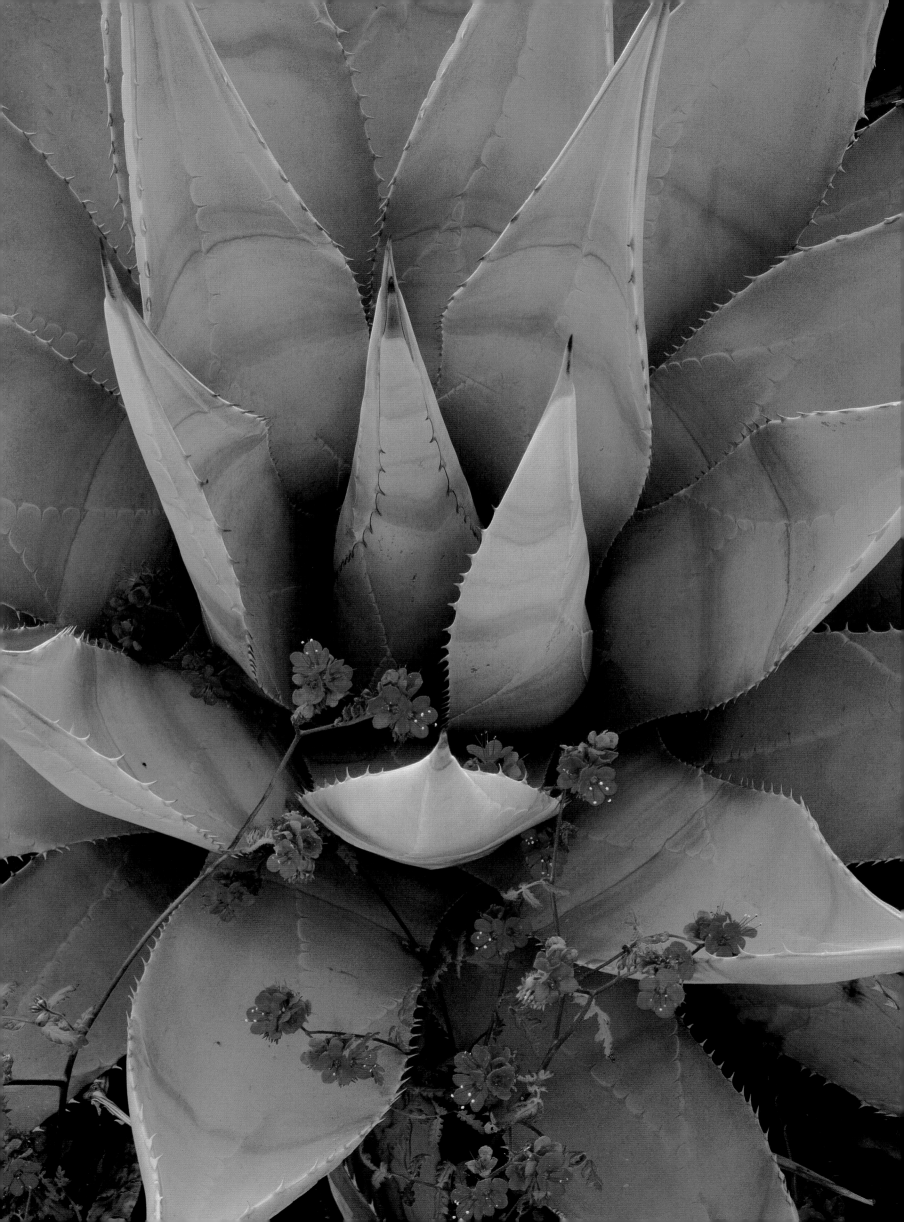

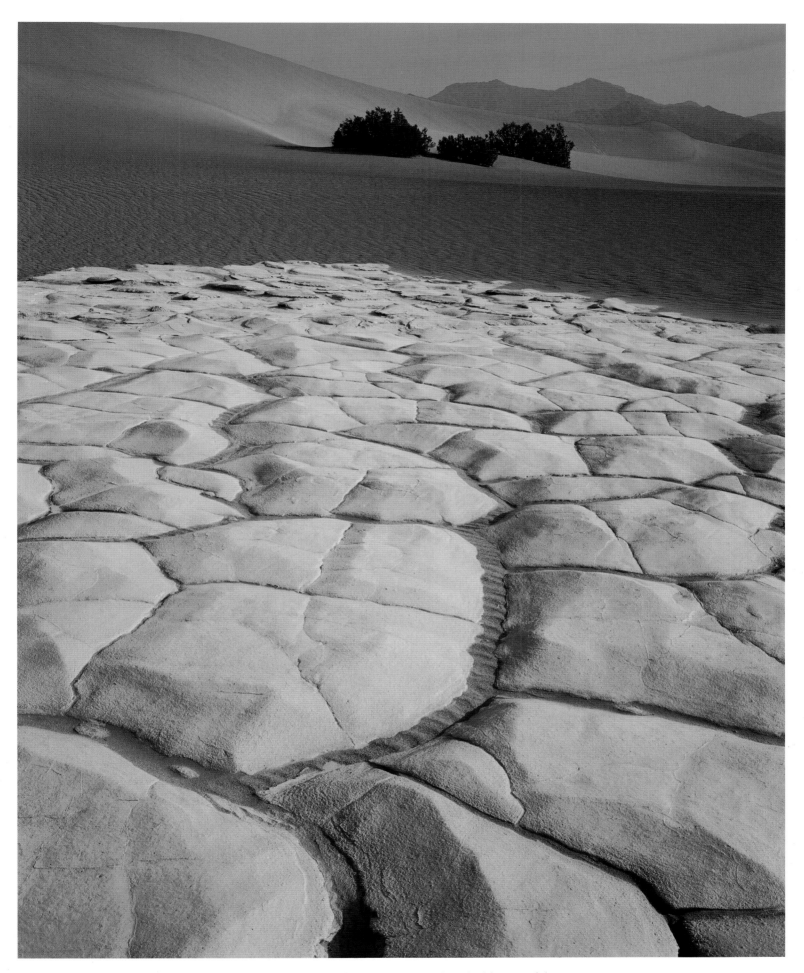

◄ Purple blossoms of phacelia intertwine with spiked leaves of desert agave in Jojoba Wash of Southern California's Anza-Borrego Desert State Park.
▲ The continent's hottest spot, Death Valley National Park includes this dried lake bottom, or playa, surrounded by numerous shifting sand dunes.

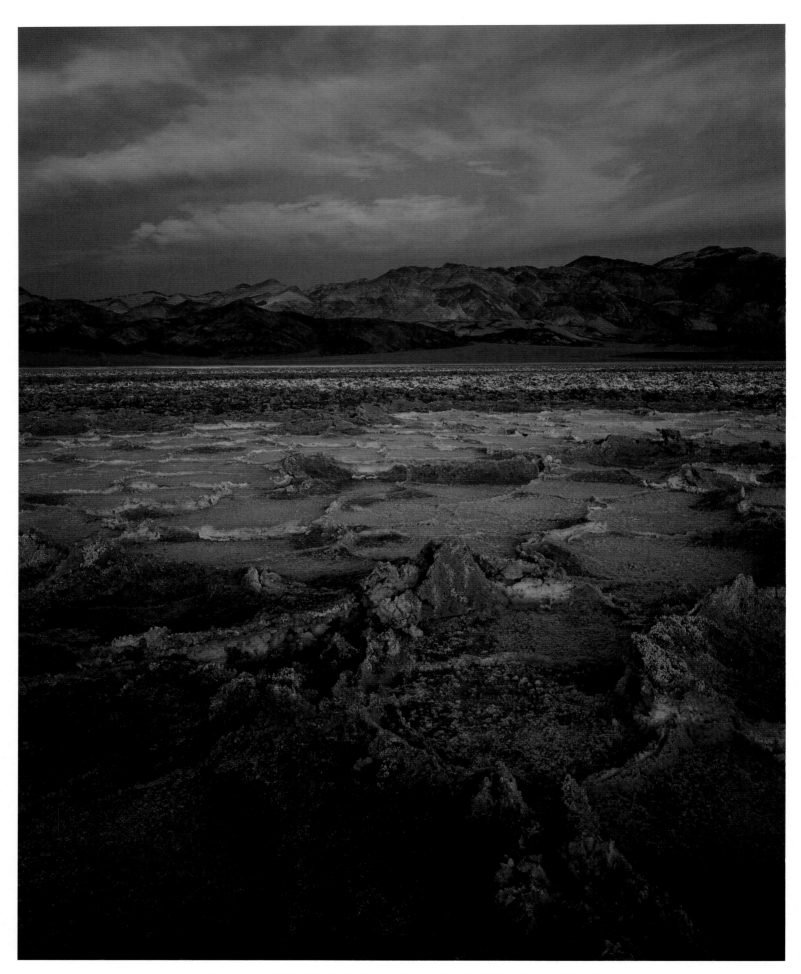

▲ Salt pans of Devil's Golf Course lie in Death Valley National Park.
Nearby is Badwater, this continent's lowest point at 282 feet below sea level.
▶ Bodie, California, a gold-mining ghost town, is now protected as a State
Historic Park. In 1879, Bodie boasted a population of about ten thousand.

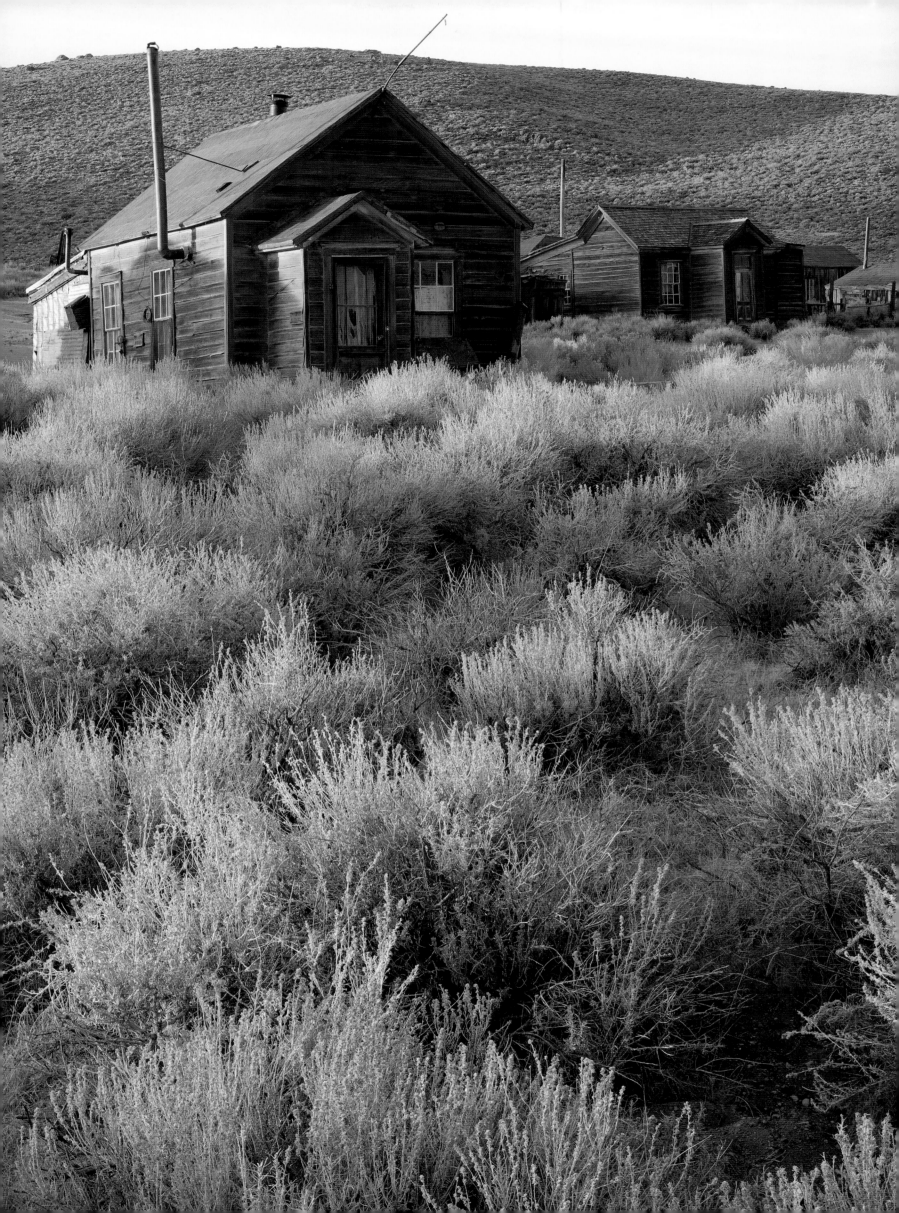

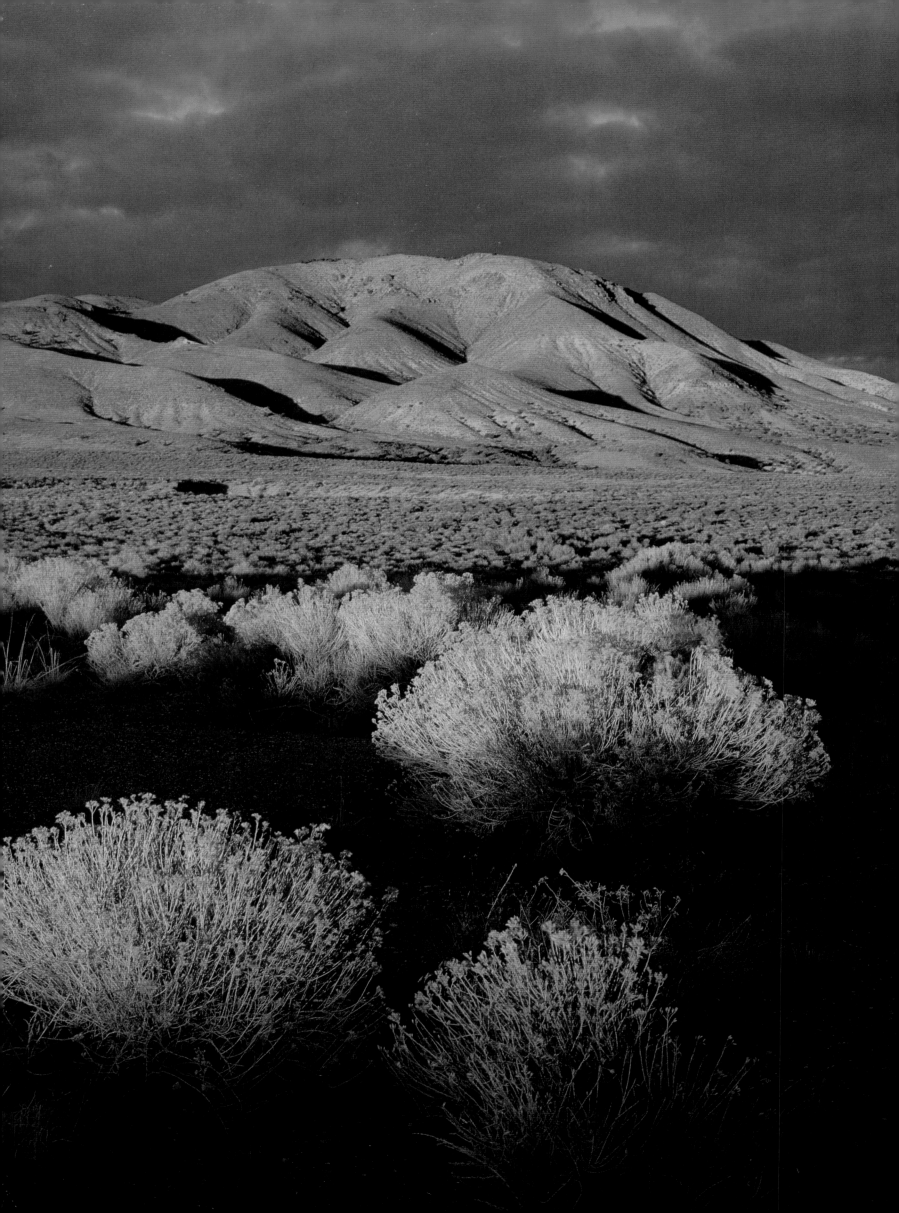

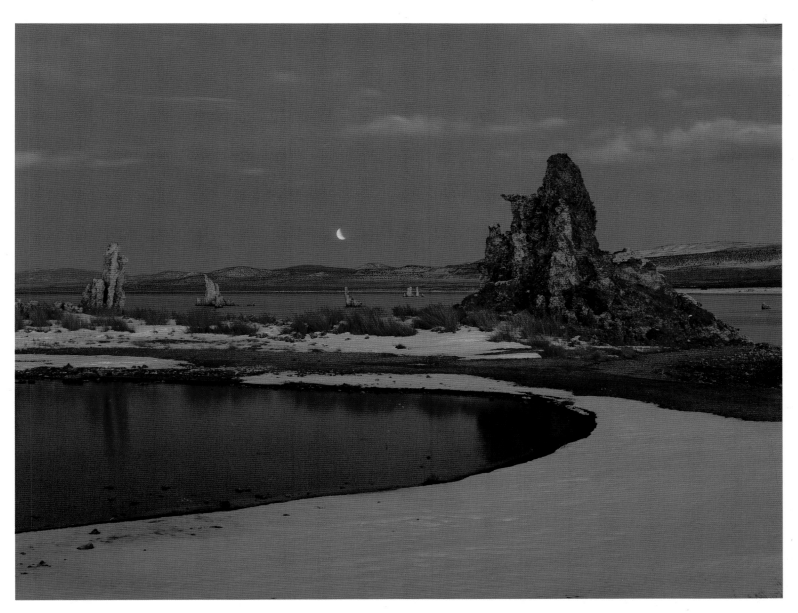

◄ The Monitor Range slices the skyline in central Nevada. In contrast to the gambling cities of Reno and Las Vegas, Nevada is 98 percent undeveloped. Still, nearly one and one-half million people live in the Sagebrush State.
▲ A partial lunar eclipse rises over Mono Lake's haunting tufa towers. The alkali waters support innumerable brine shrimp and alkali flies, which, in turn, feed hundreds of thousands of migrating or nesting water birds.

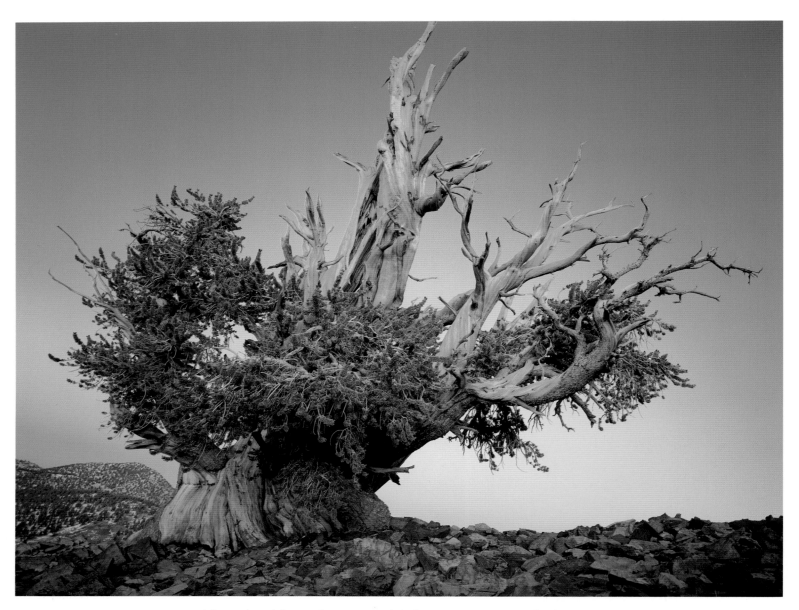

▲ The sculpted form of an ancient bristlecone pine tenaciously clings to a windswept ridge of the White Mountains, in California's Inyo National Forest. The oldest living trees on earth exist in one of the harshest environments. Some individuals have lived as long as forty-six hundred years.
▶ Rime ice coats Jeffrey pines growing along Lee Vining Creek in the Inyo National Forest. Diverted for decades to water a thirsty Los Angeles, today the creek gurgles into Mono Lake, helping to preserve a fragile ecosystem.

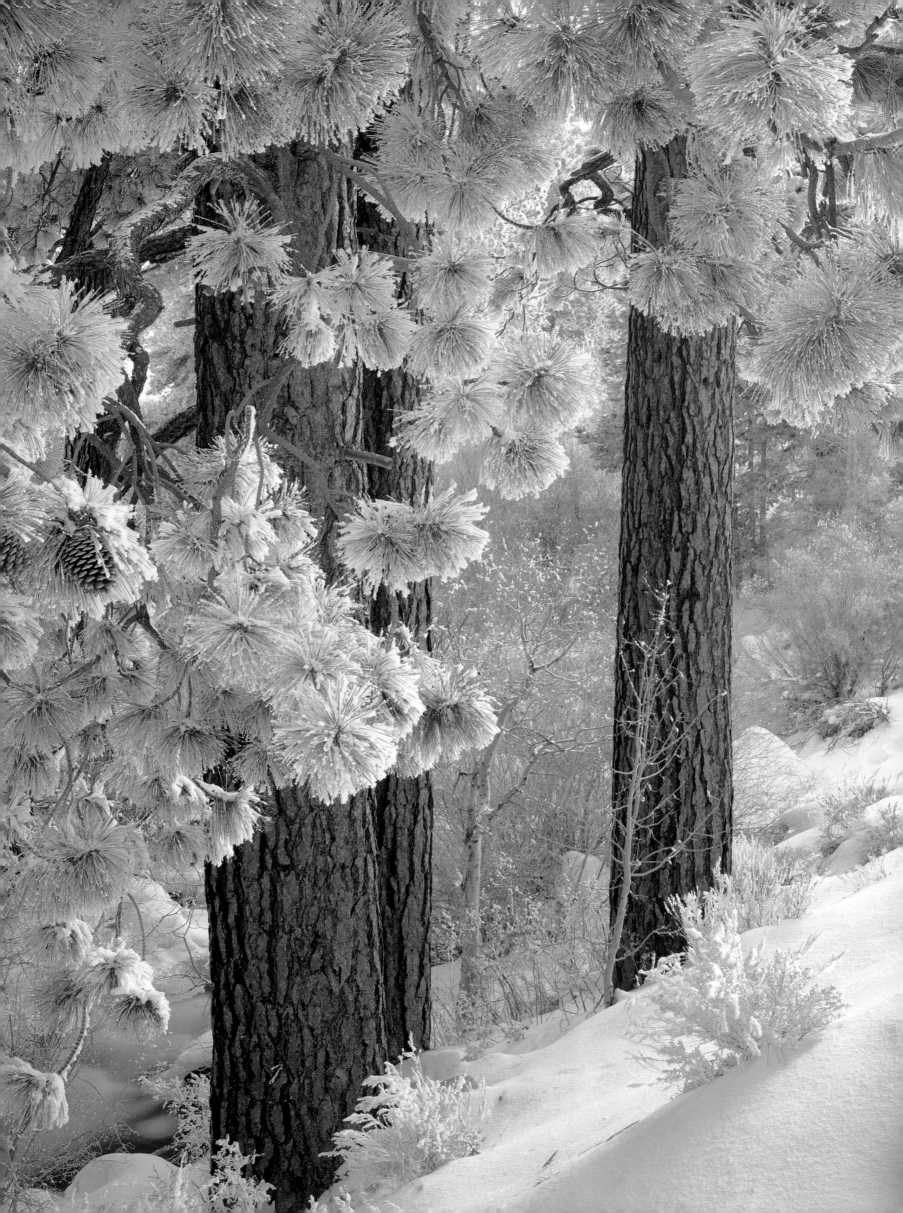

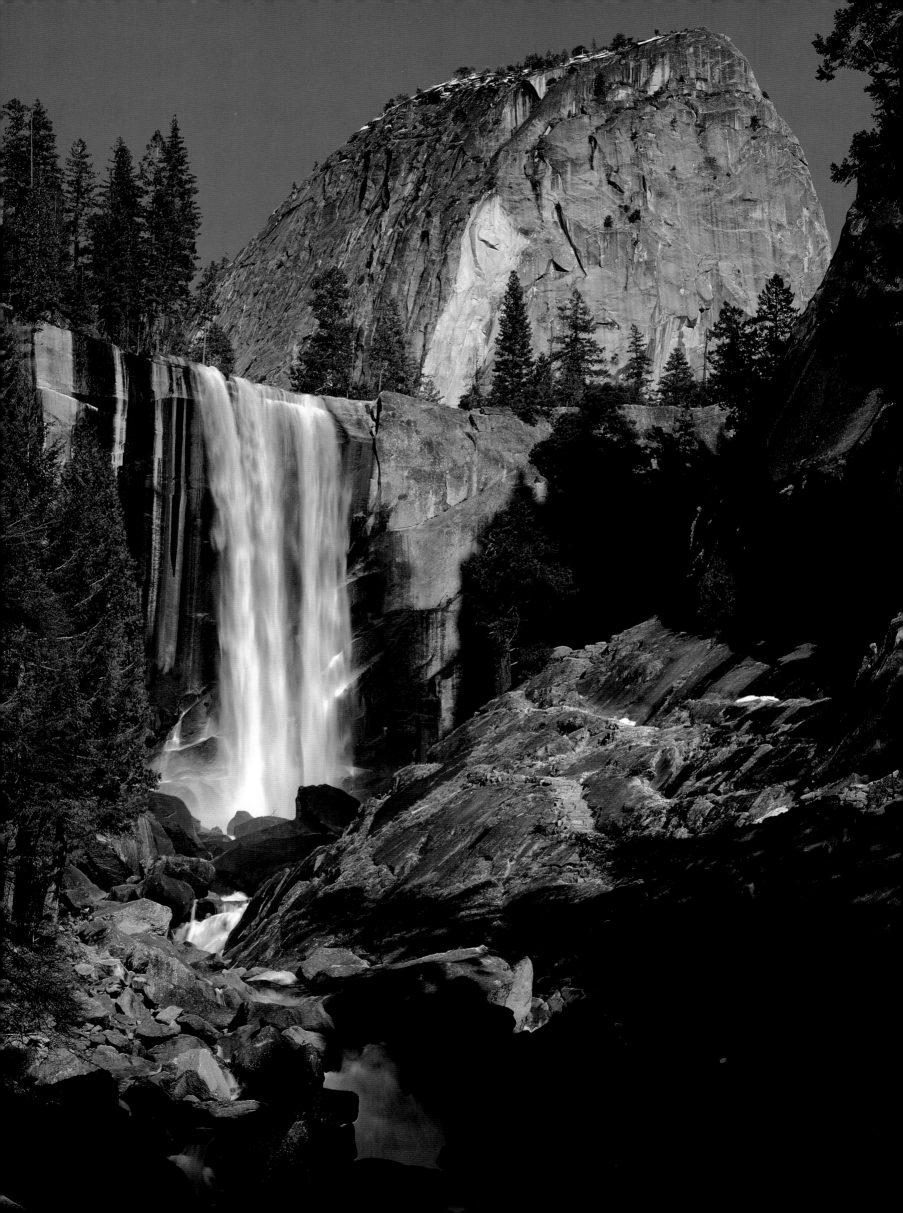

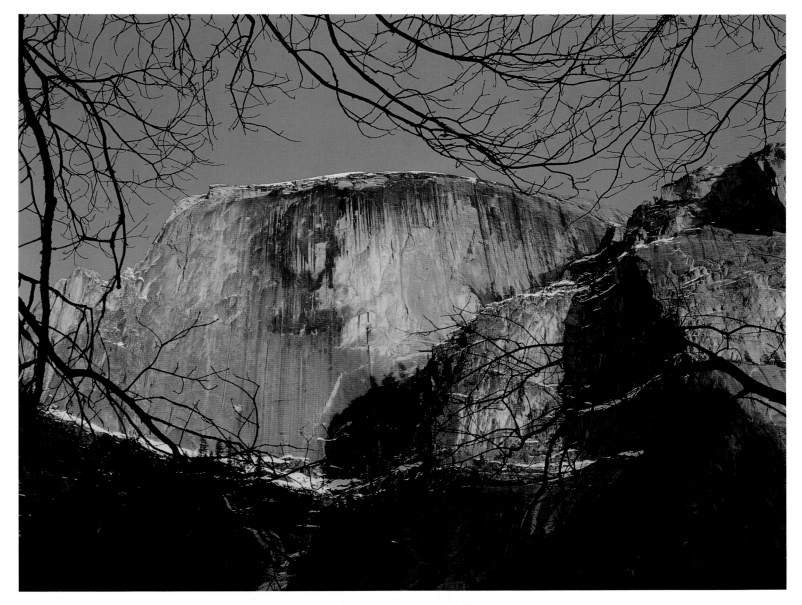

◄ The Merced River drops 317 feet over Vernal Fall, in California's Yosemite National Park. The Liberty Cap looms beyond. Created as a national park in 1890, this World Heritage Site receives over three million visitors yearly.
▲ Half Dome, a famous feature in Yosemite, is an exfoliated and glacially carved block of granite that rises 4,733 feet. Park elevations range from two thousand feet above sea level to more than thirteen thousand feet.

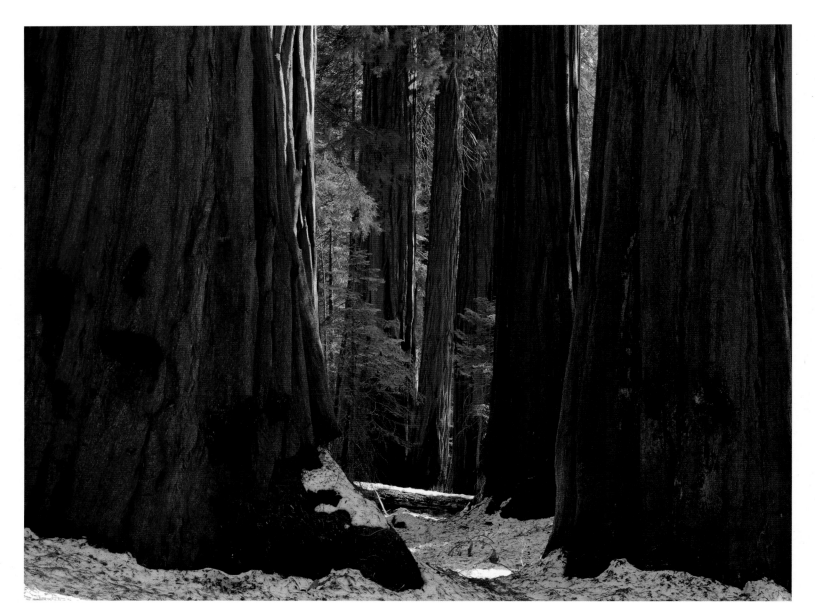

▲ The giant sequoias found in the Giant Forest of California's Sequoia National Park bestow an awe-inspiring, unforgettable beauty. Here grow the world's largest living trees. The biggest individual has a trunk volume of over fifty-two thousand cubic feet. This trunk weighs fifty-eight billion times as much as its starting seed; ninety-one thousand seeds weigh a pound.
▶ The Mariposa Grove of giant sequoias is sheltered within Yosemite National Park. Sequoias are dependent on natural fires for their reproduction. If the fires are suppressed, other trees compete with the ancient sequoias, robbing them of their sunlight and blanketing their mineral soil.

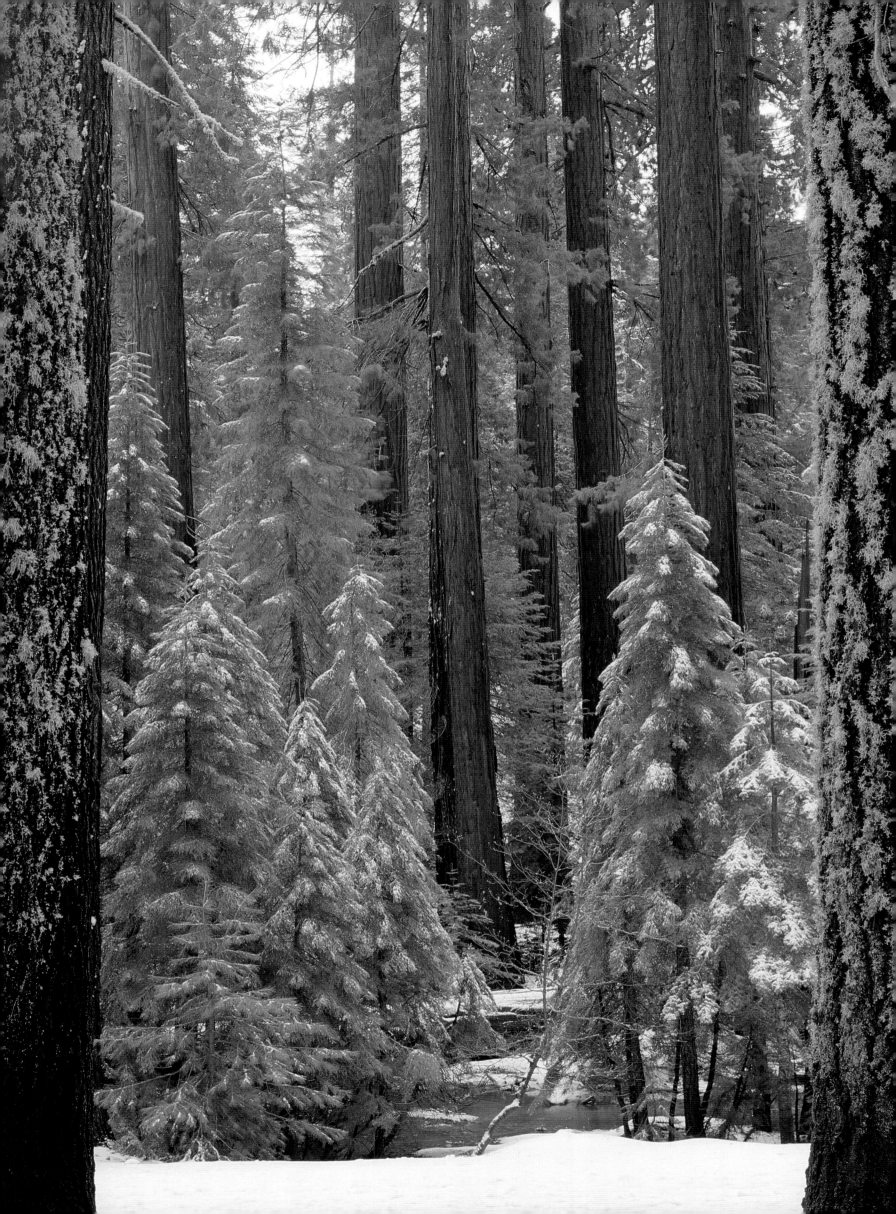

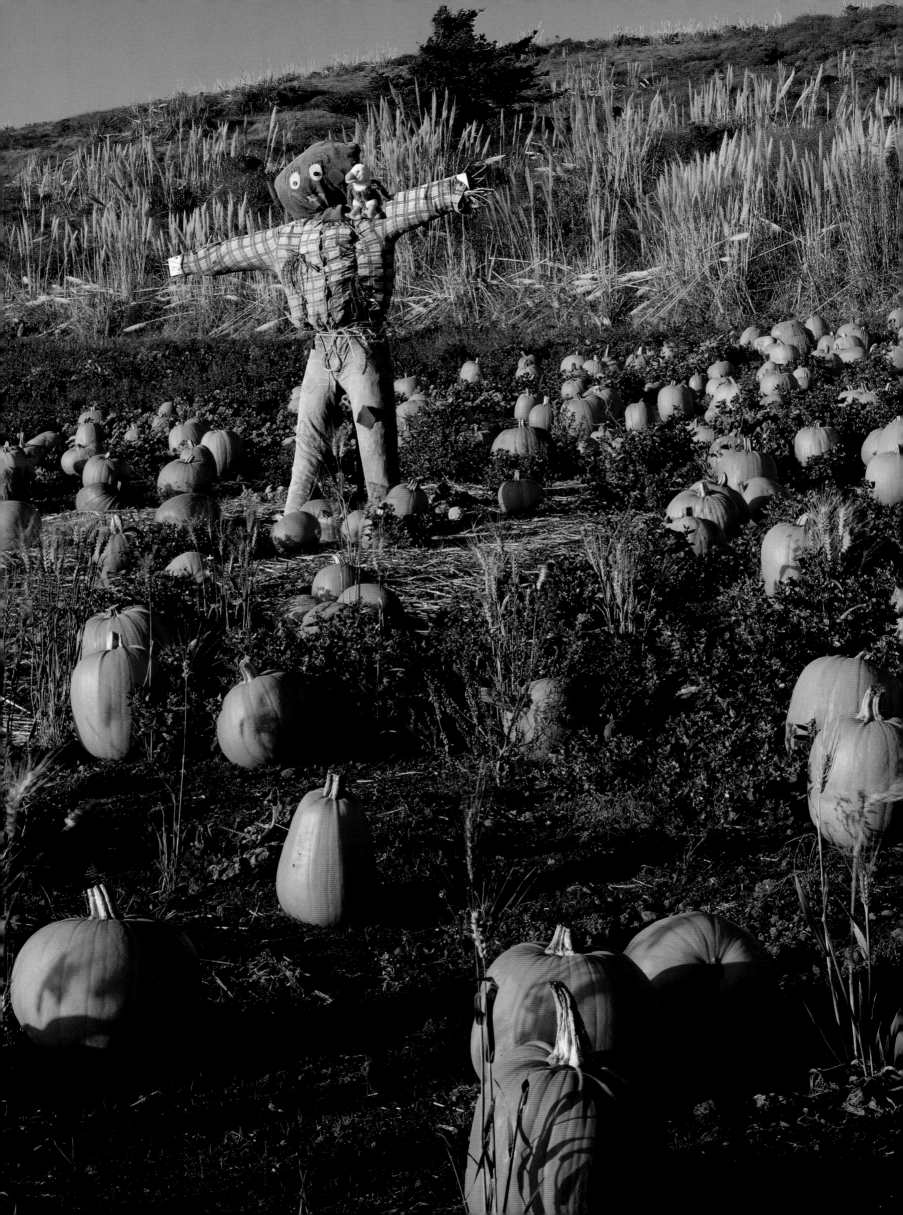

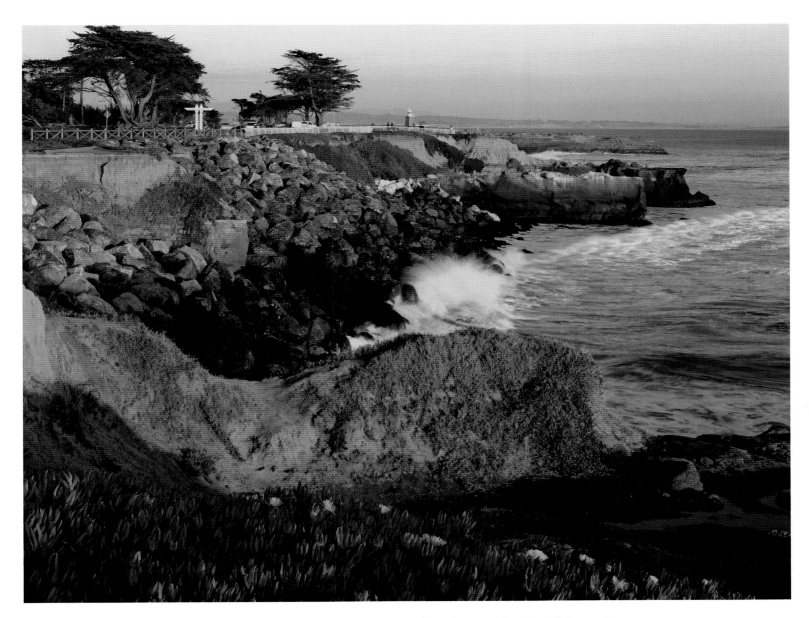

◄ Pumpkins decorate a field near Pescadero along California's Highway 1. Brussels sprouts and artichokes are also grown near this coastal highway.
▲ The Santa Cruz Light is a "memorial lighthouse" built in 1967. Illuminated on New Year's Day 1870, the first lighthouse at Santa Cruz was a frame building with a thirty-five-foot-high square tower. The original light was moved to safer ground when three sea caverns undermined its foundation.

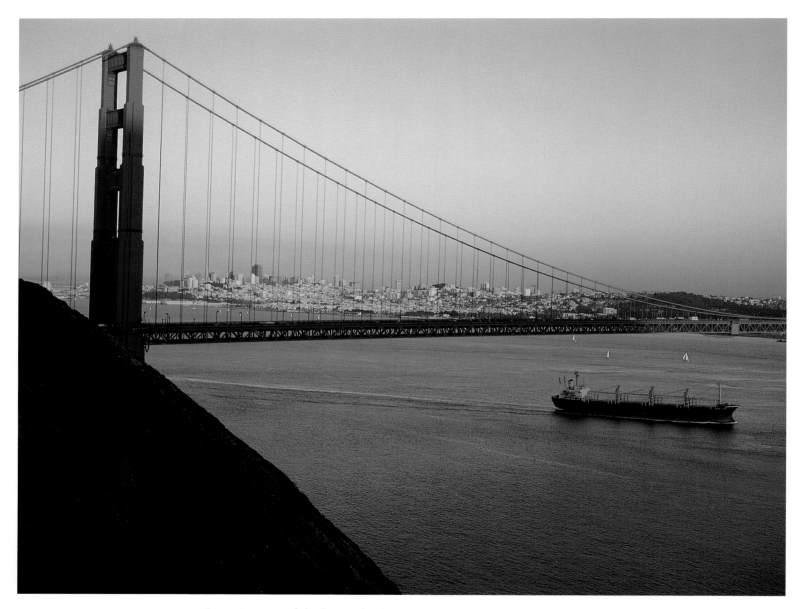

▲ Spanning one of the largest harbors in the world, San Francisco's 8,981-foot-long Golden Gate Bridge, completed in 1937, has become one of the icons of America. The San Francisco Bay area, with its population of some six million seven hundred thousand, is of vital importance to California in the fields of commerce, industry, research, education, and cultural activity.
▶ Coast redwoods tower above a country lane in Jedediah Smith Redwoods State Park and Redwoods National Park. The world's tallest living thing, coast redwoods may grow to three hundred seventy feet. These trees live in a narrow band twenty miles wide and five hundred miles long in Northern California. Redwoods have inhabited earth one hundred sixty million years.

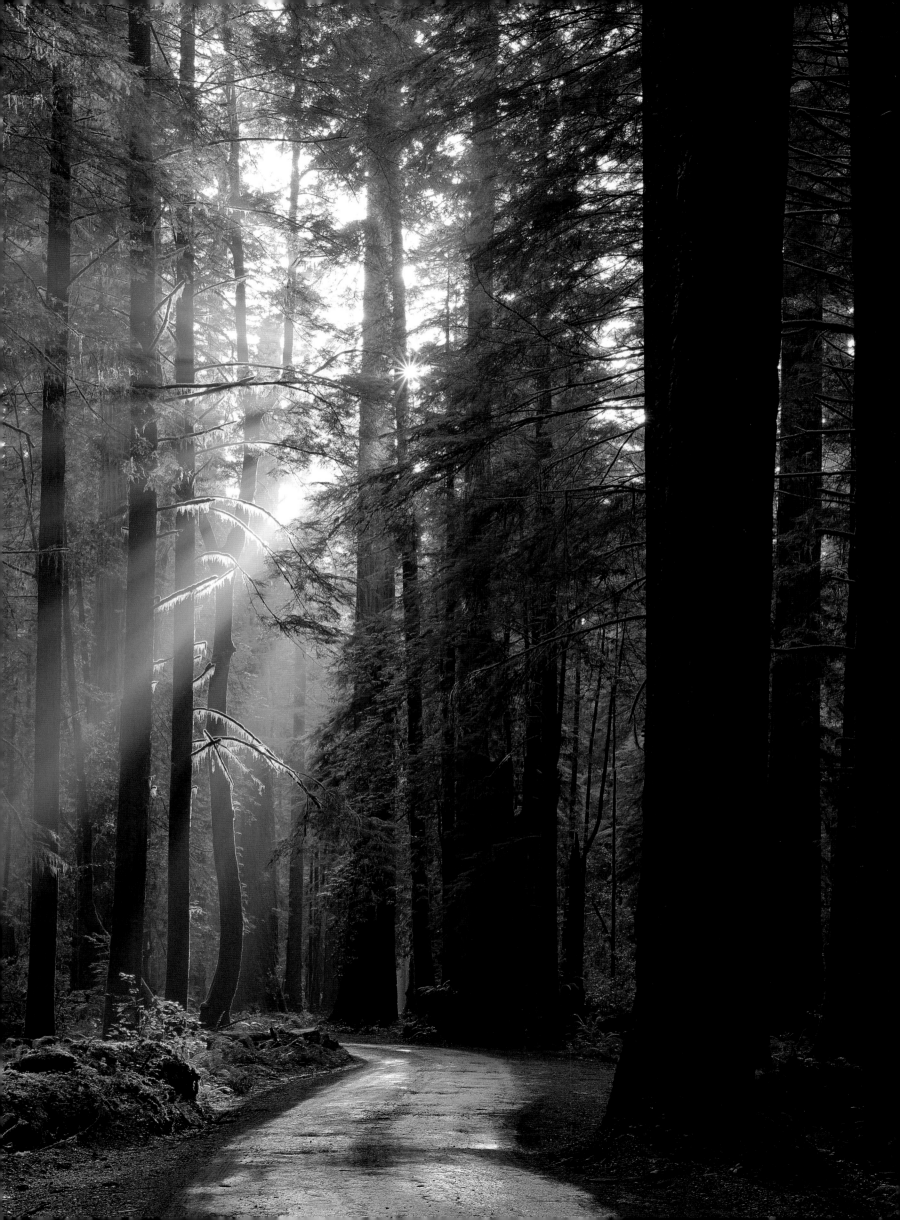

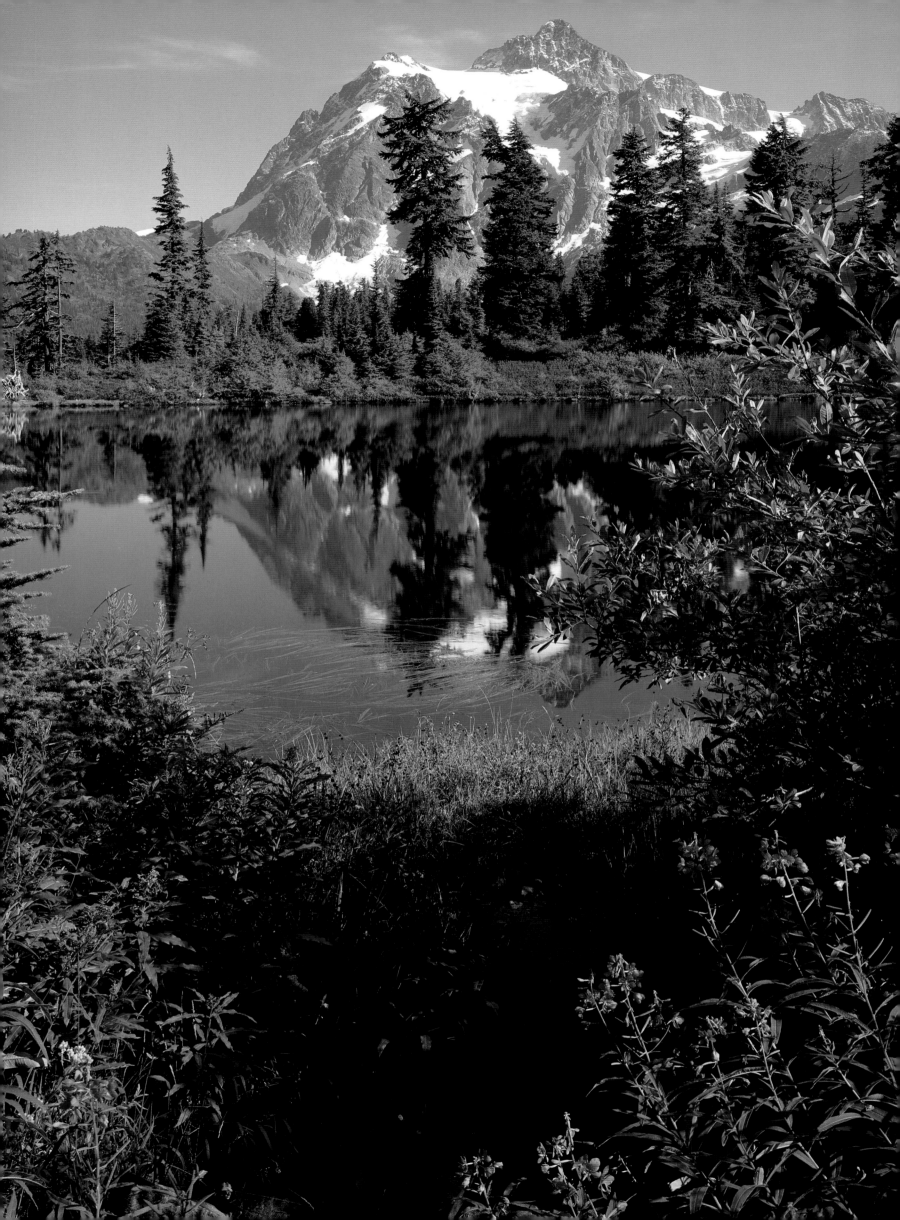

THE NORTHWEST

In 1846, at the end of the Oregon Trail, Thomas Bonney wrote in his diary, "We can say we have found the most splendid and beautiful country, with rich prairie land and timber adjoining, together with good water and springs. . . ." Bonney was one of thousands who endured a bruising, two-thousand-mile trip by covered wagon for the promise of a new life in the Pacific Northwest. They called it the "New Eden."

Above: *Ilwaco Harbor lies near the mouth of the Columbia River on the Washington side.* Above right: *A coniferous forest lies west of Big Creek Summit in Idaho's Boise National Forest. Canyons, lava fields, plains, waterfalls, mountains, forests, sand dunes, lakes, and rivers give Idaho a varied landscape.* Left: *Mount Shuksan, 9,125 feet high, reigns over North Cascades National Park. The North Cascades are called American Alps.*

Each spring in the mid-1800s, the long wagon trains from Independence, Missouri, snaked across the prairies and over the Rockies, leaving a trail of possessions and grave sites in their wake. Oregon Country began in what is now Idaho, but the wagons pushed on, crisscrossing the Snake River and rafting through the windswept, wickedly beautiful Columbia River Gorge. They were headed for the fertile, well-watered valleys beyond the Cascades.

A Native American legend explains the region's geography with elegance. Long ago, it seems, Ocean scooped dirt from Puget Sound and built a wall of mountains to keep his children, Rain and Cloud, close to home. As a result, the land west of the Cascades is lush and green, but the skies are often cloudy; east of the mountains the sun shines, but the land is thirsty.

Northwest population has concentrated west of the Cascades. Idaho residents will tell you they are glad; it gives them room to enjoy the "Light on the Mountains," which is what *E-dah-ho* means. The Northwest's

two major cities were situated for water access. Seattle weaves around Puget Sound inlets; Portland bridges the Willamette River, just before it reaches the Columbia. Seattle, dubbed "the Emerald City" for its lush vegetation, is a sophisticated metropolis with an easy, relaxed atmosphere. Clean, friendly Portland is a tribute to good planning and strong civic pride.

Snow-capped Cascade peaks grace the skylines of both cities. According to Klikitat Indian legend, those volcanic mountains were once handsome braves, in love with the same beautiful maiden. They fought so furiously that rocks and fire flew across the Columbia River and the very earth shook. To stop the fuss, the gods finally changed them into Mounts Rainier and Hood. The maiden, who became Mount St. Helens, had the last word; she blew her top in 1980.

The Northwest's Native Americans, among the continent's most prosperous, enjoyed abundant timber, fish, and game. They lived in sturdy longhouses, built stout canoes, carved handsome ceremonial masks, and held elaborate potlatches. Living as one with the land, they apologized to the spirit of each fat salmon they took from its rivers.

That richness is not lost on present-day occupants, either. Leaders in environmental concerns, they have an unabashed love of the out-of-doors. Camping in the forests of Olympic National Park, biking in the San Juan Islands, skiing on Mount Hood, rafting on the Clearwater River, walking along the cliff-lined Oregon Coast—even for city dwellers, all these pleasures are within easy reach. Hiking, climbing, hang gliding, skiing, sail boarding, white-water rafting—Northwesterners do it all.

Lewis and Clark, who forged to the mouth of the Columbia in 1806 at Thomas Jefferson's request, grumbled in their journals about the rain. But anyone who lives in the Northwest—or has, and longs to return—will tell you that gray days and drizzle are a small price to pay for those glorious, clear-skied days, when mountains rise sharp and white on the horizon. A small price, too, for easy access to forest trails, splendid slopes, and quiet beaches, all in an area where people take time to enjoy them.

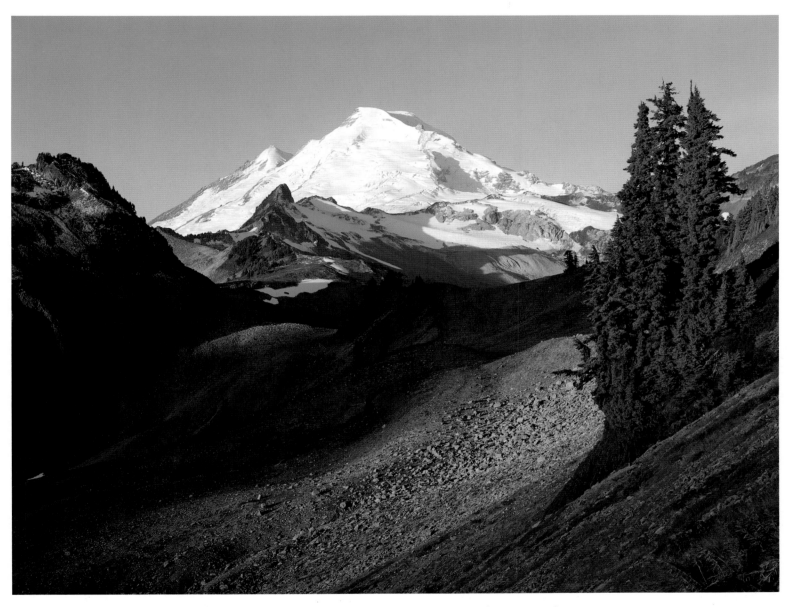

◄ Subalpine fir stands at Washington Pass, in Washington's Okanogan National Forest. Opened in 1972, the North Cascades Highway allows access to the state's wildest mountains. The Cascade Range is named for its many waterfalls. These young mountains rose five to six million years ago.
▲ A "sleeping giant," 10,775-foot Mount Baker has erupted several times since the last Ice Age. Part of the North Cascades, it reigns over Mount Baker Wilderness in Washington's Mount Baker-Snoqualmie National Forest.

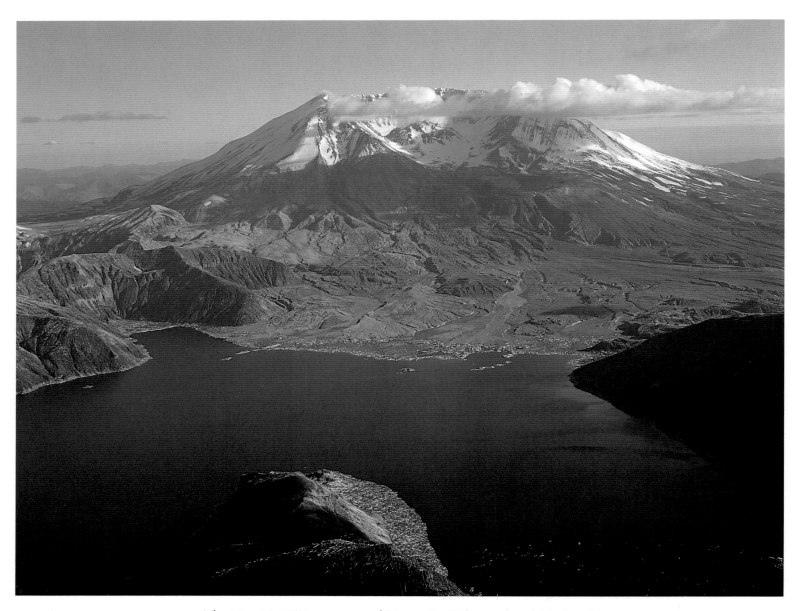

▲ The May 18, 1980, eruption of Mount St. Helens reduced its elevation from 9,677 feet to 8,366 feet. On that fateful day, a fiery billow of smoke and ash rose up over sixty thousand feet. The mountain, as well as the surrounding land, was left in a devastated condition, and sixty people lost their lives.
▶ Founded in 1825 as a part of Hudson's Bay Company's fur trading empire, Fort Vancouver was named for the Northwest explorer, Captain George Vancouver. Today, the site is part of the city of Vancouver, Washington.

◄ Spike mosses hang from branches of a bigleaf maple in Hoh Rain Forest. Washington's rain forest receives up to 140 inches of precipitation yearly.
▲ Young tree roots embrace a decaying stump in Hoh Rain Forest of Olympic National Park. Nursery stumps provide a new start for seedlings.

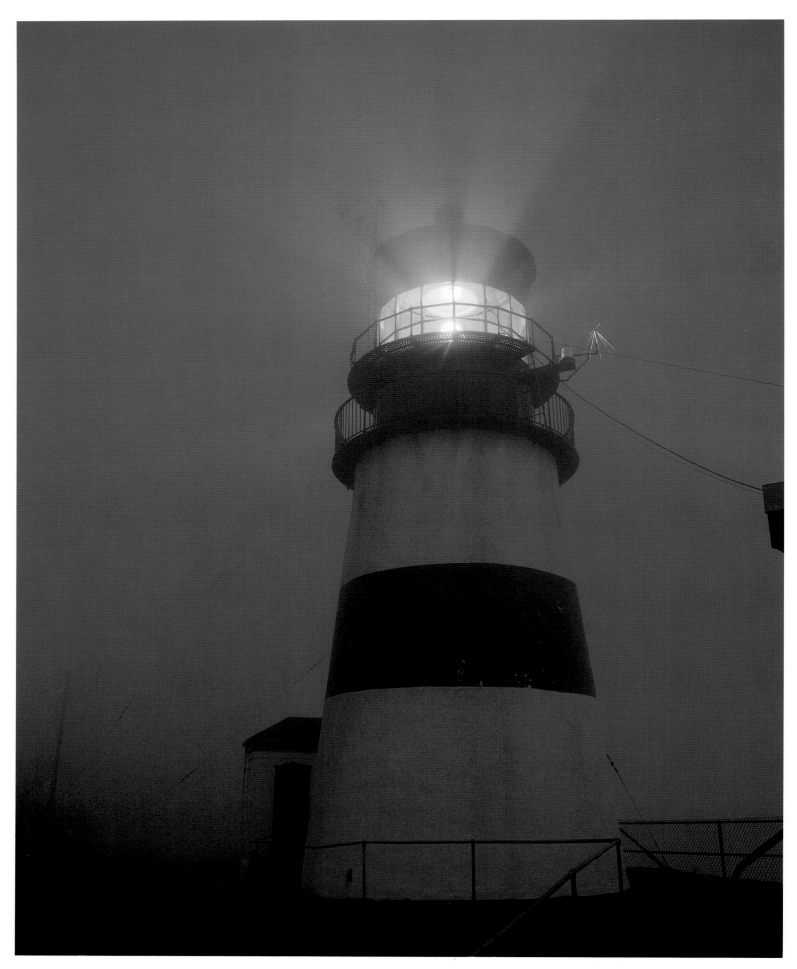

▲ Cape Disappointment Lighthouse, built in 1856 at the mouth of the
Columbia River in Washington, is the Northwest's oldest active lighthouse.
▶ Point of the Arches is on Washington's coast in Olympic National Park.
▶▶ Cape Kiwanda typifies Oregon's coast that thwarted early exploration.

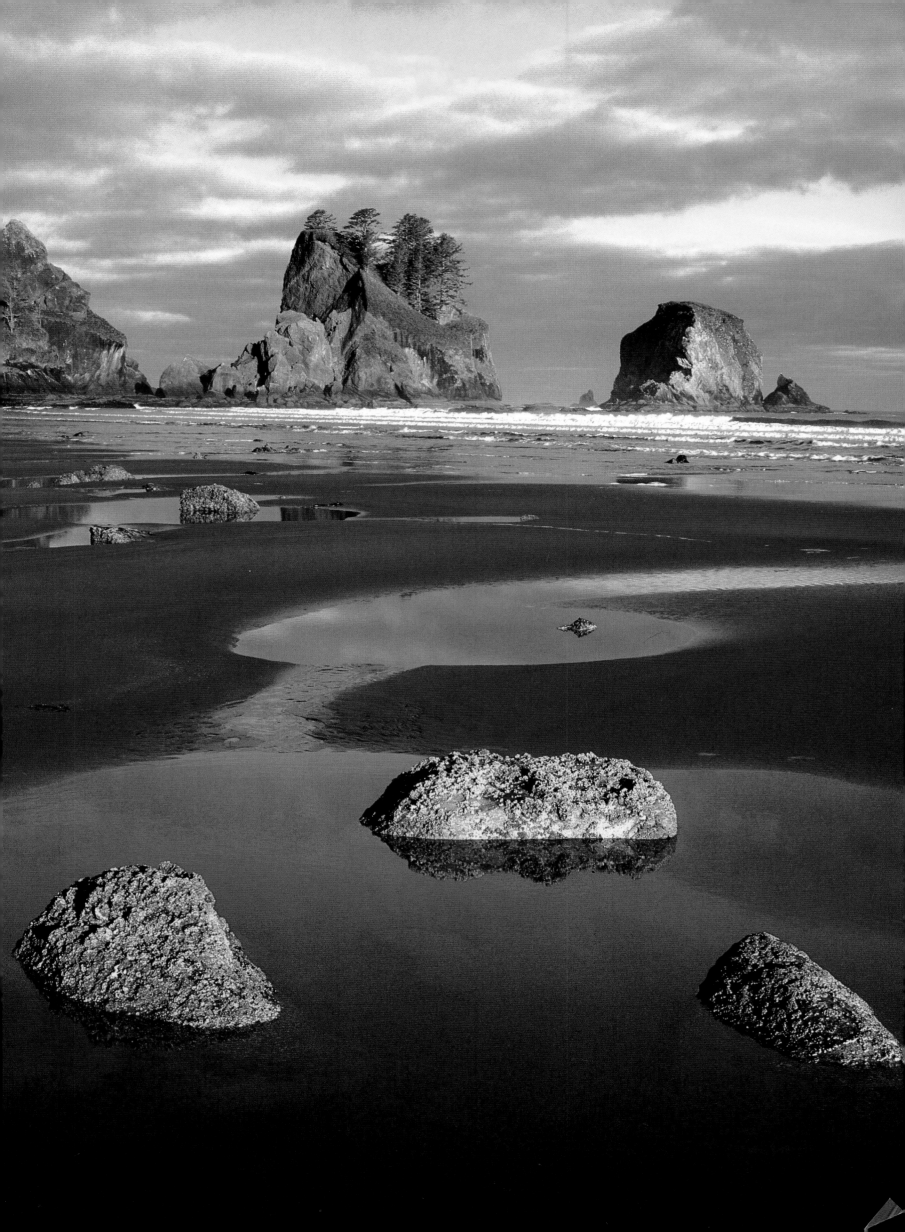

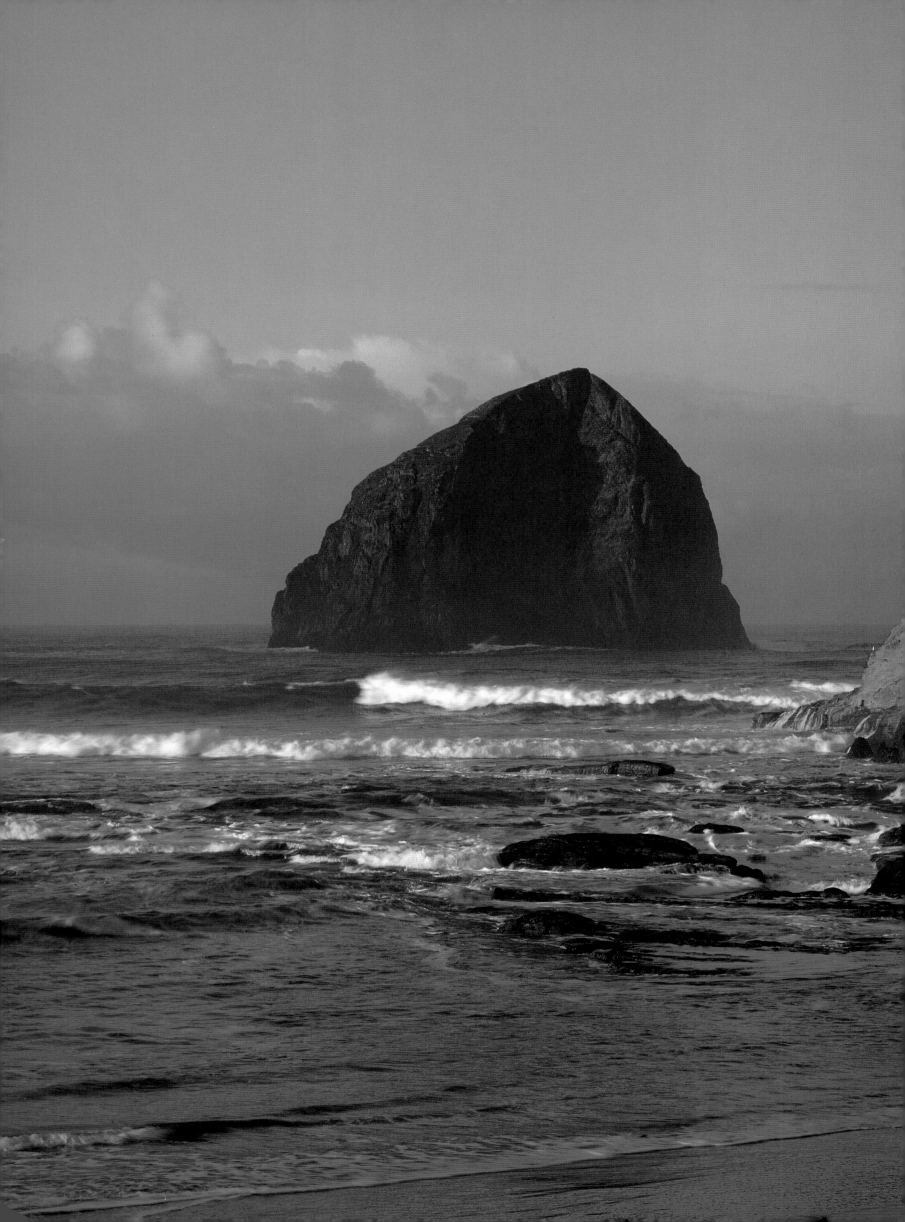

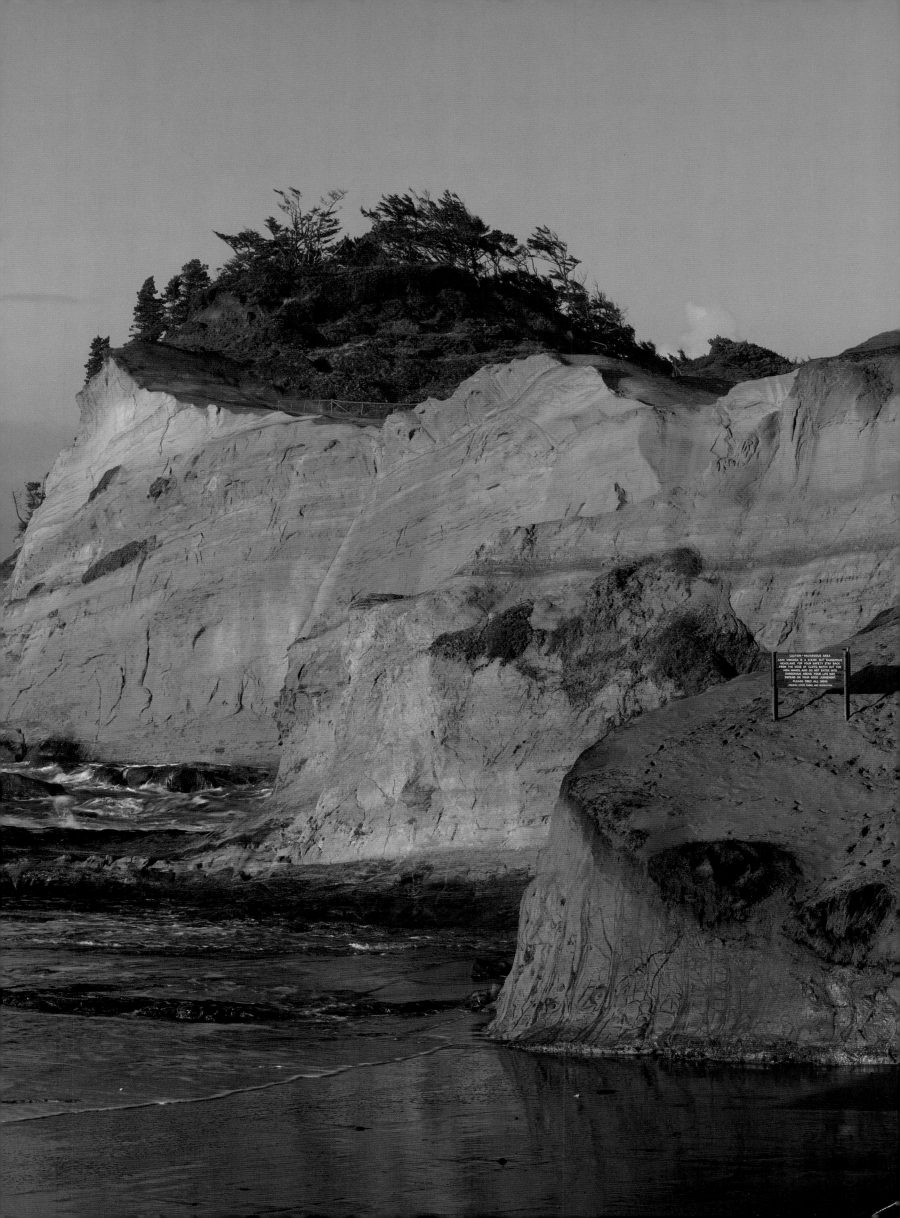

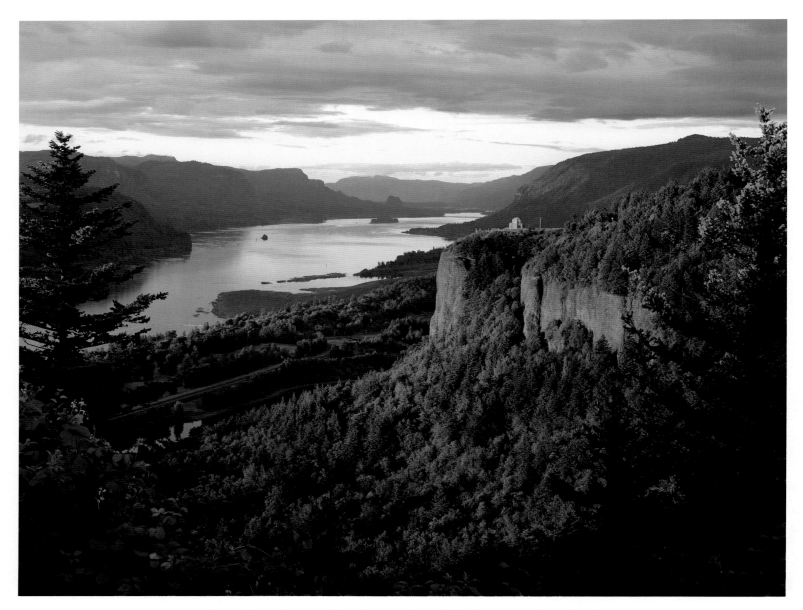

▲ Crown Point features Vista House, situated 725 feet above the Columbia River. Made of stone brought over by Italians, Vista House was completed in 1916. It serves as a complimentary rest stop along Oregon's scenic Crown Highway and offers magnificent views east and west of the Columbia River.
▶ Ornamental maples in Sandy, Oregon, provide a beautiful foreground for 11,234-foot Mount Hood. Mount Hood was both anticipated as a landmark and dreaded as an obstacle by travelers on the Oregon Trail.

◄ Steptoe Butte State Park in eastern Washington rises above rolling wheat fields. Dryland wheat grows best in conditions of ten to twelve inches of annual precipitation and yields thirty to forty bushels per acre.

▲ Winthrop, Washington, settled in 1891, still boasts board sidewalks and many of its original buildings. In its early years, the town was a supply point for the surrounding farming community. In summer, visitors are attracted to the small town—population 350—because of its frontier-style atmosphere.

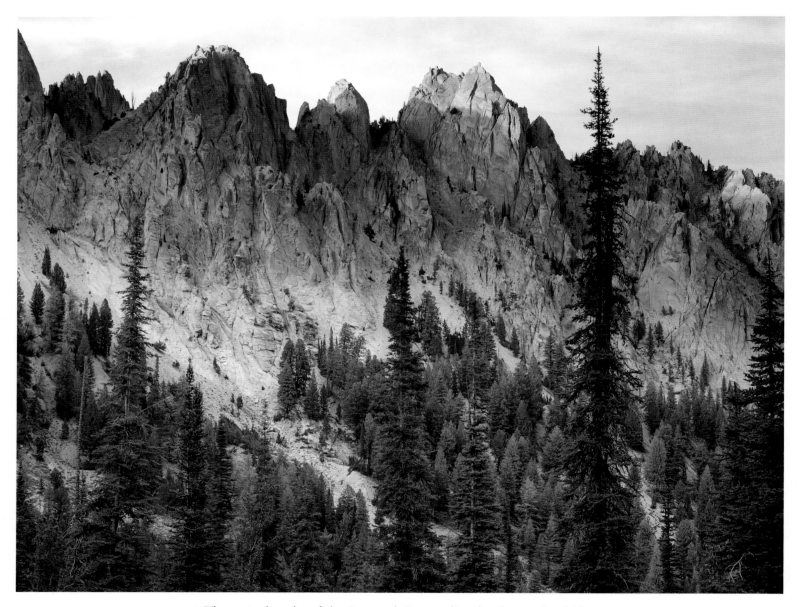

▲ The rugged peaks of the Sawtooth Range slice the sky north of Alpine Lake in the Sawtooth Wilderness in Idaho's Sawtooth National Forest. These mountains are part of a 16-thousand-acre wilderness within the 754-thousand-acre Sawtooth National Recreation Area established in 1972. Forty-two peaks in the Sawtooth Range rise higher than ten thousand feet.
▶ Mount Regan, at 10,190 feet high, looms above crystalline Sawtooth Lake. Cirque glaciers have sculpted the rugged peaks of the Sawtooth Range, creating one of the most beautiful mountain ranges in the country.

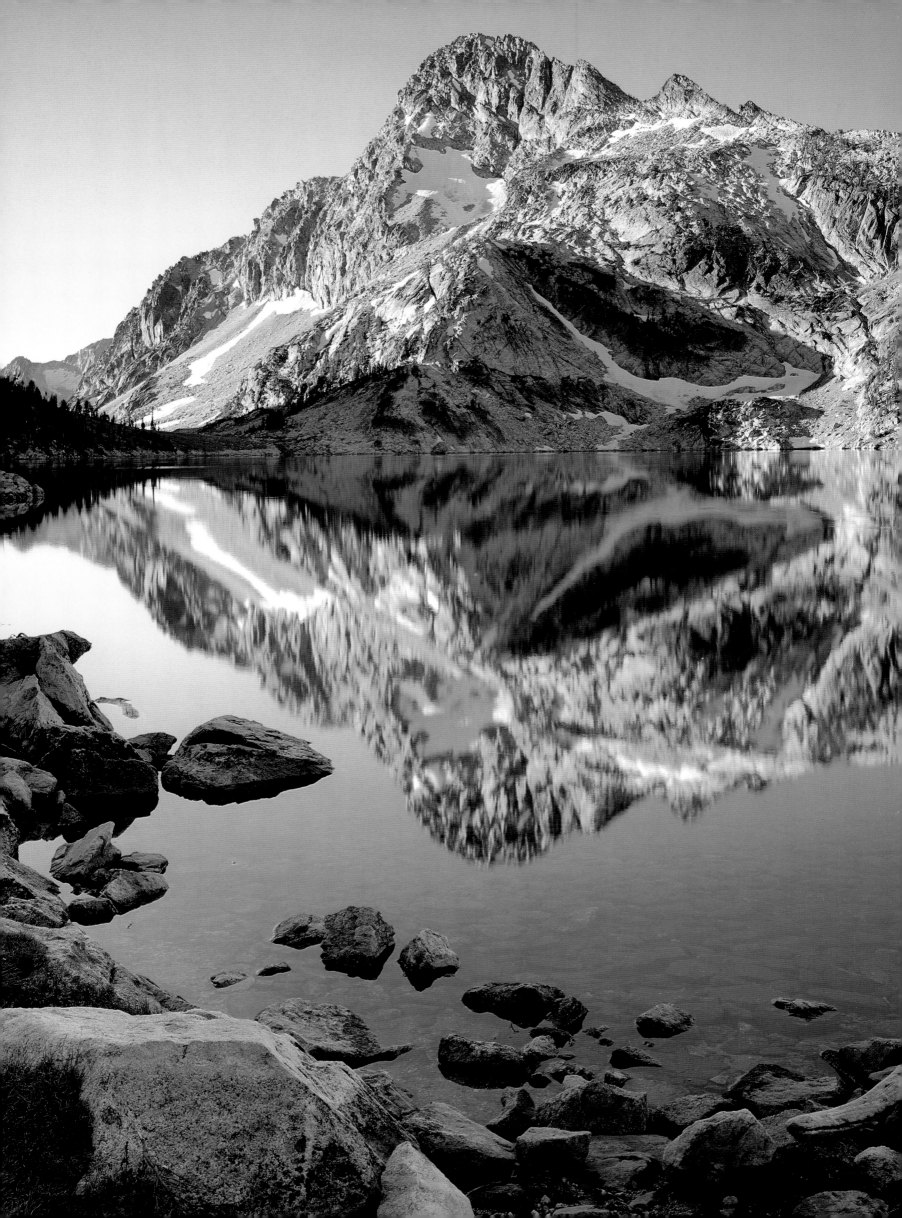

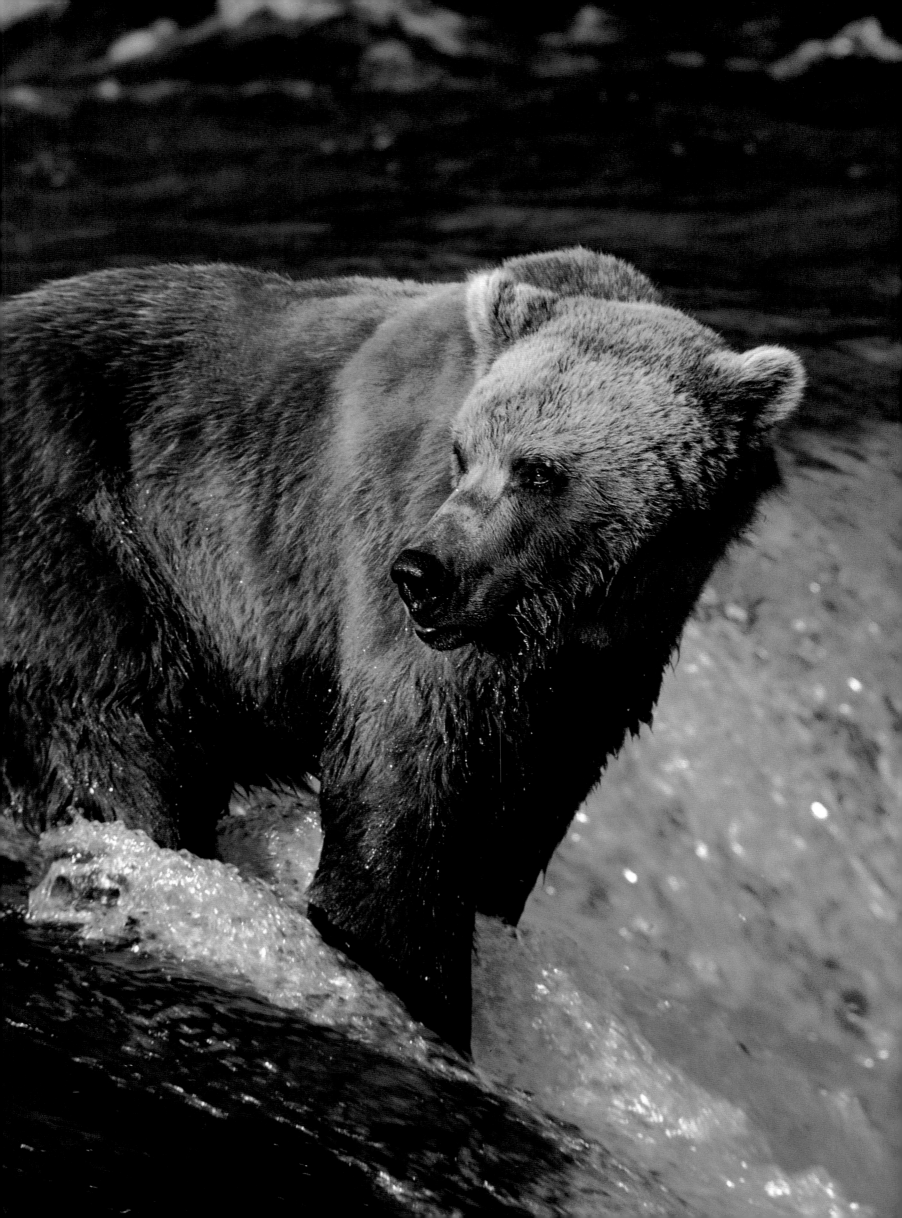

ALASKA

America's last frontier lies to the north, in the wild and beautiful 49th State. Its natural wonders inspire awe in the most seasoned traveler—massive mountains and glaciers, miles of tundra, wild animals roaming free, night skies painted with mysterious colors. Alaska offers challenge, opportunity, and elbow room to spare. Its name, from the Aleut word *Alyeska,* means "Great Land." It is well deserved.

Above: *A Dall sheep lamb pauses during a summer romp on Alaska alpine tundra.* Above right: *Round Island, in the Walrus Islands State Game Sanctuary in the Bering Sea, provides sanctuary for horned puffins.* Left: *An Alaskan brown bear, also known as grizzly, fishes for salmon. A summer diet of fat-rich salmon allows the largest bears to weigh more than one thousand pounds.*

Alaska contains 586 thousand square miles, making it one-fifth as large as all the "Lower 48." Just over half a million people live in all that space, nearly half of them in Anchorage. The rest are far-flung, some beyond reach of roads. Even Juneau, the capital, is reached only by plane or boat.

Alaska's first settlers crossed by land bridge from Asia some six to perhaps fifty thousand years ago. They comprise four main ethnic groups: Athabaskan in the Interior, Yupik and Inupiat along the coast, Tlingit and Haida in Southeast, and Aleut across the gulf. Today, common feelings about the land unite these Native people in an effort to preserve their way of life.

The discovery of "soft gold"—otter and beaver pelts—caused the first disruption. Russians moved in after Vitus Bering's 1741 expedition. Their legacy is Alaska's beautiful Russian Orthodox churches. In 1867, America bought Alaska, reluctantly, for less than two cents an acre. Many called it "Seward's Icebox" after the Secretary of State who championed the purchase.

America's policy in Alaska was benign neglect until gold was discovered in Juneau in 1880. Later, the salmon industry brought a surer fortune. Copper mining came along in the early twentieth century. The advent of the airplane in the 1920s opened up Alaska's Interior and began the era of the legendary "bush pilots." Oil became a driving economic force after the 1940s. In 1959, Alaska celebrated statehood.

Alaska could be several states in terms of geography and weather. In the cool, damp Southeast, snow-capped coastal mountains slope down to misty fjords, and evergreen forests thrive. In Southcentral Alaska, the summers are warm and the valleys fertile; in Matanuska Valley, long days of sun produce unbelievably huge vegetables. Central Alaska, bounded by the Brooks and Alaska Ranges to the north and south and cut by the Yukon River, is a vast expanse of plains, hills, and mountains. Temperatures vary wildly—from ninety degrees Fahrenheit in the summer to minus sixty in the winter. On the windy, rainy Alaska Peninsula and the Aleutians, year-round temperatures are moderated by a maritime climate. One-third of the state lies within the Arctic Circle. At Barrow, the summer sun does not set for eighty-four days; however, in winter it does not rise for sixty-seven days.

The vastness of Alaska's landscape is humbling; its natural features, monumental. Based on sheer uplift, Mount McKinley is the world's highest mountain, soaring eighteen thousand feet from base to peak. (Mount Everest rises twenty-nine thousand feet above sea level, but only eleven thousand feet above the Tibetan Plateau.) In all, Alaska has nineteen mountains higher than fourteen thousand feet, ten rivers over three hundred miles long, three million lakes larger than twenty acres, and more than half of the world's glaciers.

This big, untamed state has a spirit all its own. Alaskans refer to the rest of the nation as *Outside,* not because they are unfriendly, but because they know they share something special. They are, in fact, some of the nation's friendliest people. As a Matanuska Valley author explains, "Alaska translates into an open smile and a warm handclasp."

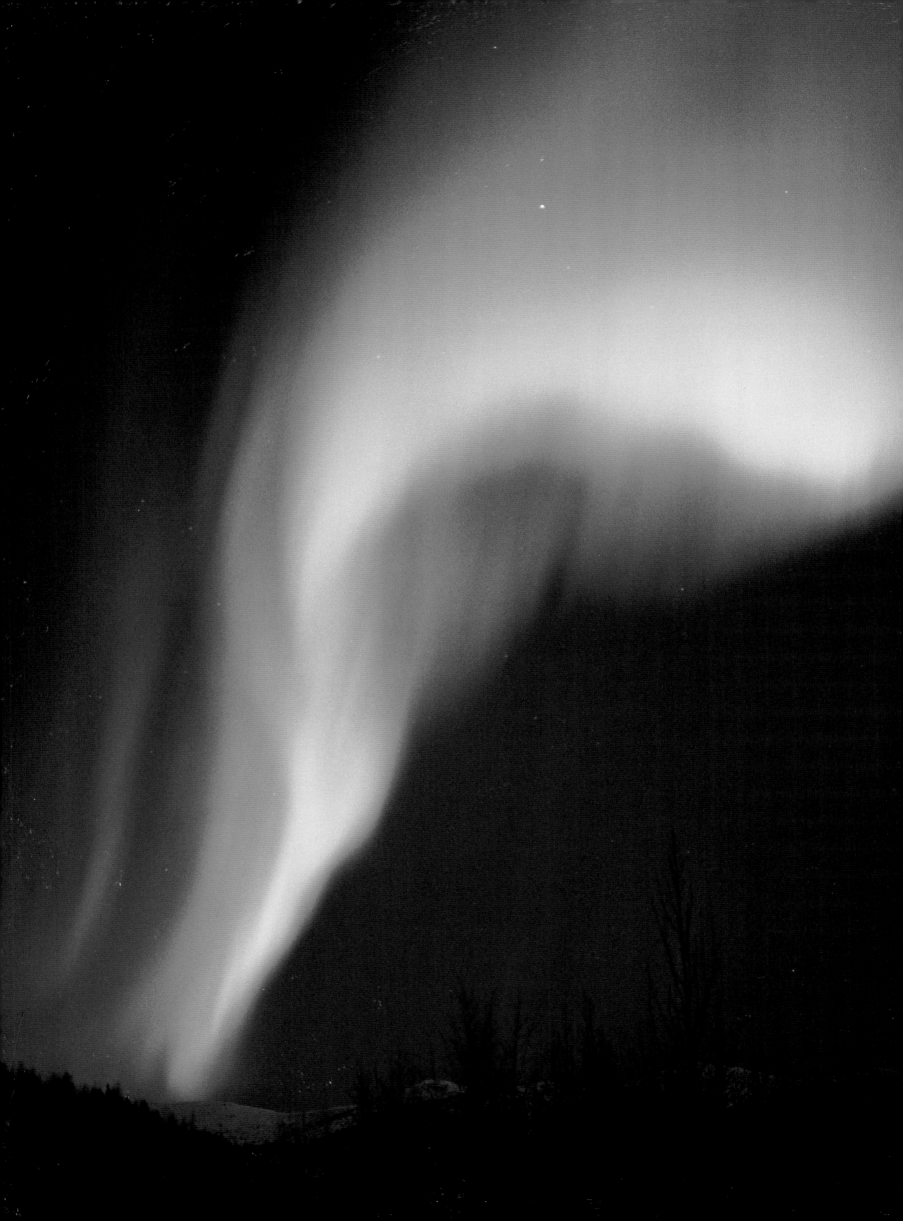

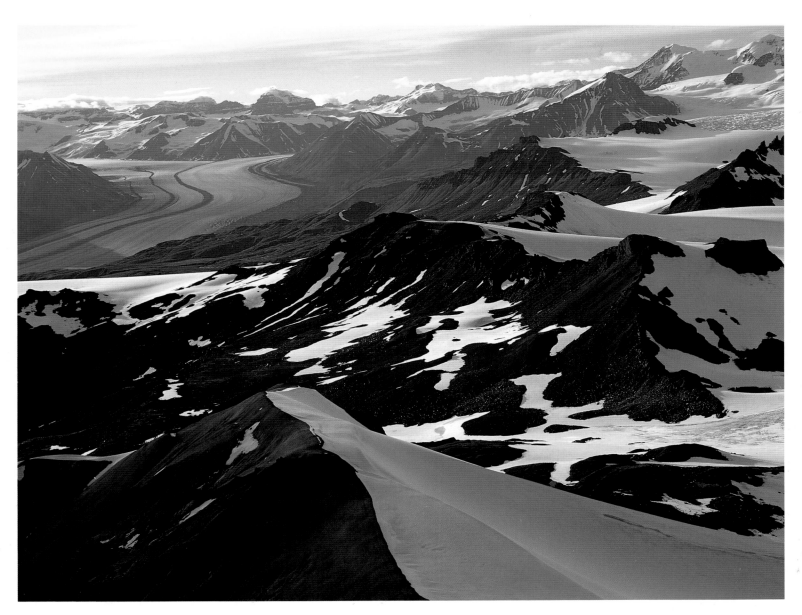

◄ Northern lights frequently brighten the night over a boreal forest east of Fairbanks, in Alaska's Chena River State Recreation Area. Technically known as the *aurora borealis,* the shimmering lights are caused by solar winds that strike oxygen and nitrogen high in very thin atmosphere.
▲ North of Skolai Creek, the Rohn Glacier is one of numerous glaciers in Alaska's Wrangell-St. Elias National Park. The nation's largest national park, at thirteen million acres, it is six times larger than Yellowstone.

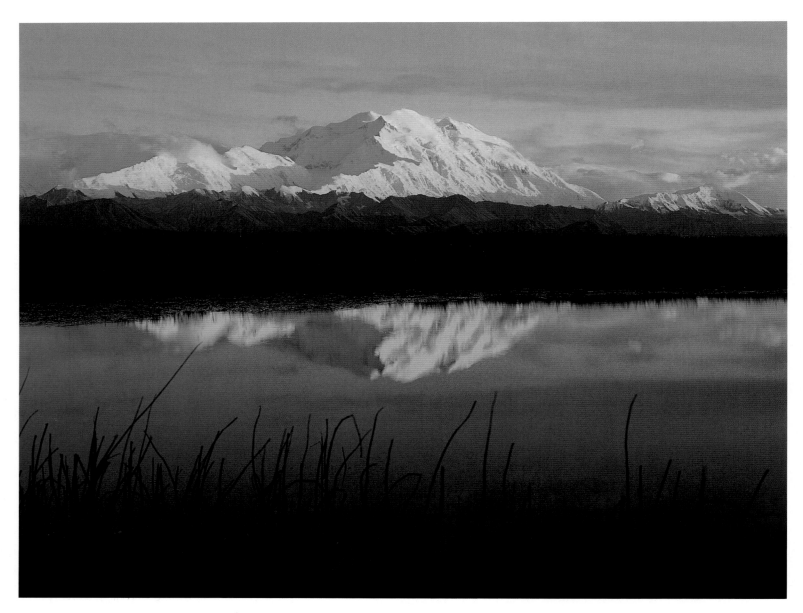

▲ North America's highest peak, 20,306-foot Mount McKinley, is more often referred to by Alaskans by its Native name, Denali, the "High One." Some one thousand mountaineers each year attempt to climb Denali. Below the towering mountain, Denali National Park is a wild and pristine wilderness inhabited by Dall sheep, caribou, moose, wolves, and grizzly bears.
▶ The iceberg-strewn Taan Fjord is situated in Icy Bay, in Alaska's Wrangell-St. Elias National Park. The park's high mountain areas receive up to fifty feet of snow. This precipitation spawns seventy-five named and many unnamed glaciers. The glaciers, in turn, generate twenty-four river systems.

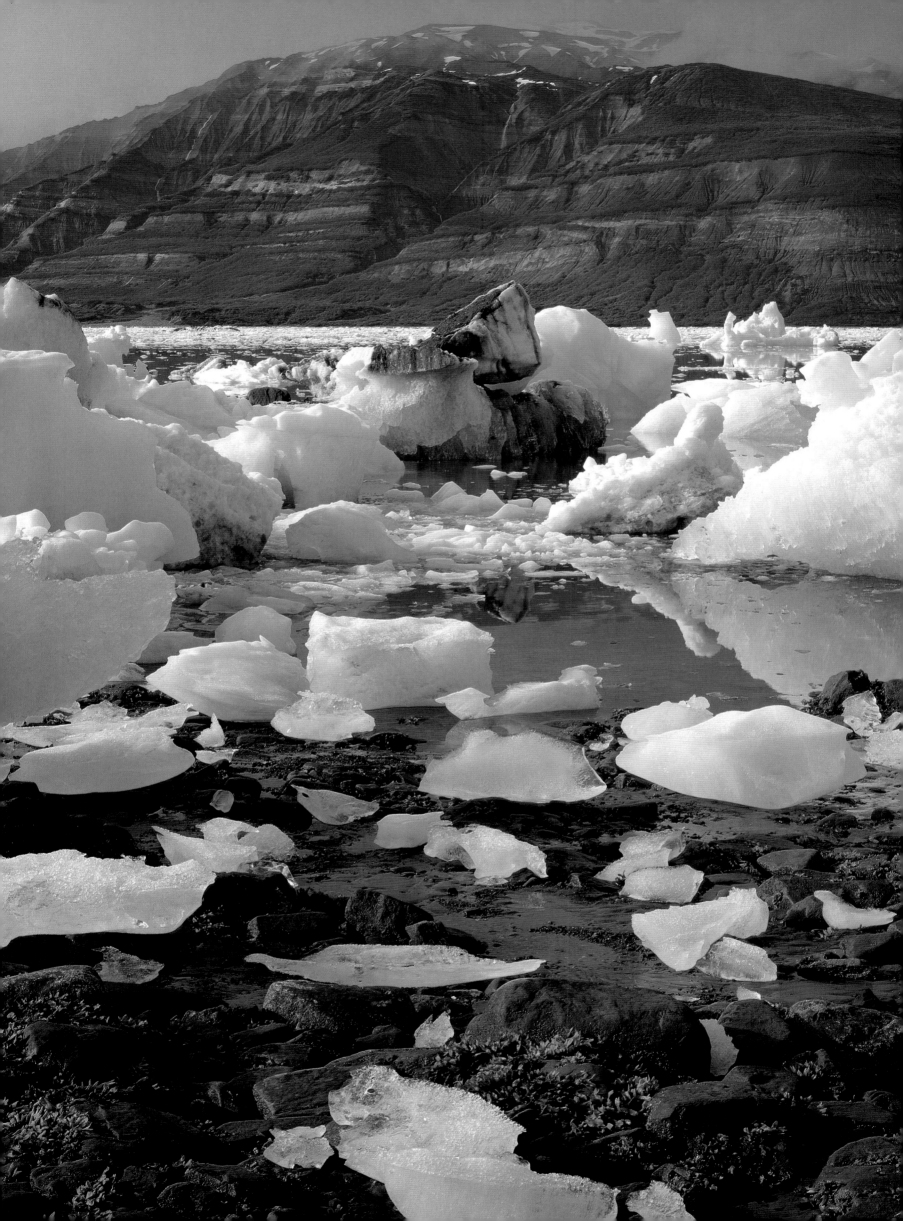

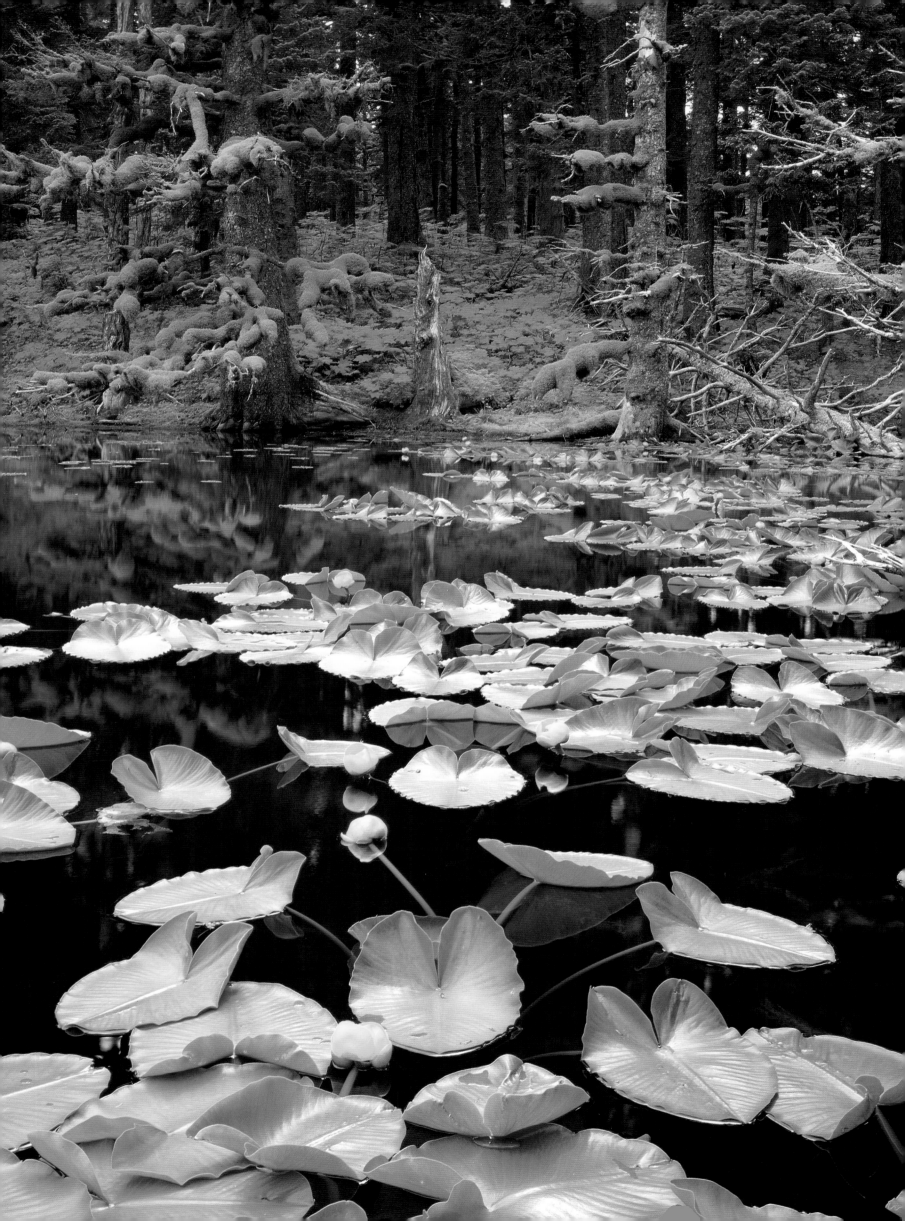

◄ Yellow pond lilies grow on Shuyak Island in the north end of Kodiak Archipelago. Nearby Shelikof Strait is known for its wild winds, dangerous tides, and steep waves. The word "Alaska" comes from the Aleut *Alyeska*, meaning Great Land. With more coastline than all the rest of the nation and more than twice as much land as Texas, Great Land seems an apt name.
▲ In 1741, Captain Vitus Bering claimed Alaska for the Czar of Russia, thus beginning the legacy of Russian influence in what would become America's 49th State. Many Native Alaskans today still hold the Russian Orthodox faith. St. Nicholas Church serves the Kenai Peninsula village of Ninilchik.

▲ Lake Clark National Park encompasses all the aspects of Alaska within its borders: magnificent landscapes, glaciers, volcanoes, tundra, alpine spires, lakes, rivers, and the sea coast; a large variety of wildlife; and the largest spawning ground in the world for sockeye salmon. Here, the wilderness shoreline of Lower Twin Lake highlights the brilliance of autumn.
▶ A bull walrus rests at a "haul-out" in the Bering Sea. The genus name, *Odobenus*, means "tooth walker," referring to the fact that the animal may use its tusks, as well as front and hind flippers, to climb and move about on land. The walrus is a very social animal, living and sleeping in colonies.

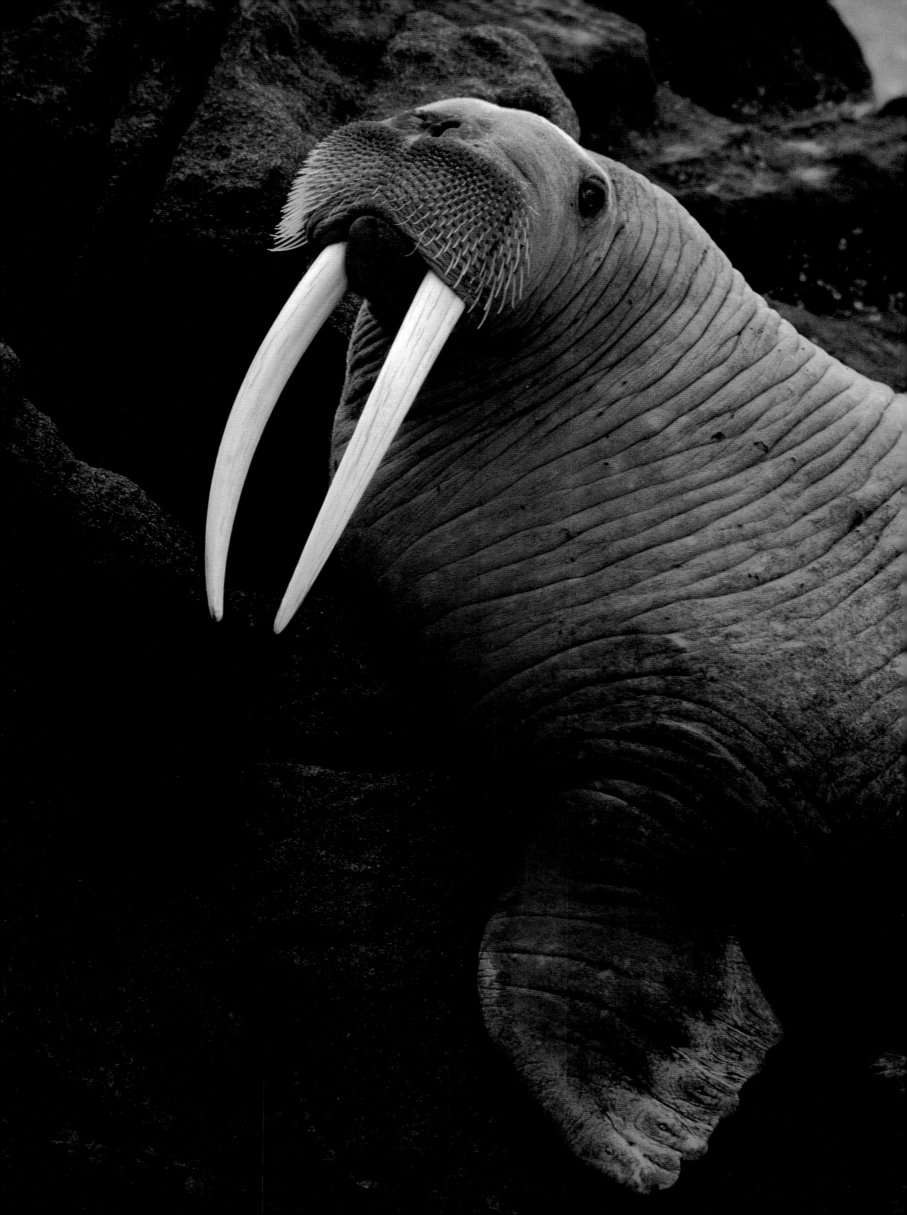

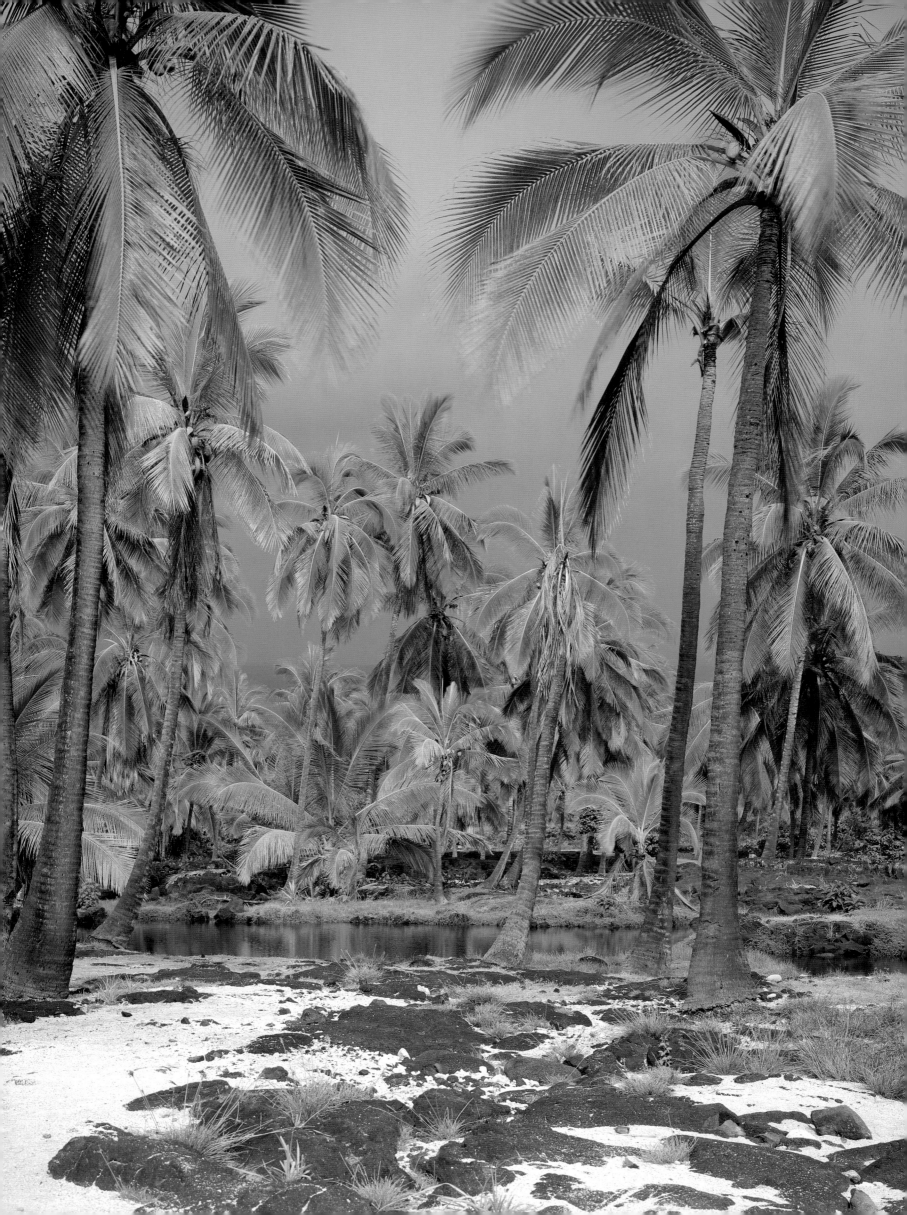

HAWAII

Samuel Clemens, better known as Mark Twain, visited Hawaii in 1866, just after steamship service began from San Francisco to Honolulu. Like so many writers and artists and tourists after him, he was captivated. He called this, simply, "the loveliest fleet of islands anchored in any sea."

Since that time, the monarchy has ended, Waikiki beach has been walled with high-rise hotels, and Honolulu has become a

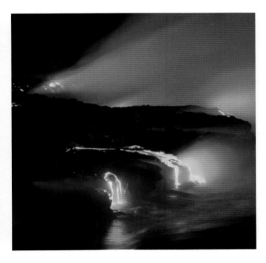

Above: *Rope lava, from the current flow of Pali Uli, in Hawaii Volcanoes National Park, is a manifestation of a Hawaiian Hotspot.* Above right: *Steam rises off lava spilling into colder waters of the Pacific. The Hawaiian Islands are the tips of immense, undersea mountains built up by volcanic eruptions.* Left: *Coconut palms line the royal fishpond of Pu'uhonua o Honaunau, a former place of refuge on the Big Island of Hawaii.*

metropolis. Tourism and commerce have added a twentieth-century stamp to the islands, and Hawaii has become America's fiftieth state. But truth has not changed. The air is fragrant with flowers, the sea is azure blue, the sun sets with unmatched splendor. The extraordinary natural beauty—and the healing spirit of Aloha—remain.

How the first Polynesian settlers found these lovely islands is something of a mystery; they lie farther from other land than anywhere else on earth. The islands were uninhabited, except by a wondrous array of birds, until adventurous sailors from the Marquises ventured north around 500 B.C. Tahitian settlers came later, bringing their culture with them. Piloting sturdy, double-hulled canoes, these first migrants navigated two thousand miles without benefit of instruments. Landing first on the island of Hawaii, they gradually settled other major islands—Oahu, Maui, and Kaui.

They fattened fish in seaside ponds and grew taro, coconuts, and bananas. They beat bark into soft "kapa" cloth and wove

brilliant bird feathers into velvety cloaks for their ceremonial dress. They paid tribute to a pantheon of gods and lived by a system of laws called "kapu." They lived well and knew how to enjoy life; favorite sports included sledding down hills on ti leaves and riding the surf on huge wooden boards.

After Captain James Cook's visit in 1778, it all began to change. An ambitious noble named Kamehameha observed the power of firearms and laid plans to unite all the Islands under his control. Europeans discovered the potential for profit in whales and sandalwood, and the center of power shifted from the island of Hawaii to Oahu and its harbor, Honolulu. The exposure to Western ways precipitated the collapse of kapu. American missionaries stepped into the vacuum, building churches and proliferating the style we call the muumuu. By the time Twain arrived, Hawaii's *alii*, the ruling class, had embraced Christianity, wedged their bronze bodies into "civilized" attire, and adopted Western manners.

Economics transformed the Islands. The missionaries' children built ranches and plantations. Fortunes were made in sugarcane, pineapple, and shipping. Laborers imported from all over the globe made the Islands a melting pot. The monarchy crumbled, American interests grew, and the Islands moved inexorably toward annexation in 1898 and statehood in 1959.

Change that could have become confusion has created, instead, a rich potpourri. Races and cultures have blended. Hawaiian pride has reasserted itself, and nature has refused to take a back seat. Honolulu's freeway is often arched with double rainbows, and sunsets still stop tourists in their tracks.

Beyond the tourist bustle, the flavor of old Hawaii can still be tasted. There are still peaceful valleys and tarrow fields, lush rain forests, wild orchids, and ripe papayas for the picking. Some of the world's most beautiful beaches still wait quietly. On Hawaii, Kilauea still belches fire; offerings to the fire goddess Pele still appear at the crater's edge.

The enduring reality of the Islands is in that well-worn greeting/goodby/love word. Literally, it is *Alo,* meaning "to face," and *ha,* meaning "the breath of life." Aloha.

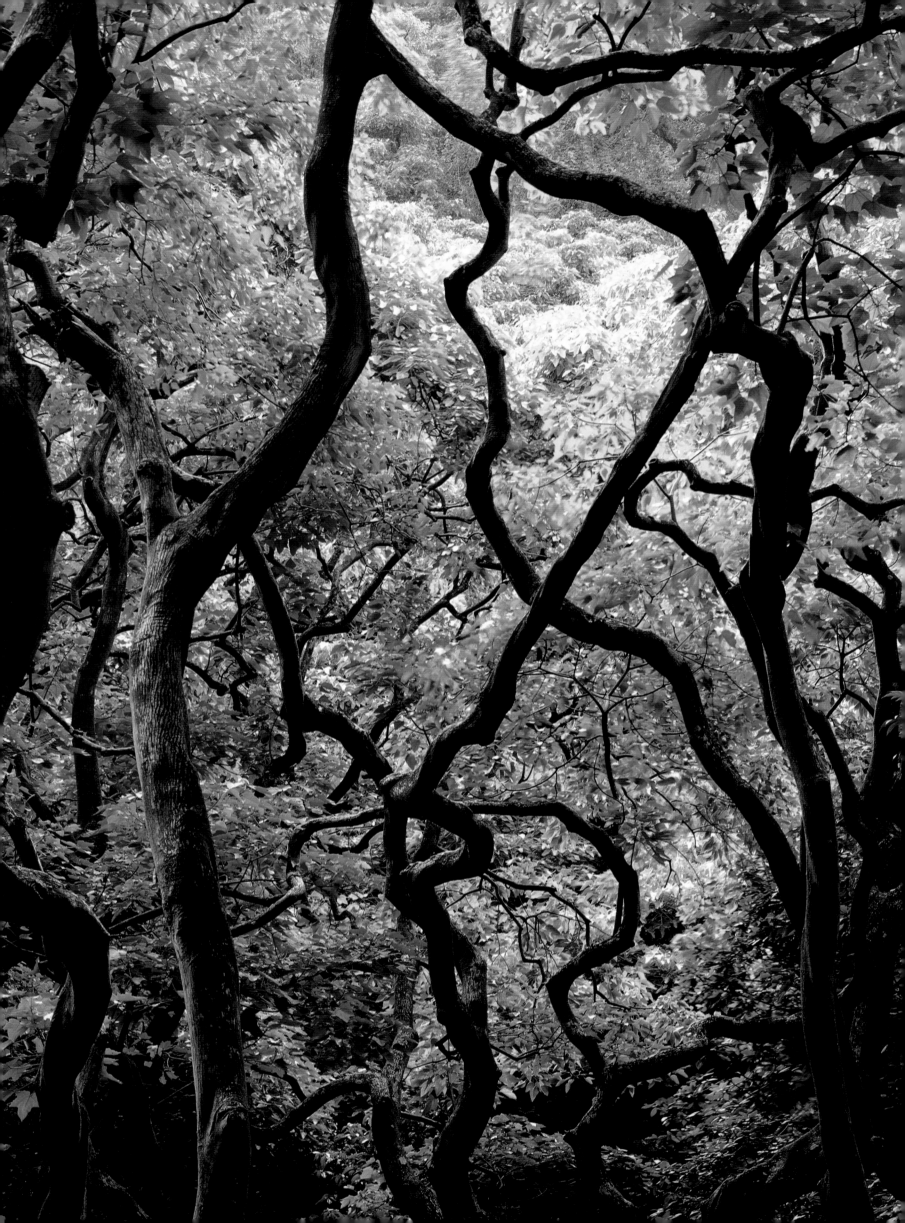

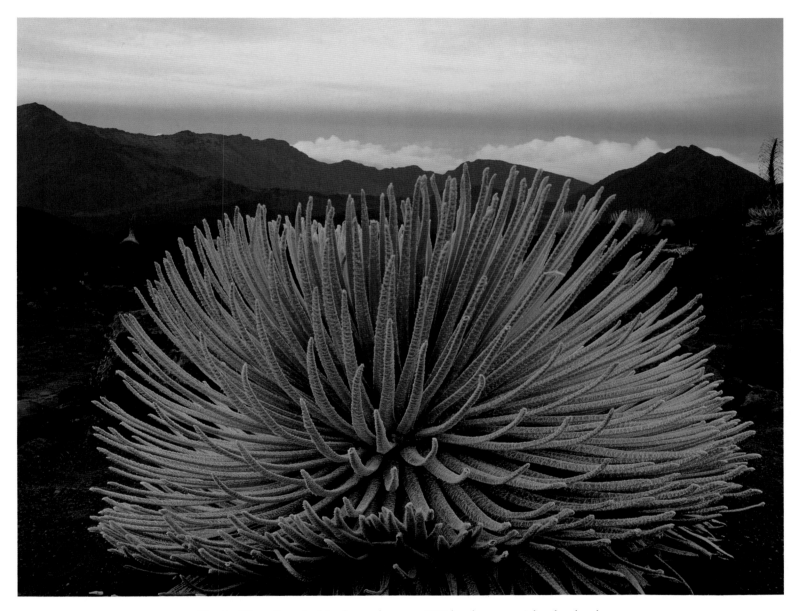

◄ In the Hawaiian Archipelago, there are 132 land masses: islands, shoals, atolls, and reefs. A tropical rain forest situated near Wailua Falls, on the Island of Maui, demonstrates the lush vegetation found on the islands.
▲ Maui's Haleakala National Park and the adjacent Nature Conservancy lands provide refuge for rare and unusual Hawaiian flora and fauna. The endangered silversword grows nowhere else but on high mountains in the Hawaiian Islands. Producing a single stem of yellow and purple florets, silversword may live twenty years. It dies after blooming only once.

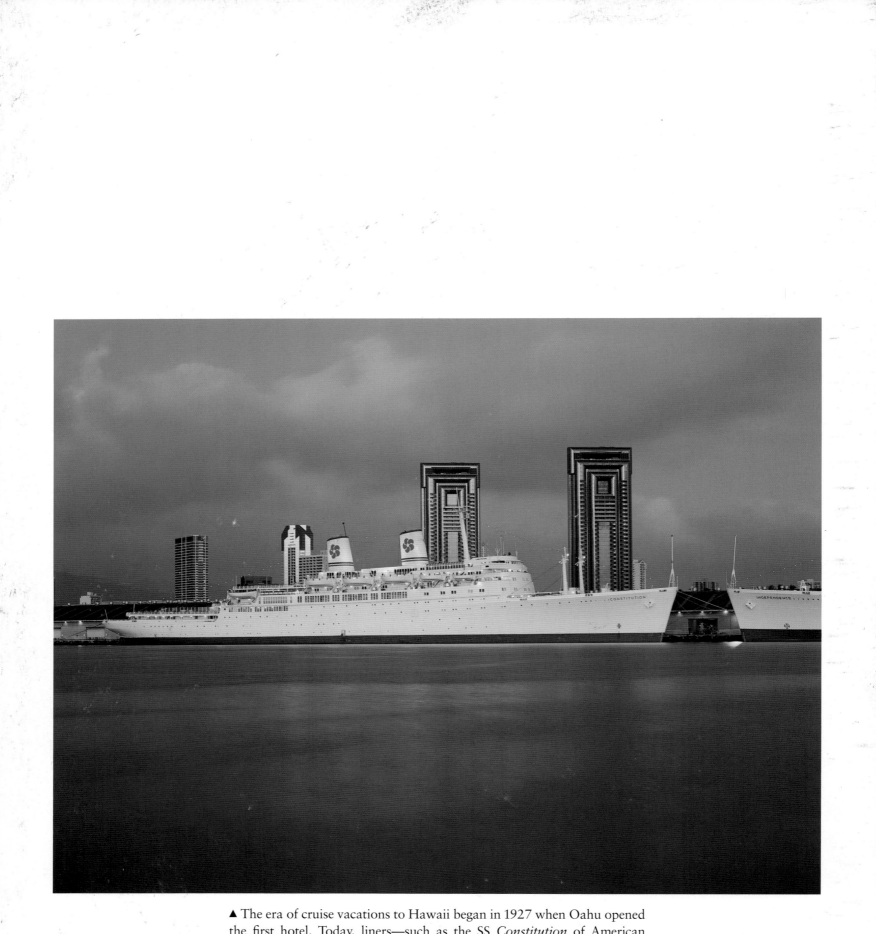

▲ The era of cruise vacations to Hawaii began in 1927 when Oahu opened the first hotel. Today, liners—such as the SS *Constitution* of American Hawaii Cruises—are frequent sights in Honolulu, Island of Oahu, Hawaii.
▶ Morning glory and lantana paint Puna Coast on the Big Island of Hawaii. Time and extreme isolation were essential for the development of Hawaii's unique native life. All mammals, except for a small brown bat and monk seal, arrived on these islands through intentional or accidental human aid.
▶▶ Water plunges 420 feet over Akaka Falls. A famous site on the Big Island of Hawaii, the falls attract up to three thousand visitors per day.